CUTTING ACROSS

MEDIA

CUTTING

APPROPRIATION ART,

ACROSS

INTERVENTIONIST COLLAGE,

MEDIA

AND COPYRIGHT LAW

Edited by

KEMBREW MCLEOD

AND RUDOLF KUENZLI

DUKE UNIVERSITY PRESS

Durham & London

2011

CONTENTS

ACKNOWLEDGMENTS

--

This book largely exists because of the conference Collage as Cultural Practice, which Rudolf Kuenzli and Kembrew McLeod organized at the University of Iowa in spring 2005. Many of the chapters contained in *Cutting Across Media* emerged directly from this event. We thank the Obermann Center for Advanced Studies, especially its director, Jay Semel, for the generous funds to hold this conference. Additional contributions from the University of Iowa allowed us to make the topic of collage a semester-long focus via a museum exhibition titled *Interventionist Collage: From Dada to the Present*, an exhibit in the entrance hall of the Main Library on *Collage and Zines*, and a collage film series, as well as a conference and several events focusing on intellectual property, which is a topic that directly bears on the future possibilities of collage in film, art, literature, and music.

All these events came about due to the enthusiastic support of colleagues and staff members in the Department of Communication Studies, English, Cinema, and Comparative Literature, as well as the University Libraries, the UI Museum of Art, the UI College of Law, and the Project on the Rhetoric of Inquiry. Funding for book indexing came from UI's Office of the Vice President for Research Book Subvention Fund. We are also indebted to a group of Intermedia students who spontaneously organized a semester-long do-it-yourself collage station in a community gallery. We thank our graduate research assistants, Raymond Watkins and Charlie Williams, for their help in organizing the conference, and Kathryn Floyd, Puja Birla, and Zane Umsted for assisting us in editing the manuscripts.

Our special thanks go to Jonathan Lethem for allowing us to reprint "The Ecstasy of Influence"; Negativland for selected passages from "Two Relationships to a Cultural Public Domain," from their *No Business* CD/ multimedia package; Carrie McLaren and *Stay Free!* Magazine for "Copyrights and Copywrongs: An Interview with Siva Vaidhyanathan" and

McLeod's "How Copyright Law Changed Hip-Hop: An Interview with Public Enemy's Chuck D and Hank Shocklee"; Mr. Len for providing a copy of the cease and desist letter he received from attorneys representing Philip Glass; and Davis Schneiderman for "Everybody's Got Something to Hide Except for Me and My Lawsuit: DJ Danger Mouse, William S. Burroughs, and the Politics of Grey Tuesday," which originally appeared in *Plagiary: Cross-Disciplinary Studies in Plagiarism, Fabrication, and Falsification* 2006.

We also thank Douglas Kahn for suggesting the title of this book. We are greatly indebted to Duke University Press, which chose the reviewers; their enthusiasm for this project and their astute comments helped us make this collection more concise and more focused. In particular, we thank Ken Wissoker for intellectual and editorial guidance, and Courtney Berger and Leigh Barnwell for their editorial assistance. I would also like to thank the following people at Duke University Press who helped usher this book into the world: Laura Sell, Amanda Sharp, Emily Young, Neal McTighe, Danielle Szulczewski, Michael McCullough, Katie Courtland, Amy Ruth Buchanan, Dafina Diabate, Beth Mauldin, and Helena Knox, as well as J. Naomi Linzer Indexing Services. Mucho thanks to the UI Communication Studies graduate students who helped me create a teaching guide based on this book and Creative License: The Law and Culture of Digital Sampling: Eve Bottando, Benjamin Burroughs, Jong In Chang, Dan Faltesek, and Benjamin Morton. Last, thanks to the world's most rockin' literary agent, Sarah Lazin.

KEMBREW McLEOD
AND RUDOLF KUENZLI

I Collage, Therefore I Am

An Introduction to *Cutting Across Media*

"A good composer does not imitate, he steals," Igor Stravinsky once re-
marked, expressing a sentiment that many well-known artists have
shared (quoted in Oswald, 1990, 89). Whether we are talking about Dada,
Cubism, Futurism, Surrealism, Situationism, or Pop Art, creators across
artistic movements have long acknowledged the centrality of appropria-
tion in their creative practices. Collage was an essential method used to
create literary works like T. S. Eliot's *The Waste Land*, Kathy Acker's *Blood
and Guts in High School*, William Burroughs's *Naked Lunch*, James Joyce's
Ulysses, and Marianne Moore's poetry. In the world of audio, collage prac-
tices played a key role in the development of avant-garde music, as well
as the birth of hip-hop—a largely African American musical genre re-
sponsible for popularizing remix culture within the mainstream, perhaps
more so than anything else.

Innovations in communication technologies (the phonograph, radio,
magnetic tape, and, later, digital media) gave people new ways of cap-
turing sound and image, which fundamentally changed their relation-
ship with media. Starting at the beginning of the twentieth century,
newspapers were the dominant media outlets that circulated cultural
and political texts, acting as ideological gatekeepers that shaped popu-
lar culture. For artists armed with scissors and paste, the messages in
newspapers' pages could be literally cut up, rearranged, and thus trans-
formed with available household tools and technologies. Later, magnetic
tape and celluloid were subjected to the hands-on manipulations of art-
ists who critiqued the dominant culture.

Collage is not merely a technique that characterizes a series of artis-
tic, literary, and musical movements, for it can be much more than that.

In his essay, "Modernism and the Collage Aesthetic," Budd Hopkins emphasizes that it is "a philosophical attitude, an aesthetic position that can suffuse virtually any expressive medium" (1997, 5). *Cutting Across Media* explores that philosophical attitude. The chapters included here implicitly or explicitly treat collage as a cultural practice that can intervene within mass media, consumer culture, copyright regimes, and everyday life. This book historicizes a wide range of appropriation tactics—ones that cut not just across media but also through national borders and human history. In doing so, it addresses a variety of media and genres: from poetry, literature, photocopied mail art, and "modified" outdoor advertisements to pop music, sound collage, and visual art.

This Ain't Just a Digital Thing

Cutting Across Media starts from the assumption that culture is a complex process of sharing and signification. Meanings are exchanged, adopted, and adapted through acts of communication—acts that come into conflict with intellectual property law. In light of these legal constraints, it is important to emphasize that these appropriation practices are variations on behaviors that make us, well, human. As children we learned to speak our native language by imitating the sounds heard around us, and as adults we often repeat pop culture catchphrases and songs drilled into our heads by the culture industry. In this way, people are organic, flesh-and-bone sample machines.

New technologies simply made it possible for people to engage with mass media in ways that echo the dialogic exchanges that occurred in more private, interpersonal settings—and in art scenes that existed at the margins of the mainstream. The Dadas showed us how appropriation could be a potentially powerful strategy for intervening in mediated representations of reality in the 1910s and 1920s. At that time, intellectual property was not a concern for Dada artists like Tristan Tzara and Kurt Schwitters. During the First World War they cut out the words of (copyrighted) newspaper articles and rearranged them according to chance, thus rendering war propaganda nonsensical.

In the early twentieth century, there was no equivalent of Gannett, NewsCorp., or any other powerful media conglomerate that might file a lawsuit against these art pranksters. Copyright also was not a concern of John Heartfield, whose later anti-Nazi photomontages decontextual-

ized mass-media photos and pulled back the ideological veils of fascism. Similarly, the Berlin Dada artist Hannah Hoech critically juxtaposed the mass media's constructions of the "new woman" in an attempt to expose these media images as yet further commodifications of women. Later in the twentieth century, Barbara Kruger's collages similarly questioned the media's more recent constructions of woman-as-consumer, as shopper, by repurposing mass-produced imagery.

The experiments of Tzara, Hoech, and Heartfield are also akin to the sign-scrambling work done by the Situationists—an anti-art movement inspired in part by Dada that emerged in 1957. They would, for instance, take a Hong Kong action film about gang warfare and replace the dialogue with one about class warfare, or they would alter comic strip speech balloons to subvert the original message. Situationists called this technique *détournement*. The closest English translation of détournement falls somewhere between "diversion" and "subversion." Another translation might be "unturning" or "deturning"—where culture is turned back on itself, against itself. Détournement is a plagiaristic act that, like a martial arts move, shifts the strength and weight of the dominant culture against itself with some fancy linguistic and intellectual footwork. This method was also a unique merging of art and politics. Situationists believed that the truths revealed by détournement, which lifted off "the ideological veils that cover reality," were central to their revolutionary project. Guy Debord, author of the influential *Society of the Spectacle*, insisted that a "Dadaist-type negation" must be deployed against the language of the dominant culture (Plant 1992, 86–87).

This impulse has manifested itself in popular music as well. Back in the 1930s, the politically active American folk singer Woody Guthrie used appropriation tactics to comment on the deluge of consumer culture in his songs. Guthrie once noted that "the Rich folks must have some way of making us poor folks believe their way, so they put out radio programs, sermons, moving pictures, books, magazines, and all sorts of silly advertising." He continues, "This junk is piled around every house in the world like a big pile of trash, but most folks believe it, and are sunk in it" (1990, 31). The impulse to appropriate from and intervene within popular culture was a key dimension of the folk music movement that emerged in the first half of the twentieth century.

By recycling folk melodies and adding his acerbic words to them, Guthrie used music to fight for the rights of workers, battling the rich

folks' "silly advertising" through song. For example, he wrote in his journal of song ideas: "Tune of 'Will the Circle Be Unbroken'—will the union stay unbroken. Needed: a sassy tune for a scab song." Guthrie also discovered that a Baptist hymn performed by the Carter Family, "This World Is Not My Home," was popular in migrant farm worker camps, but he felt the lyrics were politically counterproductive (Klein 1980, 120). The song didn't deal with the day-to-day miseries forced on them by the capitalist class and instead told the workers they would be rewarded for their patience in the next life:

> This world is not my home
> I'm just a-passing through
> My treasures and my hopes are all beyond the blue
> Where many Christian children
> Have gone before
> And I can't feel at home in this world anymore.

Guthrie understood this hymn to be telling workers to accept hunger and pain and not fight back. He mocked and parodied the original by keeping the melody and reworking the words to comment on the harsh material conditions many suffered through:

> I ain't got no home
> I'm just a-roaming round
> I'm just a wandering worker, I go from town to town
> And the police make it hard
> Wherever I may go
> And I ain't got no home in this world anymore. (Klein 1980, 120)

Guthrie was affiliated closely with the labor movement, which inspired many of his greatest songs; these songs, in turn, motivated members of the movement during trying times. This is one of the reasons he famously scrawled on his guitar, that "This Machine Kills Fascists." For Guthrie and many other folk musicians, music *was* politics, and he recognized the power of language and culture. Long before he appropriated his first tune, the International Workers of the World, or the Wobblies, were borrowing from popular melodies to write the songs that were published and popularized in their *Little Red Song Book* (officially titled *I.W.W. Songs*, and subtitled *To Fan the Flames of Discontent*). These songs also parodied religious hymns, such as "In the Sweet By-and-By," which was

changed to "You Will Eat, By and By" (Klein 1980, 82), with another sardonic line thrown in for good measure: "You'll get pie in the sky when you die" (Nelson 1989, 58).

In his book, *Repression and Recovery: Modern American Poetry and the Politics of Cultural Memory, 1910–1945*, Cary Nelson argues that this songbook was "designed as a deliberate cultural intervention." He adds, "most of the songs in the *Little Red Song Book* are set to well-known existing melodies, a practice reinforced through much of the nineteenth century in American labor songs" (59–61). As for the songs contained in the *Little Red Song Book*, their appropriations served a double purpose, according to Nelson:

> First, it ensured that people could sing many of the songs whether or not they read music. But it also had a more subversive aim: to empty out the conservative, sentimental, or patriotic values of the existing songs while replacing them with radical impulses. People in one sense, therefore, already knew the songs they would encounter in the *Little Red Song Book*, but they knew them falsely. The contrasting titles alone suggest the countervailing value systems. . . . "Take It to the Lord in Prayer" becomes "Dump the Bosses off Your Back," turning patience into impatience and replacing religious consolation with practical action. . . . Sometimes the confrontation between the two songs continues throughout the text. "The Battle Hymn of the Workers" rewrites "The Battle Hymn of the Republic" while retaining many of its phrases: "Mine eyes have seen the vision of the workers true and brave . . . their hosts are marching on." (61)

Nelson continues, "the authors of these songs mount an opposition from within the commonplace forms of the culture, thereby winning back both tradition and common sense from their articulation to conservativism" (61). Guthrie and other folk singers drew from the culture that surrounded them and transformed, reworked, and remixed that culture to write songs that motivated the working class to fight for a dignified life. Instead of passively consuming and regurgitating the Tin Pan Alley songs that were popular during the day, they created, recreated, and commented on culture in an attempt to change the world around them. This kind of sharing, adapting, and transforming is an integral aspect of how culture works; it is not an anomaly.

Confronting (and Cutting Up) Consumer Culture

Newspapers, television, popular music, roadside billboards, comics, and films (the "junk" that Guthrie was referring to in the previous section) supplied a new vocabulary for artists to express themselves. They remixed these raw materials using VCRs, digital audio recorders, spray paint, silkscreen machines, photocopiers, digital scanners, personal computers, and—significantly—tape recorders. This analog medium embodied, and anticipated, several of the cultural and technological characteristics now attributed to digital media. Long before the rise of online file sharing and even home computing, the cassette tape facilitated the same kinds of decentralized cultural production and distribution common today. Magnetic tape technologies greatly lessened the cost of reproducing, copying, and circulating sound recordings, a breakthrough that is also ascribed to MP3s and other digital media.

Magnetic tape allowed ordinary people to make copies of sound recordings and disseminate them through formal and informal social networks. Rather than using computers, as is the case today, these exchanges happened face to face, through international postal services and other physical means. Much like digital distribution—which, for instance, now allows a Brazilian DJ to quickly access and remix a popular Nigerian song and upload the results to YouTube for anyone throughout the world to hear—cassettes knew no national boundaries. The existence of cheap, portable cassettes facilitated the cultural flows described by scholar Paul Gilroy in his book *The Black Atlantic*, in which musical recordings circulated throughout the Caribbean, West Africa, Brazil, the United States, and England. With tapes, people of the African diaspora could listen to and appropriate from musical styles developed in other countries, despite being separated by long distances and great bodies of water.

In addition to facilitating musical-cultural flows across borders, tape technologies allowed artists to edit and reorganize sound in ways that anticipated "the remix" (which rapper Sean Combs claims to have invented, but didn't). Engineer and radio announcer Pierre Schaeffer coined the term *musique concrète* after experimenting with recorded noises captured on magnetic tape shortly after the Second World War. This sound collage technique became prevalent in avant-garde circles in the following decades, helping fuel a fascination with tape technologies. Douglas

Kahn's contribution to this collection, "Where Does Sad News Come From?," provides an illuminating genealogy of the cultural and critical uses of magnetic tape technologies. He does this through a case study of a largely forgotten work of audio art titled *Sad News*. Answering the question posed in his title, Kahn writes, "*Sad News* comes from a combination of the schooling unwittingly served up by the inundation of the daily glut of the barrage of cuts for what appears to be news—as well as by the creative effort to deflect and delectate it in the best traditions of satire, semioclasm, political critique, and a healthy curiosity and humorous disrespect."

Another invention that emerged in the same era as magnetic tape was the photocopier—a product of the military-industrial complex that, like the tape recorder, was introduced commercially after the Second World War. We can locate Lloyd Dunn's sound and visual art at the nexus of photocopy and magnetic tape technologies. He was a founding member of the sound collage group The Tape-beatles—originally based in Iowa City, but which has since relocated to Prague. (The group's mock-trademarked slogan is, fittingly, "Plagiarism®: A Collective Vision.") In addition to being a founding member of this notable sound collage group, Dunn was an influential participant in the mail art and zine publishing worlds, which the Xerox Corporation helped make possible.

"There's always been this very problematic but very interesting and fruitful relationship between culture producers and devices for reproduction," says Dunn in "Plagiarism® 101: An Appropriated Oral History of The Tape-beatles," another contribution to this book. "The Hungarian and graphic designer László Moholy-Nagy," he continues, "was a great champion for using devices of reproduction for productive ends. And so when you turn a photocopier into an art-making tool, basically you're détourning a business machine into doing something that could be very easily anticapitalist or antibusiness—or even revolutionary—in the right hands." Among the most important publications to emerge from the zine scene were Dunn's *PhotoStatic* and *Retrofuturism*, which date back to the 1980s. We are honored to reprint selections from *PhotoStatic*, along with Dunn's commentary written for this book.

Another method of confronting consumer culture is today's use of Situationist tactics by artists/activists who alter trademarked logos and roadside billboards. "This is extreme truth in advertising," a billboard artist told Naomi Klein. This kind of strategy provides, as Klein puts it, an

X-ray of advertising, "uncovering not an opposite meaning but the deeper truth hiding beneath the layers of advertising euphemisms. According to these principles, with a slight turn of the imagery knob, the now-retired Joe Camel turns into Joe Chemo, hooked up to an IV machine" (1999, 281–82). Klein adds that her favorite "truth-in-advertising campaign is a simple jam on Exxon that appeared just after the 1989 *Valdez* spill: 'Shit Happens. New Exxon,' two towering billboards announced to millions of San Francisco commuters" (282).

This was one of the many actions of the San Francisco Bay Area Billboard Liberation Front. Even though the appropriation of corporate logos has provoked trademark infringement lawsuits against artists, the act of "improving" billboards holds different dangers. In an audio piece by contemporary sound collage collective Negativland — *Crosley Bendix Reviews Jam Art and Cultural Jamming*, which discusses billboard "modification" — the faux radio commentator Crosley Bendix dryly notes, "The studio for the cultural jammer is the world at large. His tools are paid for by others — an art with *real* risk."

The noted collage filmmaker Craig Baldwin photographed many of these billboard alterations around the San Francisco Bay area during the 1980s and 1990s — which we have reproduced in this book, along with his commentary. For instance, he documented a billboard located in San Francisco's Mission District that originally advertised the cigarette brand Lucky Strike, but was reworked to say "MX First Strike." Baldwin writes, "This symbolic refusal of Reagan's MX Missile program landed two of my friends (Joel Katz and Pad McLaughlin) in jail (for about twenty-four hours). They were busted by undercover drug cops who were coincidentally parked in the area to intercept a street sale." In this way, billboard modification is "an art with *real* risk."

It's All about the Benjamins — and Copyright Law

The German social theorist and critic Walter Benjamin famously argued that mechanical reproduction, the engine of consumer culture, created the space for a new kind of political art to emerge. In his essay "The Work of Art in an Age of Mechanical Reproduction," Benjamin broke with those who held a wholly pessimistic view of the effects of mass production. Rather than treating the production of art as the solitary, ritualized domain of an original work made by a genius author, Benjamin believed art

should be brought into the realm of everyday life. He correlated the decay of the aura with the democratization of art and argued that through the means of mechanical reproduction art could realize its progressive potential and get "the masses" involved. When authenticity ceases to be a central aspect of making art, he maintained, "the total function of art is reversed. Instead of being based on ritual it begins to be based on another practice, politics" (1969, 218).

Benjamin engaged in a peculiar type of literary collage throughout his writing career, which was tragically cut short after he committed suicide while fleeing from the Nazis in 1940. Discussing this approach to writing, he mused in a missive to his friend Gerhard Scholem in 1924, "What surprises me most of all at this time is that what I have written consists, as it were, almost entirely of quotations. It is the craziest mosaic technique you can imagine" (1994, 256). He was referring to his nearly completed book manuscript, *The Origin of German Tragic Drama*, which sampled from several texts (many of which were still under copyright at the time). In Davis Schneiderman's contribution to this book, "Everybody's Got Something to Hide Except for Me and My Lawsuit," he meditates on "Walter Benjamin's desire to form a book composed entirely of quotations." In doing so, Schneiderman connects Benjamin's writing practices to contemporary copyright law.

To help frame his argument, Schneiderman quotes Delia Falconer, who claims that Benjamin's approach to writing has a "a special kind of metaphorical force." She continues, "Freed from their context, and left to crystallise in the depths of history, [quotations] could be brought back from the past and rearranged, without explanation, . . . so that their hidden correspondences would be revealed." Schneiderman adds, "It is easy to imagine a similarly produced 'history' of copyright: None of those words will be mine; they will be lifted from a series of previously published articles, and attributed only at the end of the resulting text — in imitation of a nineteenth-century 'cento' or 'patchwork' poem, which borrows lines and even couplets from diverse but 'metrically identical source poems.'"

Ironically, today's publishers would likely treat the collage-informed writing strategies employed by Benjamin very differently than his publishers did in the first half of the twentieth century. These companies feel compelled to adhere to a copyright "clearance culture" that presumes that any quotation of a copyrighted work must be approved by its owner. In Ted Striphas's and Kembrew McLeod's essay, "Strategic Improprieties:

Cultural Studies, the Everyday, and the Politics of Intellectual Property" (2006)—which serves as the introduction to a special issue of *Cultural Studies* on the politics of intellectual property—the authors reflect on the intellectual property implications of Benjamin's writing techniques. It is worth quoting at length, for it goes to the heart of one of the central concerns of this book:

> Benjamin composed *The Origin of German Tragic Drama* in a baroque style befitting that of his subject matter, a style that found its most definitive expression in his magisterial, but never-finished, text, *Das Passagen-Werk* (*The Arcades Project*). It, too, and even more so, consists of borrowed passages (in both French and German) juxtaposed ecstatically with Benjamin's own aphorisms and meditations, as if to mirror the felicitous unfolding of shops, sites, and spectacles that comprised the early twentieth-century Parisian arcades. Together these elements yield among the most multi-vocal, multi-layered, multi-textured, and open works of—what? philosophy? history? critical sociology? aesthetic theory?—ever produced. Stylistically and substantively *Das Passagen-Werk* is both epic and humble, and yet it also stands as a sad testament to an era that largely has passed us by.
>
> The truth is, we can hardly imagine a comparable work getting published in the West today. The 1999 release of *Das Passagen-Werk*'s English translation by Harvard University Press was an achievement, to be sure, one facilitated in no small part by Benjamin's plundering of sources most of which, having been published between the mid-nineteenth and early twentieth centuries, had slipped into the public domain. Now imagine for a moment that Benjamin, living in the late twentieth or early twenty-first century, delivered the same "crazy mosaic" of a manuscript to a publisher, having quoted extensively from sources copyrighted in the last 70 years or so. If his publisher had the courage to produce the book at all, one of three things probably would happen. The safest route would see his publisher secure copyright clearances for the numerous lengthy quotations that form the volume's backbone. Benjamin's magnum opus, as such, would become prohibitively expensive for most individuals and institutions to buy because of the "license stacking" effect, wherein a publisher would need to make royalty payments for its multiple fragmentary uses. . . .
>
> Second, a more daring publisher might decide to let things fly,

either believing—in the US, at least—that fair-use or related provisions would cover quotation of the magnitude of *Das Passagen-Werk*, or, with fingers crossed, hoping that the volume might pass below the radar of the copyright holders whom the author had sampled. In either case, Benjamin's publisher more than likely would be slapped with a cranky cease and desist letter and, if pressed, even might be compelled to pull the offending volume from library and bookstore shelves. Third, as a result of this chilling legal atmosphere, publishers might not ever agree to release such a book in the first place. Thus, *Das Passagen-Werk* would be lost, lost again, this time owing to far less tragic—but no less unnecessary and lamentable—circumstances. (Striphas and McLeod, 2006, 119–20)

Though this is a fictional example, the scenarios described here are quite real. In 2004, Indiana University Press withdrew from circulation copies of a book about a relatively obscure, deceased composer, Rebecca Clarke, because the copyright holders of Clarke's compositions intimidated the press. Liane Curtis, the editor of *A Rebecca Clarke Reader*, believes that the quoting of this work in a scholarly context did not violate copyright because the alleged infringements added up to 94 lines in a 241-page book. Had the book seen the light of day, it would have been one of a disproportionately small number of scholarly works dedicated to female composers, a group whose work historically has been eclipsed by that of their male counterparts. Unfortunately, the press conceded to the copyright holders' demands and chose not to risk a potentially lengthy and costly court battle. Sadly, it is now only available as a copied bootleg version on the scholar's Web site, not through any mainstream outlets. (On a related note, we are sorry that a fascinating piece by David Tetzlaff could not be included in *Cutting Across Media*, due to copyright and licensing problems.)

This clearance problem, which can happen fairly often in the print medium, multiplies exponentially when scholars decide to quote from audio and visual media. One of the more headache-inducing aspects of the way copyright law is interpreted is the seeming randomness of it all. When writing a book, quoting from another book is often perfectly acceptable—for instance, Derrida's *Dissemination* and Acker's *Blood and Guts in High School* borrow large chunks from the prose writings of others. But quoting more than two lines from a song's lyrics in a book—even if

it takes up only 0.1 percent of the book's total text—might get you and your publisher in trouble. As long as it is brief, singing a phrase from an old song and placing it in a new song probably will not get you sued, and a court likely would not consider it an infringement. However, courts have decided that sampling directly from a sound recording—even just three notes played over the course of a couple of seconds—is clearly a copyright infringement.

More contradictory examples: referring to a trademarked product in everyday conversation will cause no legal problems. However, studios often require movie directors to get permission from an intellectual property owner to even mention it in movie dialogue—an artifact of the overly cautious clearance culture. Inversely, recent case law has affirmed that referring to trademarked brands in pop songs is not an infringement. In 1999, Mattel sued the Swedish pop group Aqua for releasing a hit song named "Barbie Girl," which opens with the lines, "I'm a Barbie Girl in a Barbie world / Life in plastic, it's fantastic." The song was bubblegum cultural criticism at its finest, and the court ruled that it was legal as a parody. The Ninth Circuit's ruling began with the classic line, "If this were a sci-fi melodrama, it might be called Speech-Zilla meets Trademark Kong." In the closing line of the *Mattel v. MCA Records* decision, Judge Alex Kozinski stated dryly, "The parties are advised to chill." These are just a few examples of how courts and various culture industries treat similar activities across media very differently. It also shows us that art and law don't mix (pun intended).

Although appropriation has arguably always been at the heart of the artistic process, never before has it been so easy to do. Today, online audiovisual collages are regularly made in developed countries and increasingly so in the developing world. It would be an overstatement to say *everyone* is mashing it up, but not a huge one—and this fact has only exacerbated the tensions between intellectual property owners and downstream users of copyrighted content. The attempts by rights holders to suppress these critical and satirical collages often resemble a futile version of the Whac-A-Mole carnival game, rather than a realistic and effective policing effort. When companies try to smash these infringements with a court gavel, more pop up, breeding like bionic bunnies.

Art Goes to Court

As Negativland writes in its contribution to this book, "during the centuries when only live music was possible, many composers routinely included pre-existing musical 'quotes' within new work, ranging from familiar folk melodies to fragments borrowed from their classical predecessors or contemporary colleagues." With the advent of sound recording technologies, it came as no surprise that some composers added previously recorded elements into their compositions. "Music proceeded exactly as it always had and as it wanted to," Negativland continues, "with hardly a hassle from the early commercial copyright laws that were starting to congeal in the shadows."

Through the transgressive and critical manipulations of media technologies, consumers of mass media have become producers — or reproducers, remixers — of mass culture. However, this practice has also crashed head first into copyright law. Barbara Kruger has been at the receiving end of copyright infringement lawsuits, as was Negativland. Since that lawsuit, the sound collage group has vigorously argued that resistance and intervention is especially urgent in today's corporate-controlled media culture. It is also credited with coining "culture jamming"—a phrase they later distanced themselves from (for reasons of not wanting to be in a club that would have them as a member). These kinds of acts are "a much needed form of self-defense," Negativland writes, because "art and commerce have now merged to a degree where corporate commerce now finances, grooms, directs, filters, manufactures and distributes almost everything we know of as 'culture.'"

That Negativland chapter—a partial excerpt from their elaborately packaged multimedia extravaganza *No Business*, complete with a copyright symbol–embossed whoopee cushion—is the clearest distillation of the group's worldview. "The home computer is the ultimate collage and appropriation box, and every computer user in the world now knows and understands the term 'cut and paste,'" Negativland writes. "But amazingly, just as this cut-and-paste style of thinking began to spread far and wide beyond the realm of fine art (even becoming part of the public's new attitude toward an increasingly complex mass of information that they must navigate), this process also began to provoke lawsuits." Negativland reminds us that much of what we think of as *our* culture is increasingly

being privatized by companies that wield intellectual property law like a weapon.

For the most part, "corporate authors" like Disney have no sympathy for any unlicensed transformations of their properties. "We have a legal responsibility to defend our copyrights, and we do so aggressively," stated Disney's vice president of intellectual property law, Claire Robinson (quoted in Greenberg 1992, 1). Artist Dennis Oppenheim found this out the hard way. In the 1980s, he created a sculpture that included the images of Mickey Mouse and Donald Duck for a Santa Monica development. The work, which resembled a jungle gym and featured thirty-four fiberglass figures of Mickey Mouse and Donald Duck skewered with bronze rods, was designed to "contrast an ominous disease with childhood innocence" (quoted in Muchnic 1992, B1). Oppenheim cast the figures from sixty-year-old plastic toys from Japan, which were most likely pirated, making them appear even further removed from the Disney-sanctioned and -licensed versions with which most of us are familiar. Moreover, he transformed them into fiberglass and colored them dull shades of green, orange, and yellow; nevertheless, Disney's legal threats made it impossible for the artist to display the work. Oppenheim commented: "You go to a flea market, you buy a bunch of figures, two of them turn out to be Mickey Mouse and Donald Duck, and you put them in a sculpture or a collage. Artists do this all the time. That's appropriation" (Muchnic 1992, B1).

The better-known artists who have incorporated Disney characters into their works of art—Roy Lichtenstein, Andy Warhol, and Keith Haring, for instance—avoided these legal obstacles by purchasing licenses from the company. With few exceptions, Warhol was very cautious and regularly sought licensing and business partnership agreements when making art that appropriated from corporate sources. In his book *Brand Name Bullies*, David Bollier provides a detailed history of Warhol's tangled rights legacy. He notes that "Andy Warhol's encounters with intellectual property law represent a special case—the exception that proves the rule. His reputation, artistic skill, and market clout enabled him to negotiate with wealthy corporations on an equal if not superior footing. It did not hurt that his images did not directly criticize or confront company products, logos, and characters; any commentary was more subtle, if not straight 'reporting' of the prevailing imagery of our times" (2005, 55).

Companies are often more than happy to let artists and consumers

promote their properties, but only if they do not cross the line from free promotion into substantial criticism. For instance, Barbie's owner and master, Mattel, has gone through extreme lengths to control the context in which she is presented—from pop song lyrics to photography to performance art. "To judge from its aggressive litigation, Mattel seems to believe that it has the legal right to maintain Barbie dolls in a cultural bubble," writes Bollier. "Invoking both copyright and trademark law, Mattel has waged dozens of legal campaigns over the years against anyone who dares to depict or invoke Barbie without the company's permission. Songs, photographs, book titles, and anything else that uses Barbie's image or name is considered a form of cultural contraband" (2005, 84).

Utah-based artist Tom Forsythe was one of the victims of Mattel's overzealous legal campaigns when he was sued for copyright infringement. As an artistic commentary on the unrealistic beauty myth and consumer culture, Forsythe jammed Barbie dolls into kitchen appliances and photographed them, calling the series *Food Chain Barbie*. "I put them in a blender," said Forsythe, "with the implication they're going to get chewed up, but no matter what, they just kept smiling. That became an interesting commentary on how false that image is" (McLeod 2005, 143). Mattel sued Forsythe, and after a lengthy search for help, the American Civil Liberties Union and the San Francisco law firm of Howard Rice Nemerovski Canady Falk & Rabkin stepped in and defended him pro bono. This means Forsythe was not billed for his lawyers' time, though the process is far from free. It takes lots of money to hire expert witnesses, file court documents, and do the extensive legal research necessary to defend oneself against a trademark lawsuit.

In the end, Forsythe's lawyers spent nearly $2 million defending him, reminding us that freedom of expression can come with a hefty price tag. Luckily for the artist, in mid-2004 a federal judge awarded his legal team $1.8 million. In his order, U.S. District Judge Ronald S. W. Lew reaffirmed that "The fair use exception excludes from copyright protection work that criticizes and comments on other work," and asserted the right for artists and ordinary citizens to engage in parody and satire (*Mattel v. Forsythe*). Fair use is an intuitively named statute because it is designed to enable uses of copyrighted material that are considered, quite simply, fair. In other words, if you aren't taking the copyrighted material to mooch off someone's labor, but are using it for the purposes of commentary, education, parody, news reporting, and other transformative uses, then it

is fair use. "Because of the free speech protections of the First Amendment," the judge continued, "a trademark is not diluted through tarnishment by editorial or artistic parody that satirizes plaintiff's product or its image" (*Mattel v. Forsythe*).

The judge also clearly noted that "Plaintiff [Mattel] forced Defendant [Forsythe] into costly litigation to discourage him from using Barbie's image in his artwork," and therefore concluded that "it was exceptional for Mattel, a sophisticated plaintiff, to bring this groundless and unreasonable dilution claim" (*Mattel v. Forsythe*). The day after the ruling, Forsythe told McLeod, "The fee award promises to have real implications for artists who may now be more willing to critique brands and feel more confident that they will have an easier time finding attorneys to represent them. Maybe it will even keep these brand bullies from filing the lawsuits in the first place" (McLeod 2005, 147).

When companies and individuals make overreaching copyright claims just to censor speech they do not like, they are abusing the law. The U.S. Supreme Court has consistently held that copyright was designed as a means to promote the dissemination of knowledge and creative expression, not to suppress it. Over the past three decades, the high court has had an increasingly progressive track record when it comes to free speech, fair use, and copyright. Of course, fair use is not a free pass that allows people to copy and distribute anything they wish, but it was nevertheless designed to make sure copyright and the First Amendment can peacefully coexist. Still, it costs enormous sums of money to defend oneself against a copyright infringement suit, as the *Mattel v. Forsythe* case suggests. "Fair use isn't freedom," the Stanford University law professor Lawrence Lessig has said, "it only means you have the right to hire a lawyer to fight for your right to create"—adding, forcefully—"*Fuck* fair use. We want *free* use" (McLeod 2005, 329). His quip was an edgier iteration of his "free culture" argument, also the title of his influential book released in 2004. Lessig has a point: fair use often comes with a hefty price tag.

Jamming Copyright

Copyright considerations haven't stopped folks like ®™ark, pronounced "art mark," from pushing back against overreaching copyright and trademark claims made by corporations. ®™ark is the brainchild of two men, Mike Bonanno and Andy Bichlbaum (both aliases), also known as the

Yes Men. This "organization" is one of their many fronts that create the illusion that they are an unstoppable army of anarchistic interventionists. The Barbie Liberation Organization (BLO) was another one of their projects. In 1993, the BLO purchased multiple Barbie and G.I. Joe dolls, switched their voiceboxes, and "reverse shoplifted" these gender-bending toys back into the stores that sold them (Bunn 1998). During Christmas that year, in select toy stores, Barbie grunted, "Dead men tell no lies" and G.I. Joe gushed, "I like to go shopping with you." ("Mommy, why does G.I. Joe want to paint his nails with me?")

In their Web pages and press releases, the Yes Men reappropriate corporate-speak in their interventions—flipping familiar phrases in a deconstructive attempt to show how language conceals power. "We use this language because it is so effective," says Frank Guerrero, another Yes Men pseudonym. "We think that by adopting the language, mannerisms, legal rights and cultural customs of corporations we are able to engage them in their own terms, and also perhaps to reveal something about how downright absurd it can get." The Yes Men's discursive interventions are clearly inspired by Situationism, particularly in the way they deturn/return the "language, mannerisms, legal rights and cultural customs" of the corporate world. This practice echoes Situationist Mustapha Khayati's statement of 1966: "It is impossible to get rid of a world without getting rid of the language that conceals and protects it" (quoted in Meikle 2002, 126–27).

Even though we still have the ability to say what we want in the physical world, companies have gone to great lengths to police what we say in cyberspace. The Digital Millennium Copyright Act (DMCA), signed into law by Bill Clinton in 1998, stipulates that Internet service providers can only be immune from prosecution if they immediately comply with complaints—or "DMCA takedown notices"—filed by copyright owners. Even if the copyrighted materials appear in a fair use context, the DMCA makes it harder for freedom of expression to prosper online. By threatening Internet service providers and search engines, intellectual property owners can simply make you disappear if they do not like what you have to say. Such obliterations were much more difficult to accomplish in a nondigital world.

Web sites often faint at the sound of threatening language contained in a nastygram from an attorney—which, to a certain extent, *is* the fault of the DMCA. The letter of the law encourages these Web sites to cave to

any spurious demand because it is safer than not doing so. If YouTube is our new public sphere, we are definitely in trouble, at least when it comes to free speech. YouTube's parent company, Google, is more concerned with its bottom line than anything else, whether we are talking about copyright censorship in the United States or state censorship in China.

However, it's not all doom and gloom. The DMCA contains a useful legal tool for resisting unreasonable copyright claims, which comes in the form of a "DMCA counter-notice." This is what this book's coeditor, Kembrew McLeod, filed after YouTube pulled from its site one of his satirical collage videos that mashed up media from *Mister Rogers' Neighborhood*. Like for many Americans, the show was a staple of his childhood, and it left an indelible mark on his psyche, particularly because Mr. Rogers seemed quite odd. McLeod's collage comprised excerpted clips of Mr. Rogers saying ominous things like, "You can never go down the drain" and "boys' and girls' arms and legs don't fall off when you put them in water." In 2006 the show's copyright owner, Family Communications, filed a takedown notice, and it took *four months* for YouTube to make it available again.

Since YouTube reposted it, this collaged clip has provoked heated arguments on the YouTube discussion board—some people are offended ("You're going straight to hell" and "I would like to know what happened to you to make you make such a warped video") and others think it is funny ("hilarious!"), but everyone has had a chance to speak his or her mind. These exchanges are a reminder that we should encourage debate and discussion, not suppress it. As our culture increasingly becomes fenced off and privatized, it becomes all the more important for us to be able to comment on the images, ideas, and words that saturate us on a daily basis without worrying about an expensive, though meritless, lawsuit. If we do not defend ourselves, we will be complicit in letting our freedom erode when it does not have to be so. By standing up for fair use and fighting back against overreaching copyright claims, we can create safe havens for freedom of expression in the age of intellectual property.

Illegal Art and Other Delights

Two decades before the intellectual property wars erupted with full force, and a full decade before the DMCA was signed into law, many artists began challenging copyright law with their music. In "Crashing the Pop Music

Spectacle," Kembrew McLeod documents the exploits of Bill Drummond and Jimmy Cauty, an anarchic British pop duo who used several pseudonyms: The Timelords, The Justified Ancients of Mu Mu, the JAMS, and the KLF. Their brief but ubiquitous popularity nicely obscured a radical and hilariously subversive critique of the culture industry—like a goofy Theodor Adorno whose praxis involved a drum machine. To this end, the KLF practiced an aggressive brand of creative plagiarism—otherwise known as sampling—that predated Public Enemy's early forays into the copyright debates, discussed in an interview with group members Chuck D and Hank Shocklee, also included in this book.

The KLF's debut album, *1987 (What the Fuck Is Going On?)*, made extensive and provocative use of samples from the Monkees, the Beatles, Whitney Houston, and ABBA—and the album's liner notes claimed that the sounds were liberated "from all copyright restrictions." In this respect, the KLF were pop music's first "illegal art" ideologues, though they were loath to be pigeonholed as mere copyright criminals. "Illegal Art," by the way, is not only the title of a traveling art show curated by journalist and activist Carrie McLaren (whose interview with copyright scholar Siva Vaidhyanathan is included in this book), it is also the name of a record label run by the pseudonymous Philo T. Farnsworth, who contributed a short piece titled "Getting Snippety." In it, Farnsworth writes, "While we wave the banner of 'illegality' to draw attention to the absurdity that our releases would be considered as such, our motives are to promote new forms of music rather than to be criminals."

Discussing an earlier release that got the Illegal Art label into hot legal water, Farnsworth claims, "considerable transformation has always been central to the aesthetics of the Illegal Art label. Our first compilation, *Deconstructing Beck*, sounds so distant from Beck's music that many would have never known the source material without the conceptual frame in which it was conceived." Joshua Clover takes a more aggressive tack in "Ambiguity and Theft." In this chapter, he approaches the topic of collage with more than a little ambivalence—claiming that he wants not to praise collage but to bury it. Clover writes, "Collage is a political practice *of interest* insofar as there is an actual theft to which the produced collage maintains an allegorical relationship. No collage without theft. Otherwise, no charge but the aesthetic; just another spectacle."

This tension between the law and interventionist collage is an important thread that runs through this book, including novelist and essayist

Jonathan Lethem's "The Ecstasy of Influence: A Plagiarism," which concludes *Cutting Across Media*. His chapter cuts through many histories, moving back and forth in time, from "Pyramus and Thisbe" by the Roman poet Ovid to Bob Dylan's album *Love & Theft* (2001), and every imaginable thing in between and beyond. Lethem writes, "The case for perpetual copyright is a denial of the essential gift-aspect of the creative act. Arguments in its favor are as un-American as those for the repeal of the estate tax. Art is sourced. Apprentices graze in the field of culture."

Lethem argues that composing music from digital samples is an artistic method like any other; sampling is neutral in itself, neither inherently creative nor uncreative. "Despite hand-wringing at each technological turn—radio, the Internet—the future will be much like the past," he continues. "Artists will sell some things but also give some things away. Change may be troubling for those who crave less ambiguity, but the life of an artist has never been filled with certainty." One of the interesting things about this chapter is that in many ways, Lethem didn't write it, and yet he did.

The key phrase in his title, "A Plagiarism," is important. Lethem poached the words and ideas from dozens of sources—quoting, recontextualizing, and in some cases, reworking them (and, at the end of the chapter, crediting the sources). For instance, the three sentences quoted in the previous paragraph were lifted directly from McLeod's own book *Freedom of Expression®: Resistance and Repression in the Age of Intellectual Property* (2007), though they were more artfully (re)written by Lethem. By drawing on the words and ideas of scholars, artists, and others who have discussed intellectual property law, he synthesized a wide range of writing, creating a literary mash-up that works both as a polemic and as essayistic art.

Thinking Globally about Appropriation

Even though a number of the chapters in this book unambiguously valorize certain collage and appropriation practices, Gábor Vályi's "Remixing Cultures" complicates this discussion. In this chapter, Vályi acknowledges the legacy of colonialism in his analysis of the musical methods used by Hungarian composers Bartók and Kodály, who appropriated within their own compositions the folk melodies preserved and performed by indigenous groups in their country. Vályi writes, "The fate of

these folk-influenced pieces manifests the colonialist optics of copyright that denies authorship to the collectively created folk cultures, while it guarantees full protection to their appropriators. Is anyone aware of the name of singers who gave their songs to Bartók and Kodály?"

Jeff Chang wrestles with similar issues—using several examples, including the hybrid music of Brazilian artists like Gil Gilberto. In "A Day To Sing: Creativity, Diversity, and Freedom of Expression in the Network Society," he writes, "Open circulation of ideas is crucial. The music of *tropicalia*, Gil's compatriot Caetano Veloso reminds us, was based on a foundation of bossa nova and Afro-Brazilian folk traditions, but nourished by rock, rhythm and blues, and jazz, even French pop and American vaudeville." Chang continues, "In a larger sense, Veloso describes the process of riding the kinds of cultural flows that have been taking place for millennia. If we recognize in his example an analog to our current mix/remix culture, it is only because technology sometimes simply allows us to better do what is ancient." However, the motivations of tropicalia artists were not informed by the kind of "culture-blind" tendencies found in the Western avant-garde, in which appropriation is uncritically celebrated as having positive value. As Vályi and Chang emphasize, this is not always the case. We cannot accept a simplistic approach that ignores the power differentials and the status of indigenous peoples who sit at the margins of the global economy.

Race, power, and globalization also play an important role in Lorraine Morales Cox's chapter on the work of visual artist Chris Ofili, who incorporates cut-and-pasted magazine pictures taken largely from African American popular culture, blending both the formal and metaphorical possibilities of the medium. "On a metaphorical and theoretical level," she writes, "studying the use of collage by artists of color opens up numerous avenues for considering process and *how* artists approach, and confront the intersecting subjects of race, gender, class, sexuality, and nationalism through the medium of collage." Cox continues, "Ofili's formal and conceptual strategies confront postcolonial realities and prompt the viewer to do the same by creating works that defy a simple reading, that in the end make the viewer 'recon' with their critically stunning complexity."

In "Visualizing Copyright, Seeing Hegemony: Towards a Meta-Critique of Intellectual Property," Eva Hemmungs Wirtén provides a counter to the kinds of celebratory narratives surrounding so-called remix culture

by highlighting the fact that these discourses are often very American-centric. The way America's Wild West has been romanticized—freedom from constraints, rugged individualism, and ingenuity—overlaps closely with the tech talk of certain open-source and remix culture advocates. Those who lament the expansion of intellectual property and the enclosure of the digital public domain can occasionally sound like Libertarian cowboys who are repulsed by how the beautiful wide-open spaces have been fenced in by government or corporate regulation. At their worst, they come off like free-market yahoos whose primary mission is to protect the personal liberties of the computer programmer/hacker against the second enclosure movement (in this case, fencing off the public domain).

Wirtén also introduces an important dimension that is largely absent in critiques of intellectual property law: gender. "The kind of creativity sacrificed on the altar of the second enclosure movement is highly gendered, and relies to a substantial degree on recycling the ideology of genius and originality, but now in the innovator/hacker/activist-hero persona." She correctly argues that this new "innovator/creator paradigm is just as gender-biased as the old author/genius combination, and it could very well turn out to be just as long-lived." For a "free culture" movement to grow into a broad-based coalition—rather than remain in an affluent technological ghetto—its raison d'être, its obsession should center on finding new argumentative metaphors, developing a more international perspective, and fostering social justice.

ALTHOUGH THIS BOOK spans twenty-plus chapters—touching on a variety of media, art forms, and genres—it does not claim to be a comprehensive survey of collage and appropriation. *Cutting Across Media* attempts, instead, to make sometimes messy connections across a range of contexts and cultural practices. It is arranged much like a hip-hop mix tape in that it blends previously published works, like Lethem's, with newly written pieces to create a newly formed whole. Like a good mix, the book segues from one overlapping theme to another to form a panoramic snapshot of culture, creativity, and copyright in our contemporary era.

Ultimately, *Cutting Across Media* is concerned with how collage practices can intervene in and interrupt social conventions in a way that is *political*, as Walter Benjamin framed it earlier. One example of this is what

happened when U2's record label and song publisher sued Negativland for the unauthorized use of the supergroup's intellectual property. This sound collage collective used its legal woes not only as fodder for the group's collages that followed, but also as a jumping-off point to help raise awareness about copyright expansionism. As group member Mark Hosler is fond of saying, "We may not have had a hit song, but we had a hit lawsuit!" In that perverse spirit, we offer you this book. Please do something interesting with it.

Digital Mana

On the Source of the Infinite Proliferation

of Mutant Copies in Contemporary Culture

In his book *Free Culture* (2004), Lawrence Lessig writes a manifesto for a free culture that seems strangely divergent from the practice of freedom that is actually taking place on the Internet today. Perhaps this divergence occurs because, when we see the words "free culture," we are not merely trying to define a space in which certain creative uses of intellectual property are legitimated. The free culture that really interests us is, to quote a character in the Strugatsky brothers' remarkable sci-fi book, *Roadside Picnic*: "Happiness for everybody! . . . Free! As much as you want! . . . Everybody come here! . . . There's enough for everybody! . . . Nobody will leave unsatisfied! . . . Free! . . . Happiness! . . . Free!" (1977, 151). What appears to be offered on the Internet, what fuels the imaginal space of it is the utopia of an infinite amount of stuff, material or not, all to be had for the sharing, downloading, and enjoying. For free.

In the Western imagination, such moments of being overwhelmed by an infinite amount of desirable stuff form the basis of feasts, with tables stacked up to the rafters with tasty foods, of festivals in which diverse kinds of sensual pleasures come together in a mass of bodies and sensory stimuli. We think of treasure caves where gold, jewels, and precious objects are hoarded in vast mounds, of genies who grant wishes. We think of marketplaces in which the goods of the world are spread out; of department stores like Harrods in London, Bloomingdale's in New York, or Galeries Lafayette in Paris or shopping malls like the Eaton Centre in Toronto, where every imaginable consumer item available is put out on display.

Of course, if you want any part of these last fantasies, you are going to have to pay for them. You can enjoy them as spectacle, going window shopping, as my mother and father used to do in suburban London when I was growing up. But if you want more intimate enjoyment, you need money. Or perhaps a strange twist of fate, such as occurred on July 13, 1977, when the power grid went out in New York City, leading to widespread looting in poorer neighborhoods, such as Harlem and the Bronx. This day is credited in *Yes Yes Y'All* (Fricke and Ahearn 2002), an oral history of hip-hop, as being the moment of hip-hop's tipping point, where the technologies required for MCing and DJing—turntables, mics, and speakers—formerly available only to a small number of crews, were suddenly distributed to just about anyone who wanted them. This free access facilitated hip-hop's full emergence as a culture. Or one might consider the day in mid-1999 when Shawn Fanning released the first version of Napster, facilitating an explosion of file sharing that peaked in February 2001, when 1.6 million users had access to free digital copies of millions of audio recordings.

Just below the surface of contemporary consumer culture, there is a collective dream of free access to this infinity of things. Indeed, it is one of the principal themes manipulated by advertising, except of course that "free access" has been replaced by the promise of access via the purchase of a product, say, a soda or a pair of sneakers. Thus, access to the infinity of things in our society would require an infinite amount of cash, which no one has. It appears absurd of course: can there even be such a thing as an "infinity of things"? Can we ever have access to "infinity" through "things"? Through the work of Alain Badiou, it has recently become possible to think of infinity as a properly political as well as philosophical concept. If, indeed, as Badiou says, mathematics is ontology, and a correct understanding of the infinite is at the core of the ontology of the pure multiple that he proposes, one would expect this insight to be confirmed in situations far beyond the world of political scientists and professional philosophers.[1]

In this chapter, I argue that what I call industrial folk cultures have both a profound understanding of infinity and a variety of practices that represent and manifest this understanding of the infinite. By "industrial folk cultures," I mean peasant and other alternative cultures that persist, in mutated forms, in the margins of industrial societies, not fully assimilated into the industrial work world yet interacting dynamically

with it, often playing with the debris of industrialization.[2] Far from being an oxymoron, such cultures are many and various and include hip-hop, avant-garde art from Dada and Marcel Duchamp through Andy Warhol to Richard Serra, science fiction, psychedelic music, various new hybrid religious forms, street gangs, bikers, quilting bees, and hackers, to name just a few. Perhaps most people in industrial societies have participated at one time or another in such cultures, and this chapter is not so much a speculation as to what might happen in a barely imaginable utopia, but a way of thinking about what people are doing right now, and what has already happened. This access to the infinite is mediated through various technologies of copying in industrial folk cultures, and their various practices point toward an alternate way of thinking about copying—and therefore also the right to copy—property and appropriation.

Writing about his psychedelic, vision-inducing, flicker-based technology the dream machine, Brion Gysin, one of the pioneers of contemporary collage culture, writes:

> In the Dream Machine nothing would seem to be unique. Rather, the elements seen in endless repetition, looping out through numbers beyond numbers and back, show themselves to be thereby a part of the whole. . . . Art has been confounded with the art object—the stone, the canvas, the paint—and has been valued because, like the mystic experience, it was supposed to be unique. Marcel Duchamp was, no doubt, the first to recognize an element of the infinite in the Ready-Made—our industrial objects manufactured in "infinite" series. (Gysin 2001, 115)

At the beginning of the twentieth century, artists such as Duchamp imitated and appropriated processes of industrial production, taking fetishized commodities produced in large quantities and, by naming them "art," moved them to a different category, in which "an element of the infinite" was revealed. Perhaps this element of the infinite, rather than commodity fetishism, gives mass-produced industrial objects their peculiar power to fascinate. The "fetishized object" in fact attains its power by being one of an infinite series and contains within it the trace of this infinity. It is actually this trace of infinity, if one can speak of such a thing, which is desired and which fascinates, rather than the "thingness" of the object. Yet commodification attempts to objectify this infinite, and thus Gysin places the word in quotation marks, as a false or pseudo-infinite.

Gysin used this move from object to process or infinite series as the basis of many of his own projects, such as the cut-up, the dream machine, his calligraphic paintings, permutation poems, and even his paintings of the newly built Pompidou Center, which appeared outside the window of his apartment on the Rue Saint Martin in Paris in the 1970s. Gysin called the cut-ups "machine age knife magic," and I have written elsewhere about the way the notion of a sampling culture (in other words, one based on a proliferation of mutant copies) developed out of Gysin's appropriation of traditional Moroccan magical practice. The goal of so many of his aesthetic practices was to break down established systems of meaning, which functioned as control systems, and to free a flow of infinite multiplicity by "rubbing out the word." Another slogan of William Burroughs and Gysin is "nothing there but the recordings." If so, then the recordings, which would be something like Platonic ideal forms, can be appropriated, cut up, combined, and permutated in an infinite number of ways. Collage and montage work by introducing the possibility of an infinite number of changes and connections to a supposedly finite and discrete set of units and/or objects. From another point of view, they reveal the multiplicity that was already immanent but hidden in what we call objects. New technologies, such as the tape recorder, or the dream machine for that matter, increase exponentially the latent potential for revealing and appropriating the infinite that is there in all industrial technologies. Thus they become the basis for "electronic revolution," as Burroughs says. "After all, we are in proliferation," adds Gysin (2001, 132).

This insight into the strange magic of industrialization, which allows a producer to produce a seemingly infinite number of copies of something, is by no means limited to the historical avant-gardes. It may be that many folk cultures in the industrial era have understood that industrial products are not merely "objects" attaining form and power through being fetishized commodities, but that they are instantiations, stagings of infinity, of infinite variety. I am thinking, for example, of the phrases used on the first Jamaican DJing records, such as "Version Like Rain" (variant: "Rhythm Shower") which express the idea of an infinite number of copies of a song or a rhythm, which became possible in the early 1970s in Jamaica when local record producers like Lee Perry gained access to multitrack recording technology and the techniques of sound manipulation and distortion that we now know as "dub."[3] These technologies allowed them to make endless copies of a tune and transform them into

novel and startling variations, using multitracking as a way of making a sound collage. The phrase "version like rain" establishes this process of infinite multiplication as part of a second nature, of technology mimicking the excess and plenitude of nature. But it also establishes a claim on this technology, appropriating it from Babylonian industrial culture, resituating it within Rastafarian cosmology and theology, so that this proliferation of copies becomes a life-sustaining and therefore spiritual force, too. Saying "version like rain" means staking a claim to the right to make and consume this infinite number of copies.

Hip-hop's founding father DJ Kool Herc, a Jamaican ex-pat living in New York City in the 1970s, links the work of Jamaican DJs and producers to hip-hop's emergence, and once again, we find that the notion of the infinite, and of mathematical concepts and practices related to it, abound there. Houston Baker has written about "massive archiving" as one of the sources of hip hop's power—the archiving of the "recently outmoded" records no longer played on the radio or in discotheques (cited in Neal and Forman 2004, 401). In *Yes Yes Y'All*, time after time early participants in the culture speak of the obscurity of the records that Kool Herc plays, and of Afrika Bambaataa's massive record collection. Hip-hop emerges out of this vast garbage heap of postconsumer debris; it is also defined by the move from the finitude of the individual recording, played in its entirety, to the event, staged in a club or for a recording, in which the infinite is revealed by the mixing, editing, and combining of two or more copies of a record, in "real time." This is equally the case with MCs, who develop their art as a never-ending ocean of word play, in the words of the Sugarhill Gang, whose "Rapper's Delight" goes on for fifteen minutes: "well it's on on n on n on on n on / the beat don't stop until the break of dawn." Or how about "i know a man named Hank / he has more rhymes than a serious bank." Perhaps you are thinking, "yeah but, they're exaggerating." It is true that the kind of boasting and exaggeration that MCs do could fit in well with the outrageous talk characteristic of Bakhtin's marketplace, or, for that matter, the tradition of signifyin' that Henry Louis Gates talks about in *The Signifying Monkey* (1988). But in hip-hop culture, these boasts and exaggerations are transformed by being linked to a set of technologies of amplification (the mic), fragmentation and recombination (the DJ) and distribution (the radio, the club, the recording) that can deliver the goods and make actual the possibility of an engagement with the vastness of the infinite.[4]

The work of the late graffiti artist and rapper Rammellzee (he says the name can mean, among other things, "rubbish ocean") articulates hip-hop culture's fascination with mathematics, the infinite, and permutation and recombination directly. In an interview published in *Artforum*, he explains:

> Language itself is a gamble. A roll of the dice. The way you formulate your sentence, the words you pick and make that sentence is the roll of the dice. That's why I'm a rapper, I pick the best words for the sentence. If your gamble rolls right, you'll win. Where the dictionary rolls, the word's right . . . the trains out there are a big book, and as the pages are being written, as formations are being placed on the train, the page cars are switched around. And the book is scattered and rescattered into a gamble. The letters armored themselves while we were scattering them on the transit. (deAk and Rammellzee 1983, 88)

Thus, graffiti writing's power emerges not only from writing on the train cars but from the shuffling of the train carriages by the transit system, which liberates some power inherent in the words written, permutating new sentences that "started to make sense." The rolling of the dice, the word, the subway train indicates hip-hop's concern with the event in which possible combinations manifest. Rammellzee's theory of graffiti, heavily influenced no doubt by 5 percenter Islam with its concern for "supreme mathematics," attempts to undermine orthodox semiotics of the letter and the word, by bringing back the letter to universal mathematic forces and relationships. Rammellzee is particularly fascinated by the concept of infinity and the way infinity has been appropriated by Christian and industrial culture:

> The infinity sign with the fusion symbol [x] in its middle has been wrongly titled Christian [+] and thus it has to be assassinated or the x has to be removed. The infinity sign is a mathematical, scientific, military symbol. It's the highest symbol that we have and you know there isn't even a key on the typewriter for it. . . . We have to put my pamphlet into a computer and put the dictionary and the Bible in there. The old Bible, the first testament, the first dictionary, no other dictionary is like it, put it in the computer and say: write it again, write it the right way, according to the math in the pamphlet on the knowledge of infinity and the series of universal registers, and recompute. When

you recompute you'll get a whole new dictionary and every word formation will be correct to the phonetic sound formation. (92)

Once this false infinity is taken apart, the true powers of language, which are mathematical but at the same time phonetic, can emerge. Furthermore, hip-hop culture is already engaged in the practice of this taking apart. Describing the relation of his own philosophy of Ikonoklast Panzerism to hip-hop, Rammellzee says:

> Ikonoklast is when you are a symbol destroyer. Turning words around and saying them backwards and doing rhymes to them, most people don't know that a rhyme is just like a song. The only difference is in the song you use your voice in a pretty way and with rhyme you just say it, you talk it, you may give a little technology to it, a little saying to it, a little echo to it. Everything is a remanipulation, ain't nothing created. Everything is taken from here, taken from there, ideas sprayed, skipped, dipped, dyed, you know it's all been redone. We shorten the word, we take the letters away from the word, and we just bust it down, we do slang. (93)

Something similar to this can also be found in the work of sci-fi writer Philip K. Dick. In his book, *The Three Stigmata of Palmer Eldritch* (1991), for example, he describes an intergalactic marketing war between the producers of two drugs, Can-D and Chew-Z, each of which offers a transcendental experience, the former a transubstantiation that takes users back into a simulacrum of 1950s California, the latter into a world in which anything one desires can take place and time effectively stops. The choice appears to be between two types of commodity, one symbolic in an old-fashioned sense, the other infinite and, therefore, at least at first glance, more desirable. But the infinity offered by Chew-Z is a trap, since one can never truly exit from it after one has taken the drug, and, far from being free, the infinity of possibilities it offers is subtly controlled by Palmer Eldritch. It is a commodified simulation of infinity.

It is the same in Dick's later novel, *VALIS* (1991), in which the author describes in semi-autobiographical prose how he is exposed to rays that emanate from the divine in the form of VALIS, a "vast active living intelligence system." This true divine enters the entirely false "real" universe that we know from the outside: "the universe consists of one vast irrational entity into which has broken a high-order life form which camou-

flages itself by a sophisticated mimicry. . . . It mimics objects and causal processes . . . not just objects but what the objects do . . . the true God mimics the universe, the very region he has invaded: he takes on the likeness of sticks and trees and beer cans in gutters—he presumes to be trash discarded, debris no longer noticed" (70–72). VALIS manifests to Dick as information fired "at a rate that our calculations will not calibrate; it fired whole libraries at him in nanoseconds. And it continued to do this for eight hours of real elapsed time. Many nanoseconds exist in eight hours of RET. At flash-cut speed you can load the right hemisphere of the human brain with a titanic quantity of graphic data" (71).

In a characteristic Dickian move, VALIS then appears to the characters of the book as a trashy rock 'n' roll film with the same title. In other words, the revelation of the true God is immediately followed by a spectacular false double, which confuses everyone. The spectacle always throws up false copies of the attempts to undermine attempts to expose the spectacle's falseness. This happens with graffiti, too, where, as Rammellzee explains, graffiti's true mission, war on the word, is obscured and literally derailed when it moves from the subway to the gallery, and by characters like Cap in the documentary *Style Wars*, who declares a one-man war on graffiti, defacing every burner he can find. Industrial folk cultures not only have their own concept of infinity, they repeatedly tell the story of the appropriation of this infinite by capitalism and concern themselves with the problem of distinguishing true from false infinities. They are also concerned with distinguishing the true infinity from the conventional Christian figure of God as the infinite descending into the finite. These two false infinities—that of conventional Christianity and that of industrial capitalism—come together in a kind of Gnostic conspiracy where industrialization repeats or imitates the simulation of the universe by the demiurge in Gnostic cosmology—the simulation that results in "our" universe, the universe of Genesis.

All of these artists, whose work predates the era of the personal computer, were articulating the conceptual basis of what today is called "sampling," the practice of taking (or appropriating) "samples" of pre-existing materials and recombining them in ways that produce something new. What distinguishes this process from montage or collage is that sampling occurs by making a representation of an object (say, a photograph or a musical recording) digitally, taking a series of "samples" of the ob-

ject, each of which consists of a digital code that describes a part of the object (a discrete area of an image, or a fraction of a second of a sound). This series of samples can be stored and reconstituted as a sequence of samples that approximate the original object. Or as data that can be manipulated to transform the digital copy of the original into something else, or as an element to be mixed in a variety of ways with other samples which, while not from a technical point of view "infinite," come close to being "beyond measure." The digital object is thus, in an objectively different way from analog representations and from the material artifacts that provide the basis of collage, a mathematical object. The aleatory processes—use of permutation and combination that provide the basis for the imagination of a true or real infinity in industrial folk cultures—are given a further twist when the main basis of culture is number, algorithm, mathematical computation.

File sharing is of course a culture with a strong interest in large numbers. Look at the prominent display of data in my iTunes library: 3,312 songs, 12.6 days, 22.63 gigabytes. Google searches list millions of hits. Users of digital systems of exchange, representation, combination, and so on revel in a culture of numbers. Napster listed the total number of files available on the system. But unlike the foregoing examples, which cite magical, spiritual, or cosmological sources for the true infinity, file sharers and other participants in digital culture remain inchoate in articulating the source of their own claim on the infinite. At a moment when an unprecedented number of people around the globe are actually playing with this infinity, all sense of meaning or value (aside from a legal or economic one imposed from outside) seems to have disappeared. It is as though the actualized infinity of contemporary culture has been mistakenly reabsorbed into hegemonic industrial era notions of the infinite, even as the practices related to this true infinite diverge in ever more radical ways from those of the industrial era.

This source of the power of digital culture and practice I give the name digital mana, invoking the work of Marcel Mauss who, in his *General Theory of Magic* (2001), proposed the Polynesian word *mana* to describe the source of magical power and efficacy in a variety of societies. Mana is a source and manifestation of power, and the way that power comes to be named, or, if you like, the power of naming. It is also connected with taboo—since mana both sanctions the legitimate exercise of power and manifests itself in forbidden activities, objects, and events. In terms of

digital culture, the concept of digital mana expresses the sense of power that underlies the ability to make and distribute digital copies, as well as the copies themselves, those flexible, polymorphous, immaterial objects. Where mana was previously bestowed on a ruling class, the ubiquity of digital means of production means that mana is widely distributed in society—and although hegemonic corporate power structures invoke the taboo in claiming intellectual/immaterial property rights, there is no widespread consensus about the efficacy or validity of the taboo. Digital mana is open source—a widely disseminated power that is more than an echo of the society of the spectacle and its laws. In this sense, Mauss's mana connects with the biblical manna, that nourishment that rains down from heaven when the people of Israel are starving in the desert.[5]

If mana in traditional societies is connected to nature and immaterial forces guiding or controlling nature, what is the underlying source of digital mana? The digital object is made of code. The digital object is the object insofar as it can be "reduced" to its name through being coded. A long, complex, secret name—a "camouflaged" name, to use Rammellzee's term—but nevertheless a name. The name is associated with magic of course, and the power of this magic with mana.

Dick, Rammellzee, and the early hip-hoppers were aware of this possible magic of the name: Rammellzee speaks of the act of painting over someone else's graffiti tags (i.e., their name written on a train) as an act of assassination. Hip-hop rhymes often consist of little more than a listing of names, and, as with graffiti writers, inventing a name is an important part of hip-hop's performativity. We might even observe that one of contemporary popular music's most important tropes, the incorporation of a group of individuals into a band with a name (The Beatles, The White Stripes) is itself a manifestation of the power of naming—no doubt one that draws on African American culture and the erasure of African names by slavery. The act of naming is also a key part in cultures that celebrate appropriation. Burroughs and Gysin discuss it extensively in their work. For Duchamp, the naming or renaming of the object is a key part of what transforms it into an artwork—as it is for Joseph Cornell's boxes, or Robert Rauschenberg's and Jasper Johns's collages. Conversely, marketing and branding consist in giving a name to an industrially produced commodity—Coca-Cola to bottles and cans of fabricated liquid for example—transforming it into desire and fantasy-charged object that appears in our stores.

Naming takes on a new importance, however, in digital culture, where the code that defines and names the object has in some sense become the object. In mathematician Vernor Vinge's groundbreaking cyberpunk story *True Names* (1987), true names are secret names and they are code. The power of the hacker to control his or her name has its basis in mathematics and computation. Digital copying is an emergent property of mathematics or, one might say, infinity. The society of the spectacle, not to mention industrial society, also emerges from this infinity—but this is precisely the concern of the industrial folk cultures I am talking about: to distinguish a true, "natural" infinity and mathematics from a false, reified, spectacular one. Yet with access to a mathematical infinity via computers, the folk cultural imagination shifts to ways of framing and playing with this infinity: names, avatars, skins, passwords. Again, these forms are derided as objects of fantasy, "false names" if you will. Yet they again put into play something undeniable. Digital objects could never exist only as code. While the reified brands and products of industrial culture in all their variety are exposed by their immersion in the industrial folk cultures' true infinity, which reveals them as generic manipulable objects, the proliferation of an infinite variety of mutant copies of digital code today apparently requires appropriate acts of naming, which are a necessary gateway to the act of manifestation. Paradoxically, Rammellzee insists that he has no name or identity, even as he gives birth to a bewildering and beautiful pantheon of avatars and sculptural name forms. Renaming, "remanipulation" is at the heart of his work: the name that you were given (product of Platonic mimesis) is false, and the names you create through alignment with universal forces (magical or true names) are true.

Thus, digital mana is to be found in a paradox. The mathematical framing of digital culture, apparently the source of its power, in fact hides a different kind of power, that of naming. In his *Logic*, Hegel is at pains to distinguish a spurious or false infinity from a true one (1991, 149–50). The spurious infinite is the product of quantification—of adding "one more" beyond the finite and thus remaining, according to Hegel, strictly within the realm of the finite. The true infinite, according to Hegel, is related to being-for-itself, is already immanent within the apparently finite unit, and is able to recognize in itself already the movement of the infinite. There is a philosophical and a mathematical idea of infinity, and they are separate. "Beyond measure" doesn't require a mathematical definition.[6]

In his examination of Hegel's infinity, Badiou argues that Hegel is mistaken in his separation of a qualitative and quantitative infinity, and that his qualitative infinity in fact conceals a fundamentally mathematical determination that is therefore also quantitative. Thus, Hegel's good infinite is determined to be spurious, along with several others, including that of God as the "one" infinite lurking behind the finitude of nature. The true infinite for Badiou, then, is that of a pure multiple that is evental, manifesting in a situation, mathematical affirmation that being *qua* being is infinite. This is a form recognized by modern artists: "This idea comes down to acting as if the infinite were nothing but the finite, once the latter is conceived not in its objective finitude, but in the act from whence it arises. There is no separate or ideal infinite. The infinite is not captured *in* form; it *transits through form*. If it is an event—if it is *what happens*—finite form can be equivalent to an infinite opening" (Badiou 2007, 155).

This is a recognizable description of what we have found in most of the situations we have looked at so far—but with one important caveat. For the most part, Badiou ignores religious and/or spiritual collective forms, which are summarily dismissed for repeating the "ontotheological error" of Western metaphysics. The industrial folk cultures I have described, as well as the twentieth-century avant-gardes, are also concerned with separating true and spurious infinities, and they are fascinated by the power of numbers, which is indeed the source of a mathematical ontology for them. At the same time, through their practices, they present an alternative way of thinking about infinity to the "spurious infinity" of industrialization, which is merely quantitative.

After the Second World War, the twentieth-century avant-gardes themselves were increasingly split over the qualities of the true infinity. John Cage and the minimalists in music, Gysin and the Beats in literature, the advent of performance art and happenings after the war, to say nothing of the unholy trinity of sex, drugs, and rock 'n' roll, all give the infinite an increasingly spiritual meaning, one which, however playful, is at the same time concerned with power or mana, aimed at determination of self, other, and community, and with enjoyment. For Badiou, the decision is between a false religious structuring of infinity and a correct materialist one, but it is hard to see why his "pure multiple" that instantiates the infinite in the finite should not be traversed by spiritual "truth procedures" as much as any other type. The industrial folk cultures are

concerned with distinguishing an infinite that is rooted in an experience or event but at the same time full of spiritual meaning, value, and power, from the errors of both religious and materialist orthodoxies. Somehow the full manifestation of this infinite is always blocked—by Babylon, by drug-addled ineptitude and bungling, by mysterious evil forces of various kinds. It remains "subcultural," which, as Rammellzee recognizes, means a ghetto of the mind. Nevertheless, it is out there, as vision, proposal, and experiment.

With digital culture, the proximity of cultural practices and artifacts to the "spurious infinity" of quantity is much greater, and the possibility that the Internet is nothing but an advanced form of simulacrum or spurious infinity remains. But the delight that hackers and downloaders experience in fact has little to do with the quantitative infinity, even if our computer software, with its fetishization of numbers, appears to suggest this as its source. Instead, participants in digital culture are involved in a different kind of copying that traverses the quantitative, but in doing so attempts to reveal a true and open infinity, in which all objects, subjects, and processes already participate.

Notes

1. Badiou's most thorough examination of infinity, including his critique of Hegel's good and bad, quantitative and qualitative infinities, can be found in *Being and Event* (2005, 142–72). This critique is developed with regard to twentieth-century art in *The Century* (2007, 148–64), and to politics in *Metapolitics* (2006, 141–52), but it is also present throughout Badiou's work.

2. I have taken the idea of industrial folk culture from a remark by journalist Ian Penman who, in a review of Public Image Ltd's Metal Box in 1980, observed that Public Image Ltd were making a kind of industrial folk music. In fact there is a British LP called *The Iron Muse: A Panorama of Industrial Folk Music* (1963), which collects industrial workers' songs, and German synthesizer band Kraftwerk also made a claim that they were playing "industrielle Volksmusik" in the 1970s, providing one of the links to what is now known as industrial music. Although "industrial" and "folk" are usually terms that are seen as opposed to each other, I believe there is a continuity between the practices of preindustrial folk cultures, such as those discussed by Bakhtin (1984), and peasantry in the industrial world, despite the radical shifts in the peasant world described by Marx. Henry Flynt's comments on ethnic or "folk" musics and the avant-garde, in his essay "The Meaning of My Avant-Garde Hillbilly and Blues Music" (2002) have

also helped me understand folk cultures as active and dynamic in contemporary culture, rather than being archaisms.

3. "Rhythm Shower" and "Version Like Rain" are both titles of LPs by JA producer Lee Perry, the latter a collection based on versions of three rhythms.

4. Paul D. Miller points to this mathematical heritage of hip-hop in his book *Rhythm Science* (2004), and the possibility of "making a world" out of the montage and combination of two records. Other key hip-hop mathematics connections include the Wu Tang Clan producer Allah Mathematics, early hip-hop MCs, the Infinity Three.

5. See Exodus 16 for manna. It should be noted of course that biblical manna comes with conditions — that it should not be stored until the following morning, that there would be none on the Sabbath.

6. Another pathway into these questions can be found in Wittgenstein's later work, notably his argument with Russell in *Remarks on the Foundations of Mathematics* and *Philosophical Investigations*, where mathematics and logic are seen to emerge from "language games."

Copyrights and Copywrongs

An Interview with Siva Vaidhyanathan

"Thomas Jefferson would have loved Napster," Siva Vaidhyanathan has ar-
gued. And we're inclined to trust him on this, because he has been tracking
copyright law since its dawn.

Vaidhyanathan is the author of the excellent book *Copyrights and Copy-
wrongs: The Rise of Intellectual Property and How It Threatens Creativity*
(New York University Press, 2001) and teaches media studies at the University
of Virginia. I talked to him about *Copyrights and Copywrongs* in 2002.

McLaren: Copyright gives creators exclusive rights to their works; his-
torically, at least, this was to promote growth in the arts and sciences.
In *Copyrights and Copywrongs*, you discuss how expansions in copyright
law have, ironically, restricted public access to arts, ideas, and new tech-
nologies. But although you see copyright as a problem, you did make one
argument for it. You said if there were no copyright laws, then authors
would never write novels. They'd just write screenplays, because that's
where the money is.

Vaidhyanathan: I don't think we need copyright nihilism. What we need
is a flexible, humane system, much like we had before 1976.

McLaren: What happened in 1976?

Vaidhyanathan: A couple of things. Congress decided that the term of
copyright protection should not be fixed—that it should be life of the
author plus fifty years. Before that 1976 law, the term of copyright was
twenty-eight years and if you cared enough you could renew it for an-
other twenty-eight years. That's reasonable. Most copyrights were not

renewed. When they weren't renewed they became our property—they entered the public domain and we could use them. The 1976 law also made copyright applicable to all expressions fixed in any tangible medium. That means that every email you write is copyrighted, every scribble on paper is copyrighted. There's no registration process. That violates the deal. The deal with copyright is that we grant a temporary monopoly in order to allow the publisher to charge monopoly prices for a limited period of time. And what we get by giving the publisher that right is access to the work. By 1976, Congress has decided that trade was irrelevant.

Before the digital world emerged, we agreed to allow the government to regulate copies, but we certainly didn't agree to allow the government to regulate reading, because reading a piece of material or listening to a song or watching a film was very different from making a copy of it. With digital works, you can't help but make a copy when you access something. To read something online is to make several copies of it. So by agreeing in 1976 to such a high level of regulation over copying, we've allowed government, and, by proxy, corporations, to regulate what we read and what we see.

McLaren: It's funny. You think of corporations as being so antideregulation, and with copyright, it's the complete opposite.

Vaidhyanathan: Corporations are always pro-regulation when it's to their benefit. Copyright law has been way below the public's radar largely because this stuff seems so complicated and so irrelevant to daily life, but I think that's changing.

McLaren: Napster really raised the awareness level, although I'm not sure that's all good. I'm on an email list with lots of teachers, and when, say, a student uses a popular song in a video they've created, some teachers will refer to that as stealing.

Vaidhyanathan: But when many people say they're stealing, they're joking. They giggle when they use peer-to-peer systems to download songs . . .

McLaren: I think you can blame part of the problem on language. Where did the term "intellectual property" originate?

Vaidhyanathan: In the late 1960s, the phrase started making its way into law school course catalogs. Within legal discourse, "property" does not

mean what it means in popular discourse. So it wasn't a real problem until the phrase caught on with the public. When that happened, it allowed experts to call the shots. Jack Valenti [president of the Motion Picture Association of America] will say, "This is theft, this is theft, this is theft," because we're talking about property. You could then use metaphors like "If I lock something up in my garage, you can't come in and take it." Or, "You can't break into my house to watch television."

McLaren: But those arguments are pretty easy to shoot down, don't you think? Because real property isn't like copyrighted material. If someone takes something from your garage, then you don't have it anymore. But if, say, a store plays your song, you don't have any less of a song.

Vaidhyanathan: Unfortunately, the property metaphor is addictive. Whenever we debate people who belong to the content world, we end up having to work within the metaphor. Now I tend to respond by saying, "You're not talking about real property, you're talking about a government-granted monopoly." And you have to get back to that point that copyright is not natural, it's something that we the people decided to give to a certain class of people in exchange for something. And so if we're not giving what we promised to this group of people, we need to ask whether the system is properly balanced.

McLaren: Dr. Seuss went to court in the 1950s to stop someone from merchandising dolls based on his characters. He lost—twice—because the courts said that when he signed away the rights to publish the cartoons, he signed away all his rights. When did the law start recognizing that there were separate rights involved for merchandising and licensing?

Vaidhyanathan: I don't know when exactly, but recognizing that there is a bundle of rights is essential in protecting artists. I write a column for MSNBC, and they're notorious for taking too many rights away from writers. They sent me a contract that claimed for them all rights in all media "in perpetuity throughout the universe." I didn't like that so I changed it to "first digital rights." That means I can put anything I write for MSNBC into a book.

McLaren: And they agreed to that?

Vaidhyanathan: They agreed because it wasn't worth the fight: I'm not worth that much money to them.

McLaren: A lot of companies have policies where if you don't agree, they just won't let you do it.

Vaidhyanathan: Yeah, but you've got to ask anyway. I mean, when my cable modem company came in to install my cable modem there was a provision in the contract that said I cannot act as a server. Well, what does that mean? That I can't have stuff available for other people to pick up? I can't devote a folder to a peer-to-peer system? So I just crossed out that section, initialed it, and signed the contract. All contracts are negotiable. But people have to recognize that they can do that. And really I think that's the source of artists getting screwed in this system. They take legal language way too seriously.

McLaren: But what about the online "clickwrap" contracts that never give you a choice? You either click "I agree" or can't proceed. You can't alter them.

Vaidhyanathan: Those contracts aren't enforceable at this point. Corporations are trying to change the law state by state to make these clickwrap and shrinkwrap licenses enforceable. [Shrinkwrap licenses are those that consumers automatically agree to when they break the shrinkwrap on a software package.] They're trying to make it so that consumers have absolutely no rights to complain about the use of a clickwrap or shrinkwrap product. It's the biggest threat to consumer rights in thirty years, as far as I'm concerned.

McLaren: Because if you buy something and don't like it, or if it doesn't work on your machine, you can't take it back.

Vaidhyanathan: Exactly. And what's happening, especially with software, is that you can't make fair use of it. If you go to the Billboard Music site, they have a special section full of research on the music industry. But to get in, you have to sign a contract saying that you won't report any of the information. You can't distribute it publicly, which for someone like me, makes it useless.

McLaren: So, when you see those contracts, do you go ahead and just not worry about it?

Vaidhyanathan: Yeah, for the most part. I figure: bring it on, sue me. It would be fun to fight one of those contracts in court.

McLaren: Is it legal to force people to waive their free speech right? Fair use is basically a free speech issue.

Vaidhyanathan: Unfortunately, the courts lately have decided that free speech doesn't matter in the face of copyright. It's one of the reasons that the Supreme Court is now considering copyright cases because it is concerned about the conflict with the First Amendment.

McLaren: In court decisions on copyright from as late as the 1980s, there's a ton of language about the public interest. It seems like there's been a huge change within a short period of time.

Vaidhyanathan: Definitely. I have to blame Reagan because it's so easy to blame him. But there's a whole generation of judges who came to office in the 1980s who are fundamentalists on issues of privatization and private control, but not privacy (*laughs*).

McLaren: Let's talk about electronic gates. If someone scans a picture that's in the public domain, he can claim a copyright on it. What's the reasoning there?

Vaidhyanathan: If you go into a movie store right now and buy the DVD of *Birth of a Nation*, which has been in the public domain since the 1930s, you'll find that it's protected by digital rights management technology so you can't make copies of it, even though it's in the public domain. You can't make fair use of it. You can't take pieces of *Birth of a Nation* and satirize it, make fun of it, chop it up, or make a scholarly work out of it.

McLaren: Could you if you had a videotape of it?

Vaidhyanathan: Yeah, but not a DVD. Basically, they have copyright protection for technological work rather than creative content.

McLaren: Are they saying they've improved the quality of the original? That they've done something to make it different?

Vaidhyanathan: They're not really making that sophisticated an argument. They're saying if you don't give us this ability to legally protect digital rights management technologies, we're not going to give you DVDs.

McLaren: What about photographs? If a company uses a scanner to make an electronic version of an image, it gets a copyright on the electronic version. It seems like that's a great price to pay, just for scanning.

Vaidhyanathan: The photograph is still in the public domain if you can get a hold of it. But if it's in Bill Gates's storage vault, the only thing you can get is the digital form. So what they've done is take all of these works in the public domain, make the analog versions unavailable, and then sell only the digital versions, which are then highly protected.

In the next thirty years, none of us is going to have working VCRs. The movie industry is phasing out VHS. Soon we won't have Super 8, and we certainly won't have the original celluloid version of *Birth of a Nation*—all we will have is the DVD. And that means that we no longer have it in the public domain.

McLaren: What about moral rights? [Moral rights refer to the artists' right to control the fate of their works and how they're used.]

Vaidhyanathan: Media companies in the United States don't want moral rights; the last thing they want is to have their directors or actors to have power over what they do to those films. But at the same time, there is strong public support of it in Europe and perhaps in the developing world, too. I would love to see the entire world give up on the question of moral rights because I think the moral rights approach becomes censorious as well.

McLaren: What about that Monty Python case? ABC licensed Monty Python episodes but then edited the hell out of them and ran them. So Monty Python sued and won.

Vaidhyanathan: The Monty Python case is the example of moral rights creeping into American law.

McLaren: So what's wrong with that?

Vaidhyanathan: I think we need to demystify the notion of creation. There's nothing magical about it and there's nothing sacred about it. This was a commercial transaction and the folks at Monty Python signed a contract with ABC and at no point (these were Oxford- and Cambridge-educated guys with major lawyers) did they negotiate the terms of the contract in such a way that prevented ABC from doing what it wanted to do. They should have foreseen that. After the fact, they started complaining.

I think the judge made a very poor decision by backing Monty Python in that case. There's no bigger Monty Python fan in the world than me,

but I don't think we should let our critical faculties get in the way of judgments about what sort of copyright systems would be best, because the next people who try to do that are not going to be as funny or as talented as Monty Python, and they're going to have way too much control over the use and reuse of their work. There are ways to build artist protection into contracts, and I think that we need to strengthen the position of artists in the negotiating process, but moral rights is not the way to do it. The best way to do it is through collective bargaining.

McLaren: You mentioned in your book that in 1909 the law created a new definition of authorship, corporate copyright, and that was a radical change. What effect did this have? And how did it affect the idea that copyright was an incentive to create?

Vaidhyanathan: Here's the interesting thing about the incentive to create. We don't actually know that copyright works as an incentive to create. We just assume it. It's not a bad assumption, but it's almost impossible to test. If the hypothesis is no one would ever write anything if there were no copyright laws, well, that's actually pretty easy to toss out with one counterexample, and the best counterexample is the Bible, which people put a lot of time into with absolutely no copyright protection. We got copyright soon after the printing press. But the world is filled with creative material that was generated before the advent of copyright. You know, Homer didn't have copyright.

McLaren: And we all know dozens people who write with little or no possibility of getting paid.

Vaidhyanathan: Exactly. Look at the development of the Internet. Most of the content on the Internet was not done for profit: it was done for love. But the incentive is more defensible by saying that it's about the incentive to distribute, the incentive to market. It's easier to argue that nobody would make a full-length feature film and distribute it to hundreds of thousands of theaters throughout the country if there were no faith in the copyright system. So, if we agree that it's a good thing we have the *Godfather* and *Star Wars* in our lives, then it's probably a good thing that we have copyright protection. If copyrights disappeared tomorrow, there would still be poetry but there wouldn't be *Star Wars*.

As for the 1909 law, newspapers and magazines didn't have copyright protection. Because copyright was only something originating with the

author, you couldn't copyright an entire newspaper or magazine in the name of the newspaper or magazine. Because of this, publishers lobbied for a provision that you didn't have to be an individual writer to enjoy copyright protection, that you could be a corporation. It was purely meant to deal with compilations and encyclopedias and newspapers and so forth, but you still had to file for copyright protection. Even after this passed, newspapers didn't file for copyright protection (because newspapers weren't worth anything on day two), but magazines and encyclopedias did. This little tweak of the system ended up growing into the dominant factor in American copyright. Now most works that matter are copyrighted in the name of corporations.

McLaren: If the incentive is to market and distribute, then that makes sense.

Vaidhyanathan: Exactly. I don't know anyone arguing that we should move beyond that. One of the problems with moral rights is that it undermines the corporate power. All corporations aren't necessarily the bad guys in these situations. You know, if I were to write an encyclopedia article, and the publisher felt that I had done a very bad job and needed to substantially rewrite it, it would probably not be a good thing for me to have moral rights to be able to veto editorial changes, because I'm not assuming the risk — the marketing risk and the risk for libel and the risk for copyright infringement. The publisher is.

McLaren: So basically you're saying that it shouldn't be problematic for a company to hack up somebody's work, but there should be other mechanisms for rebalancing the powers between them. That reminds me of your chapter on blues artists. A lot of white people made millions by appropriating the work of poor African Americans. But the blues artists were also using everybody else's work — the idea that a tune or lyric was owned by someone was antithetical to how they made music. Don't you think it's ridiculous that these guys didn't get paid at all? But you're saying the money shouldn't come through copyright. Right?

Vaidhyanathan: Yes. They got ripped off because they didn't have any bargaining power; the situation was totally skewed for white people. But I think it's important to consider that separately from copyright. Copyright should not be where we look to fix this problem. The business practices of labels like Chess were reprehensible. They hired people like Willie

Dixon and paid them hourly to produce this incredible music. They got Willie Dixon to produce a lot of his songs as works for hire, which is one of the things that emerged from that 1909 change in corporate copyright. So they controlled all the rights to this stuff and Dixon got pennies. Ron Howard has the same labor arrangements with the companies that distribute his films as Willie Dixon had with Chess. The difference is that Ron Howard has negotiating power. Chess took advantage of Willie Dixon because he was black, because he was poor and uneducated. But he wasn't uneducated for long. He ended up learning all about copyright law, taking control of his career, and his later works were all copyrighted in his own name, which is why he then had power in the marketplace. But it wasn't just black artists that got screwed by record companies. It's just that there have been a handful of folks who've gotten lucky—the Elvises and the Madonnas—and they've been able to then bargain from a position of strength so that Elvis's RCA contract was a hell of a lot better than the exploitive contract he had with Sun. Madonna's contract with Time Warner, the second contract of her career, basically gave her complete control over her creative life. There just aren't that many artists who get to that bargaining position. But, yes, Madonna is going to take pieces from the well of gay culture and move them into her own work and make a lot of money off of it, whereas the people who invented vogueing don't make a dime. And Elvis is going to make a lot more off of R&B than Big Mama Thornton or Son House, but that doesn't mean we want copyright law to prevent either Madonna or Elvis from doing what they do.

I think we just need to be able to recognize the roots of this creativity, and if we feel like it, reward the people who were doing it before them. People will say, "Wow, if Keith Richards really likes Muddy Waters and they named the Rolling Stones after a Muddy Waters song, maybe I should listen to Muddy Waters." The system is not a zero-sum system by any means.

McLaren: What did you think of that Vanilla Ice case?

Vaidhyanathan: Vanilla Ice ended up paying royalties to Bowie and Queen . . .

McLaren: Or if, say, MC Hammer hadn't worked with Rick James on "U Can't Touch This."

Vaidhyanathan: On both of those songs, the sampled work was so extensive that it didn't really work the way most sampling works. I think that

would be an interesting case to decide whether that was fair use or not, and I would have liked courts to have actually considered the nuances of those situations. I tend to think that artists should be able to borrow freely from their predecessors. If anything, Hammer helped revive Rick James sales. People said, "Wow, I really like that Rick James song." So how much was Rick James harmed by that if Hammer hadn't cleared it? I don't know. But that's the sort of question that a court should have been able to answer. But it never really got to that point because the law basically shut down all sampling without permission, and I think that was a big mistake.

McLaren: Film director Davis Guggenheim has said that, ten years ago, if a copyrighted work—say, a poster or a concert T-shirt—appeared in a film and was recognized by the common person, the filmmaker would have to get it cleared. Whereas today, if something appears in a film and it's recognized by anybody, then it has to be cleared. How did this come to pass, and what's the logic behind it?

Vaidhyanathan: I don't know if that ten-year assessment is correct, but copyright holders have become more vigilant, so judges have reacted on their behalf. The common law is based on habits, and so, if the habit in the industry and in the culture is to clear everything, then judges will go along with that. There's no wall that stops them from maximizing this practice.

McLaren: Well, in the 1980s, Coca-Cola owned Columbia Pictures. And Columbia used to make movies that associated Coca-Cola products with good things and Pepsi with bad things. They couldn't do that now.

Vaidhyanathan: Well, when you're dealing with commercial speech and product placement, that's a whole different set of questions.

McLaren: But you have to get products cleared in the same way you would artwork.

Vaidhyanathan: Yes. Of course, with commercial products, you'd rather have the companies pay you. The money flows the other way in that case.

McLaren: Unless you want to use the product in a negative light.

Vaidhyanathan: Let's say you're making a film about McDonald's misdeeds around the world. You could certainly use the images of McDon-

ald's because you have a fair use right to do that; you're commenting on it. McDonald's would still sue you—and they'd probably sue you for libel in England, where they might actually win. What we're dealing with in most of these cases is the "found art" around us—the signs and symbols we live with all the time. You look around your room, and there are very few things within your field of vision that don't carry some sort of intellectual property protection, either trademark or copyright. And, for that reason, it's very hard to try to represent reality in any way.

In the movie 12 Monkeys, there was a chair that wasn't recognizable by laypeople, but the guy who designed it recognized it and got an injunction on the release of the film. This is the sort of excessive level of protection that can only be considered extortion. I mean this guy was not going to make more or less money because the chair happened to be in the movie scene. But he shut down the release of a major studio motion picture to shake them down for money. If the level of protection is going to be that high, then there will be a lot of problems for artists. The same thing happened with a piece of artwork used in the movie Devil's Advocate. The question we should be asking is whether we want to have the sort of culture that is so allergic to using the found symbols around us.

McLaren: Wasn't the artwork in Devil's Advocate a religious piece? The sculptor converted to Catholicism while making it, and it was used in some sort of satanic, sexual way.

Vaidhyanathan: That may be true, but that is irrelevant to a copyright claim. The nature of the work doesn't matter. The rights of the artist in terms of reasonable representation of his or her thoughts—those don't matter in the United States. They matter in Europe.

McLaren: Because Europe has "moral rights." I'm going to play devil's advocate here—har, har. My friend Jem was telling me about an influential book by photographer Robert Frank, The Americans. It was pretty radical at the time—1958—because the photos were of common people and portrayed America as a sort of grim, alienating place. Well, Don Henley took some of Frank's photos and made them seem to come to life in one of his videos; but instead of sharing Frank's ambiguous tone, Henley turned them into a real celebration of America. There was no direct reference to Frank, though, nothing to indicate that the scenes were borrowed. So then everyone sees Don Henley's video on MTV, but no one

sees Frank's photographs. In this instance, don't weak copyright laws—which is what you are arguing for—give more power to companies and reduce the power of the artist?

Vaidhyanathan: Companies with big megaphones are always going to have more power. Copyright is not the right tool to alter that formula. Basically, Don Henley built on the work of a previous artist—altered, commented, and perhaps changed the meaning, but that's what critics do. That's what Alice Randall, the author of *The Wind Done Gone*, did to Margaret Mitchell's *Gone with the Wind*. Whether one party has more cultural power or more financial backing is not something the law should be concerned with. The law should never work to lock in the previously conceived work and stifle the production of the second work. Now, all too often we've seen the second taker [Don Henley, in this case] make quite a bit more money than the first artist, but those are the breaks. We saw Elvis make more money than Big Mama Thornton. I mean, there are a lot of complicated reasons for that, but I don't think anyone should argue that Elvis should have been prevented from building on the work of rhythm-and-blues producers, especially since the next generation of creators, including Jimi Hendrix, could build on the work of Elvis. Nothing prevents you from building on the work of Elvis—except that now the Elvis estate has such high levels of protection over all of its signs and symbols.

McLaren: So you're saying that if copyright had prevented Henley from appropriating Frank's photos, then it would also prevent someone from appropriating or criticizing Henley's video. But would you distinguish between commercial speech and noncommercial speech in this case?

Vaidhyanathan: Not really.

McLaren: You could say Don Henley could use Frank's photos but not for profit.

Vaidhyanathan: But what is for profit? If you're putting a video on MTV, in a way it's an advertisement, but in a way it's a product in itself. Music videos are an art. When you're dealing with cultural products, the line between commercial and noncommercial speech is almost indistinguishable. What about Frank's book? That was being sold for a profit.

McLaren: Yeah, yeah, I see your point. But let's try another example. Nike

uses a significant part of a song by punk rockers Le Tigre in a commercial. In your ideal world, would they be allowed to do that?

Vaidhyanathan: Well, that is clearly an advertisement. I take it back. Sometimes the line is clear between commercial and noncommercial use of artwork, and when that line is clear, different rules apply. The important question here is the implied endorsement of the product. Certainly no artist should be forced into giving the impression of an endorsement where none exists. In addition, artists should expect to receive reasonable compensation for the use of substantial portions of their work in commercial settings. So Nike should do what it does—ask permission and pay substantially for the rights to a song. But my point is that the copyright holder is rarely the artist herself. Therefore we should not romanticize copyright as an author's right. It starts out that way, but that's not the whole story.

McLaren: Incidental music can't be played in a movie. What are the music owners' arguments to prevent this?

Vaidhyanathan: They want the ability to license music for specific places. If you were allowed to use music incidentally in films, then there would be no market for licensing. You couldn't get Bette Midler singing the theme from *Beaches* as an exclusive product because Bette Midler's song could be in any movie. I think courts should be sensitive to the difference between documentaries and produced films. Music is around us all the time, so what are documentaries supposed to do?

McLaren: Do you know of any filmmaker or artist groups fighting this?

Vaidhyanathan: No. I know that journalists are very concerned, though. Journalists are supposed to be able to take a snapshot or pan a particular scene to cover the news. If you went right now with a video camera and scanned Times Square, you would pick up CBS logos and NBC logos because they both have big billboards in Times Square. But a few years ago, CBS videotaped Times Square and digitally replaced NBC's logo with its own. When broadcasters start subbing in logos, perhaps they jeopardize their right to use incidental material.

Originally published in *Stay Free!* 20 (fall 2002), available online at http://www .stayfreemagazine.org.

Das Plagiierenwerk

Convolute Uii

As "Das Plagiierenwerk: Convolute Uii"
by David Tetzlaff has been determined
to violate U.S. copyright law, it does
not appear in this book.[1]

1. Prof. Tetzlaff[2] is outraged that small-minded legalisms prevent his work from appearing[3] in this book.

2. Tetzlaff may or may not be considered the "author"[4] of *Das Plagiierenwerk*,[5] depending on your philosophy, or position within the corporate economy of information.

3. However, Prof. T is consoled by the fact that *Das Plagiierenwerk* has not been *printed*, since the form of printing violates whatever measure of creative integrity the work may possess. That is to say, *Das Plagiierenwerk* is *not* an essay, and mere black-and-white text on a page cannot do it justice. (Whether or not it deserves justice being a suspended question for the moment.)[6]

4. *Das Plagiierenwerk* is an attempt to plot an introductory intellectual path into the issues around cultural works employing interventionist strategies of collage/appropriation/plagiarism entirely by using interventionist strategies of collage/appropriation/plagiarism.[7] The text of the work is entirely appropriated from other sources, in snippets ranging from pithy sentences to approximately half-page excerpts. The sources sampled include, first, a number of critical essays about copyright policy from "public intellectuals" such as Larry Lessig, Siva (say it three times fast) Vaidhyanathan, and this book's co-editor Kembrew McLeod. Also included as text sources are quotes from TurnItIn.com and other commercial and academic Web sites dedi-cated to discouraging student plagiarism, quotes from Theodor Adorno's *Aesthetic Theory*, and quotes from Convolute N of *The Arcades Project* (Benjamin 1999).[8] A few of the snippets have their language slightly altered for the occasion.

In homage to (or theft from) the great experimental filmmaker Hollis Frampton, whose algorithmic masterpiece *Zorn's Lemma* is a kind of collage art, the montage of snippets in *Das Plagiierenwerk* was generated by putting them in alphabetical order and letting them collide as they may as a result—except for the passages from Benjamin, which are placed wherever DJT thought they worked best.

5. The title *Das Plagiierenwerk* is a play on Walter Benjamin's *Das Passagen Werk*, published in English as *The Arcades Project*.[9] *The Arcades Project* is a sort of giant intellectual scrapbook, composed of small chunks of observations, insights, and quotations Benjamin collected over many years. The work was unfinished at the time of his death, and we do not know exactly what it would look like had he "finished" it. However, it seems he believed the general form the work now has— a collection of seemingly separate thoughts grouped together by means of collage/montage—was appropriate to its purpose, to capture the distinct nature of twentieth-century

urban life. The book is organized, not into chapters, sections, or other conventional divisions, but into a series of "convolutes" marked by letters of the alphabet. "Convolute" does not appear in noun form in *The American Heritage Dictionary*, but as an adjective it is defined: "rolled or folded together with one part over another; twisted; coiled."

The subtitle *Convolute Uii* refers, of course, to the American spy plane piloted by Francis Gary Powers that was shot down over the Soviet Union during the height of the cold war. (Copyright attorneys for Seeland Records should make special note of this, and be aware that Prof. Tetzlaff and the publishers of the present book are prepared to mount a vigorous defense against any claim that this subtitle infringes on the intellectual property of the recording artists Negativland.)

6. *Das Plagiierenwerk* is an exercise in Conceptual Scholarship®. Conceptual Scholarship® is something like conceptual art, but without the claims for aesthetic value. The standards for what counts as art are no doubt higher than the standards for academic work (compare say, the Routledge catalog to the collection at the Louvre, or the Bellagio). Conceptual Scholarship® is ambitious in concept (of course) but modest in practice and production. (It would really stir the pot, if only it

got out more.) It might be described as Dada strokes executed within the hostile territory of academia. There is a performance element, but the performance need not communicate or express along accepted aesthetic lines. In Conceptual Scholarship®, only the *idea* of the performance really matters. The content of the work bears little significance. Instead, whatever value the work has lies in its mere existence.

Of course, the ® in Conceptual Scholarship® is a product of Conceptual Scholarship® and does not indicate an actual legally registered trademark.

7. Prof. Tetzlaff makes no claim that the method used to create *Das Plagiierenwerk* "works." Instead, he politely requests that readers be open-minded about the kind of work this method might accomplish. It is an experiment, seeking whatever validity it may obtain in process, not product.

Perhaps it goes without saying that this process begins (but does not end) with the irony attendant in the fact that a book about interventionist collage and appropriation cannot risk including an intervention on the subject of collage and appropriation produced by methods of collage and appropriation without incurring unreasonable legal "exposure" to its publishers.[10]

(There's an essay somewhere

where Striphas and McLeod note that the publication of *The Arcades Project* in 1999 was enabled by the fact the sources Benjamin plundered for his "crazy mosaic" had fallen into the public domain, and anyone trying a similar approach today would be out of luck in a world where academic publishers run from even the possibility of a lawsuit. . . . Hey, that's *my* idea, Kembrew. Why don't you and Ted get some concepts of your own, eh?)

The text of *Das Plagiierenwerk* is essentially a summary of some of the most important ideas (at least, by Tetzlaff's estimation) circulating in the current debates over copyright and cut-and-mix culture. In this it is stunningly unoriginal, though perhaps useful as a conversation starter. The one element of the text that may have some measure of originality is the intersection it creates between these discourses and the rhetoric of the campaign against student plagiarism. Plagiarism in this literal sense, as opposed to the figurative use of "Plagiarism®" by the Neoists, is rarely if ever connected to interventionist collage. Dr. Tetzlaff would like to reassure all the institutions that have ever employed him as a teacher, or might ever consider doing so in the future, that he is in fact opposed to the practice of plagiarism by students, and has been duly diligent in ferreting out cheaters and meting

out appropriate consequences. However, he hopes that *Das Plagiierenwerk* might encourage academics to call into question the ideological presumptions that lie behind the anti-plagiarism messages directed at students and teachers, and consider the ways in which this rhetoric reproduces and reinforces the discursive support mechanisms of a repressive corporate information economy.

It is not at the level of its borrowed/stolen words that *Das Plagiierenwerk* may have value, but in the insistent purity of its *unoriginality*. As Conceptual Scholarship®, it is meant as a provocation, a probe (in both the McLuhanite and *X-Files* senses of the term, if there's any difference . . .); not product, not even process, but prod.

8. In keeping with Benjamin's goal "to develop to the highest degree the art of citing without quotation marks," none of the sources in *Das Plagiierenwerk* are cited directly. Instead, the work employs a visual/textual element: an "Originality Report" from TurnItIn.com that shows instances where elements of submitted papers can be matched to its database of works already published on the Web. Toward the top of the TurnItIn report is a listing of the URLs of all the Web pages matching content from the submission, each color-coded with a different hue and shade of text. The body of the sub-

mission follows, with passage/source matches identified by the color code established above. In the case of *Das Plagiierenwerk*, which received a similarity index of only 54 percent, warranting a yellow flag, this produced a bright and cheerful display of rainbow-colored paragraphs, mixed with occasional mysterious sections of black text (unfound on the Web and thus presumed original by the computer).

Unless/until some lawyers with nothing better to do force its removal, the visual component of *Das Plagiierenwerk* (that is to say, a copy of the TurnItIn report) can be viewed[11] at http://www.filmclass.com/dpw.

9. While the inspiration for *Das Plagiierenwerk* came from Benjamin, it does not come from *The Arcades Project* per se. In 1984, when David Tetzlaff was in graduate school at the University of Iowa, he heard a story about how Benjamin once proposed to write an entire book using nothing but quotations. The young Tetzlaff thought this idea was brilliant, and set himself an ambition to produce just such a work someday. This seemed to him at the time to be a perfect parody/reductio/extension/Dada stroke on the kind of papers he was writing at the time—along with most grad students in the humanities before and since: very heavy on block quotes, and reluctant to ven-

ture any sort of opinion that could not be referenced by citation to some accepted scholarly authority. A tenured professor in Tetzlaff's department stated publicly that no one should be allowed to write an "essay"—that is, to express a possibly "subjective" opinion—before reaching the age of fifty. In those days, young David had one or two original ideas. The articles he spun from them were rejected by academic journals for lack of appropriate back-up citation. Now Dr. Tetzlaff is past fifty. He hasn't had a new idea in years, and so he has dug out his old idea, and presented you with a work consisting of nothing but quotations, which he still fails to cite according to accepted scholarly standards. As Jerry Lee Lewis used to say, "Think about it!"

10. As *Das Plagiierenwerk: Convolute Uii* does not actually appear in this book, it should not be cited. As these notes reference a work that has not actually been published, they, too, should not be cited. Citation buries the truth that we all borrow ideas behind the lie that somewhere there is an individual point of origin, of authorship, of ownership. Steal creatively, and profligately, and stand with chutzpah on the intellectual booty of our collective history! Let this note be the first outburst of a revolution against citation. Let this note be the last note, ever.

11. *Das Plagiierenwerk* is not meant to be read, or viewed. Its proper form is as an action to be observed. A speaker is announced as part of an academic conference schedule, under a different title. When his turn to present in the panel arrives, he reveals a display of the TurnItIn printout hanging behind the lectern. This is enlarged to the point where the audience can see it is composed of multicolored text but cannot read it. The speaker does not explain what it is. He announces that the title of the talk has been changed, and hangs a title card bearing the words *Das Plagiierenwerk* from the lectern. He goes back to where he will speak, pauses, then returns to the title card and unfolds a flap revealing the subtitle *Convolute Uii*. Then he reads the text of appropriated snippets in a sincere and engaged tone of voice, without indicating in any way that the words are borrowed and have been reassembled along the dictates of a simple algorithm. The audience is left to figure out what exactly they are hearing and witnessing, what its status as discourse might be, what value it may have, what principles of ethics, honor or law it might violate, and to what extent any of this matters.

PhotoStatic Magazine and
the Rise of the Casual Publisher

Sometime during the early 1980s, a number of people in many differ-
ent places suddenly understood that they could afford to become pub-
lishers, as photocopy shops began to appear in cities around the world.
Certainly it had been possible before this time for private citizens to self-
publish, but the compromises were many: one accepted either high cost
or poor print quality (or any number of other trade-offs), and even that
only after surmounting the intervening technical barriers, acquiring or
hiring the necessary equipment and skills to realize the difficult task of
putting print to paper.

Accessible photocopying changed all that. Admittedly, the print quality
of photocopies, particularly for continuous-tone photographs, is not as
good as professional offset printing, but it was generally better than any
other inexpensive alternative at the time. A photocopy can also be more
forgiving of the technical flaws common in works made by artists still de-
veloping a set of skills; a quality that, interestingly for us, lends itself to
an attitude of experimentation. Unlike offset, which generally requires a
minimum print run too large for most small publishers to afford, photo-
copy editions can be made in any quantity at a low unit cost. One can thus
do an edition of, say, three, or ten, or fifty, just to give away to friends —
or to bulk mail to hundreds of devoted readers. Photocopy is not fine
printing, but it is good enough for many purposes. It also had an impor-
tant effect: with photocopy, casual publishing suddenly became possible.

In this context we began publishing *PhotoStatic Magazine* in 1983. We
began the project unaware that there already existed a cultural move-
ment of small magazines, or zines, many of which relied on cheap photo-
copying for their existence. It seemed the right time. Punk rock had left

in its wake many like us, who had taken to heart its do-it-yourself atti-
tude, which we placed front and center in our artistic repertory. With a
certain disdain for mass culture (or one could say it was a love-hate re-
lationship), we set out to make our own cultural world, furnishing it ac-
cording to our fancy. *PhotoStatic* was fortunate to find itself within this
blossoming subculture, comprising literally thousands of projects and
titles, and it flourished there for the next decade.

The zine movement evidently grew out of small press traditions that
had their roots in activities as various as political pamphleteering, the
self-published and idiosyncratic works of artists such as William Blake,
sci-fi and fantasy fanzine publishing (beginning decades earlier), *samiz-
dat* (from the Russian for "self-published"), Dada reviews like *Le cœur à
barbe* or *Merz*; as well as the stereotypical (though not uniquely) Ameri-
can spirit of independence and self-reliance. Like Dada and Surrealism,
and even the geekier sci-fi and fantasy crowd, the zine movement was a
rejection of conformity and an attempt to put imagination in the driver's
seat. The "unslick" aesthetic of xerox echoed and sometimes made direct
use of the qualities of *détournement* championed by Situationism, and
often seemed perfectly suited for the aspirations of an antislick subcul-
ture that felt itself "soaking in" an enveloping sur-culture pathologically
fixated on its own glossy surface without regard to its often mediocre and
unappealing substance.

Because of the fact that we were based in the U.S. Midwest and, like
many zine producers, outside of the cultural centers on either coast (and
in which we could only participate vicariously), a certain amount of cul-
tural self-reliance was necessary and desirable. The charge was often
leveled in the zine community that the fact of being free to express one-
self was valued over the content expressed. It is certainly true that zine
publishers were often enthusiastic, energetic, and prolific, and these
self-expressive and self-publishing exercises were often profound life-
transforming activities for those involved, which led to predictable ex-
cesses along the way. This was certainly the case for us.

PhotoStatic's purview was established early on as "xerox art," as we
called it, flouting Xerox Corporation's trademark by taking its name as
generic. We were interested in the xerox machine's dual nature. It was,
after all, a camera that made an image of anything placed on the platen
glass; it was also a press, delivering an edition at the touch of a few but-
tons. We wanted to explore the particular formal qualities of xerography;

its expressionistic contrasts, its electric granularity, its charcoal-sketch visual timbres, its ability to fragment and unite disparate images using collage techniques, as well as the performance aspects of interacting in real time with the sweeping scan light of the machine, producing unique prints each time the start button was pushed.

We set out in part to develop an aesthetic for xerox art and eventually attempted a casual body of criticism. We also positioned *PhotoStatic* to collect xerographic work by others and help catalyze a community, a gathering place in print, of photocopy artists. In the same spirit, and with the same interests in mind, the *PhonoStatic* audio cassette series was begun a year after *PhotoStatic*'s first issue; the *VideoStatic* compilation began a few years later. It was not just xerox that interested us; we wanted to generalize the *PhotoStatic* set of practices and apply them to all accessible media.

There were numerous strands in the zine community, and *PhotoStatic* became a meeting point for many. There were the xerox collagists, the visual poets, the correspondence artists, the punk designers, the rubber stamp artists, the home tapers, the Neoists, the Barbara Kruger acolytes, the queerzine publishers, the upside-down A anarchists, and the anti-authoritarians, as well as certain art historians and academics. The more conceptually based "generative" artists did not show up in *PhotoStatic* in the same numbers as the socially observant and critical strands of the counterculture did. And there was the occasional oddball from rural Wisconsin or Wales that just liked to make xerox collages. There was generally a feeling of greater connectedness with and a taste for popular forms of culture and a marked ambivalence among many contributors to so-called high and academic art forms.

As the 1980s wore on, *PhotoStatic*'s circulation grew (peaking at around 750), and its base of contributors became extensive, with mail arriving at our Iowa City address from five continents and both sides of the iron curtain. In the late 1980s, after a lengthy (and characteristically playful) transition period, the bimonthly *PhotoStatic* transformed itself gradually into *Retrofuturism*, during which time the project reached its apex, coinciding with the run-up to our participation in the Art Strike 1990–1993. In January 1990 and for the next three years, the *PhotoStatic* title ceased to appear, replaced by the "anonymous" title *YAWN: Sporadic Critique of Culture*, as well as the title *Retrofuturism*, ostensibly edited by The Tape-beatles. The Art Strike, whose main agitator was apparently the

English author and artist Stewart Home, was at least partly aimed at demoralizing the art world and those who unthinkingly valued its shameless hunt for the next contrived scandal around which to push art among the cognoscenti and to those buying it as an investment or to bask in its perceived prestige.

In a largely symbolic gesture, *PhotoStatic* returned after the Art Strike for a single issue, number 41, in January 1993, never again to appear; though a trickle of issues under the titles *Retrofuturism*, *YAWN*, and the *CVS Bulletin* (the official organ of the Copyright Violation Squad) followed. By midyear, the project had entered an indefinite hiatus as we turned our attention to other interests. In the period 1996 to 1998, having returned to Iowa after a year living abroad, we tried to resurrect the project, and it appeared rechristened as *Psrf*, letters chosen to reflect two previous titles, and taking up the continuous page numbering system of the previous output. By this time, however, the Internet boom was well underway, and much of the do-it-yourself and small publishing activity had moved onto the Web. This should not be surprising, because the Web offered many of the same strengths and virtues of cheap and immediate photocopying—not incidentally combined with nearly effortless access to a potentially unlimited global audience, as well as the elimination of printing and postage costs.

Signs of this transition were apparent early on. In the late 1980s, many zine editors had bought personal computers and laser printers solely for the purpose of typesetting their text. As we used these machines, we quickly became aware of additional, sometimes intoxicating possibilities the personal computer opened up. Gradually, sophisticated page layout and illustration software became one of the many possible ways to produce a zine. Some even made exploratory forays into this new field by producing content to be distributed solely on floppy disk; others delved into the possibilities of software for creating graphics that could be made in no other way. Still others became programmers, producing databases, games, and other interactive works. With the advent of widespread computer networking throughout the 1990s, yet another universe of possibilities was opened up for creative exploration.

In retrospect, it seems clear that the zine movement would split into two strands: those who wanted to cling to the old and ossify The Zine as a canonical form and praxis; and those who valued the social and aesthetic context of zines over whatever form they may have taken (which was,

after all, often merely expedient). This latter group was more than willing to take this energy into the realm of electronic media. It can certainly be argued that there is strong resonance between the zines of yore and the blogs and personal Web sites of today, from their independent creation to their fixations on vanishingly narrow interests and in the similarity in informality of tone and personality they each exhibit. People undoubtedly have not stopped making art by using photocopiers, but the historical period immediately preceding the Internet boom of the mid-1990s saw an alignment of technologies that favored works on paper, whereas afterward, the electronic media have increasingly garnered much of this attention, energy, and creativity, in large- and small-scale production alike.

Due to these and other factors, our reanimated project was no longer able to find traction, and in 1998 the final issue, *Psrf* 49, appeared. It was the only issue of our entire output that appeared in full color. It was printed on a PostScript laser printer, a technology that is essentially an evolved photocopy machine: one that uses digital code instead of a physical image and a laser as a light source, rather than a lamp and a lens. In 2002, we inaugurated the *PhotoStatic Magazine* Retrograde Archive on the Web, archiving each of the many print and cassette issues in electronic form, free for the taking. The following selection originally appeared in *PhotoStatic* number 29, from March 1988, and you will find it at http://psrf.detritus.net.

S O S

Sudamerican

STOP

DEGENERATE ART !

976

Retrofuturism no. 2

"I'm very impressed with the potential..." said Senator Randolph

THIS
degenerate art

OR

THIS
realism

SERVING CART

good art

does anything look like this?

Meet the Tape-beatles

The Tape-beatles, who are Lloyd Dunn, John Heck, and Paul Neff have been working together in Iowa City for more than one year as collaborative multimedia artists. The Tape- beatles use popular media as raw material, ingredients for investigations which often function as critique or as a challenge to audience expectations. The contents of our work is realized through audio constructions which combine media transmissions, concrete sounds and a variety of prerecorded materials. These compositions are edited and arranged on tape for use in radio broadcasts and cassette productions for national and international distribution.

Briefly, the highlights of our past work include *The Big Broadcast,* our radio debut event offering the best of one year's output, and *Ceci n'est pas une radiodiffu-*

sion (*This is not a radio broadcast*) which confounded expectations of radio listening, and brought up issues of appropriation and auteurship, the problems of ownership and notions of cultural property. We have performed live once at Gabe's Oasis in Iowa City and recently contributed a cassette compilation and manifesto for use in the San Francisco *Festival of Plagiarism,* organized by *Box of Water's* Steve Perkins. Finally, our ongoing project has been the exploration of hypermedia as a form of mass communication, targeting specifically corporate imagery, slogans, and the psychology behind the production and subsequent reception of these images.

Our goals include the publication of our first cassette containing *The Big Broadcast* and our most recent work, which is always in progress. Our publication *Retrofuturism* will continue release, primarily via mailing to other audio and mail artists on a bi-monthly basis. We received favorable responses to our test-market sample issued 1 January 1988. Intended as a sourcebook and

call for open discussion with other audio artists, it will include interviews, articles dedicated to electronic media and related issues, and reviews of submitted audio soundworks. We are considering plans for an installation based on the theme of PLAGIARISM®. We are also planning a live performance for "Cornstock V" on 28 May 1988.

 The Tape-beatles are driven by an ambition so intense that we can't keep shoes on our feet and new trousers have been lasting a week at best. The hunger for new ideas and increased output is limited only by our lack of food and shelter. However, with support from the network the Tape-beatles' vision could be seen and heard by all.

 The extension of our work in electronic media to the University of Iowa community and the network, both nationally and internationally could be a substantial tool for furthered accomplishments by the Tape-beatles. Everything considered, it's time for the Tape-beatles.

 Tape-beatle video viewer reaction: Upon seeing a

MARCH 1988

47. — CLAUDE MONET: *The Doge's Palace view.* Durand-Ruel collection (photo Giacome

In its stead, Benjamin places the (graphic) sign, which represents the
distance between an object and its significance, the progressive erosion of
the absence of transcendence from within. Through this critical
to penetrate the veil which had obscured the achievement

man Tragic Drama, p. 176.

*tique and Commentary/Alchemy and Chemistry: Some Re-
New German Critique,* no. 17 (Spring 1979): 3.

i, Venice).

Tape-beatle video in which silent footage of the Tape-
beatles in production was overdubbed (in very rough
sync) with dialog from a Soho Television interview of
John Cage by Richard Kostelanetz. Harry, an Amster-
dam video artist said. *"You should do your own original
work rather than using the Cage/ Kostelanetz interview
soundtrack* [to create something new]. *The sound from*
[the Cage/Kostelanetz] *video is so strong that all I keep
thinking of is* [it]." Another free voice speaks out against
PLAGIARISM®. —*jh*

(0) 11 91
Zeitansage

A CHILD'S CHRISTMAS IN WAILS a remembrance
 by D.T.

We arrived at Grandmother's house in time
to rescue the burning Pheasant from her
oven. Grandma had collapsed on the faint-
ing couch in the small room just off the
kitchen. She never regained consciousness
that Christmas eve. Nor did she rise the
next day or the next. We stayed for weeks
then months, then my family and cousin
Herbert's family simply moved in to watch
her. Then, a year later, on the follow-
ing Christmas eve, Grandma raised up off
the settee and glared at all of us, gather-
ed around her. What is it, Mother? My
mother asked. I'm just tired... was her
reply, and then she was gone. At her
death, the room burst into tears, and the
two families remained, mourning and watch-
ing the body, for at least another year.

WINKLEr 87

Presenting the first in a series of excerpts from the
PLAGIARISM® Press *novella*:

POPULAR CULTURE IS THE
WALRUS OF THE AVANT-GARDE

THE LAST WORDS of the poet were scribbled on the back of a discarded document: Miss Andrews is hysterical.

Literary license is now founded wearing that rather stubbornly anxious look overlaid with an aggressive optimism, which is the facial trademark of the man who becomes common property. A big man with an ingratiating smile and a carelessly charming manner.

The doors of the three elevators gave the guid-ance of tactile appropriation. One by one they, because they could be isolated more easily, lent themselves more readily to analysis.

Her thin faced twitched nervously with genial patience.

"The audience's identification with the actor is really an identification with the camera", he informed her. At the decisive moment she held notebook and pencil poised, abstained from facing the man woman to man, rather it was through the for-

malities that she penetrated him.

He spoke with the uniqueness of a work of art that is inseparable from its being embedded in the fabric of tradition, a voice that could infuse warmth, charm, magnetism into dry business phrases. He had the accent of a Harvard man but recently down from his university.

A desk.

A silver bowl, brimming with roses, stood upon it near one lovely bronze, a sexless winged figure, vibrant with dark, gleaming life.

Janet at twenty–two: amiable, serene, gay hearted. The rose–blossom flush of youth, something hot and painful and angrily insistent, a plan for the future that would deny the appearance of new necessities. Swift thoughts, watching his mouth, incredulous, surrendered to a passion of violent tears as he, a well–built man with strength and endurance, touched her shoulder, and she quivered under it. Uncontrollably.

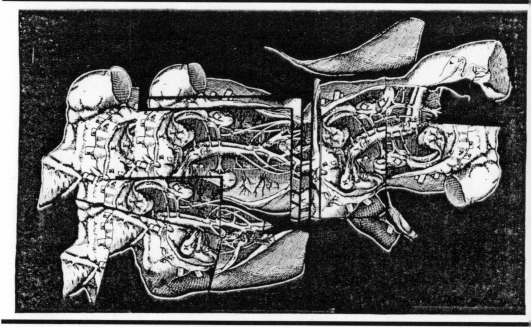

"Miss Andrews, are you ill?"

Her inadequate explanation reached him, muffled, broken and frantic with shamed embarrassment.

"Mechanical reproduction of art changes the reaction of the masses toward art", he assured her. His mind framing profanities, served him well and loyally. His gray eyes: under heavy browse, rather blunt knows, mouth, though firm was beautifully modelled, the square cleft chin; hair = brown, thick,

rusty glint; hand = fine, idle on the polished surface of the desk.

Her lips straight, thinned line, quivered, softened.

He leaned back in his chair, waiting in his relaxed, passive position, a suggestion of force in leash, of power under control, a reminder of all the perpetually interacting aspects of social reality. His gray eyes were dark with concentration, solid embracing, cushioned in soft-toned leather. The long

******** ATTENTION ********

DUE TO A LOW LEVEL EMERGEN-
CY (S)crap MAGAZINE AND THE
PLUTØNIUM PRESS HAVE MELTED
THROUGH THE EARTH TO P.O.
BOX 85777 SEATTLE, WA.
98145. RESUMING OPERATIONS
MAY 1st 1988.

CLEAN UP BEGINS IMMEDIATE-
LY.

MORE TO FOLLOW.

couch under the great windows promised relax- ation and kept that promise. Over the defiant stone mantle hung one very good etching; that of a row of pines, in black relief against a gray sky, roofed in hills of snow, marked with the delicate tracks of small four–footed creatures, it was an etching like any other, belonging to that class of laminated ob- jects whose two leaves cannot be separated with- out destroying them both: the windowpane and the landscape, and why not: Good and Evil, desire and its object: dualities we can conceive but not perceive.

Originally the contextual integration of her pale anxious eyes found their expression in the cult. We know that the earliest works originated in the ser- vice of a ritual—first the magical, then the religious kind. The business of the office wife made it easy to comprehend the distinctly social bases of the modern contemporary problem of decay of the "aura".

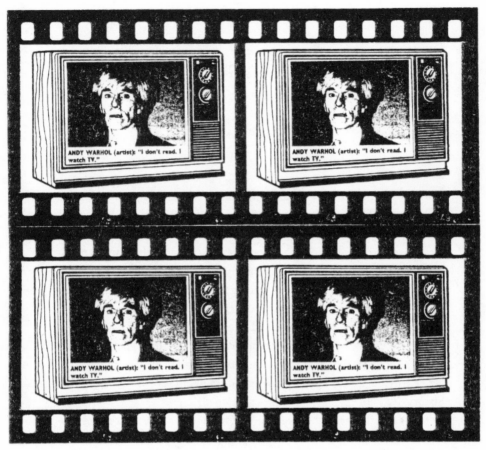

Then, Jamesun, the amiable bachelor, with relief and compunction, entered.

So, Betty Howard too, not only in her slow motion early thirties, presents good familiar looking qualities, smiled, but of movement her dark eyes revealed in them entirely remaining unknown troubled ones "which, far from looking like retarded rapid movements, give the effect of singularly gliding, floating, supernatural motions", and lightless.

"Mr, Jamesun is waiting."

Mechanically her thin face, with notebook in hand, twitched nervously as she tried to smile, standing beside him.

Friend > greeting > chair > cigarette case.

"Sorry to keep you waiting."

" 'S all right", answered Jamesun easily.

"I haven't seen you since the Standard Oil dinner."

"That", remarked Fellers, with feeling, as he thought, while recalling the famous phrase about

Plagiarism® 101

An Appropriated Oral History of The Tape-beatles

The Tape-beatles practice plagiarism as an art form. The group, founded in 1987, adopted techniques and ideas from concrete music to create a musical project intended to have broader appeal. In a nutshell, this Iowa City–based group set itself the task of creating music without using musical instruments in the conventional sense. In keeping with their most consistent and straightforward ideology, The Tape-beatles' work is uncopyrighted and in the public domain, thus challenging the notion that ideas or creative work can be owned or even called original, especially in this age of cheap, easy duplication and distribution. They approach their music as collage, the most typical and typifying art form of the twentieth century that expresses the increased fragmentation of this period in history.

In their early years, they were quite conscious of the cultural and economic context in which they worked—specifically the existence of copyright laws that define their activities as plagiarism. To this extent, they have adopted the phrase "Plagiarism: A Collective Vision" as their de facto motto. By strategically employing the word *plagiarism*, they call attention to the fact that intertextual modes of cultural production are redefined by copyright law as an illegal activity. "Plagiarism: A Collective Vision" carries with it an explicit and implicit cultural and political critique that foregrounds the notion that cultural property should be a "collective," shared thing. The logo used by The Tape-beatles is a visual adaptation of that motto. Consisting of a reproduction of the AT&T globe trademark with Mickey Mouse ears attached, it is a bold and humorous representation of their self-described plagiarism aesthetic.

John Heck: When we started working, we soon discovered that the biggest obstacle for doing the kind of work that we wanted to do was that we might have a problem with copyright laws and also attribution. And we imagined that in this kind of work, it would be clear what we were doing and we wouldn't have to apologize. We made this small joke with registering a trademark for plagiarism as a process, as a way of working. That would give us a certain amount of freedom—a freedom not to apologize for taking somebody else's work without permission, a way of simply getting our ideas out there, because that is what our work is about: ideas. It wasn't about production, you know, it wasn't about those beautiful sounds that George Martin created on some of the Beatles' best recordings. It was about taking any source that was broadcast and then treating it as if it were a found sound, as if we picked it up in the street, you know, and just made it ours. And we felt that, somehow, Plagiarism® explained that so that we didn't have to preface our work every time we presented it.

Lloyd Dunn: When working with found footage, it immediately becomes apparent that what you're doing is using the previously finished works of others to create something that's new. So what we want to do is create a situation where authorship is something that you can claim over work that uses nothing but previously discovered elements. We feel that we have an ethical and moral right to claim authorship over our works in spite of the fact that they're made completely out of fragments of other people's works.

We feel that this is a natural outcome of the technological and social environment that we're in because it's so closely applied by the kinds of machines that are available to us. Photocopy machines immediately imply a kind of plagiaristic philosophy toward books, magazines, news clipping, recipes, what have you. But people have always shared recipes, and science has a long tradition of sharing knowledge and information. I mean, these kinds of traditions are not at all alien to Western civilization and what we're really doing, I think, is completely in line with that trajectory. So we've adopted plagiarism as a positive artistic technique. And in fact, it is the modus operandi of all of our work. Everything that we do is made of entirely found material.

John Heck: It's also a bit of a game, I would say. We put our work out, and it's up to the listener to discern or not who or what the source is. We

use a lot of obscure sources, but we also very consciously play around with received culture. We play around with context. We felt that back in the late 1980s, when we really started doing this, that it was the context that could be surprising. But I don't think that it could have the same sort of surprise that it used to have.

Lloyd Dunn: Originally when we pretended to register the trademark, we wanted to create a sense of scandal. And we wanted to outrage certain more conservative parties about the creation of culture and what that entailed, and what originality was. Basically, it was an anti-Modernist move. And as time has gone by it has become less and less controversial. Now when we talk about it, people go, "Oh, okay. Fine." But back in the late 1980s, I gave a presentation at the University of Nevada at Carson City, and a man stood up in the back and asked a very confrontational question about this, and he said basically, "I don't want you *stealing* my work! I'm an artist and it's *my* work." And, you know, I said, "Fine, we won't. Don't worry about it." But that's basically the kind of things we used to have to confront—which we were happy to do, actually.

Ever since photography in the nineteenth century, artists have had to face the notion that there are suddenly machines that are able to pro-duce—*reproduce*—nature better than they could. And so my interest has always been in using machines to make art. I started out using a photo-copier because I was fascinated by the photographic aspects of it. I was also interested in the duplicative aspects of it, because the photocopier seemed to be both a camera and a press. It had aspects of both going for it, and so the photocopier is one of those challenges to originality that has come along. The phonograph is another one of those things that kind of replaces the musician. In the beginning when phonograph and radio were coming into popular use, many musicians were alarmed, and they formed labor unions to protect their interests. These musicians thought that these technological devices would replace them.

So there's always been this very problematic but very interesting and fruitful relationship between culture producers and devices for repro-duction. The Hungarian and graphic designer László Moholy-Nagy was a great champion for using devices of reproduction for productive ends. And so when you turn a photocopier into an art-making tool, basically you're detourning a business machine into doing something that could be very easily anti-capitalist or anti-business—or even revolutionary—

in the right hands. One of the initial reasons the phonograph came into existence was to replace stenographers. Basically people wanted to record business correspondence, and that was one of the primary interests in recording speech at that time. It quickly became apparent that it was kind of useful to have a way of recording music and doing artistic things with it. So eventually recording became an art form in and of itself.

According to *Retrofuturism*, an appropriation-infused zine published by Lloyd Dunn, The Tape-beatles were well aware of the history behind audio collage when they began. Dunn stated, "We were influenced by the French concrete musicians, such as Pierre Henri and Pierre Schaeffer, and a few other modernist composers like Edgard Varèse and John Cage. We were also heavily influenced by some pop music that had used tape effects and manipulation, such as the Beatles' work."

Lloyd Dunn: What we wanted to do was exploit the possibilities of recording and audiotape, and in a sort of cheeky move, to pay homage to the Beatles and their studio recording experiments in the 1960s. We decided to claim that method as our own, as far as tape manipulation went, and so we called ourselves The Tape-beatles. . . . We were certainly aware of the avant-garde sound collage traditions, but most of our attitudes and positions came from popular culture. Actually, our first impulse in getting together was to form a pop music group that didn't play any instruments. That was really the initial idea behind The Tape-beatles.

A change in name from The Tape-beatles to Public Works, which came about in 1997, was motivated by a change in membership (three group members left), a refocusing of technique, and a refinement of interests. The Tape-beatles' pre-1995 output was almost exclusively analog. By 1994, the members had begun exploring digital techniques of recording and manipulating sound. Where The Tape-beatles were proud to be "amateurs" inspired by the do-it-yourself aesthetic of punk and the 1980s–90s zine movements, Public Works recognizes that years of dedication to a core set of ideas, attitudes, and techniques cannot help but produce a noticeable level of "virtuosity." Under the current incarnation, refinement of technique and subject matter are combined with earlier interests in montage, sound effects and collage, coupled with a more self-consciously "musical" sensibility. The 1999 reversion to using the name

The Tape-beatles should be understood to reflect the stylistic tendencies of work currently being produced.

John Heck: When we first got started we wanted to find a way of responding to the things that we'd record. Our sources were radio, television, and vinyl LPs. And using the sound, we'd construct a composition using almost no equipment. When we started we really wanted to do this, to do the kind of work that anyone could do in a bedroom. . . . We had a cassette player, a cassette recorder, we had a simple Sony reel-to-reel tape deck and we were recording sounds directly onto the reel-to-reel and using razor blades and a splicing block. We would make diagonal cuts and use splicing tape to join the short segments of tape and put them back on the deck. And then we would get it threaded through the cap stand and pinch holder, hit play, and the sound would loop around and we'd send it to our recording deck.

Lloyd Dunn: We'd use this technique to sort of build sound beds, you know, sort of a musical long-lasting moment. And over that we'd put samples of voices that we'd taken from the radio, or television, or other broadcasts or other found materials such as records found at Goodwill, Salvation Army, and other sorts of thrift stores.

John Heck: So let me just add that very quickly we began to realize the limitation of only using found sound and using layers, and actually using no effects, except maybe using a pause edit and getting the machines to make whatever noises we could get them to make, noises that were completely unintended by the people who designed them. We were able to manipulate to some degree.

Lloyd Dunn: Essentially, we tried to build our work around home stereo equipment because one of the things that we wanted to say was that this was an egalitarian effort. We wanted to make music that anybody could make, in principle. We sort of wanted to undercut the notion that you have to pay some studio $300 an hour to produce a record. We really wanted to say that you could make a record in your own bedroom using home stereo equipment. That's really how *Music with Sound*, our first sort of breakthrough recording, was made.

The Tape-beatles and Public Works make use of multiple technologies, many of them obsolete, to create a carefully controlled panorama of moving pictures and sounds. From laptop computers to hand-crank gramophones, the group's arsenal of instruments spans the century. In *The Grand Delusion* (1994), The Tape-beatles began making use of a technique called PolyVision, borrowed from the French silent filmmaker Abel Gance. Gance's technique was pioneered in the 1920s and anticipated the contemporary wide-screen formats, such as Panavision and Cinemascope. Both Public Works and The Tape-beatles have continued using the technique, renamed "expanded cinema," in their presentations for *Matter* (1997) and *Good Times* (2001).

In The Tape-beatles' version of expanded cinema, three 16 mm film projectors run simultaneously, creating a wide-screen collage of motion pictures made entirely of found footage. The center image is a tightly edited and scored reel which runs continuously and nonrepetitively in wild sync with the audio. During the piece, it is intermittently flanked by projected 16 mm film loops from the two other projectors, which serve to complete the spectacle and augment the images on the center screen. Many of the loops represent short films in themselves, with numerous cuts and carefully timed transitions, though few are longer than three feet in length. The repetitive quality of the film loops counterpoints the continuous nature of the center reel, and also serves to underscore the continuity and rhythms in the music. Most important, perhaps, it provides an opportunity for The Tape-beatles and Public Works to provide commentary in completely visual terms on the footage featured front and center.

John Heck: Early on, we were invited to perform in venues when we were simply a studio music group. When we were looking for our sound sources we very often came across filmstrips, and we started watching 16 mm films and things like that. And we tried mixing sound live using various devices, but it was very unsatisfying because we didn't have a member dedicated to mixing the sound. So we arrived at simply creating a soundtrack and then using a CD to master our soundtrack, and we discovered that it would be wiser to actually perform the visuals than to try to recreate what we worked so hard to balance in our sound studio.

Lloyd Dunn: We use three 16 mm projectors. The central one, the one in the center, is a carefully timed edited reel that works in time with the

music. It has particular sync points, and we have to mess with the film speed on the projector in order to catch those sync points. And the flanking images come from film loops that we change throughout the performance, throughout the evening twenty or so times. We'll use twenty different loops in a half hour or something like that to create this widescreen collage. Part of the aim of this is to use Eisenstein's idea of collision, of collage being a sort of collision, where you take any two arbitrary images, put them together, and in time a third, new idea inevitably results.

During their presentations, The Tape-beatles and Public Works have generally presented the expanded cinema (their most recently preferred term for PolyVision) works *Good Times* (2001), *Matter* (1997), and *The Grand Delusion* (1994). Other elements have been introduced, which are more theatrical and performance-like in nature, such as the "Entr'Acte" which uses a classical gramophone recording played through a paper cone, on which images are projected by means of a hand-cranked projector.

Lloyd Dunn: All of our work was originally done on analog equipment. Now that we're working digitally, we can sort of look back on that with nostalgia. The way the machines worked together was often inscrutable, and often mysterious things would happen or mistakes would happen that would become gems. We had to incorporate these audio gems into our work because we liked them so much, you know. And this was something we didn't intend to create. This is something that sort of came about because, in a sense, we had this collaborative attitude not only between ourselves, but among us and the machines that we were using. I mean, my own background with making art is very self-consciously about making art with machines as opposed to making art with tools. I think that a machine is, simply, a more complex type of tool. So my early work was done with a photocopy machine.

John Heck: Would you say that we're making nostalgia about nostalgia? A media nostalgia?

Lloyd Dunn: Maybe, maybe. I mean, the shift to digital was a very natural one for us to make. I mean, we'd all been using computers, so obviously wanting to turn our computer into a digital workstation was a compelling

thing for us to do. . . . The method we use when we construct works using digital composition tools is: first we have to go and find a source that we want to use and then we have to digitize it—unless it's already digitized. For example, if it's a CD it's already a digital format and so we can basically rip the bits off of that platter and put it onto our hard drive in unchanged form. But if the source is analog—a tape we find at Goodwill for example—then we have to digitize it. . . . Once it's on our hard drive the possibilities become basically endless. Because you can run it through all sorts of filters and change the contours of the sound and change the envelope so that you have a different attack, sustain, decay, and release. You can also cut it into endlessly smaller units and rearrange those units in ways that are impossible for the listener to know what you've done.

The methods of working in analog and digital are very different. From my experience, the accidents in digital work are much less compelling. You almost have to plan what you want and hope you get it. And you can do this endless polishing with very little effort, and you usually can get pretty close to your initial idea. And sometimes you find that what you conceived isn't quite what you want when you actually end up hearing it. I don't want to sound like I'm down on digital, because I think it has great power and flexibility, but there are some aspects of it that are less satisfying. . . . However, because of the flexibility that digital provides, you can conceive of things in digital that you never could make in tape. It creates possibilities. It creates compositional possibilities that we've tried to exploit.

John Heck: Maybe too many possibilities.

Lloyd Dunn: Sometimes it feels that way.

This chapter is drawn from numerous sources: an interview conducted by Kembrew McLeod in March 2005; back issues of *Retrofuturism* and *PhotoStatic*; Kembrew McLeod's book *Owning Culture: Authorship, Ownership, and Intellectual Property Law* (2001); various writings found on the Tape-beatles' Web site (http://pwp.detritus.net); and an article titled "Meet The Tape-beatles" (1999) by Todd Kimm, originally published in the *Iowa City Icon*, which can be found at http://pwp.detritus.net/news/interviews/kimm-icon.html.

Ambiguity and Theft

Whereas collage is often granted a special authority as a political inter-
vention—as something beyond the merely aesthetic—I want to argue
that its status is more ambiguous than such casual assumptions suggest.
Collage does not take sides so easily in the confrontation between the
codes of "the aesthetic" and "the political"—a confrontation that retains
the world-historical charge noted by Walter Benjamin in the epilogue to
"The Work of Art" essay (1969, 241–42). It does take sides not because of
any authority proper to the form of the artwork itself but because of an
ambiguous relation to another sphere altogether: that of the law. Collage
has political substance to the extent that it takes a negative relationship
to property relations. Theft must finally be the content of collage if it is
to take the form of anything beyond cultural effluvium.

In establishing this claim, this chapter eventually takes a specific ex-
ample, both legal and cultural: the hip-hop sample. This is exemplary for
several reasons, not the least of which is that "commercial" music is rarely
granted the critical authority of sanctioned art—and yet it stands as an
art form based on the fundamental problematic of collage. Because of
its exemplary character, the hip-hop sample is in fact not a special case.
This is also to say that this chapter is not a special pleading regarding
the significance of that particular cultural object, the sample-based song.
Rather, it means to touch on the most general problems confronting col-
lage's desire to achieve some sort of social communication beyond cul-
tural artifactuality; as such, it needs to pass through a series of ambigui-
ties—seemingly but not actually prior to that of theft—that haunt the
category of collage.

The Ambiguity of Culture

Culture occupies the overlap of the two codes of the aesthetic and the political—being, crudely put, the representational space of the social. Among all cultural productions, collage indeed holds a conceptually privileged place, because the relationship is reversible. While paintings are culture, culture is paintings. However, to take up the currently charmed formula, *culture is always already collage*, insofar as culture is the aggregation, circulation, and management of symbols that dialectically express and conceal social relations. Culture, as it is formed here and now, speaks always of politics's escape into images.[1] Collage, thus, is not only a cultural object necessarily but an objectification of culture itself (which is in turn an objectification of social relations). Thus collage cannot take its meaning from some primacy of the political over the aesthetic, nor some preferability of one to the other. It can only take its meaning from the facts of the immanent and ceaseless negotiation between aesthetics and politics.

The question before us concerns, inevitably, what might be specific to collage's manner of negotiation between aesthetics and political practice. Here it is worth noticing the relationship of the collage to what Benjamin calls "the dialectical image": a trace left by mass culture, an object that holds sleeping within it elements that are incompatible, antithetical. This appears as a veiled allegory of the irreconcilable interests of different social classes, rendered as a static image by a collective that has not yet achieved consciousness of this irreconcilability. That is to say, just as a subject cannot will a symptom, the artist cannot intentionally and consciously fashion a dialectical image, which puts on display not just the breadth of class conflict but the depth of collective sleep. But one can make a collage, which takes on much of its charge exactly because it is an optative simulacrum of a dialectical image. As Susan Buck-Morss summarizes the argument, with citations from Benjamin himself regarding photomontage, "the image's ideational elements remain unreconciled, rather than fusing into one 'harmonizing perspective.' For Benjamin, the technique of montage had 'special, perhaps even total rights' as a progressive form because it 'interrupts the context into which it is inserted' and thus 'counteracts illusion'" (1991, 67).

Collage, one might say, puts mediation—generally so busy concealing its presence while holding everything else in order—on parade. It shat-

ters the illusory coherence with which modern commodity-consumer capitalism presents itself, an illusion sometimes named ideology. Collage is a kind of speech given to the mute, frozen clash of the dialectical image; it is a formal practice that reveals the discontinuities of form. Insofar as the equation *form = ideology* demands the copresence of the aesthetic and the political—and indeed opens up a specific communication between the fields—it turns out to be suspiciously similar to "culture" itself. Culture is neither ideology nor form, nor is it ideology *and* form. If you will forgive the Hegelian formulation: *culture is the identity of ideology and form*.

Collage, a broken form, endeavors to break ideology. However, it is limited in this endeavor by the source of its formal elements. Instead of drawing social relations into the realm of representation (as in, say, Courbet's *A Burial at Ornans*), collage takes its elements from the realm of representations itself, from the world where ideology has already been formalized and form already ideologized. In effect, collage *substitutes* culture for the social—another way of describing its status as a meta-cultural object. How, then, does it become a practice that extends its communication beyond culture's tendency to communicate itself?

The Ambiguity of Practice

Much as the dialectical image expresses an invisible incommensuration within the social body, the collage expresses an invisible incommensuration as well—not of its representational elements but of its practice, which is in fact always two practices. Collage requires two verbs: "to take" and "to place." Put another way, collage has two faces: one turned toward the viewer, the other turned away. Elements are placed before us; this is the face we see. These elements have been taken from elsewhere, from culture, but we do not see this action. We are merely left to recognize the taking by its material traces—to imagine it or not. This is an irony, to be certain: that collage, which so urgently designs to pierce the veil of ideology, threatens to reproduce the commodity fetish exactly, by concealing from the viewer the social labor involved in its making.

Without a developed relationship between "to place" and "to take," one is left to suggest that representational discontinuities interrupt the false continuity of *representational* space, rather than social space. This would be an indifferent act, insofar as representational space retains an infinite

capacity for the recuperation of such challenges. Collage's challenge to representation, of which Benjamin was so certain in 1935, is now utterly naturalized; what begins with the idea summarized by Gilles Deleuze in the formula, "modern thought is born of the failure of representation" (1994, xix) must end with some Dave Hickey type cheerfully proclaiming that "discontinuity is the new continuity!" The shattering of representation always happens twice: the first time as revolution, the second time as fashion.[2] Once this happens, collage loses any substantive claim on politics.

The necessary relation regarding collage is therefore not between, say, content and form, nor artist and audience. Nor is it between aesthetics and politics, except at an oblique remove. Instead, it is between "to place" and "to take." The viewer's leap to an imagined taking, from the actual facts of placement, is the basic interpretive act regarding collage. This relation between *placement* and *taking*—between the static, spatial image displayed verso and the temporality-drenched action concealed recto—is properly that of allegory. This is true at once in the crudest sense (the way in which allegory is a meta-cultural form, e.g., in Vermeer's painting *The Allegory of Painting*) and in more particular senses (e.g., collage's negotiation of spatiality and temporality, and its asymbolic quality, per Paul De Man's account of allegory in "The Rhetoric of Temporality" [1983]).

Collage achieves a political possibility, beyond cultural self-reflexivity, only insofar as the *placement* (the form) succeeds in allegorizing the *taking* (the activity of making). So it is with taking that we must focus our attentions, precisely because that which arouses our anxiety about collage's current condition is the eclipse of the political: that is, on collage's willingness to fix our glance on the placement and let it come there to rest. If we are to resolve the ambiguities currently haunting us, all passageways lead to "to take."

The Ambiguity of Taking

Having arrived, we find ourselves unsurprisingly at yet another ambiguity. Collage proposes two kinds of taking. In the cultural sphere, there are two classes of objects—those that are owned, and those that are not (by "owned," I mean only that the right to extract income from the thing is asserted by an individual or institution). There is, in turn, taking that conflicts with ownership and taking that does not. I call these two uses "theft" and "recycling" and cheerfully stipulate that all such distinctions

can be endlessly refined. The Venn diagram of *theft* and *recycling* is conjoined at the area of *use*.[3] Both theft and recycling seek to return the element in question to the realm of use value, the former by rescuing it from exchange value, the latter by rescuing it from desuetude, or at least by continuing its circulation. This second is, more or less, the brute logic behind the concept of "fair use."

Recycling/fair use either uses objects already emptied of exchange value or declines to interfere with their capacity to be exchange value. To offer examples immediate to the occasion of a critical volume: a text in the public domain is by definition a text without an exchange value, and it can be recycled without prohibition. By the same token, if you take a copyrighted passage and cite it appropriately, this is also a form of recycling or fair use. Plagiarism, on the other hand, is generally considered theft, at least by established publishers. Both theft and recycling are categories of interest from the political as well as the aesthetic perspectives. As a mode of artistic production, recycling is a powerful counternarrative to the dream of pure invention. Proponents of artistic recycling, as a general matter, tend to dismiss "originality" or "inspiration" as ideological boondoggles, fantasies of a mode of production invested in the model of the individual genius creating things ex nihilo, things over which he or she deserves absolute dominion.

However, it is not clear that the art object born of recycling meaningfully interrupts, in Benjamin's sense, this context of individual dominion; indeed, it perforce does the opposite. Recycling/fair use either operates in the realm of already devalued objects, where no dominion is asserted, or it gives credit where due, and thus secures the rights of the original even as it proposes to challenge them. The measure of fair use is nothing but a judgment that no such interruption has taken place. Insofar as recycling-based collage proposes an interpretive act, it cannot propose any account of "to take" other than one that leaves the current marketplace dispensations undisturbed.

Recycling's inability to interrupt private dominion, even as it claims to challenge myths of originality, may finally have to do with the extent to which, as a politics, recycling threatens to be something like a wish image. It purports to materiality at its most solid: a what-is-to-be-done with the stuff of daily life. Yet we know what happens to all that is solid. Recycling, too, is a dream, a dream in which a surplus is recouped rather than being continually lost in the normal course of business — and through that con-

servative action, material lack is abolished. It is, in short, a fantasy about the end of surplus value.

This is not a critique of recycling, or at least, that's not the purpose of this passage. I strive to detail, via the confrontation with devolving ambiguities, the extent to which the course of collage as political practice can lead us nowhere but to theft itself. Theft, I want to argue, is the form of "to take" by which the discontinuity of social relations is forced to stand before us: the real of interruption. "Ownership"—that is, the precedence of exchange value over use value—is forced to present itself not as a natural fact but as a contingent condition held in place only by force of law: Derrida, invoking Kant, offers the minimum dictum, "No law without force" (2002, 233). This violence—not the violence of ripping from context and forcing into another, not the violence of the scissors nor the violence of the staple gun—is the originary knowledge of collage.

The Ambiguity of Ownership

Hip-hop stands as the most widely disseminated specific collage practice yet to appear on the stage of history (again, ignoring culture itself). Though the art form and its particular relations to collage and appropriation are both well and poorly enumerated elsewhere, a very brief rehearsal is perhaps in order. Though rap music—rhyming over rhythm-centered musical tracks—predates accessible digital sampling technologies, the music achieves its adult form and begins to consummate its irresistible rise with the confluence of these two streams. However, technological determinism should be avoided: sampling technology (and turntable scratching before it) is itself the emanation of specific material histories best understood within a narrative of deprofessionalization (both within and without the cultural sphere). Just as with punk rock, early rap is a set of solutions to the problems of how one might make music without access to expensive instruments, and more expensive lessons and leisure time, which had come more and more to serve as barriers to entry in the 1970s.

If punk rock's greatest dictum is "this is a chord, this is another, this is a third. Now form a band,"[4] rap's parallel note would come from Chuck D of Public Enemy: "Run-DMC first said a DJ could be a band." To render this early history is only to say that rap/hip-hop has an economic/materialist relationship between its aesthetics and its politics: its form (based around sonic collage) is isomorphic to the social relations from

which it springs (lack of access to valorized forms of composition, performance, and production). As a challenge to ownership of culture, its practice challenged ownership of cultural commodities. In this regard, hip-hop's criticality can be understood as organic—as growing from the soil of its material conditions.[5] From this perspective, it is not just unsurprising but inevitable that rap/hip-hop's content would increasingly be about ownership.

This has remained true through this present moment, but ambiguously true. Hip-hop is now in its second decade of celebrating ownership: of cash, cars, jewelry and, alas, women. The beginning of this celebration as the dominant mode can be dated to around 1989–90, as hip-hop's world picture turned from Public Enemy's black nationalist platform to NWA's popularization of the genre that would be gangsta. If this shift did not abandon the terrain of ownership, it did retreat from political critique, or at least retreat from dramatizing inter-racial and interclass conflict as the dominant social fact. Of great note, this retreat coincided *exactly* with the historical moment in which the force of law brought an end to hip-hop's era of popular theft. This history is well documented elsewhere.

Though the music copyright case that caught the attention of the intelligentsia was, for regrettably obvious reasons, the white-on-white violence of U2 versus Negativland, the relevant (and prior) juridical moments regarding the fate of sampling and theft were *Grand Upright v. Warner Bros.* (the 1991 decision concerning Biz Markie's use of a Gilbert O'Sullivan sample) and the eventually settled case of the same year pitting De La Soul against the Turtles. The way the Markie decision and De La Soul's capitulation raised insuperable economic barriers for those hip-hop acts not already well-funded or corporately supported is, again, a well-remarked topic.[6] Any number of culture producers, forced to survive in this new landscape, discovered solutions as musically compelling as anything that had preceded them. However, I suggest that the juridical events around 1990 mainly succeeded in shattering the necessary allegory. Once they are cleared and paid for, hip-hop's placement of samples—its sonic collage— is no longer tied to an act of problematic taking, to a theft.

It is no longer a question of use but exchange, of a mutually beneficial arrangement from which both parties believe they will profit. The form remains the same, in some superficial manner. But with the allegory broken, the content of theft vanishes. Once the theft relationship is broken,

the organic critique of professionalization and cultural ownership is broken as well. The barriers to entry return; ownership is no longer contested but complicit: the material conditions of that critique no longer apply. Thus is it that the application of the force of law, shattering the allegory secured by theft—the relation between taking and placement—turns out to shatter hip-hop's criticality. This is the very image of collage without material interruption, placement without taking. One might describe the cultural mobility of capital as resting in its ability to achieve such recuperations; standing in the historical gallery, the audience for collages knows full well that they become a matter of indifference once they are rooted from their social soil of problematic taking, of material challenge to the regime of ownership.

As noted earlier, hip-hop has scarcely abandoned thematizing the violence of ownership; this has turned out to be the signal discourse in the most powerful musical genre in the world. But the contestation now stands on its head, for it has shifted from the material to the ideal, to representation. Images of extravagant appropriation have replaced actual theft—cold compensation for the loss of theft's negation, itself a pleasure to hear, floating at the edges of the listener's encounter. This is to say no more than that dialectical forces are at play everywhere. Inevitability attends this historic shift: the new form of the material transaction—sample shopping—becomes the true content of the song. Sean Combs's apotheosis as not merely the richest hip-hop star but arguably the most profligate of all celebrities—a celebration of capital's order as extravagant as any critique was ever vitriolic—is both an expression of and is expressed by his ostentatious use of the most artlessly expensive samples. The aesthetic form of "I'll Be Missing You," is neither more nor less garish than its sentiment and performer. Though this might seem like an exceptional case, it is in fact entirely indicative of latter-day hip-hop. The age of the expensive loop is equally the age of hyper-fetishized commodity. *Bling* is the sound of a Bentley's headlights glinting off a $25,000 sample.

The Ambiguity of Politics

Here we must remember that even before the new social movements (one of the immediate platforms from which rap jumps off) made a dictum of it, everything was and is political. There is a politics to hip-hop's current dispensation, just as there is a politics to almost any practice of collage;

the question, "What sort of politics?" remains before us. If one of hip-hop's political practices was, for a brief time, to place before mass culture the pleasures of the theft, its territory is inherited not by a sanctioned art form but by Napster and Gnutella. The rise of file sharing is a return to hip-hop's real; it is pre-1990 rap without the songs (except of course the songs are there, too, in the guise of the mashup, a musical form allowed by file sharing and the same digital technology used in sampling). That theft should pass into art and out again to be its own form of criticality, of the politics of negation, ought to surprise no one; as an anonymous art critic remarked in 1967, "The juvenile delinquents—not the pop artists—are the true inheritors of Dada."

File sharing as a social fact has done the work of collage a million times over: I did not suppose I would live to see the day when white suburban teens regularly engaged in fairly nuanced debate about the metaphysical subtleties and theological niceties of the commodity. The pleasures of the theft are understudied or neatly contained with the suggestion that it is a for-profit venture like any other. Yet as the same critic noted,

> the sociologists and floorwalkers concerned . . . have failed to spot either that people enjoy the act of stealing or, through an even darker piece of dialectical foul-play, that people are beginning to steal *because* they enjoy it. . . . And the modesty of something as small as shoplifting is deceptive. A teenaged girl interviewed recently remarked: "I often get this fancy that the world stands still for an hour and I go into the shop and get rigged."[7]

The world stands still because she is the one moving; this is the verb "to take" in its full glory, the real of collage in action, freed from allegory.

Before I abandon collage and advocate actual theft—which I advocate strongly—it seems only fair to tarry a moment more. It is not finally sufficient to say that theft is collage's real, that the interruption and the attendant critical pleasure can be secured with such ease. Depending on how one values the term, to call this experience "pleasure" is perhaps to diminish it; this would be a mistake, for such pleasure is one of the things that connects the social and the aesthetic. It is the experience of lived politics. But of course it is an illicit pleasure, this theft, and it cannot be repeated indefinitely without becoming ritualized—and finally becoming a submission to the laws that allow the sense of the illicit. In the relationship between theft and collage, we encounter a final ambiguity. This is an

ambiguity in its fully realized, which is to say, irresolvable form: the relationship between collage and theft is entirely dialectical.

Collage is a political practice of interest insofar as there is an actual theft to which the produced collage maintains an allegorical relationship. No collage without theft. Otherwise, no charge but the aesthetic; just another spectacle. At the same time, collage as political practice designs to lay bare, interrupt, and eventually abolish the domination of use value by exchange value, the violence which attends that domination, and the naturalization of this domination and violence—that is, the very conditions in which "theft" has meaning. Collage wishes to abolish itself. Did somebody say "sublation"? Did someone sing of the escape into everyday life? I take this as the dialectical history of all art, winding toward the destruction of its own terrain, its possibility for existing as an area of specialization. Collage makes of this a material practice; more explicitly, I think, than any other art practice, collage lives to dream its own death. In this it takes its place as an exemplary form; one praises collage because it wishes to bury itself.

Notes

1. This may seem to recapitulate the Heideggerian claim that modernity is representation; we shortly arrive at Deleuze's inversion of this formula.

2. The Louis Napoleons, as Dave Hickey has demonstrated over and over to his everlasting shame, will always mock the first republicans for their naiveté and fancy talk, while pimping their ideas on the open market.

3. The Venn diagram is the ur-form of collage; what's more, the term appears in print, according to the *Oxford English Dictionary*, one year before the word *collage*.

4. From an issue of the fanzine *Sniffin' Glue* (1977), quoted in varying but uncontradictory forms in numerous places.

5. This in contradistinction to collage expressly made for the purpose of critique, which is often more easily recognized by bourgeois/academic communities as both critical and art.

6. For a useful overview of rap/hip-hop history within a social context, touching on almost all the issues mentioned here (though not always with the same analysis), see Chang (2005).

7. *Evening Standard*, August 16, 1966; quoted in Clarke (1994), 22–23.

Where Does Sad News Come From?

Sound only. After four short tones and a long fifth comes a perfectly enunciated British female radio voice, "From the BBC Radio Newsroom, this is Harriet Cass with the six o'clock news." Her first sentence is interrupted and completed by a distinguished upper-class (and uppercase) male voice: "The Australian Prime Minister has described Nigeria's action as SAD, VERY SAD. BP's Deputy Chairman says I'M SAD, VERY SAD. BP's Deputy Chairman Mr. Montague Pennel said I'M SAD, VERY SAD." Variations of his *I'm sad, very sad* are cut into the speech of the program's announcers, its reporters, and those they interview at locations granted by the formal structures of language and news programming, creating new, oddly fatalistic news. The next sentence reveals that a whole nation is capable of speaking as one. [Male reporter:] "In effect, the Nigerians are saying I'M SAD, VERY SAD." In the next sentence, the abstract authority of an unnamed commission serves only to bolster the gentleman's despondence: "The chairman of the commission, Professor Hugh Klegg, said today that I'M SAD, VERY SAD."

Soon, we are following the news like we have never followed it before, anticipating the discursive micro-moments when this gentleman might bust in and how he might make sense. This goes on for nearly three and a half minutes—a pop song duration, but it seems interminable—with reports of numerous sad situations and all the sad people that populate and observe them. Soon, it is no longer a string of interruptions but settles into a cadence, like trading fours, where a cool, detached reporting of events alternates with a personal expression of emotions. Sometimes the uppercase gentleman is freed up to express his own opinion, that perhaps the news itself is sad, very sad. Although we never find out what made

him so sad in the first place, it is obvious that the steady build-up of sad news must fuel his resolve. He becomes increasingly persuasive. So much sadness may indeed be fair and accurate reporting, or worse, the news is not actually the news but a description of an existential situation, with no solace that the sadness of events might dissipate in time.

To translate from the English: for Americans, who year after year are losing the last threads of what used to be considered news to docudrama and state and corporate propaganda, this pervasive sadness would be an infringement of their right to the frenzied pursuit of happiness. For Americans, sadness might not place a comfortable enough distance between events and conditions and their causes. Our English gentleman being *sad, very sad* would threaten to mark off a moment of remorse in which self-reflection could intrude and begin making a true account of things; however, in those Situationist words to live by, hope is the leash of submission. Besides, for Americans, an existential situation is too foreign; the former is too French and the latter only happens in the Situation Room. "Finally, the main points again. The Americans are reported to be SAD, VERY SAD. The National Coal Board has reported that it's SAD, VERY SAD. The Basques say they're SAD, VERY SAD. BBC Radio News."

The British artist Rod Summers (now residing in Maastricht) created the audiotape collage *Sad News* with razor blade, splicing block and tape in 1979. It was sourced from three different BBC Radio Four broadcasts from occasional recordings Summers made between 1973 and 1978. He put it in a self-published compilation called *Glisten* the same year, under his cassette underground project named VEC. A total of 63 copies were sent out around the world. Copy no. 40, postmarked November 16, 1980, was sent to Dan Lander in Toronto, audio artist and coeditor of the influential books *Sound by Artists* and *Radio Rethink*.[1] The cassette may have languished in Lander's collection for a few years, since he remembers first hearing *Sad News* in a class at Nova Scotia School of Art and Design around 1983. He found it "profoundly inspirational" in the way that "it offered such a simple, yet powerful message by stating the obvious and letting the news speak for itself." He places the work in the same period and category as the Scratch video movement in London (cutting up Thatcher), my own *Reagan Speaks for Himself* from 1980 (see later discussion), and Negativland's "live (mis)treatment of Reagan's inauguration." Lander copied *Sad News* into his own compilation sent to friends

and acquaintances. I became friends with Lander in the course of con-tributing to *Sound by Artists*, and he sent me the compilation sometime in 1987 when I was living in San Francisco.

On first hearing *Sad News*, I was under the impression that it surely must be widely known as a classic in the annals of audio art, no matter how obscure those annals might be. I have played it and continue to play it for my classes on sound and the arts over the course of nearly twenty years, and it has always been a crowd pleaser. Lander had the same ex-perience: "For many years it was the one work I would always play for students. It always seemed to have a positive effect on folks and it is the perfect introduction to what I always felt was at the core of what we were calling 'audio art.'" Outside the classroom, however, the proper name *Sad News* was mysteriously missing from people's lips. I thought it must be the same neglect suffered by much underground work from the period, being outside the art world loop of discursively regulated markets and market-regulated discourses, too contemporary for the art historian three-decade lag and in the wrong century altogether for music histori-ans, too artsy for pop writers, too early for subcultural press on the Inter-net, and so on. Classics can fall through the cracks, many more through great divides.

Still, I was under thrall of a rhizomatic romance that *Sad News* must be circulating underground like a huge fungus root system (one *Armillaria bulbosa* system covers more than thirty acres), that is, until very recently when I was informed by Summers himself that "no more than two hun-dred and three people and a child named Pertinent have ever heard it." He sent out dozens of copies on compilations, but few people acknowledged receiving one, and fewer still (in fact, only one person) bothered to com-ment. His best mate Tom Winter told him, "At the beginning you laugh and by the end it's depressing." Summers says that his friend was trying to be nice, searching for something to say and ending up defaulting to a comment that could easily be applied to most human endeavor. *At the be-ginning you laugh and by the end it's depressing* could easily etch any stone in a graveyard and attract knowing nods from decades of passers-by. Just by contacting him I became the only other person to react: "Wow. A dou-bling of my fan base in one go!"

To be fair, *Sad News* aired on radio—what would seem to be its natu-ral habitat—to throngs or at least to audiences; accidental listeners alone

surely exceeded 203. Lander played it on his radio program in Toronto, and I played it once for a late Saturday night national audience on ABC-Radio in Australia. Summers was not into this particular numbers game. His audience was comprised of practitioners: "It wasn't my policy to send to radio stations, I had very limited funds and the [VEC] project was directed at getting artists to use their cassette recorders in a creative manner rather than let the general listening public hear what a cacophonic world artists were living in." The generosity and modesty that at once produced distribution of compilations along with a discomfort for self-promotion extends to his assessment of his work. On one hand, he thinks that *Sad News* holds up fairly well after thirty years, except that the news at the time, which had "perhaps a little less blood-letting" than is in evidence now, gives it away as something of a period piece. Commenting on his work in general, however, he says, "I like to believe I am trying to expose the pure sound of things rather than present any political/social motive or standpoint or deeply considered philosophical position. In the same way an abstract painting is made of recognizable colors. No. Wait a minute. Definitely pretentious!" Calloused against such precaution, I venture a few comments on *Sad News* and ask a few historical questions about a general class of cut-ups, montages, break-ins, mashups, appropriations, mimicries, and hoaxes that deal with news or news-like phenomena, whether sad or not, and then wrap up with my personal history in audiotape ventriloquism.

Enter the Break-In

The movement from laughter to depression that Summers's friend Winter experienced is achieved on the back of the *break-in* "sad, very sad." The humor arises with the surprise of the initial interruption and then continues with a fascination with the subtle applicability of further interruptions and how repetition itself begins to take on different guises. They are also break-ins by a proper stranger who turns productively mischievous, like a break-and-enter by an elf who fixes things in unexpected ways. It then shifts to a realization that the form of newscasts themselves are not merely conducive to interruption but are in effect constructed as a string of interruptions in their own right. The reoccurrence of the interruption *sad, very sad* ironically counteracts the fragmentation of the news and

begs scrutiny to how the overall form might operate and what it might mean, how the news works, and how it might relate to the reality it constructs.

At this point the comically imposed nihilism of *sad, very sad* seems to ring true and depression begins to settle in. The speed and ease at which depression itself settles in becomes a sign of powerful machinations at work, and this is sad. If artistic techniques so patently in the foreground can be persuasive, what about propagandistic techniques that work surreptitiously, including the bludgeoning repetition of reactionary talking points? Not being Tom Winter, I am more optimistic. Fox News, for instance, is a parasitic system that has grown from adolescent Republican media manipulation strategies, cultivated through years of oedipal reaction to Bill Clinton, and became tied closely to the failed cause of the Bush administration. Fox News is not an existential condition. It is thus susceptible to break-ins by media systems and historical forces created by actual human beings.

The term *break-in* is associated in part with the novelty genre founded by Bill Buchanan and Dickie Goodman's *The Flying Saucer, Part 1* in 1956. The break-in is a comical reversal of an interruption of regular music programming on radio with a news flash, with a spliced-in snippet of music programming that interrupts the news.

> **Radio announcer:** We interrupt this record to bring you a special bulletin. The reports of a flying saucer hovering over the city have been confirmed. The flying saucers are real!
> **Break-in recording:** Too real, when I feel, what my heart can't conceal. . . . [from the Platters' "The Great Pretender"]
> **Radio announcer:** That was the Clatters' [*sic*] recording, "Too Real!"

Like *Sad News*, this is news programming on radio, but once removed, alluding to the convincingly fake radio news of Orson Welles's *War of the Worlds*. Answers are given and sentences are completed with lyrics from popular songs. Interruptions and jump cuts were already widely practiced in cartoon soundtracks, and the musical quotations of novelty acts exemplified by Spike Jones, but *The Flying Saucer* was the first to make such overt use of mass marketed recordings. The voices are an American golden-throat radio announcer (Bill Buchanan) and the nasal whine of reporter John Cameron Cameron (Dickie Goodman), based on John Cameron Swayze, the first anchorman on an American television news

program, host of *Camel* (cigarettes) *News Caravan*, and known to a later generation for his Timex watch advertisements: "Takes a licking and keeps on ticking." The bulk of *The Flying Saucer* consists of Cameron providing set-up lines for response from a pop menagerie of aliens and humans on the street.

> **Reporter:** This is John Cameron Cameron downtown. Pardon me madame, would you tell our audience what would you do if the saucer were to land?
> **Witness:** Duck back in the alley [from Little Richard's "Long Tall Sally"].

Unlike the underground *Sad News*, *The Flying Saucer* was catapulted into its own pop stardom, selling a million copies in five weeks, right behind Elvis Presley's "Don't Be Cruel/Hound Dog" and the Platters' "My Prayer." Disc jockeys loved the song and began working on "break-in" collages of their own, and the genre provided Dickie Goodman with a bankable schtick for many years to come.

In American broadcasting, a *break-in* is an interruption of regular programming with an urgent announcement. Goodman's break-in genre replaced actual urgency with the split-second redirection of recognizable lyrics. Pop culture radio in the mid-1950s was already locked into the redundancies of repeated plays and play list rotations that enabled listeners to recognize the immediate contents and surrounding attributes of randomly chosen, minuscule excerpts of many songs. *The Flying Saucer* tested pop vernacular and an allegiance to commodity culture in the same manner as radio recognition contests (where listeners had to identify the sources of several fraction-of-a-second song snippets strung together) and the quiz show *Name That Tune*, and in part was a harbinger of a civil society schooled in the urgent nonissues of industrialized media culture, which is sad.

The break-in *sad, very sad*, on the other hand, is an interruption to announce a matter of no urgency whatsoever. Instead, it becomes a sign of a bigger picture that is masked by the blanket frenzy of events, especially those demanding immediate attention. It is a picture of a slow rot oozing from the violence of a thousand cuts, a wounded clown who desperately mugs to the audience while slowly bleeding to death. *Sad News* recapitulates the cookie-cutter processing of news programming—the selective choice, shooting, editing, and discursive framing of events, sequestering events from one another, from contexts and public discourse

that might render them understandable. A break-in alerts the audience to an emergency or a tantalizing development in the pursuit or sentencing of a celebrity criminal, while sadly leaving the structures, machinations, and simple existence of power unreported and intact. There is no alert to the movement of the revolving corporate-military-government-entertainment-religious door, which is spinning so fast now that if harnessed, it could eliminate U.S. dependence on foreign oil. There is no break-in for the daily events of generational poverty, environmental collapse, high-level corruption, and so on. There is no alert to true emergencies, no break-ins to repeat what needs to be repeated.

The announcers and reporters in *Sad News* are themselves historical time-warp break-ins of the BBC Advisory Committee on Spoken English that instituted BBC English in 1926. This is not the abstract authority of an unnamed commission that appears in *Sad News* and announces an existential sadness, it was the decision of an actual committee for how a system of media was to behave for decades. They enunciated that fifty years hence, BBC speakers would maintain the class bias that existed on the committee making the ruling. The director of this committee, as Stephen Coleman in his book *Stilled Tongues* (1997) points out, "was at pains to ensure that the common ear was to be addressed by far from 'common' speech." It was a paternalistic speech "against which unofficial speakers could be downgraded or dismissed" (107). The BBC speakers in *Sad News* seem to condone the interruption of "sad, very sad" not only because they exist in an environment shredded with edits but because the intruding tongue seems to belong to one of their own species. In this way, the discriminating intrusion of "sad, very sad" into the enunciation and invocatory power of announcers' speech is evidence of a fictive internalization of world events and vice versa. It is a utopian moment of candor about a dystopian situation. The humor derives from the contrast inherent in sensuous exchange of intruding tongues and reality swapping performed by automata driven by the belts and wheels of a tape recorder transport system and controlled by a razor blade and tape. It is akin to the spectacle of primitive robot sex, which I've never seen but have heard rumored can be really funny.

Another source of humor derives from how this type of editing amplifies certain natural occurrences of humor in official speech. *Sad News* relies on the phatic sounds of introjections and the same motivation as

bloopers. Bloopers tend to celebrate short attention spans, whereas the concentrated listening invited by *Sad News* teases out a subtler variety from the mechanisms of language, the anaphoric slippages Erving Goffman analyzed in the chapter "Radio Talk" from his book *Forms of Talk* (1981). Two examples:

> **Newscaster:** The loot and the car were listed as stolen by the Los Angeles Police Department.
>
> **Louella Parsons:** And here in Hollywood it is rumored that the former movie starlet is expecting her fifth child in a month.

Indeed, if we need a pre-pre-history of the editing in *Sad News*, we could follow these types of rhetorical devices all the way back to the diagrammatic cuts sunk deep within the Chomskian La Brea Tar Pits from which language itself has bubbled up, inked incisors bared on a bleached skull.

Heinrich Böll

The repeated replacement of the same audiotaped fragment of speech — the *sad, very sad* in *Sad News* — has literary precedent in Heinrich Böll's 1955 satirical short story, "Murke's Collected Silences." The story is introduced through an old-style elevator called a *paternoster* at a German state broadcasting house in which Murke, the protagonist of the story, works. A paternoster is an elevator that looped continuously in ascent and descent with passengers embarking and disembarking through open passageways where more modern elevators would have doors. The paternoster serves as a symbol for many things, including the reversible fate of higher beings and other elites (where it hits the top floor and heads back down) and Murke's own ritualized ambitions and resignations among shifting bureaucratic levels of the institution. It also sets up a clever correlation between the transport mechanism of a reel-to-reel tape recorder with openings (cuts in the audiotape) where words go in and out and the rotary repetitions of a rosary, stepping off and on at the big bead of the Lord's Prayer (Paternoster). The rosary is the first tape loop.

Murke works in radio and finds himself responsible for re-editing two half-hour radio talks by one Bur-Malottke, the conservative "author of numerous books of a belletristic-philosophical-religious and art-historical nature."

Bur-Malottke, who had converted to Catholicism during the religious fervor of 1945, had suddenly, "overnight," as he put it, "felt religious qualms," he had "suddenly felt he might be blamed for contributing to the religious overtones in radio," and he decided to omit God, Who occurred frequently in both his half-hour talks on The Nature of Art, and replace Him with a formula more in keeping with the mental outlook which he had professed before 1945. Bur-Malottke had suggested to the producer that the word God be replaced by the formula "that higher Being Whom we revere," but he had refused to re-tape the talks, requesting instead that God be cut out of the tapes and replaced by "that higher Being Whom we revere." (120)

The satire of this passage derives from how the religious fervor of 1945 had conveniently come on the heels of military defeat, the collapse of Nazism, and the prosecution of war crimes. Thus, in a pre-1945 time-frame, "that higher Being Whom we revere" was not necessarily a constrained sign of religious plurality and tolerance but could also be a surreptitious nod to Adolf Hitler. Indeed, the mid-1950s timing of Böll's story was set in opposition to the conservative restoration project then under way in West Germany.

Murke was responsible for cutting out all twenty-seven mentions of God in the two talks. He required Bur-Malottke to record enough variations of "that higher Being Whom we revere" to serve as replacements to be spliced back in those spots vacated by God. When Bur-Malottke himself realizes how complicated and tedious all this repetition and variation has become, he has second thoughts about following through with the changes. In one of the funnier scenes in the story, hoping to get out of these duties, he says to Murke, "I suppose you've already done the cutting, have you?" "'Yes, I have,' said Murke, pulling a flat metal box out of his pocket; he opened it and held it out to Bur-Malottke: it contained some darkish sound-tape scraps, and Murke said softly: 'God twenty-seven times, spoken by you. Would you care to have them?'" (124). Bur-Malottke declines the kind offer of this reliquary of disembodied speech. Once in the sound studio, Murke defaulted to martyrdom by inflicting psychological torture on Bur-Malottke, feigning machine malfunction, requiring him to repeat his repetitions of "That higher Being Whom we revere . . . That higher Being Whom we revere," in an authoritarian mantra resembling a skipping record, a tape loop, or the beads of a rosary.

Murke then circled these repetitions back into the booth, transporting Bur-Malottke to further heights of madness. Murke inflicted this torture as retribution, recycling what he himself had to endure. For instance, in his talks on the nature of art, Bur-Malottke mentioned the word *art* 134 times, and Murke had heard the talks 3 times, which meant that he had to endure subjection to the word *art* 402 times, cruel and unusual punishment.

Murke also worked on another recourse—more reclusive, not as violent—for the din of redundancy to which radio itself, and in fact all his relationships, subjected him. In a yellow biscuit tin he collected other scraps of tape, quieter than the murmur of a prayer. These, he explained, were a "certain kind of left-overs" (143). "When I have to cut tapes, in the places where the speakers sometimes pause for a moment—or sigh, or take a breath, or there is absolute silence—I don't throw it away I collect it. . . . I splice it together and play back the tape when I'm at home in the evening" (144). At home, Murke offends his lover when he asks her to record her own silence onto a tape recorder. She says, "I can't stand it, it's inhuman, what you want me to do. There are some men who expect a girl to do immoral things, but it seems to me that what you are asking me to do is even more immoral than the things other men expect a girl to do. . . . Put silence, that's another of your inventions. I wouldn't mind putting words onto a tape—but putting silence . . ." (145).

Jerry Newman and William Burroughs

A prime candidate for the ur-text of the genre to which *Sad News* belongs is *The Drunken Newscaster* by Jerry Newman; indeed, they seem to have the BBC radio news in common. I say ur-*text* rather than ur-*tape* because most people have only heard of or read about *The Drunken Newscaster*; only a handful of people have ever actually heard it, and even among them we get conflicting reports. For most people, the first reporter is usually William Burroughs, who cites *The Drunken Newscaster* as a precursor if not the inspiration to his own audiotape cut-ups. Burroughs met Newman through Jack Kerouac, who were schoolmates and drinking buddies. It was perhaps no accident that the newscaster, too, was drunk. Newman was also an important music recordist, first making the rounds of Harlem with a wire recorder and later managing a studio and label. Newman tutored Kerouac and many others on jazz. John Clellon Holmes

remembered Newman as an expert editor: "One of the first things he did was to record that marvelous serenade by Schönberg, but he had a perfect ear, and he made this performance by editing different tapes. This is common practice now, but he was one of the first to get a final production by editing several different versions" (quoted in Theado, 410).

An editor among edits, Burroughs mentions *The Drunken Newscaster* sparingly, while nevertheless lending it pride of place.

> Fade-out to a New York recording studio, 1953 . . .
>
> Jerry Newman played me a tape called *The Drunken Newscaster*, made by scrambling news broadcasts. I cannot recall the words at this distance but I remember laughing until I fell on the floor.
>
> You can evoke the Drunken Newscaster right where you are sitting now. Record a few minutes of news broadcast. Now rewind and cut at random short bursts from other news broadcasts. Do this four or five times over. Of course, where you cut in words are wiped off the tape and new juxtapositions are created by cutting in at random. (1978, 89)

In "The Invisible Generation," Burroughs notes that "cut up tapes can be hilariously funny twenty years ago i heard a tape called the drunken newscaster prepared by jerry newman of new york cutting up news broadcasts I cannot remember the words at this distance but i do remember laughing until I fell out of a chair" (1966, 207). Allen Ginsberg, on the other hand, remembered some of the words when he was delivering a lecture at the Naropa Institute on "The Literary History of the Beat Generation" during 1977. However, he remembers *The Drunken Newscaster* as a novelty or off-beat recording of an actual drunken newscaster, not one manufactured with a razor, tape, and splicing block; moreover, he gives it much greater significance than merely suggesting a minor audio-literary technique.

> Newman also contributed to Burroughs' literary development. Burroughs at times credits Jerry Newman with the inspiration for Burroughs' sense of routines and cut-ups. Because Newman had a fantastic collection, as a recording engineer and a record shop owner and as a guy who had a recording studio, he had a fantastic collection of dirty tapes and weird tapes. The most famous one that Burroughs picked up on was *The Drunken Newscaster*. He was completely drunk and would read in this drunken voice making a lot of slips. I think it was a BBC newscaster, but tongue-slipping all the time: "Princess Margaret spent

the weekend inside her parents at Balmoral Castle." That was the one sentence I remember in there. It turned Burroughs onto the idea of what would happen if you got the newscaster drunk and he said in public and displayed in public what you would do in private. What if the microphones got turned on while the dictators were in their beds, or while President Roosevelt was caressing his secretary, or while the generals were jacking-off in the locker room. What would happen to the demeanor of public as known in the 30s and 40s, very straight, strict, unbroken hypnosis of proper manners, and none of the unconscious breaking through. What if the unconscious broke through; what if the private broke through into the public; what if people wrote as they thought? What if newscasters would suddenly burst out with all sorts of obscenities in the middle of a straight news broadcast? What if truth broke out? In the media or even in the novel? So *The Drunken Newscaster*, with that phrase—"Princess Margaret spent the weekend inside her parents at Balmoral Castle."—was one of Burroughs' earliest turn-ons to his whole literary method. I think he's written about it somewhere, in fact. Dr. Benway comes out of that: a respectable character all of a sudden talking weird, or going to the operating room and operating with a can opener and a can of Sani-Flush. (1977)[2]

Anaphoric slippage becomes Freudian slip becomes an abridgement of decorum becomes unhampered abandon, all in the unwitting and witting service of truth. *The Drunken Newscaster*, in Ginsberg's representation, is not necessarily the direct inspiration for his cut-ups (Burroughs elsewhere credits Brion Gysin in this regard) but a more important technical elaboration of his performative routines, which were closer to the heart of his literary mission. Without an extant tape, however, it is still difficult to determine whether *The Drunken Newscaster* was a case of a natural alcohol-induced anaphoric or Freudian slippage or one engineered with a razor blade. It is not very difficult technically to render someone drunk or, inversely, to take drunkenness from someone's speech (speed things up slightly to bring the inebriated deliberation up to normal pace and remove the sibilants from the ssslursss). The lack of a tangible record among collectors may mean that it was a tape circulated among recording engineers, much like office art circulates among clerical workers. In any event, it seems clear that *The Drunken Newscaster* was enjoyed as parlor entertainment and, as such, had even less distribution than *Sad News*.

In most Beat literature, radio news and the radio itself was a nuisance or experiential and environmental backdrop. The tape recorder was often merely a means of transcription, a recording of experience or a new tool for correspondence, not a means for writing with recorded speech or for manufacturing media, let alone media from media news. Burroughs was, of course, the major exception. He developed an elaborate mythology of recording, a politics and countertactics of media representation, mind control and crowd control, as well as a ritualized magic involving media. In *Electronic Revolution*, he breaks in a description of resistive techniques to mimic a manipulation of the news.

> As a long range weapon to scramble and nullify associational lines put down by mass media.
> The control of the mass media depends on laying down lines of association. When the lines are cut the associational connections are broken.
> President Lyndon Johnson burst into a swank apartment, held three girls at gunpoint, 26 miles north of Saigon yesterday.
> You can cut the mutter line of the mass media and put the altered mutter line out in the streets with a tape recorder. (1982, 23)

He urged individuals to work as media guerrillas, taking advantage that the dominant media must disguise their techniques.

> You are under no such necessity. In fact you can advertise the fact that you are writing news in advance and trying to make it happen by techniques which anybody can use. And that makes you NEWS. And a TV personality as well, if you play it right. You want the widest possible circulation for your cut/up video tapes. Cut/up techniques could swamp the mass media with total illusion. (1982, 29)

Burroughs rationalized some of his more extravagant techniques by stating that their effectiveness had already been established through use by the Central Intelligence Agency (CIA). He possessed faith in the efficacy of mind control techniques directed at crowds and individuals long after the CIA itself had lost faith in them. By the mid-1960s, the CIA figured out that although they could induce amnesia, catatonic states, and death and could make people talk a lot, they were not able to force individuals to tell the truth. However, the CIA kept the faith when it came to another set of

techniques, including ones involving audio. In the U.S. attack on the duly elected government of Jacobo Árbenz in Guatemala in June 1954, the CIA used the psychological warfare soundscape technique made famous later against Manuel Noriega and the Branch Davidian compound in Waco, Texas. William Blum writes that "During one night-time [air] raid, a tape recording of a bomb attack was played over loudspeakers set up on the roof of the US Embassy to heighten the anxiety of the capital's residents" (84). In 1971, *Newsweek* magazine reported another technique:

[The CIA] has concocted a delightful little ruse to spread disaffection against the exiled Sihanouk among the Cambodian peasantry that once revered him. A gifted sound engineer using sophisticated electronics has fashioned an excellent counterfeit of the Prince's voice — breathless, high-pitched and full of giggles. This is beamed from a clandestine radio station in Laos with messages artfully designed to offend any good Khmer: in one of them, "Sihanouk" exhorts young women in "liberated areas" to aid the cause by sleeping with the valiant Viet Cong. (39)

The cultural production of media fictions by the state exists on a much grander scale with the architectural facades of the tsar's Potemkin villages, the Reichstag trials and Hitler's Polish costume drama at Gleiwitz, Lyndon Johnson and the *Turner Joy* spoof at the Gulf of Tonkin, Nixon performing film criticism in a pumpkin patch, Reagan photographically crafting another Cuban missile crisis on an aerially foreshortened Grenada airport tarmac (Maurice Bishop broadcasted live on American television the following morning from the same spot to no avail), and most recently George W. Bush's media chiaroscuro of weapons of mass destruction, highlighted with a touch of yellow-cake uranium. Historians of the arts do not give the state enough credit for its cultural creations.

Re-Editing the News: Joris Ivens

The Drunken Newscaster makes the best kind of origin story because the tape cannot be found and the story cannot be substantiated. Origins as a species, just like "that higher Being Whom we revere," do not exist in the first place, so it is appropriate when they are proffered through hearsay. Searching for gods under rocks is nevertheless a productive activity, since

one frustrated attempt engenders another, and through accumulation one can begin to understand how things are and are not what they seem to be. Following *Sad News* further back through time, one obvious way station is John Heartfield's photomontages, given their relationship to the news during and after the Weimar Republic. However, we would then have to go back further to the right-wing photomontagist Eugène Appert (which would be distasteful) and back further still to bleed history of all its cuts. Let us stanch the flow by arbitrarily calling it quits at cuts in time-based audio and visual recorded media.

This takes us to re-editing newsreels. This was most often done by movie houses who, in effect, used completed newsreels as news services, editing them to make it look like their own production. They may have been trimmed and perhaps diminished, re-edited for drama and local interest, but they were not purposefully undermined or redirected; the topics weren't sent on Sit-like detours. In contrast, the Dutch filmmaker Joris Ivens, in his autobiography *The Camera and I*, does give an example of re-editing newsreels for redirection. Under the influence of Soviet film, Ivens was just beginning to contribute his avant-garde skills to the cultural production of the working class. He was impressed with the "idea editing" of the Soviet film and particularly interested in "the skillful, dramatic use Esther Shub made of old newsreel material in her edited films about Tolstoy and the last days of the Romanov dynasty" (97). With her film *Fall of the Romanov Dynasty* (1927), Shub redirected tsarist home movies and other materials in the absence of tsarist power. On the other hand, in the following excerpt Ivens describes a tactic in the midst of power, when he worked with the Dutch Association for Popular Culture (Vereeniging voor Volks Cultur; VVVC) to re-edit newsreels:

> Up to this time my experience in *idea* editing had been rather sparse. My earliest experience was sometime in 1929 when I was given charge of the film programs for a series of workers' cultural and educational Sunday mornings. On Friday nights we would borrow a number of commercial newsreels. On Saturday we would study the material in the newsreels in relation to the international and national situation of the week [topicality, editorial timeframe], re-edit them with any other footage we happened to have available to us giving them a clear political significance, print new subtitles (the films were still silent) showing relationships between events which newsreel companies never

thought of, and which would certainly have shocked them if they had ever seen our uses of their "innocent" material. For example, we could relate the injustice of an American lynching with the injustice of the Japanese aggression in Manchuria, making a general statement about injustice which we would then localize with a current event in our own country. Previously miscellaneous material was knit together into a new unity, sometimes with the addition of a spoken word on the public address system or some cartoons, photographs or Photostats of an editorial from the Dutch conservative press. After our Sunday morning show was finished we would take the film apart again, restore its original form and return it to the newsreel companies who were none the wiser! (96–97)

Ivens describes an activity not dissimilar to contemporary re-editing practices, with their underground distribution and disregard for proprietary rights. The comparison might be too good to be true. As Bert Hogenkamp points out in his essay "Workers' Newsreels in the Netherlands (1930–1931)," the fact that VVVC newsreels were "scheduled for screenings all over the Netherlands, [contradicted] Ivens' statement that the newsreels had to be taken apart after every screening." Instead, Hogenkamp suggests that the newsreel company just "turned a blind eye to the VVVC use of its newsreels" (162). This mutes the transgressive romance created in the intensity of the production turnaround time but does not detract significantly from the oppositional nature of the practice.

So, is this where *Sad News* comes from? From a set of disparate historical instances? I am glad very glad to say no. Histories can be provocative and encouraging, but luckily they are not necessary. Summers wrote to me recently, "I have to be honest and tell you my knowledge of the history of audio art is superficial; I never really thought much beyond cave man chant and traveling story telling." *Sad News* comes from a combination of the schooling unwittingly served up by the inundation of the daily glut of the barrage of cuts for what appears to be news—as well as by the creative effort to deflect and delectate it in the best traditions of satire, semioclasm, political critique, and a healthy curiosity and humorous disrespect.

Corrective Editing: *Reagan Speaks for Himself*

I was unaware of all of the foregoing when I created the audiotape *Reagan Speaks for Himself* in 1980. The raw material came entirely from a forty-five-minute televised interview that Bill Moyers conducted with Ronald Reagan just before he declared his candidacy for president. The interview was recorded off a television speaker using a cheap portable cassette recorder and a five-dollar microphone, transferred to a quarter-inch reel-to-reel tape recorder, then cut and spliced on an aluminum block in a damp basement in Seattle. Before the first cut, I listened to the entire interview about a dozen times and took pages of notes. This was not an easy exercise. I could not stomach Reagan in small-dose sound bites, so listening to hours on end to his gosh-gee-shucks ignorance and cruelty was very unpleasant. It took a turn for the worse when I realized that I had been listening to him so closely for so long that I had begun to breathe with him. Nevertheless, it seemed necessary to perform puppetry from the inside, to feel his words reverberating through a full set of mudslide jowls. The ugly side of empathy.

Two statements helped. The first was a German saying I read in a Hans Magnus Enzensberger essay, that those who work in sewers don't have the luxury of not handling shit, and the second was George Grosz's characterization of John Heartfield as a person who knew how to hate well. My approach took inspiration from Roland Barthes's analyses of public figures and events in *Mythologies*, but the prime motivation was public service. Moyers did nothing to get to the violence that animated Reagan's ideas; he did nothing to break down Reagan's folksy repression. Reagan was obviously too distracted with the exigencies of militarism, imperialism, monopoly capitalism, racism, and sexism to express himself completely, and Moyers was not helping, so I decided the interview needed corrective editing. It would be an anagrammatic operation of sorts, in keeping with the letters *Ronald Wilson Reagan* rearranged to the more accurate *Insane Anglo Warlord*.

The cut-and-splice editing process took approximately eighty hours for an audiotape lasting three and a half minutes. It might take half that time with digital audio editing. Yet eighty hours was quick in the scheme of things because the raw material was so fertile. Because the interview took place before he had officially declared his candidacy, his responses were anecdotal and idiosyncratic and contained imagery and cinematic

narrative devices befitting a creature of Hollywood. His speech was also rich in verbal pauses as he searched through his synapses for stories to tell and opinions to cobble together. The inane lushness of his speech did not last. When he first began to run (officially) for office, he kept putting his folksy foot in his mouth, so his image managers intervened. They sapped his speech of most sustained imagery and anecdotes; tightened up his delivery by eliminating many of the verbal pauses; and turned down the volume of his breaths so he would not appear to be an old fish out of water. I tried to correct his Inaugural Address but gave up because it was too thin and tight. Down-home coronations are rare.

Verbal pauses are the step-down and step-up transformers of corrective editing. They are indispensable when constructing the realism of seamless speech in another person in their absence. A transcribed phrase from one sentence may fit perfectly with another phrase in terms of content but sound artificially discontinuous when butted up together. That is because besides the meaning of the words content in speech itself— emphasis, emotion, affect, and so on—is also communicated through rhythm, stress, intonation, and other prosodic dynamics. To get from, say, a faster, higher pitched first phrase to a slower, lower pitched second phrase that are continuous in meaning but too discontinuous to sound realistic, it is just a matter of finding a verbal pause "uhhhh" or a sequence of pauses with a sliding pitch downward. In other instances, a rising-pitched pause can be used, or a little "wouldn't you know?" laughing puff, or fragments of phatic speech, or stammered words retrieved and corrected midstream can be added so that enough time transpires for a plausible shift in delivery dynamics to take place and seem continuous, no matter how fragmented. Reagan's speech was rich in all of these, which meant that a person like myself could serve the country by assisting him with his elocution and aligning his speech with his true intent.

Imagery was most important—the accoutrements of material culture, ambient markers, social associations, and bodily imagery—to reinstate visuality in blind media (audio alone and radio) and give a visceral sense to the violence he trafficked. Because sanitized, imagery-impoverished political speech is animated by masquerade, doublespeak, and empty appeals, many cut-ups of politicians seek oppositional recourse in simple reversals—replacing a *for* with an *against*, inserting a *not* where an affirmative had been, having a president champion drugs instead of arguing against them, and so on—to highlight hypocrisy. A reworking of

images, on the other hand, offers more options when it comes to representing strategies of deception, avarice, and destruction. Given Reagan's image-rich speech along with youthful experience with Mr. Potato Head, animating bodies in an environment of material culture proved to be a useful means to highlight his malicious idiocy.

> **Moyers:** What about government's role in offsetting the negative consequences of the free enterprise, business community you talked about . . . ?
>
> **Reagan:** Ohh! Now! No now you get back, no now you get back to what I said earlier. What I'm talking about is the free marketplace. Free enterprise! The regulations that government exists to have, and are necessary, is yes to insure that someone can't sell us a can of poison meat. I think, uhhh, ahmm a can of poison meat had a problem that I think the people must recognize. The problem is, zud, if you open a can of poison meat, hold it in your hand, it gets warm very fast while you're drinking it, 'n you punch the holes in the top and drink it. Well, this fella's made a very economical stein handle, you can buy a dozen of 'em and have 'em like you have your silverware. You're serving people, ahh, poison foods in the can, you just clamp the snamp, s-snap the snant, you just clamp clamp the snan, s-snap the handle onto it and people hold it by the handle and the drink doesn't warm up, and he's going to make a million dollars.

Reagan's original references to poison meat and stein handles were in contexts of discussions about government regulation and the so-called free enterprise system, respectively. He said that because more people died in the Spanish-American War from poison meat than gunshot, regulation was necessary. To show that free enterprise was alive and well, he gave the example of the man who invented a stein handle that clamps (or doesn't) onto soda and beer cans. He probably did not mention another can during his entire two terms as president, let alone two different cans of ingestible material in one sitting. Earlier, as governor of California, he did make one notable mention of poison foods in the can. When the Symbionese Liberation Army kidnapped Patty Hearst and instructed her media mogul father to bankroll free distribution of food to poor people, Reagan stated that he hoped the canned goods contained botulism.

The Reagan tape was designed to be pop-song length ("canned music") and staged with audio-political bunting at either end. It was orchestrated

by starting with the familiar and then, once everyone was on board, proceeding to the unfamiliar. The first section played to standing jokes about Reagan's age, doing so with a new twist, and then proceeding eventually into a patently surrealist passage (by the way, the "would" is actually Moyers's voice and the "gunshots" were from the Spanish-American War):

> **Reagan:** A few Republican panaceas, myself and people like myself, organized a task force of people outside government and inside. Well, this little group gathered and we very carefully would open the car door with the window rolled down, shove the man's arm across the window, and then break it (*snapping sound*), the backbone of America, and then break it (*snapping sound*) over the window. And then, the pressure came on, that hidden longing came out, and gunshot, gunshot, gunshot, gunshots and so forth. (*happy breath*)

There were two versions of the tape; the first one was completed before the election which had Reagan saying at the start of the tape, "Ohhh! I want to say I'm president. I want to live in the White House!" After he became president and was living in the White House, I changed the intro to: "For the first time in Man's history, I uhhh, I'm President! Whuh heh! And 'n that 'n 'n, I can do this, with dash and derring-do." I ran off cassette copies of the first version and, five weeks before the election, sent them free of charge to about forty community and college radio stations in the United States, especially the Pacifica Radio Network stations. Self-censoring commercial stations would not play it because although Reagan was public domain, Bill Moyers was copyrighted material—odd since Moyers was a public intellectual and Reagan was in the hip pocket, where the wallet goes, of corporate interests. The first version also appeared in a cassette compilation issued by Sub Pop in their pre-Nirvana days.

Shortly after the election, I visited San Francisco. The Reagan tape was in heavy rotation at KPFA, the Pacifica station in Berkeley, and my friend Spain Rodriguez, creator of the comic *Trashman: Agent of the Sixth International*, suggested I send the Reagan tape to Art Spiegelman at *Raw* magazine in New York. The second version of the tape was published on flexi disc in *Raw* number 4 with an illustration by Sue Coe. There was a small, banned-in-Boston episode when Evatone, a U.S. producer of flexi discs, refused to manufacture it, even though they had recently done flexis for *Hustler Magazine* and Laurie Anderson. They wanted *Raw* to obtain a per-

former's release from Reagan. When Spiegelman replied that it might be difficult to gain access to Reagan, Evatone suggested that he contact one of his agents, as though he was still in Hollywood. The tape was then sent to the Netherlands, delaying publication, increasing the price and notoriety.

Before *Raw* came out, I had about two or three hundred copies manufactured and sent them again to the stations that had the first version, as well as to many more. I also gave copies to people who could distribute them through other means. Stories came back of tapes passed down through personal cassette players on assembly lines at factories and dictation machines in offices; tapes played at rock concerts and poetry readings; at a caricaturist's stand in a shopping mall and in a large portable cassette deck blasting regularly across a school bus yard; in college lectures and even as grace before a Thanksgiving dinner. It was also issued on a folk LP called *Reaganomic Blues* and politically mollified in a dance mix by the Fine Young Cannibals as "Good Times and Bad" on their first EP, and they promised on the phone to send some money if it made any but then did not even send the record. I chalked it up to eco-niche rarefied breed behavior of socialists with a recording contract. I also met people who could recite the entire piece from memory, replete with serviceable head-cocking/twinkle-eyed imitations of the Gipper. The best result was residual; people told me that when they heard Reagan afterward, they wondered who or what was moving his lips and what a simple rearrangement of phrases might reveal. I could hear them thinking, "I redressed him with my ears." They also realized that the same machinations were at work in the editing of the news.

The closest I got to the Gipper himself was a half-day I spent at the home of Buddy Ebsen, best known as the actor who played Jed Clampett in the television series *The Beverly Hillbillies*. In newspapers, there used to be one- or two-inch fillers to fill the voids left by manual typesetting. I collected them. The wind that picked up the beach umbrella in Sardinia and jammed it into the jugular of a vacationer. What are the chances? The most inexplicable one was why Buddy Ebsen was writing and producing a musical play about Zürich Dada and the Cabaret Voltaire. For a couple of years I photocopied that particular filler and used it as stationery. It was well known that Ebsen was a dyed-in-the-wool Hollywood Republican, the next in line after Walter Brennan, pappy on the television series *The Real McCoys*, who thought that Nixon was too liberal. What was Ebsen

doing writing a play about the anti-war bohemians that populated Zürich Dada? My institutional status as an art historian at San Francisco State University allowed me to approach his agent and set up an interview to find out. He had a videotape of the production that he was willing to show me but would not make a copy. I would have to watch it at his house. Plan A: if the play was bad enough, Mel Gordon, director and historian of avant-garde theater, and I would produce it for the celebrity kitsch market in the Bay area and I would do a radio version.

My friend Barbara Sternberger, painter and godmother to my kids, was living in Los Angeles at the time and came with me. Buddy Ebsen greeted us at the door, an ascot draped silkily across the mudslide jowls he shared with his good friend Ronald Reagan. The morning was scheduled for a viewing of the videotape, a recorded interview with Ebsen, and then lunch. He tested my art historian expertise by showing me bad Southwestern desert landscape paintings, and I praised them knowing they must be his. He also showed me cartoons he had done of the characters in *The Beverly Hillbillies*; since he could not draw faces or hands, the perspective was from the back. At one point, I realized that the play was simply bad, but not bad enough to be recuperated in another setting. The interview likewise; at a certain point I reached down and turned off the cassette recorder. Lunch was another issue. Barbara and Buddy were talking about painting and curators in the Los Angeles area when she interjected, "Doug, too, is an artist. He did this real funny . . . etc." I forgot to let Barbara know ahead of time that Jed Clampett was long riding shotgun for Reagan. The icicles instantly hung from the eaves of the lunch nook. "Oh yes, we were at the White House for dinner last week." And, "are you going to cut up my voice, too? Is that why you are here?" I reminded him that I had shut off the recorder. The rest of the lunch went quickly.

My one-hit wonder eventually faded with Reagan's own senility, but after he died it was resurrected on radio stations and the Internet as an antidote to the far-fetched attempt to construct him as a great statesman. It is doubtful a similar necrophilic occasion will present itself. Despite the indelibility of recording, the generational historical media will deteriorate as vernacular recognition grows socially senile. Resurrection is with the ventriloquism of the present.

Notes

1. For a brief description of VEC, see Summers (1990). Summers made a number of tape pieces from 1969 until 1998, when he abandoned the block, razor, and paste for the screen, bit, and click.

2. My thanks to Erik Anderson and Tim Hawkins, archivists at the Naropa University Archive Project in Boulder, Colorado, for their assistance.

Excerpts from "Two Relationships to a Cultural Public Domain"

Beginning with the Industrial Revolution, and extending all the way through the twentieth century to today's late high capitalism, the increasing co-option of our mental and physical environment by private commercial interests has intertwined with an evolving awareness in art of this ever-growing, unilateral encroachment on everyone's personal and public space. There is a certain perceptual stance most artists have always taken in relation to their work and their environment—a perception that sees everything out there as possible grist for their mill. Some art is concerned with the social consequences of what is happening around it, other art is not, but all art tends to be affected by what it looks at, whether this influence is unconsciously assimilated or openly displayed. Whether an artist paints a tree in a landscape or samples someone else's music, they just use what's out there; and everything is equally usable if it "works" to make the art they want to make. It matters not who "owns" the music they sample any more than it matters who "owns" the tree they paint. Ownership has never had anything to do with creativity.

This ancient, universal artist's view of art's potential subject matter proceeded just fine for quite a while. For centuries there were no lawsuits against landscape painters by landowners, nor did they demand a cut of the painting's price. In contrast, though it's never been tested in court, Disneyland presently claims copyright on any photos taken inside their imagined landscapes. Throughout the twentieth century, the world was surprised by many unforeseen new technologies, which began to produce new forms of thinking and new forms of creative activity. For instance, one of these new technologies—the ability to capture and reproduce sound electronically—began to allow those involved in creating

music to think differently about what music might consist of. Electronic transcription meant that music no longer needed to be performed live to be heard. Music as an artifact frozen in time and space was almost immediately seen by composers as suggesting new and inspiring possibilities for recombination. Prerecorded sounds and music began appearing in *musique concrète* performances by the second decade of the last century. At the same time that electronic invention was spreading, so were brand-new techniques of visual collage, like recombining disparate elements and imagery into a single new composition: the founding attitude of Surrealism in general.

Collage first appeared in a brand-new reproduction technology developed in the late 1800s called photography. Photography provided a way to freeze light/time into material form, which made it possible to manipulate the image post-creation. Photos could be cut up and recombined or manipulated in the darkroom to make hilarious or "impossible" photo imagery. Lots of fun. Lawsuits against early photographers were unknown, nor were there lawsuits against turn-of-the century painters who embraced collage and the reuse of found material. They began to attach materials and objects from the world around them to their canvases, including commercially produced products like candy wrappers or fragments of advertising. Still, no offense was taken. Musical collage, for the most part, remained in the realm of classical music up until the mid-twentieth century.

However, even earlier, during the centuries when only live music was possible, many composers routinely included pre-existing musical "quotes" within new work, ranging from familiar folk melodies to fragments borrowed from their classical predecessors or contemporary colleagues. When recorded music came along, it was no great leap for some composers to add such material into their compositional concepts. Music proceeded exactly as it always had and as it wanted to, with hardly a hassle from the early commercial copyright laws that were starting to congeal in the shadows.

In the realm of fine art, the use of copying and appropriation was not only a tradition but also seemed to grow in emotional relevance as the perceptual world around artists became fragmented by the new possibilities for reproduction introduced by electronic imagery and sound. We'll skip World War I and Dada's found objects, though both profoundly affected an artistic view of the world as both absurdly surreal and entirely

available to art via appropriation. With Surrealism came the concept of *détournement*, which consisted of cleverly changing the nature of existing material to make it say or show things it never originally intended to say or show, often in the form of ironic juxtaposition and derailment of meaning: the earliest form of culture jamming. And still, there were no lawsuits. So long as it was fine art, these methods remained relatively uncontested.

In the middle of the twentieth century, the "crassness" of Pop Art emerged in rude response to American society's already commercially saturated consciousness, particularly the unavoidable barrage of advertising iconography that increasingly filled public views with its insistent "taste." With the "copying" in Pop Art, we saw the beginning of lawsuits based on the infringement of the private copyrights of commercial subjects that became the unwilling content of new works. Even then, such constraints on artistic freedom were still generally seen as absurd. While the *New York Times* sued Robert Rauschenberg for an unauthorized silkscreen of one of their news photos, Campbell's Soup saw Andy Warhol's paintings of their soup cans as great free advertising. Which it was.

Jumping Music

In the late 1950s, collage and the use of "found" subject matter (apparent in classical music for some time already) jumped over to pop music. This happened most notably in the form of Buchanan and Goodman's "novelty" edits, which consisted of fragments of then-current rock and roll hits, connected by narration that was completed by clips of familiar rock and roll song lyrics. This was the beginning of collage music with mass appeal in the pop realm, and Buchanan and Goodman were legally threatened by the owners of the music they incorporated. Music owners began to take the artistic appropriation gambit as some kind of serious economic threat, increasingly criminalizing it as commercial "theft."

But collage and the artistic attitude behind it continued to grow and spread during the last century, eventually infiltrating all forms of creativity. In fact, collage and appropriation may now be considered the single most influential and most defining aesthetic for the entire twentieth century. And it shows no signs of diminishing in the twenty-first. Turn on the news: it's solid collage. Watch a commercial or a music video: it's solid collage. Go to a live baseball game and see the mix of replays

and found audio and video clips from popular culture that are shown on big screens to wind up the audience: that's collage as well. The home computer is the ultimate collage and appropriation box, and every computer user in the world now knows and understands the phrase "cut and paste." But amazingly, just as this cut-and-paste style of thinking began to spread far and wide beyond the realm of fine art (even becoming part of the public's new attitude toward an increasingly complex mass of information that they must navigate), this process also began to provoke lawsuits.

Once music became a lucrative product embedded in physical form, such music was technically no less an art form than any other, but you'd never know it by its new owners and distributors. By the mid-twentieth century, music of the popular variety had been thoroughly harnessed by marketers of recordings as a mass commodity. Though labels and producers touted the artistic qualities of popular music in their PR, behind the scenes it was definitely a commodity game. Profit and loss, not artistic integrity, determined success or failure, and popular recorded music became all about money, where it remains focused to this day. Thus art, which has never been defined as a business, became a business in the form of popular music; and the creation of mass-produced music became a competition in the hands of record labels.

This kind of corporate-thinking trend never materialized in painting or other fine arts in the way it certainly has in music (although it still occasionally happens in other arts, too), because the fine arts world is much smarter about art and what makes it tick. Culturally, they see that it's not a competition but a continuous, all-inclusive accumulation forever. They better understand that all art is steeped in "theft," and that art has always proceeded by copying from whatever appeals to it, including other art. Add to that the fact that fine art generally ends up as a singular, unique object (the "original" is all there is), while music ends up as endlessly mass-producible objects containing content that can be sold again and again over time. Music, which was once something that could only be heard live and in person, became a repeating reproduction—a mass-marketable commodity, regardless of how much art it might happen to contain—forever in competition with all other such music "products."

Music stands apart from the other arts for other reasons as well. Major and minor music label marketing, for example, is not run by artistically enlightened museum or gallery directors but by dollar-hungry entertain-

ment moguls, their accountants, and their lawyers. Crime moved in. By mid-century (and continuing to this day), many of these music labels were illegally cornering distribution with payoffs and thug tactics, co-opting airplay with payola, concocting rip-off artist contracts, cooking the books for embezzlement, and were even leaned on or infiltrated by organized crime. (This is well documented in Fredric Dannen's book, *Hit Men* [2008], and things haven't changed much since that book was published.) So you have the *industry* of pop music becoming a crass and opportunistic nest of thieves and scoundrels, in which any artistic priorities—if understood in the first place—were quickly readjusted or cast aside on a regular basis in favor of the bottom line. In pop music, with the aid of modern copyright law, any kind of perceived copying became just another way to collect money and crush possible competition, even though music, possibly more than any other art form in human history, is thoroughly based on copying the precedents of others.

In Crept Collage

Into this peculiar, highly competitive, proprietary-obsessed "art" of popular music eventually crept the well-respected, classically founded motivations and techniques of collage. Who knew? Cutting and editing analog tape recordings of musical and nonmusical material into new compositions was occurring throughout the 1950s, '60s, and '70s, but it wasn't until the 1980s that all hell broke loose. The music electronics industry began marketing various digital sampling devices and computer-controlled music sequencing software intended to allow musicians to easily play back the sounds of "public domain" flutes, cellos, and saxophones. The inventors of these "samplers" never guessed that this new device would also easily allow musicians to capture and play back bits of *any* prerecorded music or found sound and then add it into their own music. Collage (in the form of sampling others' work to make new work) began to be routinely suppressed. Pop samplers, initially emerging in rap and hip-hop, began to freely pluck the grooves they wanted from the grooves of other popular music and soon found themselves in court. By the late '80s and early '90s, lawsuits and threats of lawsuits proliferated as this particular capturing technology spread far and wide throughout music of all kinds. Musical collage and its use of "unauthorized" sound became a criminal activity. Collage music became criminal music, and the

natural evolution of rap and hip-hop was stopped dead in its freethinking tracks. Copyright law became the art police.

Presently, we have a somewhat more settled situation in which sample clearance fees, rather than lawsuits, rule the economies of collage in popular music. But music owners continue to make great efforts to stamp out unauthorized collage in music, even going so far as to intimidate and threaten, via the Recording Industry Association of America (RIAA), any CD pressing plants that manufacture any sort of "unauthorized" sampling or found sound music. The RIAA acknowledges the existence and idea of fair use only in its literature's footnotes,[1] and seems to hope this concept won't spread.

As artistically stupid as this looks on the surface (trying to control what art wants to do, whether that art happens to be a "product" or not), this kind of control has become possible because of established, inflexible copyright mandates across all the arts, which allow any and all creations to be "protected" as private, untouchable property, unavailable for any purpose other than its original purpose—including any reuse in new art by others. For artists, copyright means that other art is emphatically not allowed to be seen as part of their landscape, not allowed to be part of their usable environment, and not allowed to be something that influences their creative minds, unless they are rich enough to "buy" whatever they want to use. Art has become completely unavailable to any succeeding artist's use without payment and permission. As a consumer, one can buy it and absorb it, but one can't do anything further with it. This withdrawal of all copyrighted art from any further creative recycling goes directly against the universal and historical prerogative of artists (and consumers) to see the entire world around them as grist for their mill. If they see other art products as part of the public environment they materially draw from, copyright tells them they cannot.

Is Making Art Supposed to Be This Difficult?

Something has happened in human creativity which the authors of copyright law never foresaw and did not write to accommodate: the fragmentary reuse of others' art to make new art. The opportunistic minds behind pop music, in particular, used copyright law to argue that this proven creative form (fragmentary and transformational appropriation within new works) was no different than counterfeiting entire works. Copyright

law did not distinguish such a difference and neither did they. Sampled source owners called these collaged uses "piracy" and "theft" and sued to crush the practice because they did not and do not understand how modern art functions; they claimed that such reuses were in economic competition with their source works, and they were not getting paid for the reuse.

After a while, it somehow wore into their brains that modern musicians were not going to let go of collage as a technique and that sampling was only spreading more profusely into all varieties of new music. So the best way to handle it from a business perspective was to ignore this blow to proprietary ownership and concentrate on getting paid for the reuse. That's where we stand today, and here's what's still wrong with it.

Even when a recognized art form like music manifests as a commercial mass commodity, it is still an *art form* and necessarily depends on free expression. Free expression demands free access to the elements of its expression, even when those elements happen to be owned by someone else. *Especially* when they are owned by someone else. This is the free pass all art has always been given to speak its mind, and commercial interests of any kind do not negate this creative imperative. If we want this kind of art to occur at all, then such freedom comes with the territory. We don't expect a writer to get permission and make a payment for using particular words. We don't require a painter to get permission and make a payment to represent a billboard that sits in the middle of her painted landscape.

Yet we do exactly this in the case of music collage, which suggests that such payments and permissions are pure economic opportunism based on this particular medium's existence as mass-produced objects. How does the material form of music change the desirable principle that anything is grist for artistic mills? The simple fact that an art form happens to be *worth* more in its potential income generation does not negate the principles of free expression that form the creative foundation of all art and its reason for being. Pre-existing private properties, even pre-existing art, can and do form the "alphabet" that any form of modern collage might use. The current copyright restrictions on using this "life's alphabet" constitute a prior restraint that amounts to both inhibiting the process and censoring the creative practice itself. This intimidation of art should not be happening just because the practice of collage happens to be housed in a commercial product.

More Attitude

Collage, which places familiar and recognizable elements from our common experience into a new context, often makes a social commentary or a statement about social awareness. It often expresses forms of satire, direct reference, and criticism. It is not always polite. As such, it often represents a potent form of creative free speech that requires just as much protection as any other form of free speech. The entire range of practices we call "collage" must be considered in this way in order to protect its potential in every possible manifestation. To trivialize these concerns by pointing out how rap musicians simply use a sample of others' music just because they like the riff and are therefore just stealing other's work for its inherent qualities is to miss the point, and irrelevant. Allowing source owners to have control over this practice can also prevent another collagist from using a clip of music or disreputable dialogue in a critical or unflattering context if the owner refuses to give permission even after being offered payment for it. This permission factor is crucial to collage's free speech. Fair use may be available to parody for this reason (as defined in the Supreme Court *Campbell v. Acuff-Rose Music, Inc.*), but it's *not* available at all to satire. Do you know which is which?

"Fair use" claims for cases of sampling/collage in our courts are now a morass of tortured and irrelevant nitpicking guided by a technologically outdated law that is wholly inappropriate for acknowledging or accommodating the practice of collage. The creative process has lost all benefit of the doubt, and commerce decides what can and cannot be art on whims of selective prosecution. These being the rather insane laws of modern art that we are stuck with, we are proud to sanely make criminal music for all to hear and judge for themselves.

Pay to Play

The dangers to collage from payment and permission requirements also include the aspect of affordability. Once collage had made its presence sufficiently felt in modern music, proving that it would obviously not be driven away by litigation, the music industry settled down to pursue charging everyone to do it. They all set up brand-new suites in their office buildings devoted to this intercorporate trade in music samples, and sample usage clearance fees were adjusted to what competing music cor-

porations could pay. Purchasing a single sample can run anywhere from hundreds to many thousands of dollars, depending on what the owner arbitrarily decides the potential market will bear. If these commercial rules of legitimacy are followed, collage becomes confined to production realms in which there is a wealthy label supporting the musician's desires and a mutually lucrative trade among relatively rich and already successful music purveyors. Any independent, grassroots efforts at collage are left out of this expensive loop of sampling "legitimacy."

From our personal experience as collage music makers who have no affiliation with the major labels, we in Negativland can assure you that we simply could not be making the style of collage music we do at all if we agreed to pay for every clip and sample we use. While we agree with the philosophical and ethical idea of listing on our CDs as many of our found sound sources as can be known, the cumulative price of *paying* for the use of these samples (working in the particularly densely sampled way that we do) is totally prohibitive to grassroots, independent, barely surviving practitioners like us. Just one of our CDs may use a hundred or more different samples and fragments recorded off of radio, movies, TV, or records. The haphazard nature of found sound collecting from mass media often doesn't happen to include the owner's name and address, so we sometimes have a very practical difficulty in even knowing who actually owns the bits we recorded—some of which we don't get around to using until years after recording them.

Even knowing or finding the owners doesn't guarantee permission: the owners often ignore the artist's request for reuse. (We have heard from many other independents who seek permission that no response is a usual response.) If they ever *do* get back to you, the whole process can take years. Thus, this process can abrogate any release schedule you may be financially counting on, and this becomes crucial when you are releasing only one record at a time as a small independent label. And then, of course, even if we could afford to pay for all these multiple samples from all these multiple owners, and all that could be worked out on schedule, these usages still depend on the multiple permissions being granted. This is where source owners can prevent this kind of work from appearing at all if they don't happen to like the content or attitude of it.

Expanding Fair Use

Fair use is not a doctrine that exists by sufferance, or that is earned by good works and clean morals; it is a right—codified in §107 and recognized since shortly after the Statute of Anne—that is necessary to fulfill copyright's very purpose, "to promote the progress of science and the useful arts."—**Judge Dennis Jacobs**, concurring opinion, *NIVMX Corp. v. the Ross Institute* (2004, Case No. 03-7952)

A Distinct Lack of Understanding

Allowance for fair use is already established within present copyright law, requiring neither payment nor permission for making limited copies of a work for personal use, or for the partial reuse of another's work in the context of news, commentary, criticism, parody, and a few other education-related instances. Fair use is the only legal acknowledgment we have that copyright controls can, indeed, equal censorship of free speech and free expression if permitted total and unrestricted reign. The problem with fair use as it stands is in its interpretation with regard to *art reuses* when that art is immersed (if not sinking) in a sea of competing commercial interests, as modern music is.

Fair use, as a legal concept, slowly developed via case law and revisions to U.S. copyright law and officially appeared in the Copyright Act of 1976. It mostly preceded the modern technologies that produced and encouraged the unexpected technique of collage in music. The aging guidelines for determining fair use do not yet accommodate, or even acknowledge, the modern tendency to actually create new work out of old. This leap of understanding has yet to appear in any of our commercially biased lawmaking, despite the fact that our culture is already drenched in legal and illegal collage from top to bottom. Commerce goes on seeing collage, now a century old, only as an opportunistic target from which to acquire some unearned and unexpected income via copyright-mandated clearance fees. We see the indiscriminate overreach of copyright's control over almost all creative reuse as providing a dangerous opportunity for the selective prohibition of modern art's evolution.

From an artistic point of view, it is delusional to try to paint all these new forms of fragmentary reuse and sampling as economically motivated "theft" or "piracy." These terms must be reserved for the unauthorized taking of whole works and reselling of them for one's own profit. Artists who routinely appropriate, on the other hand, are not attempting to

profit from the marketability of their sources at all. They are using elements, fragments, or pieces of someone else's created artifact in the creation of a new one for *artistic reasons*. Collage's reused musical elements may remain identifiable, or they may be transformed to varying degrees as they are incorporated into a new work, where they may join many other fragments, all in a new context and forming a new "whole." This becomes a new "original," neither reminiscent of nor competing with any of the "originals" it may draw from. Direct referencing of something old within something new does not equal the generally accepted concept of "copying," yet both whole-work copying and fragmentary appropriation in new work are still treated equally as theft by copyright law.

Defining Art and Business

Because art is not defined as a business, yet some art, like music, must compete for economic survival in the marketplace, we think certain legal priorities in the *idea* of copyright should be revised to uphold artistic imperatives in commercial contexts. Specifically, we propose an expansion of the fair use guidelines to apply to a great deal more artistic activities than they do now. This revision would throw the benefit of the doubt to reuses within collage contexts and place the burden of proof for showing economically motivated infringement onto the owner/litigator: it would no longer be what is legally known as an "affirmative" defense. Ideally, when copyright owners wish to claim an unauthorized reuse of their property, they will have to show essentially that the usage does not result in anything new beyond the original work appropriated—in other words, that the usage does nothing more than counterfeit their property. If the contended work, however, is judged to significantly fragment, transform, rearrange, or recompose the appropriated material within a new work, then it should be automatically seen as a valid fair use—an original attempt at new creative work—regardless of whether or not the result is successful or pleasing to the source creators or owners. This would constitute a general right to free reuse *in the creation of new works*.

This level of free reuse would not cause any great or destructive economic hardship for source owners because none of them are making much of a living by just sitting back and collecting fees for rare or occasional reuses of their work in collages, and if they say they are, then perhaps they should be encouraged to do something new once in a while. Realistically, only a handful of artists get sampled more than once or

twice in a lifetime. It would be impossible to live off of copyright permission fees alone, unless you're a multinational record company that can aggregate many artists and collect a cut from all those who are sampled. The sample trade is opportunistic and purely supplemental, and it has little or no significant economic effect of any kind on individual artists.

Such an expansion of fair use would let all possible music collage works through the copyright gate while still prohibiting wholesale counterfeiting. Unlikely? Can we say that copyright law is still fulfilling its original purpose: to protect the encouragement and promotion of the useful arts and sciences? We believe collage in music is a useful art, and under the current copyright law it is not protected. Are we out to support, dare we say even *encourage*, new arts of collage in this world or aren't we? If we want collage to flourish without economic bias or ideological censorship, especially at the grassroots level, it must be able to support itself in the same way all its sources do—by selling *itself*. Otherwise, it withers in poverty, not to mention lawsuits.

A Different Value

All claims that collage is simply out to resell its sources are absurd. Anyone familiar with actual examples of collage understands that the internal snippets present within a work in no way duplicate or compete with the appeal of those original sources in their entirety. This fragmentary selecting and combining (which creates an entirely *new* effect) puts the reference in a new context. It can even be partially dependent on the recognition of that fragment as part of the expression, but creating a new whole that is more than the sum of its parts, original to the collage alone. If there is no real-world economic theft involved—if a collage and its sources are not in direct economic competition with each other—then what exactly is the fundamental objection to fragmentary free appropriation in the creation of new work?

Please consider the ungenerous and uncreative logic of our copyrighted culture. In this age of reproduction (typified by recorded music and battles for consumer consciousness through the mass saturation of our environment with logos, brands, messages, ideas, and imagery), artists, not to mention others, will naturally continue to be interested in sampling material from this modern environment of both reproduced art and psychological influence mongering.

Appropriating from all the publicly available influences that we swim in as a society is desirable precisely because of how these elements express and symbolize something potently recognizable about the society from which we spring. The private owners/public spreaders of such art, artifacts, icons, messages, and ideas are enormously concerned that their "messages" reach everyone, yet are seldom happy to see their properties in unauthorized contexts which may be antithetical to the way they wish to spin them. Shouldn't public exposure assume the risk of a public response? But their knee-jerk use of copyright restrictions to prevent any kind of publicly inspired "spin" of their property that they don't approve of amounts to corporate censorship of such direct referencing within our culture.

In this ongoing censorship, the present role of the courts (bound as they are by the lawsuits that are filed) isn't helpful. Though many of us object, few of us can actually make our case for the rights of art before a judge. Unlike the basic thrust of all the rest of U.S. law, copyright law actually assumes that all "unauthorized" uses are illegal until proven innocent. Since any contested reuse always requires a legal "affirmative" defense, such a legal expense—even when fair use *does* apply—remains beyond the financial grasp of most accused "infringers." This financial intimidation, especially on the part of large corporate source owners, results in the vast majority of unauthorized art appropriators caving in and settling out of court. Their work is consigned to oblivion, or to being illegally traded on person-to-person file-sharing networks.

Fair Use for Collage

We would like to see copyright law acknowledge the logical and inalienable right of artists, rather than publishers or manufacturers, to determine what new art will consist of. The current corporate control over our cultural output has an ominous feel to it because it has given culture over to fewer and fewer corporate committees of taste molders and marketers who are driven only by image making and an overriding need to maintain an ever-rising bottom line for their shareholders. Is the admittedly pivotal role that society places on commerce really so unassailably useful when it reaches to inhibit and channel the very direction of a modern art form, allowing it to evolve this way, but not that way? Is the role of federal law to serve the demands of private income, or to promote public good through free cultural expression? Or both?

One crux of the collage debate that we hope to raise is this: why can't we do both? Why can't we maintain all reasonable forms of fair and just compensation for artists that directly result from the work they themselves produce, while at the same time not inhibiting, preventing, or criminalizing other perfectly healthy and valuable forms of music/art such as collage that arise naturally out of new, enabling technology and which increase our total wealth of creativity as a culture? The promotion of artistic freedom should, for the first time, find a balanced representation with the purely commercial and proprietary obsessions that now dominate the purposes of our copyright laws. The minor and isolated conflicts (based on commercial interference) that this new approach might cause in no way measure up to the conflict with the public interest that is maintained by doing nothing.

Two Relationships to a Cultural Public Domain

In the isolated medium of the Internet (and in our suggestion of fair use for collage), we are being guided by new technologies to reacquaint ourselves with the cultural urge toward a rejuvenated public domain. Since we are actually *forced* to accommodate these two persistent references to the boundaries of public domain (the Internet and collage), we should begin to seriously consider what value, or lack thereof, a larger public domain might actually entail in practice. Not having a choice gives us the opportunity to find unnoticed values that an easy and habitual dismissal never considers. The billions in private income reserved for private interests under copyright controls, and the withholding and denying of all reuses of our own culture in lieu of payment and permission, may not be the best rules in sight for mass enlightenment. The "value" of totally privatized intellectual property may not outweigh the cultural value of enlarging *all* our brains in a less intellectually constricted environment, not to mention the enlargement of our enthusiasm for, and participation in, our own culture that would result from such a broadened concept of public domain possibilities. In many ways, regardless of copyright, the Internet is bringing that world to us now.

For years, copyright has been a nagging restraint on all forms of popular reuse concepts. Now, the Internet has entered the debate, and we welcome its arrival. The Net is an interesting new player because it significantly widens the formerly narrow and specialized artistic desire

to recycle found material into the general public's desire to recycle anything for any reason. The Internet tends to give every user who enters it an artist's perspective on the contents there: the suggestion to copy, to edit, to cut and paste, to appropriate, to reform, to redistribute. The degree to which *the public* will follow their own sense of free expression in this new, wide-open, digital no-man's-land might surprise us and is yet to be determined. In the broadest sense, it remains a struggle between the rights of commerce and the rights of personal creativity. The degree to which these mutually opposed interests find a reasonable balance of productive coexistence in this new domain will say much about what we value most as a culture.

Both the status of music on the Internet and the status of collage in music are primary signposts of the ever-latent urge to receive, perceive, use, and reuse the world around us as a *public* domain. For most of human history, the creation of culture was always a shared phenomenon: an activity connected to spiritual sustenance and a mutual confirmation of values between the creators and their community. Only recently has it been found advisable to withhold virtually all such creative activity until it can be paid for. That old selflessness that infuses the human urge to communicate through art may no longer be so practical in a world in which making art has become more and more expensive, and so much of the potential subject matter for art's ancient habit of free appropriation has been declared legally off-limits. But suddenly, the Internet offers an isolated "look and feel" that rekindles the ancient and generous purpose behind all cultural experience: a glimpse of no fences, possibly existing for the sake of mutual connectedness, community relevance, and "free" enlightenment—possibly, like art, existing for its own sake and no other.

Notes

Excerpted from the essay "Two Relationships to a Public Domain," from Negativland's release *NO BUSINESS* (2005) CD with fifty-six-page book and rubber novelty device. Available at http://negativland.com.

1. For more on Negativland's own involvement in how this small concession to fair use came about, go to www.negativland.com/riaa/index.html.

Everybody's Got Something to Hide
Except for Me and My Lawsuit

William S. Burroughs, DJ Danger Mouse,

and the Politics of Grey Tuesday

If the Grammy Awards broadcast in 2005 was the moment that cacophonous pop-music "mashups" were first introduced to grandma in Peoria, the strategy's commercial(ized) pinnacle may have been the November 2004 CD/DVD release by rapper Jay-Z and rockers Linkin Park, titled, appropriately, *Collision Course*. This record capitalized on the latest iteration of a long-standing tradition of mixing, sampling, and collage practiced by DJs, producers, and musicians for the last decades, called, in a current form: mashups. There are numerous sampling antecedents for the mashup practice, which generally combines a cappella vocals from one song with the instrumentals track from a second—in everything from the "break-in" practices of "The Flying Saucer" single (1956, Bill Buchanan and Dickie Goodman) to the micro-sampling ("plunderphonics") of John Oswald's *Plexure* (1993) to the social commentary of audio-collectives such as Negativland and The Tape-beatles. The current barrage of mashup tracks (inaugurated in this a cappella/instrument track form, supposedly, by the Evolution Control Committee's mid-1990s Public Enemy/Herb Alpert mash "Rebel without a Pause [Whipped Cream Mix]") began its current ascent to popularity around 2000 as "bootleg" and/or "Bastard/bastard-pop" in London's West End (Howard-Spink 2004).[1] Four years later, signaling the inevitable commodification of an underground practice, the *Collision Course* EP debuted at number one, selling more than 368,000 copies in its first week; the music press offered such banal insights as,

"in true mash-up spirit, the union of the artists' styles is greater than the sum of their musical parts" ("Review: Jay-Z/Linkin Park's" 2005).

Mashups: A Project for Disastrous Success

One wonders if *Collision Course* would have been possible without Jay-Z's earlier passive foray into a subgenre of mashups—the merger of vocal tracks from his chart-topping *Black Album* with noncontiguous musical samples from The Beatles' 1968 record, *The Beatles*, better known as *The White Album*. The resulting mixture, the DJ Danger Mouse–assembled *Grey Album*, gained its fame during the appropriately titled Grey Tuesday protest organized by the nonprofit music activist Web site Downhillbattle .org on February 24, 2004. Over 170 other Web sites offered the twelve tracks for download, and many others turned grey in solidarity. A widely circulated cease and desist letter from Capital/EMI sought to elevate the purported "copyright infringement" of The Beatles' music catalog to a matter of universal concern: "Distribution of The Grey Album constitutes a serious violation of Capitol's rights in the Capitol Recordings—as well as the valuable intellectual property rights of other artists, music publishers, and/or record companies—and will subject you to serious legal remedies for willful violation of the laws" (*Rantings and Ravings 3.0* 2004). This rhetoric suggests that even Danger Mouse appreciates the gravity of his copyright violation ("I just sent out a few tracks [and] now online stores are selling it and people are downloading it all over the place" [quoted in *Ranting and Ravings 3.0* 2004]).

Neither the tone nor the demands of the letter should surprise in a climate where the "fair use" doctrine, codified in the Copyright Act of 1976, is regularly underutilized, where copyright protection functions too often as a defense of corporate property, and where, as one critic notes, "to the Disney Corporation and major film studios"—and we can add, the major record companies—"there simply is no such thing as fair use. . . . It's . . . suicide to ask those type of multinationals for permission" (quoted in Orlans 2002: 143). As fair use allows for the limited use of protected works via a set of four factors that, when applied favorably, provide exceptions to copyright law, it is no surprise that its interpretation remains subject to significant debate. Corporate interests repeatedly press ownership claims to restrict fair use by sampling artists, increasingly claiming that intellec-

tual property violations occur *whenever* a cultural property is used in an artwork, regardless of the often nonderivative, or transformative context (which can in part *favor* a claim of fair use).[2] Unfortunately, corporate interests have been so successful in defending "cultural property" that most people remain unaware of the exact laws regarding copyright—assuming too often that all cultural products are "naturally" owned by private interests. The rampant expansion of "authorship" to cover new categories of intellectual property has no doubt contributed to this assumption (see Coombe 1998: 52–55), and an investigation of the case of *The Grey Album* followed by a discussion of William Burroughs and Brion Gysin's cut-up text *The Third Mind* will dramatize this point toward a potentially contrarian praxis based upon user interaction with protected works.

In the case of the Grey Tuesday protest, Downhill Battle's defense is to claim that fair use *must* be exercised, even under legal threat, in order to maintain and hopefully expand the statute's unsettled interpretations. Despite the importance of this strategy, a telling problem with EMI's claims seems to have become obscured in the rhetorical uproar of the cease and desist letter. The Electronic Freedom Foundation, a nexus for intellectual property revision, notes that there is "no federal copyright protection for sound recordings made before 1972," making the claim that EMI "owns" the 1968 Beatles recordings ("Capitol's rights in the Capitol Recordings")—at worst—a lie in the form of a threat, and—at best—a reference to the possibility that pre-1972 state laws might offer protection to the 1968 recordings. Given the fact that EMI did *not* pursue legal action, we might conclude that the cease and desist letter was, in fact, a threat meant to curtail resistance to the perception of universal corporate ownership.[3]

Even with Jay-Z's tacit approval, the *apparent* illegality of the event coupled with its publicity as organized political action produced enough downloads for the record to achieve "gold" status (500,000 copies, although none were actually purchased). The peer-to-peer distributed *Grey Album* offered a potent combination: using the Internet to illegally download an apparently illegally produced product, implicating the listener into an increasingly common practice that conflates notions of aesthetic pastiche with the ability to capture information.[4] This bundling of "crimes" is significant, as copyright law (particularly in prosecutions for downloading media content) equates "theft" by an "author" to "theft" by a "consumer." In this case, the user, through downloading, becomes

complicit in Danger Mouse's "crime" of assemblage by choosing to inter-
act with his project, and it is precisely in the digital realm where such
a confluence of production and consumption assumes its most disrup-
tive potential. The implications of the medium may be well ahead of the
"intentionality" of either side.[5] The result is a radical "third" praxis—a
merger and mingling of user and creator—reflected in the collaborative
cut-up exercises of William S. Burroughs, and poised in the coming de-
cades to fundamentally alter the complex interweave of creativity, copy-
right, and capital in the digital sphere.

If I Hold a Conch Shell to My Ear,
Do I Owe a Royalty to Neptune?

First, let us consider Walter Benjamin's desire to form a book composed
entirely of quotations. This project, as Delia Falconer (2001) notes, pos-
sesses "a special kind of metaphorical force. Freed from their context,
and left to crystallise in the depths of history, [quotations] could be
brought back from the past and rearranged, without explanation, . . . so
that their hidden correspondences would be revealed." It is easy to imag-
ine a similarly produced "history" of copyright: none of those words will
be mine; they will be lifted from a series of previously published articles,
and attributed only at the end of the resulting text—in imitation of a
nineteenth-century "cento" or "patchwork" poem (Saint-Amour 2003:
40), which borrows lines and even couplets from diverse but "metrically
identical source poems" (41).[6] The Victorian version of these works, ac-
cording to Saint-Amour in *The Copyrights: Intellectual Property and the
Literary Imagination*, are meant to serve as "the sum of its maker's read-
erly acts or consumption, just as the maker's identity is at once consti-
tuted and eclipsed by those acts of reading" (2003: 42).

In the Danger Mouse case, unlike the cento, the maker is neither
anonymous (as was generally the practice) nor does the object, as Saint-
Amour claims regarding a particular cento, decline "a discreet identity
of its own" (2003: 42). The cento emerges in a neoclassical context that
still validates and respects the "canon" of texts used as borrowing points.
Yet these centos—strange concatenations of Wordsworth and Coleridge,
Congreve and Milton, Spenser and Chatterton (a literary forger)—today
seem to possess as much "discrete identity" in their content as *The Grey
Album*, which is to say, they *fail* in the effort to drown their assumed

claims to independence in a sea of previous influence. While the cento may be a literary footnote, under contemporary scrutiny, it is far from a neutral sampling of the literary past.

If many nineteenth-century cento writers feel obliged to remove their names in an attempt at distilling the "mark" of originality, this urge is less present for today's samplers. Contemporary "creators" have no problem applying their Duchampian mustache, with signature, to the palimpsests of the past, and calling themselves "Authors" and "Artists" (with capital letters).[7] The shift from the professed anonymity of the cento to ego/name-centered sampling culture is reflected in the development of copyright legislation that has extended the proprietary rights of the Author—even when the art that is produced might be considered in the "countermold" of that Victorian poetic practice.

The idea of what constitutes an Author has proven particularly malleable to business interests in the last century, so that the copyright often has as little to do with protecting the rights of the person who "writes" or "creates" as pre- and early copyright laws made. In the period prior to the Statute of Anne (1710), the power of the copy fell to the Stationer's Company, a London bookseller guild, which attempted to fend off pirated editions of their books. Assaults on the rights of the Stationers to protect their investments during the rise of commercial printing, signaled, as Mark Rose demonstrates in *Authors and Owners: The Invention of Copyright* (1993), how copyright is "produced by printing technology, marketplace economics . . . it is an institution whose technological foundation has recently turned, like an organ grown cancerous, into an enemy" (142). Three centuries later, the 1998 Sony Bono Copyright Term Extension Act ensures that Mickey Mouse will be kept in fresh steamboats for several decades (a twenty-year extension of the previous monopoly period). The Digital Millennium Copyright Act, also from 1998, focuses on the protection of digital property in a way that has been used to stultify market competition, embroiling computer printer makers in lawsuits with companies that produce after-market cartridges (see McLeod 2005: 4–5).

Unsurprisingly, the economic stakes at work in maintaining outmoded definitions of "authenticity," "originality," and "genius," are intertwined with technological developments. Whereas collage-oriented visual artists often use a direct reproduction of the source work (think Andy Warhol's silkscreens), "plagiarizing" writers tended—in the pre-electronic era—to engage in appropriation by *retyping* source material. In the electronic age,

it becomes easier and more common for the writers to cut and paste, and thus borrow content *as well as* the "physical/electronic" substance of a quotation. The changing methods of *transfer* over the past decades, if not centuries, influences definitions of authenticity.[8]

Also relevant to this inquiry is the status of "collaborative" art. Although *The Grey Album* is composed of the work of three musical acts (Danger Mouse, Jay-Z, and The Beatles), it is not surprising to hear Danger Mouse promote his record within the *traditional* bounds of an anxiety of influence: "I'm just worried whether Jay-Z will like it, or whether Paul and Ringo will like it. If they say that they hate it, and that I messed up their music, I think I'll put my tail between my legs and go" (quoted in Greenman 2004). This statement positions Danger Mouse as a "mixing machine" fitting together already extant works of *individual* genius. Regardless of whether he actually intends to eliminate his Authorship claim, the final product can be fitted into a strong tradition of *individual* production that David Greetham calls the "Wordsworthian formula" (141). In this Romantic formulation, collaboration can still be considered, as it was in the 1842 British Copyright act, as another form of *organic genius*: "synthesis can operate at a secondary or meta-level of composition and loses neither its intuitive and organicist credentials nor its protectability as a result of the cumulative effort" (142). Thus, the "genius" of Danger Mouse becomes not his ability to interweave previous work per se or to sink himself into the glorious sonic past, but his ability to sample, mix, and *sign* with his nom de plume in the present. The copyright regime finds Danger Mouse acknowledging the "genius" of his precursors as a way of assuming the mantle of "single" creator within his "multiple" production methods.

Even so, Danger Mouse's position as a singular Author threatens not so much the authority of The Beatles or Jay-Z, but the economic positions of those corporations who hold the related copyrights—and who demand fealty to their ownership claims. His unwillingness to clear his samples, coupled with his facility for navigating the dangers of this "illegal" position, speaks to a crisis of the economic engine that has no intention of giving up its construction of business-oriented "originality" without (at least) the threat of a lawsuit.

One direction for dissent from the equally problematic notions of Authorial and corporate "ownership," as practiced by the Creative Commons approach, offers possibilities for revised legal doctrine—working from the *inside*. Yet a necessary alternative to such legal strategizing

remains a fundamental *rejection* of the legislative system through *material* practice, through collaborative art that refuses to accept the current corporate-driven state of copyright law as anything more than an economically driven definition of property, far removed from its original intent as a compromise measure between creators and users. A defense of historical "originality" thus becomes as misplaced as current Authorship manifestations—having little to do with how art is actually produced. Steve Tomasula, aping painter Diego Velázquez in his novel *The Book of Portraiture*, and so echoing the work of countless writers and scholars antagonistic to these legal fictions, notes: "Truly, the imagination, which may seem to bear much individual fruit, is root'd in a compost of forgotten books" (71). Unfortunately, merely reifying the *noncorporate* Author-as-person (due all the rights to her creative output) will do no more than reify the flawed, Romantic notions of Authorship and creativity. Rather, through a method of redefining the production and consumption of art toward its own collaborative model, the myth of "original genius" makes ready to wilt on the possibilities of its electronic vine.

Technical Deposition of the Virus Power

The practice of encouraging the "solitary genius" at the expense of collaboration (or, redefining collaboration as singular, per the "Wordsworthian formula") affects not only the corporate sphere of the United States but also the nonprotected or underprotected products of indigenous cultures, oral cultures, and collaborative-based societies. In the so-called third world the pressures of the hegemonic intellectual property regime dramatizes not the universal "naturalness" of the Author, but the complex manner in which these Western notions of Authorship have expanded—as in the 1993 General Agreement on Tariffs and Trade's Agreement on Trade-Related Aspects of Intellectual Property—further exploiting a growing roster of protected intellectual properties (computer programs, databases, etc.) to the detriment of countries with alternative production models. If a country embroiled in international trade does not recognize the Author/Owner in the Western corporate sense (and the attendant implications of this recognition for patents and trademarks), its legal structures often lack the ability to protect cultural elements that do not fit Western definitions of property, ownership, and their paternal meta-narrative of Authorship.

Intellectual property scholars, including McLeod, Rosemary Coombe, and Shujen Wang, have effectively demonstrated this exploitation of the non-Westernized "Other" in terms of biopharmaceutical cultural mining, the theft of oral tradition, and the unreciprocated power relations of Western documentarians. As intellectual property battles are increasingly fought in so-called developing or non–first world countries, particularly Brazil and India, the multinational stakes become clearer. A Silva government official's support of Open Source as an anti-colonial measure notes: "Every license for Office plus Windows in Brazil—a country in which 22 million people are starving—means we have to export 60 sacks of soybeans" (quoted in Dibbell, 193).[9]

Rhetoric or fact, this statement recognizes a crucial link between semantics and material practice. Copyright, in its extended monopoly period, becomes a regime equally defined by sociopolitical circumstances and *a particular language of expression* ("expressions," not "ideas," are protected under the statute). John Locke's *Two Treatises of Government* (1690) is an often cited precursor to the development of this protection as a "natural right" for the Author and his legislative descendants, but here we dovetail with critical legal studies, which maintains that the law does not enact a regime that presupposes or exists separately from it, but that it simultaneously creates *and* enforces through a process of articulation. This articulation, of course, often sounds like the oratory of the West, embodied by the well-known RCA trademark, "His Master's Voice."

Despite the extraordinary inequities imposed by exploitive and colonialist practices, resistances may be discovered in the Western canon using the same method deployed by Saint-Amour—to find that "the protective, prohibitive, and policing functions of the copyright/censorship nexus" has "left its imprimatur on the works themselves" (2003, 161). This is a key point. The legislative facade of the "solitary genius" begins to crack under the weight of textual study. This practice need not only center on current works such as *The Grey Album*. Saint-Amour focuses on the textual intersection of literary modernity and copyright legislation, and since the exploitive aspects of the multinational intellectual property system are predicated on the primary notion of singular Authorship, I propose to unearth an additionally effective investigation primarily focused on the material conditions—how a text is produced, and in the case of Burroughs, the collaborative methods of how it is also *reproduced*.

Millions of People Reading the Same Words

The cut-up and anti-narrative work of William S. Burroughs attempts to materially counter writing's traditionally metaphoric work. Burroughs did more than write about the omnipresent post–World War II control system impinging on notions of individual freedom, but sought to expose "Control" through a complex of interrelated writing methods harkening to the counterdiscourses of Marcel Duchamp's divided square constructions, Tristan Tzara's automatic poems,[10] and John Dos Passos's "Camera Eye" segments in the USA novels. Burroughs's collaborations with musicians, visual artists, and writers were often (but not exclusively) attempts to escape from the stigma of Authorial constraint, to allow chance to shape prose production, toward "making the words talk on their own" (Burroughs 2001: 17). More significantly, Burroughs was a literary "plagiarist" who often violated copyright protection in the works he utilized, particularly with his "cut-up" method.[11]

His uses of modern literature have included what we might label outright theft in even non–cut-up contexts. A comparison between Burroughs's *The Place of Dead Roads* (1983) and Jack Black's *You Can't Win* (1926) demonstrates points of extreme similarity (Miles 2002: 226). Elsewhere, lifts were also made directly from Joseph Conrad's *Lord Jim*, and Burroughs even notes the opportunities for plunder in the famous text: "Conrad did some superb descriptive passages on jungles, water, weather; why not use them verbatim as background in a novel set in the tropics?" (*Adding Machine* 20). Of these different types of plagiarisms and infringements, the formal innovations derived from Burroughs's collaborative production techniques and cut-up-related works provide tantalizing intersection points due to the aberrance of these methods from "mainstream" writing.

Danger Mouse juxtaposed Jay-Z and The Beatles without their knowing participation, and my comparative text is an assembled cut-up/fold-in manifesto by William S. Burroughs and Brion Gysin (composed in 1965) called *The Third Mind*, first published in English in 1978. An ex-Surrealist visual artist, writer, and co-inventor of the Dreammachine, Gysin comments on the text's dedication, "to and for all our collaborators/at all times third minds everywhere," as related to the inability of certain languages to express certain ideas" (Wilson and Gysin: 206).

Not only does this quotation indicate that our understanding of artis-

tic production remains tied to the language of articulation, but we might also take his comment as a revelation as to hidden multidimensionality of the collaborative page. For instance, any aesthetic frame produces, *materially*, a certain set of at times predictable interpretations. When Picasso affixes a piece of oilcloth to the canvas in *Still Life with Chair Caning* (1912), we become aware of the *assemblage* in its contoured visual dimensions rather than flat, painterly ones. Picasso's material experimentation is evident *on the canvas*, but writing eschews such immediate markers of collage, and is (as per Gysin's dedication) not usually able to express the manner of its own production. The written page, in its physical substance, does not generally announce collaborative assembly. Thus, any study of contemporary writing can only *textually* produce findings about copyright and intellectual property, in possibilities opened up by the flatness of written language, without recourse to the work's hidden multidimensionality.[12]

Saint-Amour provocatively explores the possibilities of this self-constraining textual trait in *Ulysses'* "Oxen of the Sun" chapter, which, he claims, depends for its history of the English language on a set of available source texts limited through tensions between private property and the public domain. According to this argument, Joyce critiques the literary property regime *without* the three-dimensional markers that we find in a visual work, and as Saint-Amour ably contends, such critiques can still perform "deep skepticism about copyright's notion that ideas and facts are anterior to their particular expressions" (2003: 189). Saint-Amour's reading pushes toward a reassessment of the "facts before expression" vector, but it must rely upon the usual methods of textual scholarship to stake such a claim. *The Third Mind* offers a different possibility.[13]

The Burroughs/Gysin cut-up method *materially* flips this ideas-before-expression vector, maintaining that ideas might very well be *posterior* to their expression: cut-ups articulate (expression), yet their meanings (ideas) emerge only *after* their arrangement on the page. As Oliver Harris notes, cut-ups subscribe to a material skepticism by introducing a *prospective*, or future-oriented function (2004: 177) requiring the participation, and perhaps belief, of the audience. He writes, "community was not projected on the basis of reception alone . . . but on recruitment to future acts of production—acts that in turn promised to produce the future" (2004: 181).

In what the 1978 dust jacket calls a "series of dazzling and often dizzy-ing collaborations," *The Third Mind* presents *relatively* straightforward statements on method from both Burroughs and Gysin, interpolated commentary by Gérard-Georges Lemaire, cut-ups, fold-ins, Gysin's per-mutation poems, discussion of "grid" arrangements, a fragment from the early *Naked Lunch* screenplay, and toward the end, examples of scrapbook montage and hieroglyphic exercises that concerned Burroughs in later texts such as *The Job* (1969, 1974), and *Ah Pook Is Here* (1979). Also, *The Third Mind* contains just under thirty "images": cut-ups, scrapbook pages, word constructions, photo-headline montages, arranged film stills, and so on.

Yet the most provocative portions do not simply discuss or demon-strate method, but do both together. Much of the book was published elsewhere between 1960 and 1973, with significant amounts drawn from the first published cut-up book, *Minutes to Go* (1960), a collaboration be-tween Burroughs, Gysin, Sinclair Beiles, and Gregory Corso.[14] *Minutes to Go* also compares to *The Third Mind* in its engagement with the biblio-graphic codes, or publishing markers, of the text. For instance, the scanty end citations to the cut-up poems in *Minutes to Go*, including notations such as "Cut up Paris Herald Tribune articles" (1960: 17), are moved to the beginnings of the poems in *The Third Mind* section "First Cut-Ups."

The section also called "First Cut-Ups" in *Minutes to Go* contains only five numbered pieces, all of which are replicated in *The Third Mind*, in order; yet in *The Third Mind*, these "First Cut-Ups" include three *additional* pieces from later portions of *Minutes to Go*. The title of this first extra piece, "MAO TZE: TA TA KAN KAN . . . KAN KAN TA TA" (1960: 20), is replaced in *The Third Mind* by its formerly postscript citation (although the subtitle remains), with a note that the poem is a cut-up of Beiles's poem "Stalin." The second extra piece from *Minutes to Go*, "FROM SAN DIEGO UP TO MAINE" (1960: 21), is reproduced in the same way in *The Third Mind* (1978: 56–57)—with a second important difference. The final line of the poem in *Minutes to Go* appears to be "Unimaginable disaster . . . Royal Knights Teen Age Future Time," followed by two postscript lines: (1) "Cut up articles on Juvenile Delinquency" and (2) "*Time* and *New York Herald Tribune* (European adition)" [*sic*]. However, the (double) spacing of these two lines seems to link the first of these ("Cut up articles") as *single-spaced* against the end of the main piece. Significantly, in its republication in *The Third Mind*, the final line of the poem *changes in the transfer*, be-

coming, "Cut up articles on Juvenile Delinquency" (instead of the "Teen Age Future Time" line). This former postscripted line has been appended to the main text of the poem, no doubt, in a less-than-careful reset of the work.[15]

The significance also transcends random typographical error: consider other changes across the two editions, published eighteen years apart. In *Minutes to Go*, the compositions are often given titles, whereas they are titled in *The Third Mind* only by scanty source attribution. Second, author initials in *The Third Mind* replace the full names of the "makers" in *Minutes to Go*.[16] One likely possibility is that the position of those early cut-ups, which were (in 1960) "new" if not "unique," had passed from being worthy of titling and authorial attribution into a lesser mode when re-presented in 1978—subservient to the idea of *composition as process*.[17]

Even so, this physical transfer from *Minutes to Go* to *The Third Mind* stops the texts from becoming mere ego-centered reproductions of their own institutional pasts, and rather re-energizes their positions as texts capable of producing not only *future* Burroughsian texts (as per Harris's argument) but future versions of themselves that express differences from the originals, despite the wishes of the Authors. Most important to this argument is the apparently *accidental* annexation of the line "Cut-up articles on Juvenile Delinquency" into the poetic space. This slippage is representative of a sea change in the type of collected experiments in *The Third Mind*, compared with *Minutes to Go*. Harris notes that the cut-ups in the earlier collection "gave priority to the material process of cutting up over its products" (2004: 182) leaving the explicitly manifesto-like "call to arms" to more linear pieces by Gysin. Yet in the intermittent years, the "content" of the cut-ups changed, partially because Burroughs came to focus increasingly on small-press publications (Miles 2002: 178–79), deploying this minor literary form through magazines and journals with small distributions. The promise of the cut-ups to speak messages directly to the cutter, and the reader, were dependent, of course, on getting the message into the proper hands—and so the message of the cut-ups began to appear explicitly in the space of the cut-up texts—an economy crafted to not lose a *single* reader.

The second section "original" to *The Third Mind*, "First Recordings," follows the blueprint of much of the three cut-up novels, *The Soft Machine* (1961, 1966, 1968), *The Ticket that Exploded* (1962, 1967), and *Nova Express* (1964), with exposition on process followed by rearrangement and inter-

polation of this exposition. The first pages of "First Recordings" detail several cut-up concepts applied to "real life": someone singing about advertisements washed together in the rain and the playing of a tape called *The Drunken Newscaster*, followed by an explanation of how to cut up the news; the next example extends the process by further eliminating the Author's words, calling into question the efficacy of any Authorial proclamations: "If fragments of newspapers be the 'poorest' material for cut-ups, the treasures of world literature as rendered into English are, presumably, the 'richest'" (Burroughs and Gysin 1978: 89).

Accordingly, other critics are now intermingled into the cut: "As you cut and fold in the texts of other writers, they become inextricably mixed with yours. So, who owns words?" (91). One of Samuel Beckett's translators, Patrick Bowles (mimicking Beckett's own complaint against cut-ups: "'That's not writing,' Beckett snorted, 'it's plumbing'" [quoted in Morgan 1990: 323]) accuses Burroughs of a type of word rustling to which the text replies: "I prefer not to use my own words. I don't like my own words because my own words are prerecorded *on my bare honestie and being dead do stick and stinke in repetition* . . . From *The Unfortunate Traveler*" (Burroughs and Gysin 1978: 91–92). Burroughs refuses to finish with his own words, since "his own" explanations, allowed to play out across the standard Aristotelian-logical line, contradict the collaborative assumptions of the process and thwart the anti-Authorial message of the project.

This type of literary interruption permeates *The Third Mind*. In the section "Fold-Ins" (a method by which one text is placed over another), the text discusses the method of forming a "composite" of writers, living and dead, in response to the events of the John Calder–organized 1962 adjunct to the annual Edinburgh festival of the arts; by the end of the three-day event, Burroughs had moved from relative obscurity to become a "luminary" (Morgan 1990: 341). The resulting mix ("Notes on These Pages," Burroughs and Gysin 1978: 97–101) includes texts Burroughs read at the conference, newspaper articles about the conference, and work from many writers: "Shakespeare, Samuel Beckett, T. S. Eliot, F. Scott Fitzgerald, William Golding, Alexander Trocchi, Norman Mailer, Colin MacInnes, Hugh MacDiarmid" (97). The results include: "in the tarnished mirror dead eyes of an old dream and dreamer gone at dawn shirt . . . take his way toward the sea breath of the trade winds on his face open shirt flapping . . . cool path from ruined suburbs . . . stale memories . . . excrement mixed with flowers" (100).

Since a portion of this prose is composed of Burroughs's own confer-ence statements, this composite work opposes the idea of a single Author. If we are to believe the writerly initial "W.S.B." that signs "Fold-Ins," this demonstration becomes a method of folding individual Authorship—where the writer "creates" his own new work (inspired by his cultural con-sumption) only to then find that work *materially* diluted by the writing of others into *composite* results. As Shakespeare, by today's vague standards, is both a "genius" and a "plagiarist," will readers four hundred years hence see Burroughs the same way (accepting the difference in popularity)?

We return to the question of the law. Shakespeare wrote before statu-tory copyright, and his works (and those he borrowed from) remain in the public domain (with the exception of copyrights claimed on edited versions). Burroughs produced in the twentieth century and is thus covered by the Author-centered copyright regime. Significantly, the composite publication of *Minutes to Go* reads "*Copyright* Jean Franchette, 1960," while *The Third Mind* reads "Copyright © William S. Burroughs and Brion Gysin, 1978."[18] Burroughs's question ("So, who owns words?") thus becomes even more prescient as he develops ambivalence toward an ego-driven doctrine of the cut-up: who, *if not Burroughs*, owns these words that are copyrighted to him and his publisher? A better question might be: to whom will the ownership of these words be assigned if we believe in the cut-up project? We discover not only the failure of the first cut-ups to sit quietly in their "original" form during transfer, but also the inability of Burroughs to eliminate his Authorship from the trade con-ventions of book publishing. Already famous to some degree at the 1962 Writer's Conference, by 1978 (when *The Third Mind* appeared in English), Burroughs could no longer even pretend to anonymity. Thus, the prob-lem of the cut-ups is always the problem of the authority vested into the figure of the Author. No matter what Burroughs's random experiments "say" or "predict," everything remotely freeing in his method becomes to some extent countermanded by the © symbol.

Between the cut-up articulation of collaborative authorship and the very real restrictions of the legal copyright regime, a third possibility arises (as with the "third mind"). Between these two poles, the cut-ups model not the *elimination* of the Author sublimated to the text, but a programmatic *expansion* of the Author to encompass all words. If copy-right does not so much discourage collaborative production as *encourage* a certain idea of singular Authorship within an economic matrix, then to

simply produce collaboratively will never fundamentally alter a system capable of accounting for the many under the sign of the one. Rather, as many other copyright scholars have argued, the idea of singular literary property must be reconceived. By his often stated goal of spreading ownership of words to everyone, and thus wielding final power over precisely *no words*, Burroughs sketches a critique of copyright that hits the wall of his own literary personality. Any tentative success hinges on the reader's willingness to become an "ally," to proceed through the difficult cut-up text.

We might then propose that to actually read any extensive cut-up material—whether in Burroughs or Gysin, or Ted Berrigan or Harold Nourse or Kathy Acker or Carl Weissner—inculcates the reader into the *project of plagiarism*. Morgan cites Paul Bowles's negative judgment on the cut-ups: "You could read it, you could force yourself to go from word to word, but you came out at the other end no happier or wiser" (1990: 322). This is the sentiment of Bowles the serious writer, far from a straight realist, but still a writer whose dissatisfaction can be seen as based on more than mere fatigue. The key words are "happier" and "wiser"; Burroughs's project shows little interest in either term, for one may be perfectly content after a lobotomy.

Who Is the Third That Walks beside You?

We are told, in these texts, that something beyond the work of an autonomous writer is in operation, and if we buy this premise, even for a moment, if we find ourselves stopping at random lines spread across two columns, then we are perhaps willing victims to the way cut-ups manipulate the supposed profundity of traditional prose. A perfectly profound epiphany-producing phrase is one thing at the end of a story in James Joyce's *Dubliners*, but how are we to feel when the same effect is produced, apparently at random? Burroughs comments, repeatedly, on how the texts were made, and we are thus never in the position of the unsuspecting dupe. To read these words, not Burroughs's but everyone's— despite any contradictory statements of the text or the law behind the copyright notices—means that we are consuming *adulterated* text. Even reading the brief examples in this chapter, we are perhaps thieves, if not full-blown copyright infringers.

This brings us back to the initial comparison with *The Grey Album*. In

the deliberate infringement of previously copyrighted works, Burroughs/ Gysin and Danger Mouse actualize a complex assault on ownership standards that moves beyond their own intentions. The Grey Tuesday protestors argue for a fair use defense, with Downhill Battle co-founders Nicholas Reville and Holmes Wilson noting they have "a fair-use right to post this music under current copyright law and the public has a fair-use right to hear it" (quoted in Nebulose.net 2005). Downhill Battle argues that the "user," by "using," also exercises "fair use"—becoming a collaborator in the process of production as she willfully ignores the quasi-legal warnings.

Both *The Third Mind* and *The Grey Album* assume new political meanings beyond the control of their "originators." We know that theft has occurred; it is not hidden—but the exact circumstances of production, as in the typographical shifts of *The Third Mind* are kept at a tantalizing distance. Danger Mouse claims to have known all along that *The Grey Album* would never see commercial release, effectively casting himself as a respect-paying artist who never meant for his work to be "used" in Grey Tuesday. He tells the *New Yorker*: "That's one of the things I struggled with. I told myself, 'Never will this come out. . . . Must still do . . . must still do,'" adding that note of respect for the "originals" worthy of a centoist: "I'm just worried whether Jay-Z will like it" (Greenman 2004).

In both cases, this elision of a singular Authorial persona is confused by contradictions from the "makers," uncertainties from the texts, and complications from the marketplace. The collaborative ethic behind the cut-ups and *The Grey Album* move beyond mere articulation of a radical anti-Authorial position toward an active conscription of the *audience*— complicit in the success of the "illegal" endeavor. Both projects hinge on the reader, not as a replacement for the "maker" the "Author" or the "Artist" aligned with traditional notions of cultural production, but as an absent collaborator no less important for her ability to be manipulated and cut up in the process as that of the "source texts" themselves. Here, the source texts resonate beyond the position of mere raw material, becoming, with the audience, integral and constitutive of the material processes of transfer. If peer-to-peer protocols and electronic plagiarism continue to force the consumer into apparently untoward positions, it is possible that entrenched notions of intellectual property may yet be revised in the wake of our ecstatic, participatory contortions.

Notes

An alternate version of this essay previously appeared in *Plagiary: Cross-Disciplinary Studies in Plagiarism, Fabrication, and Falsification* (online), 1.13 (2006): 1–18, and *Plagiary 2006* (print), 1 (2006): 191–206.

1. "The Flying Saucer" cuts samples from popular songs between a faux-pretentious newscast meant to satirize Orson Welles's *War of the Worlds* mock radio broadcast. Oswald's *Plexure* is a complex twenty-minute audio collage of "1,001 electroquoted contemporary pop stars" including "Percy Faithful," "Joni Cocker," "Superloaf," and "Jon Bon Elton" (http://plunderphonics.com). The current mashup craze has produced a number of recognized "hits" beyond sub-rosa web experimentation, including 2001's "A Stroke of Genie-us" by Freelance Hellraiser, a combination of Christina Aguilera's "Genie in a Bottle" vocal and guitar background from The Strokes. A useful summary of the practice, aside from Howard-Spink's essay, can be found in the "Bastard Pop" entry at http://wikipedia.org—itself a collectively produced information locus.

2. Litigation (and threats of) has become the de rigueur response from corporate entities that find their "property" appearing, in any form, as an element in a generally critical artwork. While this litigious strategy creates a chilling effect for small producers without recourse to legal support, a notable instance of this strategy's failure is the case of artist Tom Forsythe's "Food Chain Barbie" series. His photos introduced the impossibly proportioned doll into the domestic situations associated with her homemaker image. Forsythe notes: "I use things like Barbie enchiladas, I have a fondue Barbie where I have the Barbie heads skewered on fondue forks inside the boiling fondue pot. I've got Barbies in blenders, stir-fry Barbie, and use your imagination from there" (Johnston 2001). Sued in 1999 by Mattel for the series, Forsythe was fortunate enough to find pro bono legal representation in the American Civil Liberties Union. The Supreme Court dismissed the case against Forsythe in 2003, and in 2004, Mattel was ordered by a lower court to pay all legal fees and expenses. Find out more at http://tomforsythe.com.

3. This does not mean that *The Grey Album* escapes its brand as "illegal art," for a number of other rights owners are involved, including Sony/ATV—the Michael Jackson corporate partnership that owns the publishing rights to The Beatles' catalog; the entity attempted to shut down the Stay Free organization's *Illegal Art* Web site for hosting the *Grey Album* tracks through an attack on their Internet service provider (ISP) (under a Digital Millennium Copyright Act provision). The group switched to a new ISP, the Online Policy Group, committed to protecting free speech. Details can be found at http://www.illegal-art.org/audio/grey.html. The *Illegal Art* site is supported by Carrie McLaren's excellent

Stay Free magazine, with additional help from the Online Policy Group, an ISP devoted to freedom of expression, and the Prelinger Archives (recently acquired by the Library of Congress).

4. "Pastiche" here is used in its secondary definition as a descriptive phrase for work composed of elements from previous works. The primary literary definition of pastiche as imitation becomes relevant in discussion of a work such as *The Grey Album* and, later in this chapter, the Victorian "cento" form, in that the act of imitation becomes constituent of the act of borrowing. The goal of these works is not to simply connote an earlier artwork (if one were to write in the style of a past author), but to transport the older artwork into a new form that deliberately and often explicitly makes use of previously produced material. Pastiche, in this form, includes the imitative quality that emerges as the function of the direct use of previous works, and serves to describe qualities of a work that may include "plagiarism" or "copyright infringement," but not necessarily both (see note 13).

5. The "maker" of *The Grey Album*, Danger Mouse (a.k.a Brian Burton), neither sought nor obtained permissions for his work, defiantly noting: "As far as art is concerned, I've never really worried myself too much with what's legal" (quoted in Eric Steuer 2004: 196). This comment may be read as willing naiveté about the market—all part of the act—and Danger Mouse was predictably accused of engaging in a publicity stunt. One Internet poster, "Lucifervandross," echoed EMI's larger concerns: "I never steal music from the net—that is just tacky! . . . if you were an artist and someone was giving out cheap replicas of your work, wouldn't sit too well in your stomach . . . ?" [*sic*] (http://waxy.org). Such posts demonstrate the pervasive hold that traditional notions of "originality" still impress upon the consumer, even when their cyberspace actions increasingly transcend such limitations.

6. The analog is the matched "beats per second" of contemporary DJ culture—where the initial recording paradigm of capturing performance in the studio (toward attaining aesthetic "singularity") gives way to the ubiquity of the "mix." Part of this ethos can be traced again to Burroughs's early work with text, tape recorder, and video cut-ups. Robert A. Sobieszek notes that Burroughs's film and recorder projects "startlingly anticipate MTV rock videos of the 1980s and 1990s as well as the devices of 'scratching' and 'sampling' in punk, industrial, and rap music of the same decades" (1996: 20–21). In his book/CD *Rhythm Science*, Paul Miller, a.k.a. DJ Spooky That Subliminal Kid (who takes his name from a Burroughs character), elaborates on the DJ philosophy that grows from the omnipresent cultural fusion (linked, perhaps, to the postmodern turn): "Think of [Rhythm Science] as a mirror held up to a culture that has learned to fly again, that has released itself from the constraints of the ground to drift through dataspace, continuously morphing its form in response to diverse streams of infor-

mation. Sound is a product of many different editing environments, an end result of an interface architecture that twists and turns in sequences overlaid with slogans, statistics, labels, and grids" (2004: 5).

7. Danger Mouse has gone from this initial underground project to considerable acclaim as a producer, working with such acts as Gorillaz and forming one-half of hip-hop/soul duo Gnarls Barkley.

8. The emergence of new recording and distribution capabilities is a subject of great interest to modern thinkers, particularly Benjamin, in his essay "The Work of Art in the Age of Mechanical Reproduction." Consider also Herman Hesse's depiction, in *Steppenwolf*, of Harry Haller's displeasure at hearing recorded music. Also, for this discussion in terms of Burroughs, see "Burroughs's Writing Machines" by Anthony Enns (2004).

9. Globalization activist Roberto Verzola, in his article "Cyberlords: The Rentier Class of the Information Sector" (1998) makes a similar link, yoking demands for a fully democratized intellectual property regime (compulsory licensing of protected materials, nonpatenting of life forms, expansion of fair use, etc.) to "the demands of other change-oriented classes and groups in the ecology and industrial sectors, such as farmers, fisherfolk, workers, women and indigenous peoples." He hopes this will lead to a "rethinking of property concepts that . . . will then reinforce demands for restructuring the industrial and agriculture sectors as well."

10. From Tristan Tzara's *Dada Manifesto on Feeble Love and Bitter Love*: "To make a dadaist poem. Take a newspaper. Take a pair of scissors. Choose an article as long as you are planning to make your poem. Cut out the article. Then cut out each of the words that make up this article and put them in a bag. Shake it gently" (quoted in Miles 2000: 196).

11. It should be noted that plagiarism and copyright infringement are not necessarily the same. The "plagiarizer" generally presents the work of others (often uncited) as her own, and may, when using protected source materials, commit infringement. Conversely, the infringer might use protected materials with full disclosure to the reader, and so in no way commit plagiarism. Yet by calling Burroughs a "plagiarist" and a "copyright infringer" we are forced to reckon with, as Morris Freedman notes, the fact that the academic community has "never in practical terms rigorously formulated the boundaries . . . of either originality or its violations. This has allowed them to make originality, plagiarism, and even fraud infinitely inelastic terms" (1994). Also, while much of *The Third Mind* does provide some scant indication of source texts, Burroughs is nonspecific in his attributions, and in many other cut-up instances, does not attribute sources (making him, explicitly, a plagiarist).

12. I am deliberately conflating two notions of collaboration: the first is between more than one author (Burroughs and Gysin, et al.), and the second is be-

tween at least one author and the texts of other writers. Burroughs critic Oliver Harris notes the importance of this conflation for Burroughs, citing Kenneth Koch's essay for *Locus Solus II* (1961) (to which Burroughs contributed), where texts were not only "made by 'two or more poets actually together while they wrote' but also 'composed by poets working with already existing texts'" (Harris 2009).

13. In "Introductions," from *The Third Mind*, in the first text—apparently not reprinted from a previous source—the "officer" character addresses two cadets: "No two minds ever come together without, thereby, creating a third, invisible, intangible force which may be likened to a *third mind*" (1978: 25). This term is drawn from *Think and Grow Rich* (1966) by Napoleon Hill, a proto–self-help book containing a secret that is repeated many times but never stated directly.

14. Corso later broke off, appending an infamous "postscript" to that text ("poetry that can be destroyed should be destroyed, even if it means destroying one's own poetry" [1960: 63]).

15. The significance of this difference cannot be understated, particularly as the misspelling of "adition" in *Minutes to Go* is "corrected" in *The Third Mind* to "edition." A definite editorial mechanism is in operation.

16. In *Minutes to Go*, the two Burroughs/Corso collaborative pieces, "Everywhere March Your Head"" and "Sons of Your In," assume a different mode: "Words by Rimbaud, arrangement by Burroughs & Corso" ("Everywhere") and "Words Rimbaud, arrangement Corso & Burroughs" ("Sons"). Perhaps Corso's dedication to traditional notions of Authorship influenced these arrangements, where the two names seem to jockey for position, or represent a pre-arrangement.

17. The cut-ups initially assumed a sort of Benjaminian "aura" by virtue of their position as *discovery*: Gysin was often attributed as contemporary "discoverer" by Burroughs, yet Gysin never hesitated to position Burroughs at the fore: "I realised right away that the cut-ups would never serve or suit anyone quite like they fitted William and served him" (Wilson and Gysin 2001: 163). Both men, perhaps out of professional respect, preferred to maintain the myth of single "mastery" even within their communal pronouncements. Harris's note on the method's legacy follows the same Author-centered logic: "*Everyone* who took up the practice faded away—except Burroughs" (2004: 188).

18. Two different books, yes, but the latter contains a not insignificant amount of material from the former. We can imagine that Burroughs and Gysin had no problem securing their own work for republication, or that they retained the copyright on the individual pieces while the publisher, Jean Franchette, held the compilation copyright for *Minutes to Go*.

How Copyright Law Changed Hip-Hop

An Interview with Public Enemy's Chuck D and Hank Shocklee

When Public Enemy released *It Takes a Nation of Millions to Hold Us Back*, in 1988, it was as if the album had landed from another planet. Nothing sounded like it at the time. *It Takes a Nation* came frontloaded with sirens, squeals, and squawks that augmented the chaotic, collaged backing tracks over which P.E. frontman Chuck D laid his politically and poetically radical rhymes. He rapped about white supremacy, capitalism, the music industry, black nationalism, and—in the case of "Caught, Can I Get a Witness?"—digital sampling: "Caught, now in court 'cause I stole a beat / This is a sampling sport / Mail from the courts and jail / Claims I stole the beats that I rail . . . I found this mineral that I call a beat / I paid zero."

In the mid- to late 1980s, hip-hop artists had a very small window of opportunity to run wild with the newly emerging sampling technologies before the record labels and lawyers started paying attention. No one took advantage of these technologies more effectively than Public Enemy, who put hundreds of sampled aural fragments into *It Takes a Nation* and stirred them up to create a new, radical sound that changed the way we hear music. But by 1991, no one paid zero for the records they sampled without getting sued. They had to pay a lot.

Stay Free! talked to the two major architects of P.E.'s sound, Chuck D and Hank Shocklee, about hip-hop, sampling, and how copyright law altered the way P.E. and other hip-hop artists made their music.

The following is a combination of two interviews that Kembrew McLeod conducted separately with Chuck D and Hank Shocklee.

Kembrew: What are the origins of sampling in hip-hop?

Chuck D: Sampling basically comes from the fact that rap music is not music. It's rap over music. So vocals were used over records in the very beginning stages of hip-hop in the '70s to the early '80s. In the late 1980s, rappers were recording over live bands who were basically emulating the sounds off of the records. Eventually, you had synthesizers and samplers, which would take sounds that would then get arranged or looped, so rappers can still do their thing over it. The arrangement of sounds taken from recordings came around 1984 to 1989.

Kembrew: Those synthesizers and samplers were expensive back then, especially in 1984. How did hip-hop artists get them if they didn't have a lot of money?

Chuck D: Not only were they expensive, but they were limited in what they could do — they could only sample two seconds at a time. But people were able to get a hold of equipment by renting time out in studios.

Kembrew: How did the Bomb Squad [Public Enemy's production team, led by Shocklee] use samplers and other recording technologies to put together the tracks on *It Takes a Nation of Millions*?

Hank Shocklee: The first thing we would do is the beat, the skeleton of the track. The beat would actually have bits and pieces of samples already in it, but it would only be rhythm sections. Chuck would start writing and trying different ideas to see what worked. Once he got an idea, we would look at it and see where the track was going. Then we would just start adding on whatever it needed, depending on the lyrics. I kind of architected the whole idea. The sound has a look to me, and Public Enemy was all about having a sound that had its own distinct vision. We didn't want to use anything we considered traditional R&B stuff — bass lines and melodies and chord structures and things of that nature.

Kembrew: How did you use samplers as instruments?

Chuck D: We thought sampling was just another way of arranging sounds. Just like a musician would take the sounds off of an instrument and arrange them their own particular way. So we thought we was quite crafty with it.

Shocklee: "Don't Believe the Hype," for example—that was basically played with the turntable and transformed and then sampled. Some of the manipulation we was doing was more on the turntable, live end of it.

Kembrew: When you were sampling from many different sources during the making of *It Takes a Nation*, were you at all worried about copyright clearance?

Shocklee: No. Nobody did. At the time, it wasn't even an issue. The only time copyright was an issue was if you actually took the entire rhythm of a song, as in looping, which a lot of people are doing today. You're going to take a track, loop the entire thing, and then that becomes the basic track for the song. They just paperclip a backbeat to it. But we were taking a horn hit here, a guitar riff there, we might take a little speech, a kicking snare from somewhere else. It was all bits and pieces.

Kembrew: Did you have to license the samples in *It Takes a Nation of Millions* before it was released?

Shocklee: No, it was cleared afterward. A lot of stuff was cleared afterward. Back in the day, things was different. The copyright laws didn't really extend into sampling until the hip-hop artists started getting sued. As a matter of fact, copyright didn't start catching up with us until *Fear of a Black Planet* [1990]. That's when the copyrights and everything started becoming stricter because you had a lot of groups doing it and people were taking whole songs. It got so widespread that the record companies started policing the releases before they got out.

Kembrew: With its hundreds of samples, is it possible to make a record like *It Takes a Nation of Millions* today? Would it be possible to clear every sample?

Shocklee: It wouldn't be impossible. It would just be very, very costly. The first thing that was starting to happen by the late 1980s was that the people were doing buyouts. You could have a buyout—meaning you could purchase the rights to sample a sound—for around $1,500. Then it started creeping up to $3,000, $3,500, $5,000, $7,500. Then they threw in this thing called rollover rates. If your rollover rate is every 100,000 units, then for every 100,000 units you sell, you have to pay an additional $7,500. A record that sells two million copies would kick that cost

up twenty times. Now you're looking at one song costing you more than half of what you would make on your album.

Chuck D: Corporations found that hip-hop music was viable. It sold albums, which was the bread and butter of corporations. Since the corporations owned all the sounds, their lawyers began to search out people who illegally infringed upon their records. All the rap artists were on the big six record companies, so you might have some lawyers from Sony looking at some lawyers from BMG and some lawyers from BMG saying, "Your artist is doing this," so it was a tit for tat that usually made money for the lawyers, garnering money for the company. Very little went to the original artist or the publishing company.

Shocklee: By 1990, all the publishers and their lawyers started making moves. One big one was Bridgeport, the publishing house that owns all the George Clinton stuff. Once all the little guys started realizing you can get paid from rappers if they use your sample, it prompted the record companies to start investigating because now the people that they publish are getting paid.

Kembrew: There's a noticeable difference in Public Enemy's sound between 1988 and 1991. Did this have to do with the lawsuits and enforcement of copyright laws at the turn of the decade?

Chuck D: Public Enemy's music was affected more than anybody's because we were taking thousands of sounds. If you separated the sounds, they wouldn't have been anything—they were unrecognizable. The sounds were all collaged together to make a sonic wall. Public Enemy was affected because it is too expensive to defend against a claim. So we had to change our whole style, the style of *It Takes a Nation* and *Fear of a Black Planet*, by 1991.

Shocklee: We were forced to start using different organic instruments, but you can't really get the right kind of compression that way. A guitar sampled off a record is going to hit differently than a guitar sampled in the studio. The guitar that's sampled off a record is going to have all the compression that they put on the recording, the equalization. It's going to hit the tape harder. It's going to slap at you. Something that's organic is almost going to have a powder effect. It hits more like a pillow than a piece of wood. So those things change your mood, the feeling you can get

off of a record. If you notice that by the early 1990s, the sound has gotten a lot softer.

Chuck D: Copyright laws pretty much led people like Dr. Dre to replay the sounds that were on records, then sample musicians imitating those records. That way you could get by the master clearance, but you still had to pay a publishing note.

Shocklee: See, there's two different copyrights: publishing and master recording. The publishing copyright is of the written music, the song structure. And the master recording is the song as it is played on a particular recording. Sampling violates both of these copyrights. Whereas if I record my own version of someone else's song, I only have to pay the publishing copyright. When you violate the master recording, the money just goes to the record company.

Chuck D: Putting a hundred small fragments into a song meant that you had a hundred different people to answer to. Whereas someone like EPMD might have taken an entire loop and stuck with it, which meant that they only had to pay one artist.

Kembrew: So is that one reason why a lot of popular hip-hop songs today just use one hook, one primary sample, instead of a collage of different sounds?

Chuck D: Exactly. There's only one person to answer to. Dr. Dre changed things when he did *The Chronic* and took something like Leon Haywood's "I Want a Do Something Freaky to You" and revamped it in his own way but basically kept the rhythm and instrumental hook intact. It's easier to sample a groove than it is to create a whole new collage. That entire collage element is out the window.

Shocklee: We're not really privy to all the laws and everything that the record company creates within the company. From our standpoint, it was looking like the record company was spying on us, so to speak.

Chuck D: The lawyers didn't seem to differentiate between the craftiness of it and what was blatantly taken.

Kembrew: Switching from the past to the present, on the new Public Enemy album, *Revolverlution* [2002], you had fans remix a few old Public Enemy tracks. How did you get this idea?

Chuck D: We have a powerful online community through Rapstation .com, PublicEnemy.com, Slamjamz.com, and Bringthenoise.com. My thing was just looking at the community and being able to say, "Can we actually make them involved in the creative process?" Why not see if we can connect all these bedroom and basement studios, and the ocean of producers, and expand the Bomb Squad to a worldwide concept?

Kembrew: As you probably know, some music fans are now sampling and mashing together two or more songs and trading the results online. There's one track by Evolution Control Committee that uses a Herb Alpert instrumental as the backing track for your "By the Time I Get to Arizona." It sounds like you're rapping over a Herb Alpert and the Tijuana Brass song. How do you feel about other people remixing your tracks without permission?

Chuck D: I think my feelings are obvious. I think it's great.

Originally published in *Stay Free!* no. 20 (fall 2002), available online at http://www.stayfreemagazine.org.

Hip-Hop Meets the Avant-Garde

A Cease and Desist Letter from Attorneys

Representing Philip Glass

Mr. Len, a hip-hop producer and DJ, was busted for including an unlicensed sample on his solo album, *Pity the Fool*, in 2001 (fortunately, Mr. T didn't go after him for trademark infringement on the title as well). This dispute involved a sample taken from a record by avant-garde composer Philip Glass—titled "F-104: Epilogue from Sun and Steel"—which forced his label, Matador Records, to pull the album from retail shelves. Mr. Len acknowledges that one is supposed to clear all samples on a record; that is standard practice in the recording industry. However, the hip-hop producer says that he has to consider how much the record might sell and how much money he has to pay in licensing fees before deciding whether to clear a sample when releasing a track. In most cases, he is willing to take a chance. "I'm definitely gonna gamble, there's no question about it," he says. "And if the record blows up, then I'd much rather know that I blew a record up through all the hard work than to not take the risk at all."

After getting the cease and desist letter from Glass and his representatives, Mr. Len proudly hung it in a special place in his studio. "I keep the letter on the wall next to where I make beats," he says. "It's my medal that makes me an official hip-hop producer. You're nobody 'til somebody wants to shut you down!"

(*opposite*) **1.** Cease and desist letter from attorneys representing Philip Glass to Mr. Len (via Lyle Hysen).

WARNER
SPECIAL PRODUCTS

3500 West Olive Avenue, Suite 800
Burbank, California 91505
Tel: (818) 953-7900
Fax: (818) 953-7960

Janet Harris
Vice President
Business Affairs

CERTIFIED MAIL
RETURN RECEIPT REQUESTED

April 2, 2002

Mr. Lyle Hysen
Matador Records
625 Broadway, 12th Floor
New York, NY 10012

Re: "F-104: Epilogue from Sun and Steel" (the "Sample")
 embodied in "Taco Day" (the "Master" included in
 "Pity the Fool" (the "Album")

Dear Mr. Hysen:

It has recently come to our attention that "Taco Day" by Jean
Grae contains a sample of "F-104: Epilogue from Sun and Steel"
by Philip Glass. We understand that notwithstanding your failure
to clear the Sample with us and to enter into an agreement with
us regarding the use of the Sample in the Master, an Album
embodying the Master has been released. As such release is
without authorization from Warner Special Products, agent for
Nonesuch Records, it is a willful infringement of our rights.

Accordingly, we demand that Matador Records immediately:

 1. Cease distributing the Album.

 2. Direct all persons or entities to whom copies of the
Album have been distributed to cease distribution and sale of
the Album.

 A Time Warner Company

Getting Snippety

The label that I manage, Illegal Art, specializes in releasing works that rely heavily on sampling pre-existing recordings. Since our inception in 1998, we have held to the philosophy that the music our artists create are new works and, though composed of fragments of other music, are incredibly transformative. The projects we release are distinct enough from the sampled sources that it would be absurd to consider such content a threat to the markets of the originals. The common perception of sampling is that something has been stolen or that an artist has unjustly profited from another's work. Often overlooked, though, are the potential benefits that might be gained from having one's work sampled and recontextualized into a new work. The immediate black-and-white rules of infringement in the 1990s were such that almost all unauthorized sampling was perceived as harmful and therefore had to be litigated without question. Although such attitudes are well entrenched, there are hopeful signs that new attitudes toward appropriation may be emerging.

One of our artists, Girl Talk, has risen significantly in popularity. The cautiousness of the industry persists, though, and prevents such an artist from selling the number of units the market may demand. But while manufacturers and distributors have curtailed the project at various phases, it is interesting that not one artist has issued a complaint about being sampled on Girl Talk's *Night Ripper*. With hundreds of articles and reviews, and inclusion on the "best albums of 2006" lists of *Rolling Stone*, *Spin*, *Blender*, *Pitchfork*, and others, it certainly isn't because of a lack of publicity or knowledge that there is a scarcity of complaints.

In 1998, within days of releasing the *Deconstructing Beck* compilation, we received legal threats from Beck's publisher, label, and personal lawyer. Though the case never went to court, it is interesting to note how

quickly a response came from one artist sampled in 1998 and how differently 150-plus acts have responded in the last year to Girl Talk's *Night Ripper*. Oddly, there has been some communication from the larger music industry, but it has taken a different tone. Recently, several major and independent artists have solicited Girl Talk for remixes. Similarly, multiple major labels have proposed a giant mashup of their back catalogs. But why does everyone stop there? Why does Girl Talk have to create contrived and premanaged mixes, when he has already created a full-length masterpiece unencumbered by the restrictions of preauthorization? While I love the authorized remixes, Girl Talk's genius and most thrilling work often rests on combining sources that traditionally would not be mixed. As artists and labels recognize the benefits of allowing "official" Girl Talk mixes of their material, could the benefits not also be realized of allowing such albums as *Night Ripper* to reach full market potential?

Going back to 1983, Double Dee and Steinski entered a remix contest held by Tommy Boy Records. Their entry unanimously won with a mix that used a wide variety of samples from other sources. While the track known as "The Payoff Mix" became an underground hit, it was never officially released because of sampling issues. Not only did the artists make nothing from their brilliant work (besides the $100 for winning the contest), the industry also failed to make one cent from music that was instantaneously resonating with urban audiences. What would have happened if the sampled artists/labels had combined efforts and allowed the record to reach its market potential? If reasonable and automatic fees existed for such sampling, most sampling artists would be happy to pay royalties in the same fashion that mechanical licenses exist for covering a song. Simultaneously the sampled and the sampling artists could reach a larger audience, and both would receive compensation for copies sold. In the end, "The Payoff Mix" only reached the bootleg market, and only the bootleggers achieved minimal benefit from this critically acclaimed track.

With the budgets that are regularly allocated to market and create new trends, it seems absurd that when Girl Talk or "The Payoff Mix" achieves popular momentum the industry wouldn't go out of its way to make these types of work legitimate in the market. How often does a new style of music emerge? How can the music industry afford to not promote a type of music that has already proved its mass appeal? If rereleasing works in new formats or in newly remastered editions causes even

a small percentage of fans to repurchase music, how much could authorizing sample-based music increase the ability to resell bits of popular songs? The mechanisms that allow covers have mutual benefits for the performer and the composer, so why not create a similar system for sampling?

Whether or not the music industry ever supports a reasonable sampling license that allows monetary benefits on both sides, it is at least becoming more evident that sampling is far from harmful and actually promotes the artists sampled. Such artists as Girl Talk not only increase the awareness and exposure to the sampled material but also popularize collecting music from a wider range of genres, years, labels, and cultures. It is difficult to see how encouraging such obsessive musical interest could damage the market. The day may come when the only thing worse than being sampled without permission is that no one is sampling your work. With the advent of YouTube, MySpace, and what is being labeled Web 2.0, the trend toward more participatory forms of entertainment is firmly in place. Sampling is definitely an important aspect of that participatory culture, and whether Web 2.0 is embraced as a form of viral marketing or becomes a critical business model, technology is facilitating creative appropriations.

Although Illegal Art has a fair-use legal defense for its releases, we would love to discuss the possibilities of opening up things further with anyone in the larger music industry. Our interests have never been to completely dismantle copyright law, but we operate on the fringes due to the extreme reactions by the entertainment industry to sampling. While we wave the banner of "illegality" to draw attention to the absurdity that our releases would be considered as such, our motives are to promote new forms of music rather than to be criminals. If our aim were merely to do something illegal, our releases could appropriate even more liberally and without significant transformation. We could exploit more fully the underground market for mashups, a genre of sampling that typically juxtaposes a vocal and instrumental track for the length of the song with minimal editing. In contrast, though, considerable transformation has always been central to the aesthetics of the Illegal Art label. Our first compilation, *Deconstructing Beck*, sounds so distant from Beck's music that many would have never known the source material without the conceptual frame in which it was conceived.

While Girl Talk's *Night Ripper* album is sometimes described as a

mashup, it is important to note how exceptional the juxtapositions become. Rather than simply taking two tracks and mixing them together, Girl Talk blends dozens of tracks together into a new song. In a demonstration filmed for a documentary and currently posted on YouTube, Gregg Gillis (aka Girl Talk) demonstrates how he constructs a track out of multiple sources. Toward the end he comments on his sampling of Elvis Costello's "Radio Radio" hit. After showing how he cuts up, rearranges the sample, and mixes it with other elements, he states: "So that pretty much sounds nothing like that original song, and I would say that that's roughly the equivalent of, you know, taking a familiar Beatles melody on your guitar and rearranging the notes and putting a new guitar pedal sound on it and calling it your own song. So obviously this has kind of become its own entity beyond the Elvis Costello song." This is precisely the transformative philosophy of sampling that Illegal Art encourages and seeks to publish.

The catalog of more than twenty releases from Illegal Art reflects this transformative philosophy and illustrates some of the styles of new music emerging from sampling pre-existing recordings. Our biased stance is that this body of music is often more original and inventive than the plethora of derivative genre music that is produced without legal questioning each year. We are in no way suggesting that unimaginative music should be legally curtailed, but rather that transformative sample-based music should be allowed to coexist. Music has always borrowed heavily from its predecessors, and sampling only further extends this tradition that has created a rich and evolving musical culture.

Crashing the Spectacle

A Forgotten History of Digital Sampling, Infringement,

Copyright Liberation, and the End of Recorded Music

Copyright infringement, billboard "alteration," an evil secret society known as the Illuminati, the country music legend Tammy Wynette, the incineration of £1 million in cash, and No Music Day; these odd, interconnected events were engineered by Bill Drummond and Jimmy Cauty, an anarchic British pop duo who used several pseudonyms: The Timelords, The Justified Ancients of Mu Mu, the JAMS, and the KLF. Between 1987 and 1992 they racked up seven U.K. top ten hits, even crossing over to America with the songs "3 A.M. Eternal" and "Justified and Ancient"—the latter of which went to number one in eighteen countries (Simpson 2003: 199). Those super-cheesy singles are the main reason this duo is remembered as a novelty techno-pop act. (The hook "KLF is gonna rock ya!," from "3 A.M. Eternal," is wired directly into the synapses of millions.)

Their brief but ubiquitous popularity obscured a radical and hilariously subversive critique of the culture industry—like a goofy Theodor Adorno whose praxis involved a drum machine. To this end, the KLF practiced an aggressive brand of creative plagiarism—otherwise known as sampling—that predated both Public Enemy's early forays into the copyright debates (on 1988's "Caught, Can I Get a Witness?" Chuck D rapped, "Caught, now in court 'cause I stole a beat / This is a sampling sport") and Negativland's impish copyright activism (which was prompted by a 1991 lawsuit for daring to sample and satirize rock superstars U2). The KLF's debut album, *1987 (What the Fuck Is Going On?)*, made extensive and provocative use of samples from the Monkees, the Beatles, Whitney Hous-

ton, and ABBA—with the album's liner notes claiming that the sounds were liberated "from all copyright restrictions."

In this respect, the KLF were pop music's first "illegal art" ideologues, though they were loath to be pigeonholed as mere copyright criminals. "As far as sampling is concerned," they wrote in one of their many KLF Communications Info Sheets, this one dated January 22, 1988, "I'm sure we will continue doing it and from time to time get into trouble because of it, but it has always been only a part of the process of how we put our records together and not the reason for them existing" (KLF Communications 1998). However, this didn't stop them from also firing off zingers like, "Intellectual property laws were invented by lawyers and not artists" (Butler 2003).

Drummond and Cauty were megastars compared to the relatively obscure sound collage collective Negativland—whose de facto spokesman Mark Hosler has observed, "We've never had a hit single, but we had a hit lawsuit!"—as well as other sonic outlaws like John Oswald, whose *Plunderphonics* (1989) record drew the wrath of Michael Jackson's lawyers. Given the scope of the KLF's fame, it seems strange that those relatively little known collage artists have cast a much longer shadow on the history of sampling, sound collage, and other aural transgressions.

In the process of reconstructing this largely forgotten story, I also uncover another secret history: one that links these Brits to an underground of computer programmers, artists, so-called culture jammers, and other counterculture types who later drew the battle lines in the twenty-first century copyright wars. Although it is true that the KLF are by no means *the* central characters in this copy-fighting narrative, they were the first to widely circulate critiques of copyright, authorship, and ownership to a broad audience. Along the way, they were interpolated into the *spectacle*, as Guy Debord called it, and then they ran for the hills—deleting their own music catalog and eventually calling for an end to all recorded music.

The Illuminati et al. v. the KLF, Hackers, and Tammy Wynette

To be sure, the works of Vicki Bennett, John Oswald, Wobbly, Negativland, The Tape-beatles, and other sonic outlaws are more willfully difficult than Drummond and Cauty's pop music transgressions. Neverthe-

less, the KLF could make an unholy noise, like they did on their 1987 single "Whitney Joins the JAMS," in which they abducted the voice of pop diva Whitney Houston, forcing her to "join" their group. (Fittingly, the word *plagiarism* is derived from the Latin term for "kidnapping"; Rose 1993: 39.) "Oh Whitney, please please *please* join the JAMS," shouts Drummond over a hijacked *Mission: Impossible* theme song, a drum machine, and various other samples—adding, "You saw our reviews, didn't ya?" After more coaxing from Drummond, a snippet of Houston's "I Wanna Dance with Somebody" finally breaks through the cacophonous collage (with a little help from their friend, the sampling machine). Delivering the song's punch line, Drummond exclaims, "Ahhhhh, Whitney Houston joins the JAMS!"

A simulated, sampled collaboration with Whitney Houston is one thing, but one of the strangest musical events the KLF conjured up was their collaboration with country diva Tammy Wynette, who sings on the single "Justified and Ancient." This catchy, puzzling pop confection features Wynette uttering lines like, "They're Justified and Ancient, and they drive an ice cream van," and telling listeners that we are "all bound for Mu Mu Land." (At the time of the collaboration, Wynette told a reporter, "Mu Mu Land looks a lot more interesting than Tennessee, but I wouldn't want to live there"; Webb 2000: 14.)

The Justified Ancients of Mu Mu, one of the KLF's many monikers, were key characters in the fantasy/science fiction/conspiracy cult novel *The Illuminatus! Trilogy*, co-written by Robert Shea and Robert Anton Wilson. It was not just a passing cultural reference. This trilogy helped shape a cryptic cosmology that weaves its way through many of Drummond and Cauty's various pop projects. Embedded in the duo's lyrics are references to epic battles between the Illuminati and the revolutionary order of Mu Mu, among other things (though it is actually spelled "Mummu" in the novel) (Wilson and Shea 1984). Drummond observes, "Both secret societies have had a long history in fact and fiction and in the minds of conspiracy theorists everywhere" (Drummond 2002: 231). In fact, as far back as 1976, Drummond was enlisted by British theater iconoclast Ken Campbell to design and build the set for a twelve-hour theatrical adaptation of the *Illuminatus! Trilogy* (Drummond 2002).

Hackers and budding copyright activists also embraced the trilogy's irreverence throughout the 1980s and 1990s. *Illuminatus!* appealed to those who actively resisted systems—social, technological, legal—that

imposed restrictions on the way we can play with, remix, or "hack" computer code, culture, and even reality. "The Justified Ancients of Mu Mu," Drummond and Cauty write in one of their many KLF Communications press releases, "are an organization (or disorganization) who are at least as old as the Illuminati. They represent the primeval power of Chaos" (Young 1994). (According to Shea and Wilson's *Illuminatus! Trilogy*, the members of Mummu worshiped Eris, the Greek goddess of chaos, whose name translates into Latin as Discordia. More on that shortly.)

As for the Illuminati, a man named Adam Weishaupt founded this radical secret society on May 1, 1776, prompting the government of Upper Bavaria to ban it, along with the troublesome Freemasons. That much has been historically documented, but it quickly becomes more muddled and confusing—depending on how far down the conspiracy theory wormhole one has fallen. According to some, George Washington and the other figureheads of the American Revolution were part of the Illuminati, which was supposedly behind both the American and French Revolutions, not to mention every other major world event since the eighteenth century. Drummond and Cauty cleverly argued that the reason major record labels churned out such bad music was because these big companies are Illuminati fronts (which is one reason the KLF operated their own independent label).

In a Möbius-like twist, *The Illuminatus! Trilogy* stole a large chunk of its mythology from a prank religion named Discordianism, whose congregation also included the KLF. Discordianism was essentially a joke that emerged from the 1960s countercultural underground, and its irreverence had a certain appeal for the nascent hacker movement of the 1970s and 1980s, as well as other budding copyfighters. The late Robert Anton Wilson, coauthor of *Illuminatus!*, was something of a hero to many hackers. There are references to him scattered through many iterations of the Jargon File, a glossary of hacker slang that has been maintained and updated online since 1975. Discordianism inspired another joke religion, the Church of the SubGenius, which had ties to Negativland (SubGenius Church founder Reverend Ivan Stang appeared on the group's masterpiece *Escape from Noise* [1987], for instance). The Jargon File, whose contents were eventually published in a book edited by Eric Raymond titled *The New Hacker's Dictionary*, also contains several references to the Church of the SubGenius, Discordianism, and other related topics (Raymond 1996). Something strange was afoot.

Even though Drummond and Cauty operated on a higher commercial plane than artists like Negativland, they shared many characteristics, including a love of conceptual high jinks—such as what happened after the KLF sampled ABBA's "Dancing Queen" on their first album. After the Swedish group took exception to having their music "liberated," the diabolical duo took a trip to ABBA's homeland at the end of 1987. As one story goes, the KLF burned copies of their own record while standing in front of the group's Polar Music business offices—all while a prostitute dressed as one of the women in ABBA received a fake gold album inscribed "For sales in excess of zero." Cauty explained, "We knew that nobody would see us, we just thought that if it goes to court and it looks like we've done everything we can to put our side of the story, it'd look better for us. It worked in the end cos they decided to drop the damages charge as long as we didn't carry on making the LP" (Smith 1987). Cauty left open the question of why he thought record burnings and a prostitute dressed as an ABBA member would help their cause.

In another provocation, when the legal threats against their 1987 album began flying, the KLF quickly released—almost as if the whole affair was planned from the beginning, which it probably was—an edited version of this copyright-infringing album. The edited version deleted or truncated all offending samples and included instructions for how consumers could recreate the original version by using old records: "If you follow the instructions below you will, after some practice, be able to simulate the sound of our original record. To do this you will need 3 wired-up record decks, a pile of selected discs, one t.v. set and a video machine loaded with a cassette of edited highlights of last week's 'Top of the Pops'" (Frith 1993: 5). Today, with home computers making cheap editing technologies widely available, it is possible to follow their instructions with relative ease; in the 1980s, it was not a feasible option, which only made the joke funnier.

One of their sample-heavy singles from this time—"All You Need Is Love," released under the name the Justified Ancients of Mu Mu—was an overtly political comment on media coverage of the 1980s AIDS epidemic. Much like Public Enemy did on *Fear of a Black Planet* (1990), the KLF mixed together news coverage with samples from popular music to make social statements. In the song, Drummond raps, "With this killer virus who needs war? / Immanentize the eschaton / I said shag shag shag some more," which translates roughly from Discordianism and British

colloquial slang as, "With AIDS, who needs war / bring the Armageddon / fuck fuck fuck some more!" In the case of "All You Need Is Love," they swiped sounds from the Beatles (you can guess which song they sampled), proto-punks the MC5 (known best for their song "Kick Out the Jams," which the KLF sampled several times), and lesser known acts like 1980s dance-pop has-been Samantha Fox. Nominally a hip-hop record—primarily because of the drum machines, samples, and Drummond's thick-accented rhyming—this single is more like a punk version of hip-hop, as Drummond later put it.

Discussing the single in their KLF Communications newsletter, they mentioned their "illegal but effective use of graffiti on billboards and public buildings. This was done in a way where the original meaning of the advert would be totally subverted" (KLF Communications 1990). Drummond and Cauty were referring to the fact that in 1987, they altered highly visible billboards featuring Greater Manchester Police Chief Constable James Anderton, who infamously blamed gays for AIDS. (Anderton was quoted as saying, "I see increasing evidence of people swirling about in a human cesspit of their own making. . . . We must ask why homosexuals freely engage in sodomy and other obnoxious practices, knowing the dangers involved.") The billboard's original slogan read "Halo Halo Halo," over which the KLF wrote "Shag Shag Shag" next to a picture of the chief constable, all of which was used as the cover artwork of their "All You Need Is Love" single (KLF Communications 1990).

Changing public advertisements for critical purposes is one element of what is known as culture jamming—wherein artists and activists attempt to speak back to the spectacle, creating a dialogue where there was only a monologue. The term was coined by Negativland on their record *Over the Edge, Vol. 1: JAMCON '84*, in which the fictional character Crosley Bendix pontificates on this practice: "The studio for the cultural jammer is the world at large. His tools are paid for by others, an art with *real* risk." (Negativland has since tried to disassociate itself from the term, with Hosler telling me, via Groucho Marx, "I don't care to belong to any club that will have me as a member.") During the first Gulf War, the KLF altered a billboard that advertised the *Sunday Times*, which read "THE GULF: the coverage, the analysis, the facts." They replaced the letters *GU* with a *K*.

Assassinating the Author

The KLF were well aware of how technology would change popular music in the late 1980s and beyond: "It's obvious that in a very short space of time the Japanese will have delivered the technology and then brought the price of it down so that you can do the whole thing at home" (Drummond and Cauty 1989: 121). Their prediction came true, and today it is possible for twelve-year-old kids to remix works in ways that the original authors never intended. The KLF attempted to assassinate the author on numerous occasions, both with their music and in their missives to the public. The duo's critique of the myth of the individual "genius" creator was especially evident on the sleeve art for their hit record "Doctorin' the Tardis," released under the name the Timelords. (The Time Lords are a fictional alien race from the BBC science fiction show *Doctor Who*, whose theme song they sampled, along with Gary Glitter's "Rock and Roll [Part Two]" and other British pop culture staples.)

Drummond and Cauty claimed that their automobile—a Ford police car allegedly used in the movie *Superman 3*—talked to them, giving its name as Ford Timelord. "Hi! I'm Ford Timelord. I'm a car, and I made a record," read the liner notes of "Doctorin' the Tardis." "I mixed and matched some tunes we all know and love, got some mates down and made this record. Sounds like a hit to me" (Timelords 1988). The way the KLF approached sampling was already an attack on the idea of originality, but claiming that a machine (a car) created this song took their critique one absurd step further. As Mark Rose argues in his book *Authors and Owners* (1993), the idea of the "original genius" emerged from the early nineteenth-century Romanticist movement, which assumed that a great author can only create something totally new from scratch.

However, the idea that an individual author is *solely* responsible for all aspects of a work is an ideological sleight of hand, a fiction that some contemporary philosophers and literary critics—not to mention the KLF— have tried to exterminate. "When I was nineteen and at art school, I had ambitions to be a great painter," Drummond tells me. "At the age of twenty, fueled with the idealism of youth, I turned my back on this ambition (the fact that I lacked the talent helped me to do my back turning)." He adds, the "idea of making the one-off artwork touched by the hand of 'genius' to be then sold to the highest bidder meant you were no more than a lackey

to the wealthy and ruling classes. I was for the mass produced art—art that could be bought by anybody, used and thrown away when no longer relevant. This was the art that found its form in the seven-inch single, the paperback, the motion picture" (personal communication 2008).

Digital recording technologies, particularly samplers, complicate issues of ownership and authorship, and they also give the "death of the author" a new meaning. This is especially true when we turn our attention to their assaults on the author—such as claiming that their automobile crafted their "Doctorin' the Tardis" with, well, a machine. Discussing this hit single, Drummond stated, "We thought, this is going to be massive, let's go for it, and we went the whole hog. The lowest common denominator in every respect" (Sharkey 1994). Their authorial assassination was also connected to a larger critique of spectacular capitalism, particularly the culture industry. After fast becoming critics' darlings, Drummond and Cauty focused their crosshairs on the British music press, which was repulsed by this crassly commercial song. When released, *Melody Maker* dismissed "Doctorin' the Tardis" as "pure, unadulterated agony" and *Sounds* prophetically stated that it was "a record so noxious that a top ten place can be its only destiny." The song went to number one.

The next year, the KLF self-published seven thousand copies of a satirical book titled *The Manual (How to Have a Number One Hit the Easy Way)*. It is packed with business addresses, phone numbers, and other contact information, as well as ridiculously absurd and obvious instructions, such as the following.

THE RECORDING STUDIO
DON'T BE TEMPTED TO SKIP THIS SECTION ON STUDIOS. IT MUST BE READ OVER LUNCH—BEFORE BOOKING YOUR STUDIO.
The recording studio is the place where you will record your Number One hit single. There are hundreds of recording studios scattered across the country, from the north of Scotland to deepest Cornwall. . . .

CHORUS AND TITLE
The next thing you have got to have is a chorus. The chorus is the bit in the song that you can't help but sing along with. . . . Do not attempt writing chorus lyrics that deal in regret, jealousy, hatred or any other negative emotions. These require a vocal performer of great depth to put it over well. . . .

THE GROOVE
In days gone by it was provided by the bass guitar player, now it is all played by the programmed keyboards. Even if you want it to sound like a real bass guitar, a sampled sound of a bass guitar will be used, then programmed. It's easier than getting some thumb-slapping dickhead in.

And so on . . .

At least one group scored a number one single in several European countries by following the instructions in *The Manual*. As Drummond remembers, two men from Vienna stopped by for a visit in 1988 — chatting up an idea they had for a single that involved hip-hop break beats, lederhosen, yodeling, and ABBA samples. "They wanted Jimmy and me to produce their concept for them," Drummond writes in his memoir, *45* (2002). "We said, 'We don't need to, you can do it yourself,' handed them a copy of *The Manual* and sent them packing back to Austria." Within the year, "Bring Me Edelweiss" by Edelweiss became a number one hit in several European countries, even going top five in the United States. Drummond adds, "It was as bad a record as (or an even greater record) than our Timelords one, with the added bonus of a truly international appeal" (Drummond 2002: 191–92).

Flaming Out

It all came to a crashing halt in 1992, the year after they had become the biggest selling act in the world. When the KLF were voted Best British Group at the Brit Awards in 1992, the premiere U.K. music industry awards ceremony, they bit the hand that fed them. Hard. During the awards ceremony, the duo performed an ear-bleeding rendition of "3 A.M. Eternal" with the grindcore metal group Extreme Noise Terror (an accurately descriptive band name, I might add). As they pummeled the audience with deafening decibels and distortion, Drummond fired on the audience with a machine gun filled with blanks. "The KLF have now left the music industry," went the post-performance intercom announcement, echoing the famous exit line used at the end of Elvis performances.

Later that night — in an admittedly tasteless (or downright repulsive) move — Drummond and Cauty dumped the carcass of a sheep on the red-carpeted entrance of the awards show afterparty, accompanied

by eight gallons of blood. Around the carcass's neck was a sign: "I DIED FOR YOU — BON APPETIT." (Drummond seriously considered chopping off his own hand and throwing it into the audience during their performance, though he never went through with it.) Scott Piering, a record promoter who worked with the duo, explained that the machine-guns-and-dead-sheep incident was an attempt to torpedo their runaway success. "They really wanted to cleanse themselves and be ostracized by the music industry" (Shaw 1992).

After trying to subvert pop from the inside, they realized that it was a pointless, impossible task. "We have been following a wild and wounded, glum and glorious, shit but shining path these past five years," they wrote in a KLF Communications Info Sheet dated May 14, 1992. "The last two of which has led us up onto the commercial high ground — we are at a point where the path is about to take a sharp turn from these sunny uplands down into a netherworld of we know not what" (*New Musical Express* 1992: 3). After the awards show, the KLF deleted their entire music catalog — a feat made possible by the fact that, in the do-it-yourself spirit of punk, they owned their own independent record label. "When we stopped doing The KLF and deleted the whole catalogue, it was not to create scarcity value," Drummond tells me. "It was so that it could be over and done with, gone, forgotten — thus giving us a space to get on with whatever we would be doing next. I do not like things hanging around" (personal communication 2008).

Drummond and Cauty both had a genuine love of pop music, which was equally matched by a contempt for the music industry; regardless, they never got caught up in the starry-eyed rhetoric of infiltrating the system and bringing it down from the inside. "I never believed in that," Drummond told the British experimental music magazine *The Wire*. "All that happens is that oneself gets corrupted. . . . We're all weak, really, so we can all be seduced and we can hate ourselves for it" (Watson 1997). Their only choice was negation and implosion.

After the KLF's demise, they morphed into the K Foundation, directing obscene hand gestures at the professional art world. The year after the Brit Awards, they targeted the Turner Prize, the prestigious honor bestowed upon hip-but-establishment-approved young artists. In 1993, the K Foundation awarded the title of "Worst Artist of the Year," along with £40,000 in prize money, to that year's winner of the Turner Prize, Rachel Whiteread. The K Foundation Award was announced in a television com-

mercial aired during Channel 4's live coverage of the Turner Prize, and it was quite an event. While people gathered at the Tate Gallery, which co-ordinates the Turner Prize, the K Foundation transported (in a fleet of gold and black limousines) roughly twenty-five critics and other influential members of the art community to a nearby field.

Not surprisingly, the winner/loser refused to accept the K Foundation award, even though it doubled the Turner Prize's £20,000 stipend. Drummond and Cauty came within minutes of igniting £40,000, but before they lit the match, Whiteread reluctantly accepted the award, claiming that she would distribute the sum to needy artists. Part of their motivation in targeting the art world was to shoot holes in the often absurd ways it creates value through a combination of manufactured prestige and planned scarcity. "I still hate the cynically created limited edition, the one off, the . . . you know what I mean," Drummond tells me. "I have never been a collector. Never wanted to amass the complete works of anyone. But I know that I have been guilty of creating things that have ended up being collectible items. As for limited editions, I have been guilty of producing things have often ended up being limited because I cannot be bothered printing or pressing up any more."

Taking Neil Young's advice that it is better to burn out than it is to rust—quite literally, in fact—Drummond and Cauty torched the remaining money they earned as pop stars (in doing so, they were reportedly responsible for the largest cash withdrawal in U.K. history). In 1994, the two flew to a remote Scottish island accompanied by journalist Jim Reid and their roadie Gimpo, who filmed the blaze. In an article for the *Observer*, Reid soberly explained, "The £1 million was burnt without ceremony in an abandoned boathouse on the Isle of Jura, in the Inner Hebrides, between 12.45am and 2.45am on Tuesday, 23 August. It was a cold night, windy and rainy. The money, practically all the former chart-topping duo had left in their account, made a good fire." Describing what it is like to watch £1 million burn, Reid wrote, "I could tell you that you watch it at first with great guilt and then, after perhaps 10 minutes, boredom. And when the fire has gone out, you just feel cold" (Reid 1994: 28).

Reid's observation was also a crisp, illuminating comment on the nature of the pop music spectacle—not to mention consumer culture more generally.

No Music Day

Next on Drummond's hit list: the entirety of recorded music. In the first decade of the new millennium, he produced a series of broadsides that used a simple but bold black, white, and red design scheme—which he posted in public spaces and on the Internet.

ALL RECORDED MUSIC HAS RUN ITS COURSE.
IT HAS BEEN CONSUMED, TRADED, DOWNLOADED, UNDER-
STOOD, HEARD BEFORE, SAMPLED, LEARNED, REVIVED, JUDGED
AND FOUND WANTING.
DISPENSE WITH ALL PREVIOUS FORMS OF MUSIC AND MUSIC-
MAKING AND START AGAIN.
YEAR ZERO NOW. (Drummond 2008: 3)

In many ways, this statement was the crystallized climax (or anti-climax) of Drummond's "career" in the music industry. He recalls that "when Napster first hit the World Wide Web I thought it was the best thing that had happened in the music business for the last 110 years" (2008: 13). With the advent of file-sharing networks, anyone with a computer and Internet connection could listen to virtually anything in the history of recorded music—with just a click of the mouse. He saw this as a fantastic turn of events, great for people who love music, great for music itself. But despite Drummond's delight in seeing the century-old music business crumble due to changing technologies and its own unchecked greed, music's newfound accessibility left him with an empty feeling.

The same is true of Drummond's feelings about sampling, whose shock-of-the-new provocations eventually morphed into another respectable way of making music (especially after the rise of the contemporary copyright licensing regime that legitimated sampling, legally). "Jimmy and I used the 'Mind the gap' voice from the London Underground on our first LP together back in '87," Drummond remembers, discussing their desire to appropriate from the everyday soundscapes that surrounded them. "But these days, every last sound that the world has on offer has been sampled up and used on a record somewhere" (2002: 235). When it became possible for most anyone to access and repurpose pre-existing sounds, the magic and mystery faded from the act of collage—especially after everything from James Brown breakbeats, Bollywood soundtracks, and cooing babies have been sampled in top ten hits.

The paradigm-shifting tremors generated by sampling had long since subsided, and it is now little more than a pastiche-laden technique used to resell old hits in new packaging.

"Recorded music was great, but it is over," Drummond says. "Music has so much more to offer than something to block out reality of our bus ride to work or the pain of jogging in the park." He maintains that the promiscuous availability of music has fundamentally changed our relationship with music, especially because accessing the history of recorded music is as easy as turning on a tap. This has resulted in a perpetual, monotonous background hum that has the effect of canceling out the *experience* of taking in music. "After years of believing in the democratisation of cheap massed produced art," Drummond tells me, "I have come to—or at least since I got myself an iPod—the opinion that it no longer works" (personal communication 2008).

Enter No Music Day, a holiday of sorts established in 2005 by Drummond, which he refers to as "an aspiration, an idea, an impossible dream, a nightmare" (2008: 252). He chose to observe it on November 21 because it immediately precedes St. Cecilia's Day, the patron saint of music. In one of his posters, Drummond pronounced, in part:

ON NO MUSIC DAY:
NO HYMNS WILL BE SUNG.
NO RECORDS WILL BE PLAYED ON THE RADIO.
IPODS WILL BE LEFT AT HOME.
ROCK BANDS WILL NOT ROCK . . .
MCS WILL NOT PASS THE MIC.
BRASS BANDS PRACTICE WILL BE POSTPONED . . .
RECORD SHOPS WILL BE CLOSED ALL DAY.
AND YOU WILL NOT TAKE PART IN ANY SORT OF MUSIC MAKING
OR LISTENING WHATSOEVER.
NO MUSIC DAY EXISTS FOR VARIOUS REASONS, YOU MAY HAVE
ONE. (Drummond 2008: 245)

Such statements could have been overlooked as the raving lunacy of an ex–pop star, but it struck a chord, so to speak. In 2007, the BBC embraced the idea, and Radio Scotland avoided playing music for a full twenty-four hours that November 21. The regular music used in *Good Morning Scotland*, for instance, was replaced by other sounds, and BBC News reported that other programs that typically featured music were substituted with

"discussions, interviews and a chance to contemplate a world without music" (BBC News, 2007). However, it's not as if Drummond wishes that recorded music never existed—or at least ceased to exist after Thomas Edison, the inventor of the phonograph, tested his new invention in 1877 by recording himself singing "Mary Had a Little Lamb."

For Drummond, recorded music was a good thing. It was the great art form of the twentieth century, he says, capturing the imagination of the public—which, for the first time in history, could now access archived sound and listen to ghosts of the past. Drummond tells me, "In 500 years time, it will be what the twentieth century will be remembered for, from a cultural point of view" (although he acknowledges that cinema has left a bigger footprint and continues to carry on, and thus will not solely be associated with the twentieth century). He argues that every medium has a life span, though some last longer than others. "Some come to an abrupt ending like the silent film, irrelevant overnight with the coming of the talkies," he says. "Others take decades to fade and die. Still others live on in evening class lessons, carried out by those in need of a hobby" (personal communication 2008).

In the history of music, sound recording is not much more than a blip on the radar, a microscopic dot on a *very* long timeline. Given that, it seems strange that recorded music has become so naturalized and hegemonic, especially when there are so many other ways to make and listen to songs, sounds, and noise. Because of the ubiquity of sound recordings today, Drummond feels that people will begin wanting something different out of music—hence his command to "dispense with all previous forms of music and music-making and begin again." It's a radical gesture, an impossibility, though not at all surprising coming from a man who has spent most of his adult life contemplating the art and business of popular music. "I believe that the creative and forward-looking music makers of the twenty-first century will not want to make music that can be listened to wherever, whenever, while doing almost whatever," Drummond concludes. "They will want to make music that is about time, place, occasion, and not something that you can download and skip over on your iPod."

Billboard Liberation

A Photo Essay

Craig Baldwin is a California filmmaker, publisher, and educator. His work reflects the "Funk" or neo-Dada aesthetic that weaves through the Bay Area artwork of the past half-century, as well as Situationist strategies of *détournement* and media intervention. Over the past two decades, Baldwin has been curating and screening thematic programs of radical documentary and experimental work in his weekly Other Cinema showcase. In 2003, the exhibition series grew to include a DVD distribution company, OCD. Much of the work he has presented could be characterized as collage films and compilation docs—media-archaeological assemblages that often invert and subvert the original meaning of the mass media and industrial source material. Baldwin's own films and his curated film series can be seen as part of a broad and diverse subcultural praxis known as culture jamming. This is also true of his billboard alterations and the billboard "improvements" of others, images that were captured in the 1980s and early 1990s, which are presented here accompanied by his commentary.

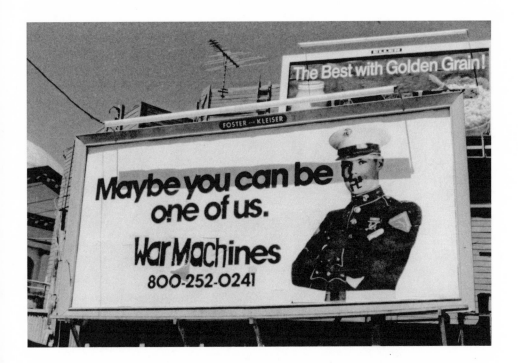

1. War Machines. This billboard alteration was done by myself, which I pulled off on San Francisco's busiest boulevard, Market Street. In fact, a Super 8 film was shot of the action. It was unfortunate that when I returned to document it for myself on a sunny day, the shadow partly obscured the swastika on the mouth.

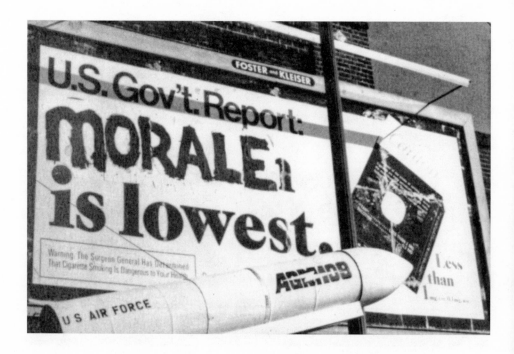

2. MORALE is Lowest. This was a relatively simple alteration by Glen Scantle-bury and Dana Hoover. They wheat-pasted "morale" over the slogan used in a billboard for a low-tar cigarette, which was located in a South of Market neighborhood. This happens to be part of the documentation of a national tour by that performance art pair, who drove a truck-mounted mock cruise missile to military museums and political conventions for street actions and "tailgate" video screenings.

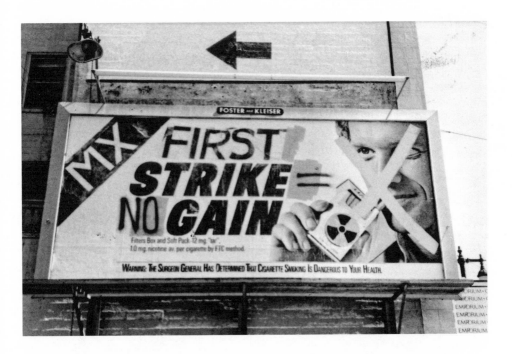

3. MX First Strike. By targeting a Lucky Strike cigarette ad on San Francisco's Mission Street, this symbolic refusal of Reagan's MX Missile program landed two of my friends (Joel Katz and Pad McLaughlin) in jail for about twenty-four hours. They were busted by undercover drug cops who were coincidentally parked in the area to intercept a street sale, though my roommate Jeff Skoller was able to scamper away.

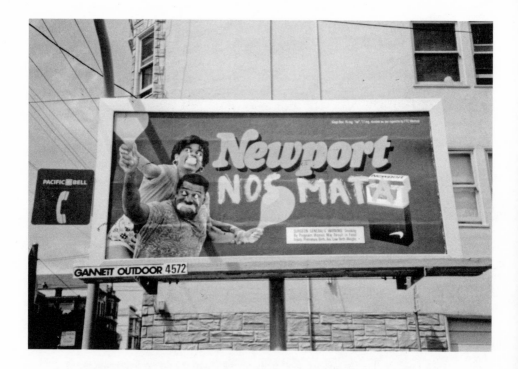

4. Newport. "Nos Mata = Kills Us." One of a long and hilarious series of hits on Newport Cigarettes billboards, which were infamous for their thinly veiled S&M imagery. The company must have preleased the billboard space for a year, because for many months their new designs were regularly met with playful— and painterly!—"improvements," often including artfully placed 3D collages of street trash!

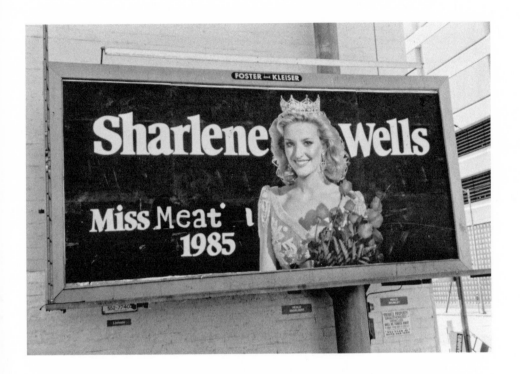

5. Sharlene Wells. Some anonymous citizen improved on this retrograde promo for a likewise unknown sponsor (who could it have been?). It was arguably even more inappropriate in San Francisco's Haight-Ashbury, where I chanced upon it with my camera.

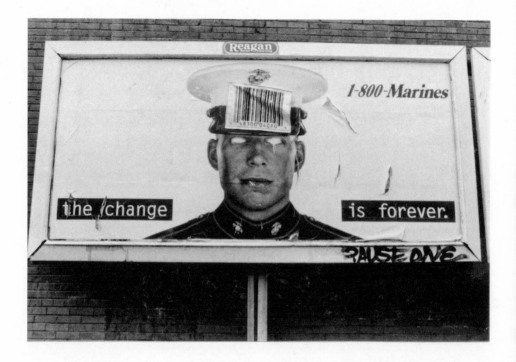

6. Marines: The change is forever. A righteous graphic attack by an unidentified anti-militarist, though I cannot recall in which San Francisco neighborhood this billboard was located.

On the Seamlessly Nomadic Future of Collage

Brief Email Exchange

"The future of collage" . . . Does it have any? — **Pierre Joris**

Yes, it does! e.g.: We are all collages now. Or collage as
opposed to what? — **Charles Bernstein**

Not because I could have been a wax archangel
Or evening rain or car catalogue. — **Tristan Tzara**

So what about the future of collage — or at least of collage in poetry, my
specific area of investigation? I could, of course, make it up, and nobody
could check because the future is always tomorrow. Unless we decide that
the future is always already today, and then we can know about the future
of collage if we look at where it is today. I will take that tack, not much
believing in the prophetic or vatic function of the poet any more, even if
she can, I believe, speak and maybe predict today better than our (secretly
or not so secretly) collaged news media.

As behooves any writer on collage, I was going to start in the past with
Pablo Picasso — not with his painting/collage work but with his writing.
This means that we would in some way be dealing with Pablo Picasso in
the present, because, at least in the English-speaking world, an aware-
ness of his work *as a writer* is just now emerging. Then I thought better of
it and decided to first quick-collage some theoretical considerations on
language collage. Obviously there is very little *colle*, very little actual glue
in verbal collage — the word has to be taken at a metaphorical level, which
opens up its possibilities and has done just that throughout the past cen-
tury. If, as Marjorie Perloff argues, "on the visual level collage entails the
loss of a coherent pictorial image," then on the verbal level it entails "the

loss of what David Antin calls 'the stronger logical relations' between word groups in favor of those of similarity, equivalence, and identity. In collage, hierarchy gives way to parataxis — 'one corner is as important as another corner'" (1986, 75).

I come back to the paratactic nature of verbal collage when I get to Picasso, but first let me extend the concept of verbal collage in another direction, to suggest that all writing is at some level — and one could even say at all levels — collage. Jacques Derrida is the one writer/thinker and practitioner of verbal collage who has probably given us the most radical and incisive insight into how this works:

> And this is the possibility on which I want to insist: the possibility of disengagement and citational graft which belongs to the structure of any mark, spoken or written, and which constitutes every mark in writing before or outside of every horizon of semio-linguistic communication; in writing, which is to say in the possibility of its functioning being cut off, at a certain point, from its "original" desire-to-say-what-one-means and from its participation in a saturable and constraining context. Every sign, linguistic or non-linguistic, spoken or written (in the current sense of this opposition), in a small or large unit, can be *cited*, put between quotation marks; in so doing it can break with every given context, engendering an infinity of new contexts in a manner which is absolutely illimitable. (1972, 381)

We could extend this play of signifiers, as Derrida does, there and elsewhere, and bring in his notions of cutting free, regraft, or of dehiscence, of decomposition, and so on. But let us just cite Derrida from his book *Glas*, as recited by both Perloff and Ulmer (two of the most incisive critics to have thought through these matters):

> That the sign detaches itself, that signifies of course that one cuts it out of its place of emission or from natural relations; but the separation is never perfect, the difference never consummated. The bleeding detachment is also — repetition — delegation, commission, delay, relay. Adherence. The detached [piece] remains stuck by the glue of différance, by the a. The a of gl agglutinates the detached differents. The scaffold of the A is glutinous. (1981, 188)

In *Glas* — maybe the greatest philosophical-writerly collage of the twentieth century — Derrida builds an anti-systemic work by pure quotation,

graft, collage. There is of course the question of how to cite, how to give due, if due has to be given. Not an easy question. In *Applied Grammatology*, Gregory Ulmer approaches some of these matters as follows:

> The first step of decomposition is the bite. To understand the rationale for all the interpolations, citations, definitions used in *Glas*, Derrida says, one must realize that "the object of the present work, its style too, is the '*morceau*' [bit, piece, morsel, fragment; musical composition; snack, mouthful]. Which is always detached, as its name indicates and so you do not forget it, with the teeth" (*Glas* 135). The "teeth," as Derrida explained in an interview, refer to quotation marks, brackets, parentheses: when language is cited (put between quotation marks), the effect is that of *releasing* the grasp or hold of a controlling context. With this image of biting out a piece, Derrida counters the metaphor of concept—grasping, holding (*Begriff*). (1985, 57–58)

Derrida himself, in the interview "Between Brackets," speaks to the question of bracketing, putting into parentheses that which is collaged, quoted: "It . . . gets unhooked. Like hooks that unhook. Like pliers or cranes (somewhere, I think I have compared quotation marks to cranes) that grab in order to loosen the grasp." And then he formulates what I think of as a core question for the collage writer: "But how is one to efface or lift the brackets once one begins writing [here and now] anything, whatsoever?" (1995, 9). The philosopher, essayist, or commentator cannot do this the same way the poet does: the former borrows and acknowledges a debt (in *Glas*, for example, although the quotation marks are dropped, the quoted material is identifiable by page layout and print conventions); the latter, the poet, traditionally "steals," or at least confuses the origins of the intertextualities at work in her writing, by dropping the citation marks. I return to this matter when I consider Allen Fisher's work. Right now, after the short theoretical graft, I feel like returning, finally, to Picasso to read you one of his texts and follow it with my reflections on the nature of those texts, via a Deleuzean (rather than a Derridean) approach.

Here is Picasso writing on February 12, 1938:

> accurate representation engraved on the grain of sand of the rain-drops' silence this afternoon of emptiness on the laundry laid out on its feather bed of a wax figure imitating a child at the edge of a river

having fun with a prunus branch teasing two beetles she sits on potato peels on the sink of her shadow reflecting on the hairy back of the marble hand reproducing the image accurately molded from the imprint of the foot of the chicken wing singing far away in the oat field curled up on the portrait of the cat molten into the wax of the ink dish's corner sheltered under the left arm of the armchair blue wetting the large loaf's crumb biting its fleas and I want to tell you the boredom the joy the songs and the laughter at the wind's colic of love climbing up the rungs of the ladder playing at knuckle bones at trundling hoops jumping rope playing hopscotch freeze tag playing knife playing numbers old sun torn by scabies shivering and freezing covered with snow hidden under the closet licking its wounds hand held out begging for alms plus three hundred ninety three hundred twenty seven meters of cotton cloth 387 zero 250 and three hundred pleasantly warm dinner rolls butter carrots oil six chairs a sideboard a kitchen table coal garbanzos bacon a drum its sticks old newspapers brushes a meter of hail a bucket a cage bed a gallows the executioner of wounds and sores and a clothes-brush a dog an old woman delousing herself a tree and a huge mirror in the middle of the kitchen reflecting a battle two horsemen attacking each other with lances covered in sweat and blood another one his horse wounded dead on the ground and the spectators clapping on the table covered with a wax cloth the wine spilled on it flowing over the floorboards grabbing on to the window panes tearing the nails of the light of the wolf trap of the dress wrapping it up completely in its chains of children's screams. (2004, 162–63)

A dismissive or traditional lit-crit reading of this text will subsume it under the species of "surrealist automatic writing." I prefer to consider it under a different light, the light of my own "nomadic poetics," which, I think, is better able to articulate the collage or assemblage aspect of the work with its syntactical disruptive modes (modes just about absent in classical Surrealist "automatic writing"). Exactly at that level I see the use of Picasso's writing for us today, suggesting in my introduction to *The Burial of the Count of Orgaz and Other Writings* (2004), that his work is "unhampered by the sedentarizing effects of normative grammar, syntax and discursive forms . . . To use the terms of Deleuze & Guattari, the lines of flight of a Picasso poem . . . are never reterritorialized, are never re-inscribed onto the grid of just 'literature.'" Picasso, I go on,

raids this foreign language (raids that he has already practiced on the mother tongue, i.e. the language of the country he has by now long left behind)—and the core principles or rather the practical engines are a nonstop process of connectivity and heterogeneity along the entire semiotic chains of the writing, the characteristics of a rhizomatic and nomadic writing. The way this plays itself out in Picasso's poems can be traced not only in the heterogeneity of the objects, affects, phenomena, concepts, sensations, vocabularies etcetera that can and do enter the writing at any given point, but mainly at the level of the assembling of these heterogeneities: eschewing syntax and its hierarchical clausal structures, the writing proceeds nomadically by paratactic relations between terms on a "plane of consistency" that produce concatenations held together (& simultaneously separated) either by pure spatial metonymical juxtapositions or by the play of the two conjunctions "and" or "of." One could of course claim parataxis as a category of syntaxis, though it seems to me that in Picasso's writing the very exorbitant use made of the paratactic process suggests that one may better see this process—in Giorgio Agamben's word—as "atactic." (2003, xxvi)

Picasso is a great teacher of how to let go of the desire to get back to original statements, images, whatever. As he says about collage:

> If a piece of newspaper can become a bottle, that gives us something to think about in connection with both newspapers and bottles, too. This displaced object has entered a universe for which it was not made and where it retains, in a measure, its strangeness. And this strangeness was what we wanted to make people think about because we were quite aware that our world was becoming very strange and not exactly reassuring. (quoted in Perloff 1986, 44)

Now, in a Picasso collage-painting, it is important to read the text of the newspaper glued on the canvas (Picasso always picks text that adds to and speaks to the rest of the work, often on a political level—which is very much where he thought the world was becoming strange!), but it is as important to realize, as he said himself, that it is there not to "represent" a newspaper but the shape it has been cut/torn into (e.g., a bottle) in the new context.

If I found it easier to speak about Picasso's writing as a nomadic

poetry, perhaps this is because the word *collage* may no longer be the term best suited to think through the implications of "the dramatic juxtaposition of disparate materials without commitment to explicit syntactical relations between elements," as David Antin defined collage (1972, 106). Maybe this "juxtaposition" needs more and different signifiers, as it may be beholden too deeply to an older Euclidean geometry and Aristotelian poetics. This is also why in another essay ("Collage and Post-Collage: In Honor of Eric Mottram," in Joris 2003) I bring in Steve McCaffery's thinking along Deleuzian lines of these matters, a text I quote (collage?) here:

> To try to think such a post-collage technique, the most useful theoretical insights I've found have been Deleuze and Guattari's meditations on rhizomes, machinic assemblages & lines of flight—the complexity of these concepts seem to me rich enough to permit a rethinking of the limits of modernist collage—for example of the question of seams vs. the seamless (which I will get back to in a minute) Perhaps even more useful will be the Deleuzian concept of the fold—which Deleuze derives from Leibniz, and which has been present in poetry, though in a rather secret fashion, from Mallarmé to Blaser. In an excellent essay, Steve McCaffery teased this Leibnizian/Deleuzian fold (as well as the monad/nomad linkages), out of the philosophers' and the poet's work. Of the fold he writes: "Leibniz and Deleuze both opt for the organic and privilege the fold over the subset through a theorizing that traces the complications in being over the clear differential of the matheme. The fold is fundamentally erotic; it is enigma and intricacy; it complexifies, introduces detours, inflexions, and instabilities into systems. . . . Above all the fold is antiextensional, antidialectical, and intransigently inclusive.
>
> It is this plication which McCaffery perceives as one of the underlying poetic strategies of Robin Blaser's Holy Forest, and Blaser's own citation—quotations, McCaffery suggests, "are not to be considered fragments but rather tactical folds of a poetic interior"—of Deleuze on the fold in the poem, is thus central: *the pleats of matter, and the folds of the soul*, reading Gilles Deleuze. (89–90)

Concepts such as the fold and plication, the rhizome and lines of flight may indeed show a way beyond "collage" stricto senso. Another way of thinking about collage I have found useful has been the homophonic pair seams/seems when discussing the work of a poet whom one does not

usually consider a "collage" poet, namely, Charles Bernstein. Still, Bernstein gave one of the sharpest insights into how juxtaposition works in collage. He writes: "Juxtapositions not only suggest unsuspected relations but induce reading along ectoskeletal and citational lines. As a result the operant mechanisms of meaning are multiplied and patterns of projection in reading are less restricted" (1984, 117). When I wrote on the poems in his book *Rough Trades* (1991), I suggested that the rapid de- and recontextualizations of his collage of heterogenous discourse fragments has the effect of creating a

> continuously shifting ground, "true" temblor topographies, seem- & seam-scapes lacking any ontologically secure "ground," in the Heideggerrian sense of that term. The "seams" do not necessarily follow the visible "poetic" markers of lines or stanzas, they happen(stance) for example inside lines as well, making for cracks in the syntax & shifts in the voice(s) at times visible & audible in the discourse, at times invisible & inaudible. (Joris 2003, 96)

Clearly the basic concept of collage has disseminated through a wide range of acts of writing, creating a number of approaches: writing, the collage elements of which show the seams of their facture, and those that hide those seams, fold them in open themselves; writing that has invisible seams—in fact, disguised as a sequence of end-of-sentence periods—running through the text. I am thinking here of the sentence-based work of someone like Ron Silliman or the procedure-driven sentence-based work of Lynn Hejinian whose *My Life* could be read as paradigmatic for a certain kind of postmodern collage writing. Many others could usefully be read from this angle: Jackson Mac Low and John Cage's procedure- and chance-generated texts; Rosmarie Waldrop's collaging or folding in of Wittgenstein's language in *The Reproduction of Profiles* (1987), of which she says that she "used Wittgenstein's phrases in a free, unsystematic way, sometimes quoting, sometimes letting them spark what they would, sometimes substituting different nouns within a phrase." In fact, the list of poets using collage-derived techniques today is vast, encompassing a major part of the experimental poets—with probably only those belonging to the School of Quietude (Ron Silliman's phrase via Poe) or Official Verse Culture in the main uninterested in collage-derived procedures, stuck as they are on linear personal narrative, and the presumed "truth" claimed for such transcribed experience.

I want to give two more examples of work that uses collage in an attempt to bring it into the twenty-first century. The first will be relatively straightforward, the second more complex. Let me begin with a work in progress of my own, called "The Tang Extending from the Blade." This is a sequential work generated by a combination of procedural and processual methods. The wider context in which they appear is an open-ended sequence called *Canto Diurno*—in this specific case, the procedure consisted of picking on a specific day a specific number (seven in the case of the Tang sequence) of online newspaper or journal articles, simply those that seemed the most interesting and engaging, downloading them, and in the next two weeks by a process of reading and choosing, of collaging—maybe the better term here would be *interweaving*—a number of sentences, usually one from each article, though I give myself permission to break such rules to create a sequence of fifteen poems. Here are two of them.

> You hold your knife by pinching the blade between thumb and
> forefinger,
> which is normal though at the end
> recognition is the determining precondition for participation
> and integration.
> Which, in turn, are imperiled by rising temperatures and seas
> through no fault of their own. How could this be
> or come into existence?
> N has helped drive a powerful insurgency.
> If large numbers of their knives get dull before their time.
> When I walk through the streets I meet people
> who create such a strong surge of compassion
> that I would like to approach them and help.
> This bashful entrenchment countered by that blithe
> being-naked before the world.

> I am often melancholic, but I like being here. Every morning I am
> pleased to wake up again where the handle meets the blade.
> Would you give a small person a smaller hammer? This is
> weapons-grade anger and no longer simply an environmental
> problem, but as an assault on their basic human rights. The
> country could spiral

into civil war. They predict conflicts where we imagine paradise.
Political interest is sub par, and the citizen's engagement elsewhere.
>Here Uncas, a large copper weather vane of an Indian, has long
>been the pride of Gilbertsville, N.Y. But most ethnic and religious
>differences went on sale last year to a wealthy New Jersey art
>collector who caused a big rift in this village's population of 375.
>Concerning immigration their standpoints are quite demeaning.
And that is not the usual memory of the old person's but of
childhood's memory.
Where does all that one has thought go? All that one has felt and
made?
Even the thought that the world goes on seeks some width in the
blade. Then
you have to give the fingers ample clearance
though no enforcement powers.

I do not want to erase the seams completely; in fact, in some of the other texts in this sequence I am working in several languages, splicing/collaging German, French, and Arabic into the English text. Of course, this poses specific problems: I do not want these languages to function in the hieratic/iconic way that Chinese ideograms function in Ezra Pound's high-modernist *Cantos*. My vision of these linguistic/lexical lines of flight is connected to what I call "nomad poetics." In such an organization, which is always trying to think itself from the multiple and never from the single, the collage structure and its intersections, connections, and seams are free to follow the model of the rhizome, described as follows by Deleuze and Guattari:

> A rhizome as subterranean stem is absolutely different from roots and radicles. Bulbs and tubers are rhizomes. . . . Burrows are too, in all their functions of shelter, supply, movement, evasion, and breakout. The rhizome itself assumes very diverse forms, from ramified surface extension in all directions to concretion into bulbs and tubers . . . The rhizome includes the best and the worst: potato and couch grass, or the weed. . . .
>
> A rhizome ceaselessly establishes connections between semiotic chains, organizations of power, and circumstances relative to the arts, sciences, and social struggles. . . . There is no language in itself, nor are

there any linguistic universals, only a throng of dialects, patois, slangs, and specialized languages. . . . Language is, in Weinreich's words, "an essentially heterogeneous reality." There is no mother tongue, only a power takeover by a dominant language within a political multiplicity. (1987, 7ff)

The essential quality of the rhizome—parallel to that aspect we learned from early collage, namely, that "one corner is as important as another corner"—is that the rhizome has no beginning or end; it is always in the middle, between things, interbeing, intermezzo.

Such complicating, expanding, exfoliating of the classical notion of collage has been necessary for this technique to remain of essential use. Its avatars will no doubt remain of use in the future, even if much of the rather simple, near-Euclidean geometries will have to be reviewed and adapted. Let us have a quick look at some of the work of the English poet Allen Fisher, who is especially relevant as his main current projects, all using some revised, retooled modes of collage, are supposed to be finished sometime in the future. He has always worked with such long-term projects, the first major one of which was *Place*, a ten-year project completed in 1981, in which, as he says, he

> tackled the consequence of spacetime in terms of location, history and situation using a method of composition by "field." The location of South London, chosen in 1970, was used as the *Lichtung* from which to research into local histories and the actuality of contemporary situations in the street, so-to-speak, both responded to and instigated. (Fisher 2005)

This poem thus involved mainly a processual structure—not dissimilar to how Charles Olson collaged historical materials into his *Maximus* poems—into which a wide range of local geographical and historical facts were integrated, more or less interwoven with the processual "personal" material. However, the latter was never of the nature of personal lyrical ego structure of the "confessional" mode but was always already exteriorized, politicized, inscribed into the public arena of South London by a range of ostranenie-ing, defamiliarizing procedures torquing the public and the private.

An important term Fisher and a few others—myself included—started to use at this time was that of "process-showing," rather than

trying to merge the outside materials, searched for or "found," and then brought into the frame of the poem in such a way as to erase all seams and obscure the origins, it seemed important to us to show the process by and from which the various material had been generated. In Fisher this process-showing often takes the shape of a bibliography of "resources" and other appendixes, but as he writes (and this distinguishes his bibliographies from the footnotes of the high modernists like Ezra Pound or T. S. Eliot), "this is not intended to be an itinerary for further reading, or a listing to give authority to the text. It is to thank those who have taken part in the perception and memory that have made the text, and to keep open the opportunity to hear them" (2004a, xii). This last modulation, however, grants us, the readers, permission to continue our readings in that direction.

On the long work whose completion still lies in the future, and whose overall title is *Gravity Considered as a Consequence of Shape*, Fisher says that structurally it "uses [his] book composed in 1982, *Ideas on the Culture Dreamed Of*, in which he drew from the vocabularies of contemporary physics, biology, and chemistry and combined these with a selection of notated jazz dances into an A-Z which formulated an index base from which to compose." The structure of *Gravity* is also a critique of what Fisher calls its "classical and ideal" models: "The overall plan, conceived as the loci of a point on a moving sphere, in PLACE was replaced in *Gravity* with the looser diagram of a cylinder marked off in the Fibonacci ratios and then crushed, thus leading to a new set, but of damaged proportions" (2002).

Fisher's pursuit of "structural homologies in the sciences" (Sheppard 1992) involves in a first (often nearly invisible) move a multilayered collaging of variable vocabularies, and then a complex work of interbraiding these language shards into a new local coherence (local because overall coherence is not the goal)—but one that does not want to erase the seams, that wants to show its "damage." As one of his poems puts it:

The quantum leap
between some lines
so wide
it hurts. (2004a, 6–7)

In a wider, systemic sense, *Gravity* is an investigation of perception and consciousness. Writes Sheppard:

"The simple beautiful morning conceals the complexity of perception," Fisher notes, and in *Gravity* nothing is taken for granted. By fracturing different kinds of systemized knowledge and then rearranging them, he is miming the processes of consistent memory and inventive memory. . . . He is also offering a model for the development of new perceptions and the expansion of consciousness in the meeting of the necessarily stable and the necessarily changing. The rearrangement says something new, which the individual knowledges would hide. (1992, 15)

The hope, as Sheppard also notes, is that "as readers enter into the 'participatory invention' of the texts creating temporary coherences line by line, they are restructuring their perceptions, changing their consciousness." The complexity of the work—both in terms of its epic proportions and of its inclusiveness—are such that classical notions of collage are no longer sufficient to do justice to the multiplex of events, both procedural and processual, that underlie the becoming of the poem.

I close by reading the two opening sections of the sequence—"Pirate's Walk"—from the "Traps or Tools & Damage" section in *Entanglement*, the second volume of *Gravity*. But first let me give you the list of "resources," that is, the list of those sources on which Fisher drew to create his postcollage text: T. W. Adorno; the *Biotechnics* journal for January–March 1995; Jeanne Calment on the radio at 120 years old; the article "Concentration and Transport of Nitrate by the Mat-Forming Sulfur Bacterium *Thioploca*," published in *Nature*, by Fossing, Galardo, and others; Jin Xing after a sex change in April 1995; Kenji Miyazawa's poem "The Thief"; Miriam Rothschild describing the worm *Halipegus* and its parasitic life cycle involving four different hosts on BBC TV; Jalluddin Rumi's poem *Diviani Shami Tabriz* (thirteenth century); Oliver Sacks from his book *Migraine*; R. O. L. Wong, A. Chernjavsky, S. J. Smith, and C. J. Shatz's article, "Early Neural Networks in the Developing Retina," from *Nature*. He further mentions that "electricity from Sizewell B nuclear power station was connected to the National Grid in January 1995" (Fisher 2004b, 279).

Pirate's Walk

1.

Skeletons in the cupboard fluoresce
a compound of relations between forces

the culture that improves using
dideoxy fingerprint detection
measured by single base sequence changes
in polymerase chain reactions

"I acted clearly and morally without regret.
I'm very lucky."

Consciousness is like that
a biological feature of certain animal brains.

given understanding and courage

"crimes of opinion" bring about arrests that
encourage the determined

a casualty of commodity values

every moment melts away

events inseparable from lives realities
actualized

Thioploca white hair emerges from sheaths
embedded in the stretched sediment story
of a desire environment with needs for more
an optimal condition of nitrate uptake

prevails in an apophanic realm
beyond grasslands in the depths
of oceanic farms

the Skeleton in the sky below
a multiple of constellations

2.
Culture mimics the Rothschild worm

detects changes in amplified DNA segments

noting in life needs to be immune
where "maybe" perpetuates

consciousness caused by neurobiological processes
participates as natural biological order

the physiological event determined by affection

what does not happen remains
or remainders as globules of anticipation

description to avoid constitutions of reality

induced illusions from fire
from fireworks from raygun typography

virtual consistency to the concept provides
the function's references

the large liquid vacuole store
an extracytoplasmic reservoir
formed by an inflated membrane intrusion
surrounded by numerous singular globules

such ascendancy of moments distributed values
its shadow moves over frosted flags
at milk call

Cultural Sampling and Social Critique

The Collage Aesthetic of Chris Ofili

In an effort to weave greater transcultural threads of inquiry into the discourse of the collage aesthetic, this chapter takes up the work of British-born Nigerian artist Chris Ofili. This contemporary artist uses collage as an interventionist strategy for addressing the complex matrix of issues surrounding the subject of African diasporic identity, from cultural icons to issues of sexuality and exploitation. In a body of paintings begun in the mid-1990s, Ofili first incorporated the collaging of cut-out magazine pictures taken largely from African American popular culture, drawing on both the formal and metaphorical possibilities of the medium. His use of the collage aesthetic connects to other modern and contemporary artists who embrace the aesthetic of collage for its ability to reflect the fragmentation of the modern world. However, the themes and experiences that Ofili shares and confronts differ a great deal from those of the early modernists of the Parisian avant-garde, the Dadaists working in Berlin and Zurich between the world wars, the British and American media–inspired collage and assemblage artists of the 1950s or even the more progressive Fluxus and Beat artists of the 1960s. The transcultural collage aesthetic found in Ofili's work creates a critical juncture for addressing the historical and contemporary realities impacting the racialized black Atlantic world of postcolonial and postemancipation societies, ones that continue to be held hostage to hierarchical attitudes on race, nation, and gender.

Ofili's collage paintings premiered in the United Kingdom in 1998, in his first solo exhibition co-organized by the Serpentine Gallery and Southampton City Art Gallery. This exhibit brought the young artist much acclaim, as did the prestigious Tate Gallery Turner Prize awarded to him in December that same year. The sensation and controversy in

1999, which followed the inclusion of Ofili's collage painting *The Holy Virgin Mary* (1996) in the Brooklyn Museum of Art's exhibition of Charles Saatchi's art collection, has often overshadowed the production of contextually informed and critically engaged readings of this body of work, a point this chapter seeks to rectify. Themes to be found in Ofili's work, from stereotypes and marginalization to empowerment and humor, warrant critical analysis especially in relation to the social problems that continue to be perpetuated in our dynamically changing world of globalization, international terrorism, and the continued individual and institutionalized forms of racist and sexist oppression.

Over the course of the twentieth century, artists seeking to address social conditions as subject matter have often turned to collage as a viable form for addressing their personal, social, and political experiences and critiques. In his essay on collage, Thomas Piché Jr. writes that for women, gays and lesbians, and ethnic and racial minorities, "the medium of collage lent an ephemeral, dislocated character to their work that questioned modernist expectations of gravity and certainty" (2005: n.p.). Irony, humor, and subversion remained part of the strategies employed by such artists as they began to speak out. Romare Bearden's urban photo collages of African American life and culture, Miriam Schapiro's provocative *femmages*, and David Wojnarowicz's poetic indictment of conformity, materialism, and homophobia represent some of the key innovative forms which have expanded collage to include a broader spectrum of voices, images, and experiences.

Collage is inherently about new ways of seeing, as Katherine Hoffman writes in the introduction to her important edited anthology, *Collage: Critical Views* (1989). Yet we might problematize this statement and ask, "who is doing the seeing?" For some artists, the collage aesthetic not only serves as a way to see new things or disrupt ways of seeing, but can also emerge from efforts to bring into view what has traditionally been marginalized and denied visibility due to a history of oppression (be it racial, gendered, or economic) and as such gives shape to what one might call a "survivalist aesthetic." What a viewer or critic may see as revolutionary or radical in the development or employment of collage, may in fact reveal, articulate, or meaningfully affirm the thoughts and experiences of more diverse viewers. Such viewing subjects may also relate the collage aesthetic not to some modern avant-garde practice but to practitioners of popular folk traditions or self-taught sensibilities, such as the improvisa-

tional crazy quilts made by African American women, including those in Gee's Bend, Alabama, who used scraps of shirts, sheets, aprons, and other salvaged cloths to create glorious functional objects with an aesthetic rooted in the spontaneity of African tribal beats and patterns.[1] Such aesthetic links possess their own unique history, which is rarely told in the traditional canonical discourses of art history.

Picasso's and Braque's early twentieth-century explorations, which took ephemeral bits and pieces out of their context and patched them into new ones, were followed by various forms, including Stuart Davis's "Cubist-American Collages," Hannah Hoech's proto-feminist Dada photo collages, and the Surrealist-inspired collaged visual puns of Max Ernst. These practitioners were followed by the next wave of media-inspired collage works, which often carried strong sexual overtones as reflected in the Pop Art collages of Tom Wesselman and William Rosenquist or the West Coast Beat-inspired collages of Wallace Berman and Bruce Conner. During the second half of the twentieth century, fragmentation and dissolution have become the norm, not only for postmodern art but for popular culture as well, to which collage continues to speak. The standard reading of postmodernism often centers on ideas, objects, and theories that break from established orders and create a sense of "chaos," "disintegration," "fragmentation," and "dissolution," terms often used to describe the collage aesthetic. Opening up the field of inquiry on collage to a more diverse group of artists expands the discourse to include new and alternative metaphorical readings of this modern aesthetic medium, while furthering our understanding of collage as a critical practice and vehicle for generating greater cultural awareness.

Some of the more engaging and challenging scholarship taking place in the field of the visual arts, in relation to issues of race, class, gender, and nationalism, has emerged in the recent studies and debates centered around photography. In 2003, the International Center for Photography mounted the exhibit *Only Skin Deep: Changing Visions of the American Self*, curated by Coco Fusco and Brian Wallis. The exhibit and accompanying catalog took on the controversial topic of race and nation in relation to self-definition and identity, including a rather comprehensive collection of both archival images and contemporary photographs. In that show, the curators made important links between the past and the present, highlighting the extent to which today's hegemonic cultures continue to perpetuate the mindset of the colonizer or master, as addressed by the

work of several artists in the show. In the introduction to *Photography's Other Histories* (Pinney and Peterson 2003), co-editor Christopher Pinney cites Algerian poet Malek Alloula's description of photography as "the fertilizer of the colonial vision [producing] stereotypes in the manner of great seabirds producing guano" (3). Pinney talks of "recovering" images from the public domain into a more enclosed arena in which they are controlled by the image's subjects and their descendants. He writes of the potential "indexicality" of photographs, the notion of images as fixed and stable, and suggests moving "beneath photography's skin" (6).

By analyzing collage in relation to critical race theory, an additional level of inquiry opens up for considering the medium as a strategy for disrupting essentialist assumptions about race and ethnicity while simultaneously considering collage a survivalist aesthetic of cultural expression. Ofili's work can thus be understood as one such postcolonial subversion of the colonial gaze, a process that disrupts, ruptures, and intervenes to reroute the reading and understanding of the "other." Ofili's work reveals, affirms, and disseminates the marginalized identities that have too often been left out of the meta-narratives on modern and postmodern collage.[2]

Pinney's methodological approach to photography lends itself to a critical consideration of collage in the work of Ofili, whose incorporation of cut-out magazine photographs both reveals and conceals a complex matrix of meaning. Viewers must also seek to get "beneath the skin" of his images to fully appreciate the deeper metaphorical levels of meaning that resonate within. Ofili engages in a complex relationship posed by the embrace and simultaneous yet subtle critique of blaxploitation films, urban hip-hop culture, and diasporic African sexuality and gender, in works that can be controversial and painful as well as poignant and heroic. Contextualizing his work within such cultural matrixes thus opens the work up to more expansive and nuanced readings. (See plates 1–4.)

Ofili gave his exquisitely ornate collage paintings such titles as *Blind Pop Corn* (1996), *Afrodizzia* (1996), *Black Paranoia* (1997), and *Pimpin ain't easy* (1997), inspired by a track by musical rapper the Notorious B.I.G. Ofili fills the canvases with various sized heads, eyes, breasts, legs, and other body parts of black and brown bodies cut from popular magazines such as *Jet* and *Sports Illustrated*, music-related print material including rap and hip-hop posters and industry magazines like *Vibe* and *The Source*, as well as porn magazines such as *Big and Black*. These materials are pasted to the

canvas and combined with painted figurative forms or patterned shapes rendered through a series of small colored dots. On top of this, the artist covers the whole canvas with thick layers of clear resin that drip and spill over the largely vertically oriented canvases. In many of the collage paintings, Ofili "gives a shout out" to various noteworthy individuals of the African diaspora—from musical figures such as James Brown, Lil' Kim, Snoop Dogg, LL Cool J, Aretha Franklin, and Janet Jackson, to big-name sport personalities like Don King, Tiger Woods, and Michael Jordan— alongside political and religious figures such as Nelson Mandela, Louis Farrakhan, and the Reverend Al Sharpton, along with such film stars as Pam Grier, to name just a few.

On an immediate level, Ofili seeks to disrupt the "conventional" manner in which a viewer sees a painting. He props his images on two hardened and lacquer-covered balls of elephant dung, which he describes as a way of "raising the paintings up from the ground and giving them a feeling that they've come from the earth rather than simply being hung on a wall" (quoted in Vogel 1999). Such a statement reflects Ofili's interest in connecting art to life and in turn to his viewers. In the painting *Afrodizzia* (1996), colored pin tips pressed into floating orbs of elephant dung spell out the names of people in popular black American culture, including the boxer Cassius Clay, the movie character Shaft, and the jazz great Miles Davis.[3] In this body of paintings, dot patterns float in and over layers of resin, created through a labor-intensive technique inspired by the ancient Matopos cave paintings Ofili saw in 1992 while on a scholarship-sponsored trip to Zimbabwe.[4] The resin, on which the small painted dots lie, possesses a quality that, according to Coco Fusco, "evokes other reflective surfaces such as mirrors and lakes, forming a sustained visual metaphor for self-reflexivity" (2001: 38). The names and images in the collages and glass-like reflective resin reveal the artist's own introspective musings while also teasing the viewer to consider his or her personal thoughts, experiences, and/or assumptions. The luring quality of the reflective, glitter-filled surfaces also bear an interesting resemblance to the sequined beaded flags, bottles, and jackets used in Vodou ceremonies to attract and summon the deities.

Ofili's floating cut-out faces, representing a pantheon of modern-day black cultural heroes swirl in a vortex of rainbow-colored glitter and plastic resin. The celebrity faces reflect a spectrum of talent and fame, from careers that have just begun to rise to those that have transitioned to

legendary status, and others that have burned out along the way. Blend-
ing high and low culture, a hallmark of collage imagery, Ofili equally
blends talents of the past with the present which he metaphorically as-
sociates with the subject of popcorn, found in both title and image as
in *Popcorn Shells* (1996). In this work, small head shots float around sev-
eral larger head shots, with concentric lines formed around them, thus
grouping the heads into the shape of popcorn. These "kernels" of fame
appear either as large and fully popped, half-popped, or in some cases
only as small unpopped kernels filled with a single face. Popcorn thus
makes reference not only to pop culture but also to the degree of one's
popularity within it. At the same time, the labor-intensive process evi-
dent in Ofili's work, particularly his painstakingly tedious dot patterns,
gives his glistening baroque canvases and media-famed subjects an air
of reverence. On one level, the viewer might compare these images to
devotional icon paintings. On a more mundane level, the images recall
the collaged poster-covered walls of a star-struck, fan-worshiping teen-
ager. Ofili's works also bring to mind public community projects, such as
the civil rights–era Wall of Respect, an outdoor mural of African Ameri-
can heroes painted on the front of a building in 1967 on the South Side of
Chicago.[5]

Ofili's collaged pantheon of famous black leaders and entertainers cre-
ates a visual parallel to the musical tradition of the West African griot, a
bard or storyteller who recounts cultural stories through song. The griots,
who in the old days were court musicians who sang praise to their re-
nowned leaders, continue today in singing the history of a tribe or family
at naming ceremonies, weddings, and other social and religious occa-
sions. Ofili's images also "sing" the praises of various individuals across
generational time and place, including 1960s Motown greats, the leading
actors of 1970s blaxploitation films, black African political leaders, the
"fathers" of 1980s urban rap, as well as the emerging contemporary male
and female hip-hop and rap sensations of today, which global capitalism
markets on the world stage. The griot metaphor certainly resonates, as
the artist himself stated that he seeks "to make paintings that make you
hear them, rather than see them" (quoted in Gayford 2002).

The paintings also have "attitude" with their cut-out head shots, en-
hanced by exaggerated and regularized black afros painted on each by the
artist, thus appearing resilient and playful, militant yet comical. Their
elephant dung "feet" provoke and defy the observer, while possessing

a presence reminiscent of a raised black power fist, or as one critic described them, "like cool dudes slouching against a wall watching urban street life go by" (Worsdale and Corrin 1998: iii). Collectively these paintings celebrate the talents of the many individuals collaged and layered together, and on an additional level, they remind us of dreams unfulfilled, commercial exploitation, media stereotypes, and creative expressions not always born of pleasure and choice but from cultural survival — self-reliance in the face of oppression.

The cultural history of collage as a folk aesthetic born out of economic necessity — the collaging of scraps and found objects versus a formalist method, as developed by Picasso and Braque — bears mentioning when considering Ofili's use of the aesthetic.[6] For many folk artists, collage often emerges not as a formal artistic choice but due to economic constraints — what one might call "collage as making do." Similarly, for some cultures (particularly those working outside of Western Europe), assembled collage is connected to spiritual object making, from West African fetish objects to various religious objects found in Vodou or Santeria ceremonies in the Caribbean. On one hand, Ofili's collaging of "debased" or inexpensive magazine pages connects to both the formal developments involving the collage aesthetic over the course of the twentieth century, from Hannah Hoech to Robert Rauschenberg. On the other hand, by introducing ethnographic material that travels across and through the African diaspora, from elephant dung to musical rappers, the artist interjects new angles and twists to the debates surrounding the slippery boundaries between high and low culture as more than a simple modernist binary construction. In addition, and equally significant, Ofili brings to the development of collage the broader subjects of pre- and postcolonial identity and critique, sprinkled with playful humor, which adds a broader lens to current debates surrounding the collage aesthetic, be it modernist or postmodern.

Ofili's incorporation of collaged faces also suggests a deeper metaphorical engagement than a formal papier collé cut-and-paste technique. The bodiless heads recall the images of lifeless victims, necks broken with heads crooked to one side, found in horrific photographs of lynching from the early twentieth century. In those images, audiences of white Americans boastfully pose next to their victims. Those pictures and that history have an uncomfortable way of bubbling up through the faces found in Ofili's paintings. For some viewers of his work, the specific indi-

viduals and personalities need no identifying names because their status and respect is formidably situated in black diasporic culture. For those viewers not familiar with such culture, the images read as a nameless collection of black faces, viewed within the museum or the gallery space box by a largely white and dominant culture. For some of these viewers, they recognize the faces not as their own but as the black and brown faces of refugees from genocide or urban criminals as seen so often on the evening news and as Pinney and Alloula spoke of in relation to photography. Such visual associations become ingrained by a media culture that chooses to show a disproportionate sampling of black faces "making it" as either victims or perpetuators of violence, or as those that become momentarily sensationalized as "just another" black rap star or competitive athlete, thus furthering stereotypes that limit the hopes and expectations of black youth.

Ofili's work unleashes an array of visual textual dynamics that occasion a rupture in the viewer's perception and reception of Ofili's collaged paintings. This rupture then moves to capture the fixity of black representations within the dominant media, while also articulating a space whereby Notorious B.I.G.'s (a.k.a. Biggie Smalls) political economy of the black ghetto expressed in the song "Things Done Changed" (1994) presents us—and perhaps Ofili—with a troubling commodified visual space. Paul Gilroy considers that space an "American centered, consumer oriented culture of blackness" (2002: xvii):

> If i wasn't in the rap game
> I'd probably have a key knee deep in the crack game
> Because the streets is a short stop
> Either you're slingin' crack rock or you got a wicked jumpshot.

Biggie's political economy of the black ghetto and Gilroy's "consumer oriented culture of blackness" (both concerned with a material reality that often gets suppressed, as black-culture-as-surplus gets exported into a global economy) ruptures the colonizing photographic realm Pinney and Alloula noted. This optic rupture is in fact a sexual cut. Ofili's *The Holy Virgin Mary* becomes a sexual articulation of Ofili's black stars. They present dialectical interanimations whereby both Ofili's British ghetto and Biggie's Brooklyn boroughs find place and space in each other. Place and space as presented in these works occasions a black vocality and aurality that exists through a type of articulation that cuts and augments

while also opening and closing Alloula's understanding of colonial scopic economies as manifested in New York city Mayor Rudy Giuliani's aesthetic value judgments of Ofili's work as "blasphemous," "pornographic," "anti-catholic," "religion-bashing," and "sick stuff."[7]

An additional theme involves the subject of essentialist traits of blackness that appear in Ofili's collage paintings, including the recurring fragmented images of hair, lips, noses, and butts, iconic markers of racial difference that have a long history of exploitation and stereotyped exaggeration.[8] The many layers on which these images can stir both pleasure and pain certainly suggest that the works carry within them more than simple shock value, as many in the press, including Giuliani, sought to describe his work. Ofili understands the power and history of images, icons, and materials and smartly deploys them precisely to provoke, disrupt, and stir important social and cultural debate.

Ofili's method of collage connects to the hip-hop tradition of sampling, scratching, and rapping, which fosters the layering of disparate subjects, such as religion and pornography, which lie at the center of his painting *The Holy Virgin Mary* (1996). In this painted collage, butterfly-shaped cutouts of female genitalia, lifted from black porn magazines, flicker around a black Madonna. The perceived elements of shame and holiness, in particular the artist's use of elephant dung for the Virgin's right breast, brought unprecedented attention to the young Turner Prize winner when the work was exhibited in 1999 at the Brooklyn Museum as part of the traveling exhibit *Sensation: Young British Artists from the Saatchi Collection*. New York City civic leaders labeled the work blasphemous, offensive, and beyond bad taste, including then-mayor Giuliani, who criticized it before he actually saw it in person. The heated responses to the work bring to mind Carlo Ginzburg's writing on early colonial documentary photography and the misread gestures and reactions that occur in the process of the photographic or oral documentation resulting in the production of a "conflicted cultural reality." Ginzburg describes cultural filters that "mediated and modulated evidence to suit the agendas of the Inquisitors: where there was recognition, templates and other preexisting schema were mobilized that appropriated the new experience to old expectations. Misrecognition thus emerges as productive" (quoted in Pinney and Peterson 2003: 7). Ofili clearly knew that *The Holy Virgin Mary* would stir a reaction. The extent of the reaction however, to the point of over-reaction, may have come as a surprise to the artist. Yet within the

strong reaction to the work lies the possibility of considering counter-meanings, empathetic understandings, and alternative readings. In relation to *The Holy Virgin Mary*, Ofili argues that a misunderstanding of this painting is not symptomatic of the work's failure, but in fact is within the misunderstanding that the work exists (quoted in Worsdale and Corrin 1998: 8). Thus in Ofili's case, Ginzburg's point can be taken a step further, in that a great deal of information can be gleaned by investigating *how* and *who* reads and interprets a given work of art and to what ends.

The round, blank, staring face of Ofili's black Virgin Mary, with its exaggerated eyes and oval red lips, connects with a long history of racially offensive images of dark-skinned characters with caricatured facial features. Such physiological distortion comes largely from stereotypical images that emerged in nineteenth-century illustrations, most notably the characters of Helen Bannerman's children's book, *Little Black Sambo* (1899). One can also see such imagery in the grotesque anti-black Golliwog character with jet black skin, white-rimmed eyes, red or white clown lips, and wild frizzy hair popular in England, where it first emerged in Bertha Upton's children's book *The Adventures of Two Dutch Dolls* (1895).[9] In one of the last illustrations of the popular *Little Black Sambo*, a story set in India about an Indian boy who catches a tiger, the Scottish Bannerman depicted Sambo's mother, Black Mumbo, holding a frying pan and making pancakes and wearing a red scarf wrapped around her head and knotted above her forehead. Bannerman's stereotyped facial distortions of Black Mumbo visually corresponded to similar offensive nineteenth- and early twentieth-century images of the African American mammy. Bannerman's book actually became very popular in the United States, and her images were quickly absorbed into an American culture already familiar with the female minstrel character played in drag and blackface that first emerged in the 1870s, particularly the cakewalk performance of the popular "Old Aunt Jemima" song (M. Harris 2003: 84).

This stereotypical character, rooted in the oppressive discourse of slavery and perpetuated through the image of the black domestic, was adopted by Charles Rutt in 1889 as a symbol for his self-rising pancake flower. Rutt actually hired a young black woman, Nancy Green, to travel and promote the product as a "Negro women who could exemplify southern hospitality" (M. Harris 2003: 88). Rutt's innovative marketing strategy, based on the myth of the asexual subservient mammy, further embedded the image of the accommodating black domestic in the

Plate 1. Chris Ofili, *Popcorn*, 1995. Oil, acrylic, paper collage, polyester resin, map pins, and elephant dung on linen. 72 × 48 inches (182.9 × 121.9 cm). © Chris Ofili, courtesy Victoria Miro, London.

Plate 2. Chris Ofili, *The Holy Virgin Mary*, 1996. Acrylic, oil, polyester resin, paper collage, glitter, map pins, and elephant dung on linen. 96 × 72 inches (243.8 × 182.9 cm). Courtesy Chris Ofili/Afroco and David Zwirner, New York.

Plate 3. Chris Ofili, *Double Captain Shit and the Legend of Black Stars*, 1997. Acrylic, oil, polyester resin, paper collage, glitter, map pins, and elephant dung on linen. 96 × 72 inches (243.8 × 182.9 cm). Courtesy Chris Ofili/Afroco and David Zwirner, New York.

Plate 4. Chris Ofili, *Afrodizzia (Second Version)*, 1996. Acrylic, oil, polyester resin, paper collage, glitter, map pins, and elephant dung on linen. 96 × 72 inches (243.8 × 182.8 cm). Courtesy Chris Ofili/Afroco and David Zwirner, New York.

American psyche. The title of "aunt" was a commonly used term of sub-ordination and familiarity for African American slaves who wet-nursed and cared for the slave owner's children and after emancipation worked as domestic servants, nannies, and maids. Harris notes how the Aunt Jemima construction further maintained "white patriarchal authority over both white and black women while allowing sexual access to and domination over them" (2003: 90). The image of domestic care taker in American product advertising continues to circulate today on bottles of Aunt Jemima maple syrup, boxes of Farina breakfast cereal, or packages of Uncle Ben's rice. Ofili thus conflates the Virgin Mary, who accepted her role as a servant of God and mother of his only son, to that of a slave woman forced to serve her master in numerous ways.

The butterfly cutouts of female genitalia surround the entire body of Ofili's black "mammy" Virgin while radiating lines of angelic light adorn her head. Reading beyond their pornographic source, these cut-outs can also be read in relation to female fertility, a subject at the heart of most African woodcarvings. They also relate to the process of reproduction which the Virgin Mary fulfilled by becoming God's virginal vessel. At the same time, there lies a history behind the pornographic cut-outs that touches far beyond the modern development of explicit porn magazines. It connects in the case of black females to the stereotypes surrounding black female sexuality, sometimes referred to as the Jezebel stereotype, which also historically involves the eroticized "exotic" mulatta in North America, the Caribbean, and Brazil, often the offspring of the white mas-ter raping his black female slaves. The legacy of the sexual myth of the black Jezebel, born out of a history of rape and exploitation and expanded in the racist ideology of the post–Civil War period and its accompanying Euro-American fear of miscegenation, continues to be perpetuated in today's fashion media and racy rap lyrics and videos. It is not surprising, then, that Ofili titled his 1996 exhibit, in which many of these works were shown, as *Afrodiziac*—a play on the word *aphrodisiac*—thus stirring the connections of sexual arousal with the mythologized history centered on black sexuality and exploitation. In an interview in 1998, Ofili expressed his interest in the play between beauty, attraction, and repulsion, stating that he became interested in the subject after buying porn in the stores fronted as bookshops in Kings Cross, London, where he had his studio in the early 1990s. At that point, he became interested in "making things that were beautiful and attractive, but also playing with ideas of what is

suppose to be attractive and what isn't" (quoted in Worsdale and Corrin 1998).

The collaged and painted elements in *The Holy Virgin Mary* and their rich and numerous layers of meaning offer a poignant commentary on the exploited history of black female identity. The most horrific history that comes to mind in relation to this issue would be the twenty-year-old bushwoman Saartjie Baartman, who in the early nineteenth century was taken from her home in South Africa, put on display, and masqueraded throughout England and then France. The exploitive nude presentation of her body in front of fully clothed Europeans generated the spectacle of "the Hottentot Venus," as she came to be known. Even after her death, Baartman's exploitation continued, this time in the name of science. Her sexual organs and brain were dissected and displayed in the Musée de l'Homme (Museum of Man) in Paris, where they could be seen until as recently as 1985.[10] In 1995, photographic artist Lyle Ashton Harris collaborated with Renee Cox in creating the photograph *Venus Hottentot 2000*, which presents a naked Cox wearing only an exaggerated body–formed plastic breast and buttocks. In commenting on this piece, Harris states that reclaiming the image of the Hottentot Venus is a way to explore "what it means to be an African diasporic artist producing and selling work in a culture that is by and large narcissistically mired in the debasement and objectification of blackness" (quoted in Read 1996: 150). Ofili has also commented on the relationship between his own work and black female identity. In a interview in 1998, he stated that the starting point for *The Holy Virgin Mary* was

> the way black females are talked about in contemporary gangsta rap. I wanted to juxtapose the profanity of the porn clips with something that's considered quite sacred. It's quite important that it's a Black Madonna. I concentrated more on bumshots and rear crotch shots in a way, playing with the sexuality of the Holy Virgin Mary, wanting to really put it all right up to the forefront. . . . I wanted to make a '90s version of the Holy Mary, an in-your-face '90s version of Christ's mother. . . . I really think it's a very beautiful painting to look at, full of contradictions which is perhaps why it's been misunderstood. (quoted in Worsdale and Corrin 1998)

Ofili thus draws on the history of black female bodies and spectacle, employing images and icons not only for the sake of spectacle and shock

but to provoke and disrupt to stir productive contemplation and debate about the whole subject of debasement and objectification of the black female body, as it continues in the 1990s not only from without but also from within the black community, as he himself notes occurs in "gangsta rap."

Ofili's interest in reimaging the Virgin Mary has a subtle correlation to Betye Saar's famous assemblage, and perhaps more poignant critique of black female exploitation and stereotyping, titled *The Liberation of Aunt Jemima* (1972), in which Saar turns the Aunt Jemima/mammy construction on its head. In that piece, Saar symmetrically placed what appears to be an early twentieth-century Aunt Jemima promotional ceramic note pad holder (comparable to Ofili's large symmetrically placed Virgin) in a shadow box. Collages on the inside of the box repeat images of the modernized Aunt Jemima, with lighter skin and pearl earrings. Yet Saar transformed Aunt Jemima into a militant and defiant woman, with a rifle in one hand, a broom in the other, and a pistol nestled under her right arm, next to her exaggeratedly large breast. In painting over Aunt Jemima's face, Saar gives it the caricatured look of a blackface minstrel with thick red lips and bulging white eyes against jet-black skin. Saar replaced the notepad in front of Aunt Jemima with a drawing of a domestic servant or slave holding a crying white child under her arm. In front of this, she placed a raised black fist. The more direct militant tone of Saar's piece differs from the more subtle yet somber and sad tone that emerges from critically reading Ofili's work and its layered meanings and associations.[11]

In *The Holy Virgin Mary*, Ofili blends the high and low, the heavenly and the earthly. He offers up more than the simple virgin/whore dichotomy by intersecting it with the history of blackness and the eroticization of black female sexuality. Thus, the work raises two historical representations of stereotyped black female identity still prevalent in U.S. and British society today, that being the dichotomy of the mammy/Jezebel construct that continues to essentialize black women as domestic care takers or sexual seductresses. *The Holy Virgin Mary* opens up a space for critical reflection of black female identity and stereotyped media images. The lack of intervention by those privileged by the hierarchies of race, class, and gender to disrupt and negate such stereotypes further allows racial oppression and destructive imagery to perpetuate what Michael Harris calls the "pathology of oppression" (2003: 142).

In further discussing the image of the Virgin in this work, Ofili has

stated that "all the shapes of her dress and hair are vaginal shapes, flowery" (Worsdale and Corrin 1998). Similar to Andres Serrano's photograph *Piss Christ* (1989), Ofili's work also links spirituality with materiality, from the butterfly shapes and the elephant dung to the labia-shaped petals that form the Virgin's dress.[12] The artist's linking of Christian religious imagery and sexuality comes in part from his early visits to the British National Gallery Saintsbury Wing, where he viewed Van Eyck's paintings of the Mother and Child, just prior to painting *The Holy Virgin Mary* (Worsdale and Corrin 1998). In discussing those visits, Ofili states that he "just wanted the image of the breast really. The exposed breast is hinting at motherhood but those images are very sexually charged" (quoted in Worsdale and Corrin 1998). In describing the Virgin as "this beautiful, passive, angelic woman, pure and very attractive looking," he also speaks of how he thinks the Virgin Mary was an "excuse for pornography in the homes of these holy priest and Godfearers. So I think in the 90s a version of it would allow the pornographic images to come more to the surface" (quoted in Worsdale and Corrin 1998). The connections noted by Ofili reaffirm the already noted connections in his work between the past and present and the moral and cultural ambiguity of his images defy simple reading, and for good reason. The boundaries between high and low, fine art and mass reproduction, not only become slippery but highly productive in reading his work, an important attribute of the collage aesthetic itself.

In Ofili's collaged painting, *Double Captain Shit and the Legend of the Black Stars* (1997), from his *Captain Shit* cycle of works, five pointed black stars float around the double image of a gyrating, pimp coat–wearing, chest-exposed, black superstar. The repetition of the figure—one hand on his hip, the other held to his chest in the gesture of a gun—immediately recalls the "king" of rock and roll immortalized in Andy Warhol's *Double Elvis* and *Triple Elvis* silkscreen paintings of 1963. In those quintessential Pop Art pieces, Warhol chose an image of Elvis as he appeared in the film *Flaming Star*, released in December 1960, at the height of his silver screen career. Ofili's referencing of this canonical Warhol image depicting a legs-spread-apart Elvis posed with a phallic pointed gun in hand, draws further attention to American popular culture and the Hollywood conflation of sex and violence along with linking his own work to the heroically celebrated Warhol and his signature silkscreen painting, well established in the canon of twentieth-century art history. With these associations,

Ofili locates his own identity in relation to this leading postwar American "art star," one of the first to appropriate images of Hollywood actors and starlets.

The additional power punch of Ofili's work lies in not only the image one sees, but also the associations those images bring with them. The Warholian reference becomes a dark comical foil to Ofili's pop culture character Captain Shit, who suggests not white Hollywood of the 1960s but the blaxploitation film actors of the 1970s, such as Richard Roundtree (*Shaft*, 1971) and comic book heroes like Luke Cage (the first African American hero in Marvel Comics) or Black Lightning, characters who aspired to be situated among more well-known mainstream heroes such as Clint Eastwood and Superman. In 1996, the National Film Theatre (NFT) gave U.K. audiences the chance to see many of the blaxploitation films that up to that point had rarely been seen in the United Kingdom. Ofili, who bought tickets to the blaxploitation film season at the NFT, stated: "I went to every one. It was just so virulent, nigger this, bitch that, tits and ass everywhere. I haven't seen *Jackie Brown* yet, but I wonder if it's possible to make a blaxploitation film anymore" (quoted in Worsdale and Corrin 1998). Clearly, the works Ofili produced from 1996 on, including *Double Captain Shit and the Legend of the Black Stars*, reflect his having seen these films. The works become a response to his provocative questioning of the production of explicit blaxploitation films of the 1970s (and perhaps music videos of today) in relation to his direct contemporary experience of living in the neighborhood of Kings Cross with its high traffic flow of pimps and prostitutes that the artist actually filmed as a way of dealing with it.[13]

Captain Shit's "aura," as created by Ofili in his painting, presents itself not as a glowing muscular, cape-flowing superhero, but as the celestial aura of floating black-painted stars that fill the entire canvas. In the middle of each star, the artist collaged a pair of anonymous (although occasionally recognizable) black eyes. The contrast of the whites of the eyes against the stark black uncomfortably recalls the stereotyped imagery found in exploitive black memorabilia largely circulating in the United States from 1894 to 1950. They also recall the look of blackface minstrels, which in turn reminds the viewer of the earliest performance spaces where African Americans entertained white audiences. The stars camouflage the identifiable features of the celebrity "stars" themselves and the faces from which they come, similar to those of a masked villain

or disguised superhero. Collectively, these stars create a celestial galaxy of superstardom, yet individually they read as anonymous eyes, denied their full facial reference that would communicate their celebrity "star" status.

Perhaps unintentionally, Ofili's choice to show only the eyes references Warhol's other celebrity subject—his series of silkscreen paintings which repeated patterns of Marilyn Monroe's face, lips, and specifically, her eyes, shortly after her suicide in August 1962. Warhol's reduction of Marilyn to body parts, however, reflected his fascination with the media bombardment of her image, as she was seen "everywhere," which in turn resulted in the ability of an increasingly visually sensitive public to recognize her physical synecdoche for her entire being. Warhol's work, specifically *Marilyn Monroe's Lips* (1962), creates an interesting foil to Ofili's collection of small celebrity black eyes that historically have been denied the celebrated level of media attention and recognition as received by Monroe both before and after her death.[14] All of these collaged layers and linkages in *Double Captain Shit and the Legend of the Black Stars* serve in both subtle ways to highlight Western media's obsession with the tripartite formula of sex, race, and violence.

The role of double-edged humor in Ofili's work also warrants further analysis because the thread of comedy and satire runs throughout many of his works. The history of African American humor, born out of pain and suffering, incorporates various forms of self-deprecating jokes. According to Will Haygood, "there is nothing like Negro humor. It is loud, profane, juicy, wondrous, scabrous, willful, tricky, and sometimes delivered in coded language. It is steeped as well, in American history, in blackface and Jim Crow laws and segregation" (2000: 31). This connection between black humor and history is telling depicted in Ofili's work. The terms with which Haygood characterizes Negro humor, specifically in relation to the African American experience, find a similar diasporic parallel in much of Ofili's art and imagery. The role of humor as a kind of mental survival strategy for dealing with oppression and racist hostilities certainly exists on a subtle level in Ofili's work.

The role of humor and satire in black culture has often been discussed in relation to the role of the trickster based in Africana folklore. This character, which in folktales often comes in the form of a monkey, hare, or tortoise, can appear as playful and innocent, yet cunning and sly. Their dominating characteristics come from their ingenuity, which allows them

to outsmart bigger and stronger animals. The blended qualities of these characters also connects to the blended genres of African American literary language, a form which Henry Louis Gates Jr. describes as "signifyin'," a kind of collaging of genres which he describes as that which subsumes "several other rhetorical tropes, including metaphor, metonymy, synecdoche, and irony (the master tropes)" (1988: 52). In relation to Ofili, we find an artist who, like a trickster, wittingly "plays" with his viewers, "signifyin'" with images layered with numerous associations that are both masked and unmasked in humor, metaphors, and visual ironies.[15] The artist himself has stated, "I'm trying to make things you can laugh at. It allows you to laugh about issues that are potentially serious" (quoted in Worsdale and Corrin 1998).

In considering the world of the visual and histories of oppression, Deborah Poole offers the interesting concept of "visual economies" as an effective approach for understanding the creation and sustainability of stereotypes and how the visual can either counter or perpetuate them. Pinney notes how Poole's concept "advocates a stress on unequal flows and exchanges: hence 'economy' rather than 'culture' (Pinney and Peterson 2003: 8). The term "economy," as used by Poole, "suggests that this organization has as much to do with social relationships, inequality, and power as with shared meanings and community" (8). Visual economy thus captures this sense of how visual images move across national and cultural boundaries, as noted by Ofili, a born and raised British artist of Nigerian parentage who uses predominantly African American imagery for his postglobalization collages. Increasingly this topic is one cultural anthropologists have been investigating in relation to the visual objective conditions created by global connectivity, one that Brad Weiss describes in his study of urban Tanzania as a global "circuit of imagery" shaped by the dissemination of mass-mediated material imagery including CNN reports on global conflicts, syndicated African American sitcoms, and advertisements that promote the pleasures of an exotic safari (Weiss 2002: 96). Where the phrase "visual culture" inherently suggests a supposition of consensus and homogeneity, "economies" advocates unequal flows and exchanges, which "suggests that this organization has much to do with social relationship in equality and power as with shared meanings and community" (Pinney and Peterson 2003: 8). Ofili's appropriation and collaging of popular culture highlights the connections between national and social issues of power and local community themes, as situated

within the broader culture of the black Atlantic. Yet his work also comes from a deeply personal space in which he seeks to come to terms with his own postcolonial identity as well as the realities of the oppressed and the global community of "blackness." Just as his images are taken from popular culture, their metaphorical connections will also continue to evolve, shift, and exchange.

Ofili's collage aesthetic, along with issues of identity and "otherness," takes a different path than that of simply disrupting realities. The manner in which the artist lifts and collages images of blackness and reconfigures them on his canvas, with its subtle satiric jabs, poetic riffs, and sampling of art history, reflects a different but equally important path than the inverted, resistant, and deconstructive strategies to race-sensitive material taken up by contemporary artists such as David Huffman, Kara Walker, or Michael Ray Charles. Catherine Hoffman writes that collage shatters the "monolithic absolute" (1989). Yet in Ofili's work, collage becomes a vehicle not only for shattering realities but also for gathering those realities whose stories have not been told. He brings together the random yet related fragments of historical "othering" as imposed on the black Atlantic and the broader African diaspora. In doing so, he simultaneously puts forth a pan-African resistance to oppression that celebrates pride in the face of pain.

Collage plays a critical role in creating these outcomes. It goes beyond an interventionist method for critiquing the monolithic discourses on race and gender by disrupting what is perceived as the "normal" reality, created by the white imagination, to make visible those realities deemed "abnormal," "impure"—a reality of "otherness." A full critique of Ofili's work requires going beyond those approaches that situate "reality" within a monolithic Euro-centric or Euro-American context and aesthetic. On a metaphorical and theoretical level, studying the use of collage by artists of color opens up numerous avenues for considering process and *how* artists approach and confront the intersecting subjects of race, gender, class, sexuality, and nationalism through collage. Ofili's formal and conceptual strategies confront postcolonial realities and prompt the viewer to do the same by creating works that defy a simple reading—that in the end make the viewer "recon" with their critically stunning complexity.

Notes

1. For further reading on this, see R. Thompson (1984) and Arnett and Arnett (2002).

2. See for example Brandon Taylor's recent publication *Collage: The Making of Modern Art* (2004).

3. Ofili began incorporating the elephant dung after traveling to Africa on a British Council Scholarship while a student at the Royal College of Art, London, in 1992.

4. See Godfrey Worsdale, "The Stereo Type," in Worsdale and Corrin (1998), 2. The quotes by Ofili cited elsewhere in this text from Worsdale's essay come from an important Ofili interview with Kodwo Exhun, "Plug into Ofili," which is included unpaginated, at the back of this same catalog.

5. This mural stood for many years on the South Side of Chicago. Created by a group of visual artists from the Organization of Black American Culture, it was destroyed by a fire in 1971.

6. Some scholars have noted that Picasso's synthetic collages were most likely influenced by the assembled and synthetic qualities of African objects that used materials such as beads, shells, and fabric, what has come to be termed "bricolage."

7. Such statements by Giuliani appeared in numerous newspaper articles throughout the run of the Brooklyn Museum exhibition and subsequent legal battles involving his threat to cut the $7 million city subsidy for the museum if they did not cancel the *Sensation: Young British Artists from the Saatchi Collection* exhibition. For more details on the controversy, see Alan Feuer, "Giuliani Dropping His Bitter Battle with Art Museum," *New York Times*, March 28, 2000.

8. It is important to note the continued recycling of such imagery in our culture today as seen in the afro-headed dancing office boy found in the Office Max advertising campaign occurring over the past few years in TV commercials and print ads, and the more recent controversial Mexican stamps of the 1950s-era character called Memin Pinguin, a caricature of a naive black boy with wide eyes and exaggerated lips.

9. The Golliwog (originally spelled Golliwogg) typically appears as a male in a jacket, trousers, bow tie, in a combination of red, white, blue, and occasionally yellow. The character is found on a variety of items from postcards to dolls and paperweights.

10. In May 2003, prompted by the 1994 request of then South African president Nelson Mandela, France finally returned Baartman's remains to the land of her birth.

11. Saar's work comes from period at the height of the black arts move-

ment in the United States, in which the subject of the stereotypical mammy became a central image to be reinterpreted and subverted into a militant resistance fighter, noted in works by Murray DePillars, Joe Overstreet, and Jon Onye Lockard. For further discussion, see M. Harris (2003), 107–24.

12. In relation to the connections between Ofili and Serrano, see Rambuss (2004), 497.

13. Ofili discusses the neighborhood of Kings Cross and his response to it in several sections of his interview with Kodwo Eshun, in Worsdale and Corrin (1998).

14. Today, hip-hop and rap legends such as Tupac Shakur and the Notorious B.I.G. have received their own cult-like status in the afterlife of their violent deaths, but still on a much smaller scale than anything experienced by the "afterlife" of Marilyn Monroe.

15. The African American vernacular of the trickster has its roots in the West African trickster, whether, as Ananse the spider from Ghana or the Yoruba òrìṣà, Eṣa Elegba. See M. Harris (2003), 116.

GÁBOR VÁLYI

Remixing Cultures

Bartók and Kodály in the Age of Indigenous Cultural Rights

While musical appropriation, or borrowing, is well accepted in the field of the Western classical art music tradition, copyright legislation sees sampling—the collage of sound in digital form—as theft if unauthorized. Thus it poses questionable limits to artistic expression (Sanjek 2001). One way of fighting for the legitimacy of sampling as an unbound compositional practice might be tracing its similarities with an accepted, even celebrated, instance of musical appropriation. We could, for example, trace correspondences between the compositional methods of Hungarian ethnomusicologists and composers Béla Bartók and Zoltán Kodály, who used the folk melodies they collected as the raw material of their music, and the musical producers of our time who stitch together bits and pieces of sounds they happen to find. We could then argue against copyright restrictions of audio collage by saying that Bartók and Kodály would not have created their lasting musical heritage if their hands had been bound by copyright.

Another legitimating strategy arises from the foundations of pragmatism. The argument is that once the music is recorded, it enters the media limbo where it is transmitted, coded and decoded, downloaded, shared, and continuously transformed. Where the author can no longer in effect control the integrity of his or her work and everybody can participate in creatively reinterpreting it or borrowing from it, a new kind of folk culture is coming to life (Oswald 1990; Negativland 1995). Obviously, because copyright holders are not likely to give in to this postmodernist line of reasoning, we might just do what Bartók and Kodály did: sample music that is without a single clearly identifiable author, creating collages out of fragments of folk music.

No matter how enthusiastic we might be about liberating musical appropriation from the crippling grip of copyright, we shall not forget that the works of Bartók and Kodály are increasingly problematic today in the face of claims that native cultural groups make to retain control over their own cultural heritage. The fate of these folk-influenced pieces manifests the colonialist optics of copyright that denies authorship to the collectively created folk cultures, while it guarantees the right to be credited and to reap the financial benefit of these works to the appropriators. Is anyone aware of the name of the singers who gave their songs to Bartók and Kodály?

Enter the postcolonialist/postmodern schizophrenia: on one hand it appears perfectly reasonable to fight for unlimited artistic freedom in creating musical collages, whereas on the other hand we feel that it's morally no longer acceptable to maintain such an unjust and uneven distribution of power and wealth in the field of musical creation. In this chapter, I first explore the similarities in current practices of digital audio collage and the musical appropriation of Bartók and Kodály and then proceed to analyze the politics of their compositional practices. Lastly, I investigate the possibility of morally acceptable ways in which elements of recorded folk music could be reused in musical collage, and I argue that despite all the previously outlined ambiguities, Bartók's and Kodály's respectful engagement with folk music could still serve as a potentially positive example for today's digital appropriators.

Bartók and Kodály: A Case for Musical Appropriation

Béla Bartók and Zoltán Kodály were both Hungarian composers who, motivated by nationalist thought, became self-taught ethnomusicologists in the first decade of the twentieth century. At that time, Hungary was in the process of liberating itself culturally from the rule of the mainly Austrian-dictated Austro-Hungarian empire. Since the mid-nineteenth century, historians and linguists had been searching for the origins of Hungarian culture, while artists experimented with forms of expression that built on this heritage and expressed unique national sentiments. These efforts to unearth an "authentic past" on which the identity of an independent nation could be founded clearly inspired Bartók and Kodály at the early stages of their careers as they realized the need to break with the strong Austro-German influences that dominated

Hungarian art music education and composition. Bartók's and Kodály's work was just as strongly rooted in traditional Hungarian folk music as inspired by modernist possibilities opened by a range of Western composers, from Claude Debussy to Arnold Schoenberg. Their artistic program is not without precedents: we find examples of borrowing Hungarian folk styles in Western classical music since the sixteenth century in the works of Haydn, Beethoven, Schubert, Weber, and Brahms (Kodály 1974a). Bartók and Kodály were also influenced by Stravinsky and de Falla who reformed their respective national modern musics by building on already transcribed traditional folk melodies.

Throughout their artistic development, Bartók and Kodály differed from each other significantly in terms of their Western influences as well as in the ways and extent of drawing on folk music. Their particular approaches have also transformed over time. A thorough description of their oeuvres and the various ways of their changing engagement with folk music would beguile us away from the moral dilemma that this chapter tries to unpack, and a number of excellent publications already provide sufficient insight into this complex history (e.g., Dobszay 1982; Lampert 1982; Bónis 1983). To provide depth and context to the examples of Bartók and Kodály, it is enough for now to state that appropriated folk melodies, harmonies, and rhythms play a key role in a significant part of their works, ranging from piano arrangements of folk songs for children to highly complex orchestral and choral works. Their legacies became the foundation of modern music in Hungary, and had profound influences well beyond the boundaries of the Central European country. Bartók is now celebrated as one of the most important composers of the music of the twentieth century, and Kodály's method of music teaching—also strongly based on folk music material—became widely used internationally.

Before discussing *how* their compositional practices can be seen as similar to today's cut-and-paste digital production methods, it is important to highlight *why* they chose folk music as their inspiration and raw material. For now, I am more concerned with highlighting the motivations behind their appropriative practices:

"In 1906, in their first series of folksong arrangements, Bartók and Kodály defined the aim of the genre: folksong arrangements should select from the best pieces in the treasury of folk music for the purpose of acquainting and endearing folk music to the public" (Lampert 1982:

401–2). Although this early formulation underwent a number of transitions, refinements, and specifications as they developed as ethnomusicologists and composers, the sensibility it communicates remained key to their modus operandi. The composers saw aesthetic worth in the then-neglected folk forms and sought to redeem them by making them both accessible and contemporary through their compositions.

Bartók and Kodály have obviously never spliced tape loops or re-edited their phonograph recordings using a sampler or computer programs; still, their work is closely related to the practice of collage both in terms of their compositional aesthetics and the effect of their work. In Bartók's composition manifesto,[1] he names three different compositional methods for using folk melodies: (1) create an overture, interlude, or arrangement to an already existing folk melody; (2) use the folk melody only as a "motto" when the newly composed material is of primary importance; (3) imitate folk music by using its "form-language" and stylistic elements (Bartók 1948b: 22–23).

Although Bartók and Kodály did not have the technological means of appropriating sounds directly from the recorded source, it is very easy to see parallels between their three ways of hijacking folk and today's (1) remix of an original piece, (2) the use of samples as elements of a new production that is very different from—although influenced by—the song that the samples were taken from, and (3) new compositions that imitate the music of an earlier era by making use of tiny, in themselves insignificant sampled fragments—such as drum hits, horn stabs, and guitar riffs—building on their distinctively "retro" sound as well as vintage instruments and studio technology besides drawing on harmonies or rhythmic patterns.

In terms of copyright law, there is not a substantial difference between digital sampling and the more abstracted kinds of musical borrowing composers engage with regard to their potential to be criminal. They infringe a different set of rights unless an agreement is reached with the rights owners: borrowing has to respect the composers' and authors' rights to be credited, to maintain the integrity of their compositions and lyrics, as well as the right to the benefits drawn from these, whereas sampling also has to take into account the rights of particular performers and the owners of the original sound recording.

Even in their own times, Bartók's and Kodály's appropriative practices would have been seen as morally wrong and criminal without the

permission of the copyright holders if they chose to borrow from relatively contemporary art and popular music. However, at that moment in history, it seemed unproblematic to borrow freely from a "common" musical heritage, something that was passed on for generations without barriers of the "rights talk" that arose from an individualistic notion of authorship associated with creative geniuses and the commodification of music that went hand in hand with it. I shall soon discuss the reasons that make such an ignorance of "collective folk/indigenous authorship" appear problematic today, but first I consider how the two Hungarian composers gathered the material they used in their compositions.

Bartók and Kodály went out to the "research field" themselves to draw "from the pure source"[2] of Hungarian folk music. They spent long months under very tough circumstances in different parts of the country (many of those places belong to Slovakia and Romania today) recording and transcribing the music of the villages in their search for the ancient Hungarian melodic treasure:

> In order to let this music grab ourselves with its full power—we need this if we want it to govern our composition—learning the melodies themselves is not sufficient. Seeing and becoming acquainted with the environment in which these melodies live is of equal importance. We have to see the mimicking of the singers, take part in their dances and funerals (i.e., all these special occasions have their special, often very typical melodies). I have to stress: our goal wasn't just obtaining melodies and mounting them in their wholeness or in part into our music and cover them in a usual way. It would have been the work of a craftsman and would not have led us to the creation of a new, coherent style. Our duty was feeling the spirit of this—until then unknown—music and create a musical style building upon this spirit that could be verbalized only with difficulty. It was so important to carry out the collection in the field ourselves, because we needed to get to know the spirit of this music correctly. (Bartók 1948a: 15–16)

This uniquely respectful engagement with the culture that surrounded the music is quite telling of the honest intentions and goodwill of these composers. Instead of taking the easy path of drawing on someone else's ethnomusicological research, or providing a shallow and easily digestible (mis)interpretation of folk melodies, Bartók and Kodály tried to understand the rural musical culture to present it in an undistorted, authentic

manner in their works. Instead of treating folk music as a mere subordinate raw material to a superior art music practice, they engaged with it on its own grounds. Their compositions emerged from a dialogue with (rather than a reading of) peasant culture. And they did so at a time when folk music was considered worthless, savage, and vulgar by even the intellectual leaders of villages who looked down on the culture of peasants in Hungary, not to mention the urban elite.

They went out searching for "raw material" and ended up thoroughly documenting and systematizing Romanian, Slovakian, and Hungarian folk music because they understood that it was the "final hour"[3] before modernization and industrialization completely transformed or destroyed the traditional way of life and culture in the villages. As the cultural elite of Hungary failed to recognize folk music as a valid and valuable form of culture, Bartók and Kodály had to finance this mission of preserving the national folk music heritage themselves for many years, knowing that their limited budget and time was insufficient for accomplishing their vision.

The First World War and the following peace treaty, which reduced Hungary to one third of its original size, put an end to their research project. The nationalist and revisionist politics and public attitude in Hungary was taken up by defensive and hostile nationalisms in the newly founded surrounding states. At that time Bartók and Kodály were already beyond their initial romantic nationalism; they recognized that folk music does not know clear national boundaries. Bartók was treated as a traitor and public enemy by the right-wing establishment for many years because of his interest in documenting and analyzing Slovakian and Romanian folk music, as well as for his often propagated idea that the ethnic groups living in and around the Carpathian basin should form a peaceful brotherhood. In an essay published in 1942, he argued against the Nazi "racial purity" position by explaining that the musical exchange of ethnic groups that lived in close proximity was actually mutually beneficial for their respective musical cultures (Bartók 1966).[4]

Apart from the amazing body of work Bartók and Kodály produced by building on the folk music they collected, they also successfully preserved and revitalized folk music that would have otherwise been lost forever. Although hip-hop producers never followed a similar conscious agenda, they brought back long forgotten soul, jazz, and R&B of the 1960s and 1970s into musical circulation in a similar way: through sam-

pling old records they have inspired other people to look for the original sources (Allen 1999). The demand for the original recordings that have been sampled in classic hip-hop productions has resulted in a wave of reissues and compilation albums containing music that has been out of print for decades. We could argue that sampling any kind of music does the same. It raises awareness, maintains these forms in the collective cultural memory, and creates new, contemporary forms of musical expression. By the time copyright stepped in to protect the original artists that have been sampled, hip-hop had years to develop into an internationally popular musical form. By then, the million-selling superstars of the genre—and the major music corporations that profited most from their sampled beats—could clearly afford to pay a share of the revenues to the people whose musical ideas they incorporated. However, the rights holder's right to name the price, the fact that the rights to the sound recording itself are most often held by major corporations, as well as the difficulties of sample clearance made sampling a troublesome, time-consuming, and often very expensive compositional method, beyond the possibilities of artists who operated on a small scale. Those outside the financial and legal support of recording industry majors do not have too many choices besides infringing copyright—trying to stay under the radar by maintaining a low circulation, not licensing their music for further uses such as advertisements to avoid exposure, or choosing obscure material to sample—or abandon sampling entirely.

In the light of the effects of copyright restrictions for sample-based music making, we can only speculate what would have happened to Bartók and Kodály if they had to get permission and pay licensing fees for the folk music they borrowed. Considering the relatively marginal commercial potential of their music—especially in the early decades of their careers as composers, and in Bartók's case, his lifetime—it is doubtful that they could ever have managed to realize the oeuvres we know today. Furthermore, if they had to pay a fee for every song they recorded and included in the heavy volumes that documented their work, their important archivist projects would have been doomed to failure simply because they lacked funds. At this point, we could feel tempted to say: copyright constraints must go!

The Politics of Musical Borrowing after Colonialism

Still, collecting folk music and reusing it in new compositions has never before seemed as problematic as it does today. In an extraordinary essay, ethnomusicologist Steven Feld (2000) argues that processes in the age of globalization, the increasingly effective technologies, and strategies of commodifying music and difference have radically changed the context of such musical appropriations: "[The] escalation—of difference, power, rights, control, ownership, authority—politicizes the schizophonic practices artists could once claim more innocently as matters of inspiration, or as a purely artistic dialogue of imitation and inspiration" (Feld 2000: 265). By tracing different appropriations of Central African songs across various genres, he demonstrates two interrelated processes of music reproduction that split sounds from the original contexts and inject them into the unpredictable global circulation of music commodities:

> The primary circulation of small-scale, low-budget and largely non-profit ethnomusicological records is now directly linked to a secondary circulation of several million dollars' worth of contemporary record sales, copyrights, royalties, and ownership claims, many of them held by the largest music entertainment conglomerates in the world. Hardly any of the money returns to benefit to or benefits the originators of the cultural and intellectual property in question. (Feld 2000: 274)

Ethnomusicological field recordings are easy prey for today's musical borrowers as easily and readily available depositories of distant sounds. These recordings are usually copyright protected, often "owned," rather problematically, by the record companies that issue them, rather than the people who performed the music they contain (Hesmondalgh 2000). However, the fact that often these field recordings are released by small-scale enterprises, rather than powerful recording industry conglomerates, makes them a lot less risky as sources of unauthorized appropriation than pop hits. Besides the rights holders' limited resources in looking for potentially infringing music and pursuing legal action against those people who might sample them, the limited circulation and lesser known status of these ethnomusicological records radically reduces the chances that unlicensed appropriations will ever be discovered. The problem, as Feld so rightly notes, is that people who make use of these musical ideas

might earn millions of dollars in today's global musical marketplace. One of the best known examples is Moby's use of a field recording of Vera Hall in his 1999 hit "Natural Blues" (Lindenbaum 1999). Neither ethnomusicologist Alan Lomax nor the natural blues singer could foresee where this recording would end up when Lomax's tape recorder captured it in Hall's kitchen in 1959. However, Lomax is said to have been careful to always sign contracts with the artists and send them their royalties regularly, even if they were most often as low as $5 or $15, due to low sales volumes. Lomax's relatives claim he lived on grants while he returned the profit he made on records to the artists and into funding his further research projects. Moby's *Play* album, which included the sample, topped the British charts for five weeks, while the song that centered around Hall's singing was licensed to a Calvin Klein advertisement without contacting or compensating either Lomax or the singer (Leiby 2000). The album contained numerous other samples. In the sleeve notes, however, he claimed full authorship of these songs—"written, produced, engineered, and mixed by Moby." It took threats of legal action from the rights holders he long ignored to later reduce his initial 100 percent authorship to 35 percent in favor of the publishers of the original artists (R. Osborne 2006).

Timothy D. Taylor (2001) describes a similar story in which Taiwanese singers Kuo Ying-Nan and his wife, Kuo Hsin-Chu, have only learned about the unauthorized reuse of their "Jubilant Drinking Song"—recorded during a performance in probably 1978 or 1979 and later released without their knowledge by the Chinese Folk Art Foundation—as the sample source of Enigma's million-selling 1994 hit "Return to Innocence" when it became the theme song of the 1996 Summer Olympic Games in Atlanta. They have not received any compensation for the song until, aided by a San Jose law firm, they filed a lawsuit against Michael Cretu of Enigma, who took full credit for the song ("San Jose Law Firm" 1998). The dispute was settled out of court after which the Kuos set up a foundation for the preservation of their tribe's culture and music ("Taiwanese Settle Lawsuit" 1999).

"It is this basic inequality, coupled with the production of negative caricature, that creates the current ethnomusicological reality: discourses of world music are inseparable from discourses on indigeneity and domination. As elsewhere, this means that aesthetic practices are being deeply felt and portrayed as markedly political ones" (Feld 2000:

274). Feld's argument registers the increasingly important problem of inequality that copyright is to solve—that is, how to balance the revenues from new musical products between originators and borrowers—but goes beyond it by positioning appropriations in the domain of identity politics. Musical borrowing practices are highly politicized: the most urgent question is whether the indigenous people have control over how they get represented through uses and abuses of their music.

Not being named as authors of the music they have created can in itself feel humiliating. It can read as a declaration of the "primitiveness" of their art, a statement of unworthiness. However, there are appropriative practices that often go hand in hand with such neglect, that shatter the unity of music and use their fragments as exotic seasoning over club music or advertisements for ready-made ethnic food products, cars, or home insurance. In many cases, such decontextualizations can upset the people who value and cherish this music in their everyday lives and rituals. Other times, these musical fragments are blended with other sounds—like rap lyrics propagating violence or expressing sexist or homophobic sentiments—that appear problematic for those who are attached to the original music.

The lack of respect for—and ignorance of—the original social meanings and uses of indigenous music is apparent in accounts like that of Banco de Gaia's Toby Marks who gives little if any consideration to these issues: "Other times I stockpile stuff and when I'm working on a tune if I need a male Arabic vocal to fit a section I'll see if I have anything which would be suitable" (Taylor 2001: 153). What appears to be a practical method of music making from the perspective of the producer that needs samples to "fit a section" and evoke a certain mood or image of a faraway place or people can equally easily be condemned as exoticization, the reduction of musical meaning to the level where the appropriated fragments only signify otherness or cultural difference,

Michael F. Brown's *Who Owns Native Culture?* (2004) describes how indigenous groups struggle today to establish copyright-like tools that build on the concept of collective authorship to police the use of their cultural artifacts, religious symbols, knowledge of biomedicine, or for that matter songs. Their attempts are a reaction to the processes described by Feld. Indigenous groups fight fire with fire, trying to stop commercial exploitation of their cultural heritage by appropriating Western con-

cepts of intellectual property and ownership. Furthermore, their efforts go beyond claiming an acknowledgment of their right to profit from uses of their cultural knowledge. In a way, they can be seen as similar to the strategies of big corporations that use trademark and copyright legislation as tools that allow them to maintain strong control over the ways and contexts in which their brand names and products might appear (McLeod 2007). Whereas these corporations abuse intellectual property rights to pre-empt or silence unwelcome opposition, criticism, and commentary on their brands and commodities, indigenous groups claim collective authorship over their cultures as a way to stop offensive or exploitative appropriations of their symbols, songs, and stories. Although intellectual property rights are used in both cases to limit the freedom of expression, the stark differences in the amount of power and wealth at the disposal of these two different kinds of rights owners makes such attempts more acceptable from indigenous groups that have been robbed and abused culturally and economically for centuries.

Besides the need to be protected from commercial exploitation and misrepresentation, there are other, less obvious but equally serious reasons that make such struggles over claims of collective authorship understandable, such as the existence of secret songs that function as boundaries that maintain/signal social hierarchies within a community or differentiate tribes. Ethnomusicologist Anthony Seger (1997) tells the story of the Brazilian Suyá tribe's songs that members of the tribe must by all means keep secret from other tribes. These songs are the very foundations of their identity as group members. There are further reasons that are beyond the grasp of Western rationality, and yet are very real and extremely serious to many indigenous groups. These are related to songs that operate in the realm of the sacred. Sampling these songs might not just be a seriously offensive act, but could be seen — at least by the members of the group — as potentially dangerous to the uninitiated or unauthenticated. Some of this is music that is assumed to have the power to kill (M. F. Brown 2004).

In the remainder of this section, I look at the appropriative practices of Bartók and Kodály in the light of these recently emerged concerns. Of course, it would be wrong to judge them retrospectively against the knowledge and insight that was opened up by postcolonialist thinking. Whereas the foregoing problems seem so obvious to us today, they were

partly rendered invisible by the discourse of their episteme, partly arose only later as a result of developments—like the extent of and effect of the commodification of music—that had been then impossible to predict.

In the previous section, I presented Bartók's and Kodály's good intentions and respectful engagement with the cultural context and content of folk music, in practices of collection and composition. Their approach would probably make even the most dedicated anti-colonialists sympathetic toward their efforts, although the question still remains: how have the folk singers and musicians and their communities benefited from having their songs and music recorded and turned into new compositions? The singers and musicians usually asked for some fruit brandy or wine in exchange for their music, although the ways and extent of the creative reuse of these melodies were yet unsure even for Bartók and Kodály at the time. Furthermore, the range and fate of commodities that were built on these recordings—printed and recorded folk music anthologies, sheet music, and records of derivative compositions—were also unforeseen even by the ethnomusicologists themselves. However, this didn't mean that the peasants were naive or completely unaware of potential profit. Kodály wrote:

> There have certainly been instances when peasants received us with suspicion. Village folks had been duped and disappointed by the city so many times that their distrust for strangers in urban clothing was no wonder. It wasn't so bad if you traveled on foot, but when you needed a cart for the phonograph-equipment they immediately suspected some sort of villainy, or smelled business. They have even asked me: "Tell us, what do you get for all this, mister?" (Kodály 1974b: II:457)

However, singers and musicians always received the modest compensation they asked for from Bartók and Kodály, even though they were not the authors of the music they played, and neither of the composers made a fortune in their lifetimes from the copyrights of their works that appropriated folk music. Despite his current status in the history of art music, Bartók died in poverty in his exile in New York toward the end of the Second World War. Kodály lived a long and full life as a respected music teacher, but his benefits from folk music appropriation were modest compared to the revenues of today's pop superstars. Furthermore, Kodály's and Bartók's reinterpretations and appropriations of folk melodies went against the grain. In their search for innovative but still au-

thentic folk classical fusion, they created music that was less commercially marketable than if they had just written popular songs. They were definitely concerned about giving credit to the folk groups who lent them their melodies. Kodály's condemnation of a composer who used a folksy church song without giving credit is quite telling:

> The melody above has appeared a few years ago as the work of Menyhért Litkey in *Szent karácsony* (Holy Christmas), a church music publication. The few notes that Litkey changed does not grant him copyright [to this song]. Litkey couldn't compose this melody, if for no other reason, than because it is recorded with insignificant differences in Ádám Horváth's 1814 manuscript collection. (quoted in Eősze 1956: 45)

Calling authors like Litkey "parasites of folk music" (ibid.), it was obvious that Kodály was furious about the case.

We could thus say that Bartók and Kodály were trying to be as fair and respectful as possible by the norms of their time. Because they mostly appropriated music of Hungarian folk groups, their practices could be also conceived as what Feld describes as "a brother's kind of thing" in the context of Afro-American borrowings from African musics, where the imagination of a shared identity and common heritage can be evoked to legitimate these compositional methods as being rooted in the precopyright word-of-mouth passing down and reinvention of musical traditions.

Whatever we make of it, the folk groups that gave Bartók and Kodály their music are almost all nonexistent by now. They have mainly assimilated into the Hungarian, Romanian, and Slovakian societies, and only a handful of heritage preservationists keep these folk cultures alive. Even if it was possible to give back the rights of the appropriated songs, there would be no one left to reclaim them. Even if these cultural groups were still intact and vital, the question of selecting the appropriate representatives for each who would negotiate the terms in the name of their people would pose immediate problems, since the boundaries between cultures are fluid and constantly changing. In fact, the fuzzy boundaries and the internal diversity of indigenous cultures, coupled with the challenge of how to choose legitimate representatives, make claims to collective "ownership" for cultural groups highly problematic on a practical level.

What we have left beyond and after these dilemmas is an archived

body of folk music assembled by these composers and their compositions that evoke this rich heritage when performed.

So What Do We Do with Our Samplers at This Point?

As we could see in the previous section, copyright can work in some cases to protect the rights of indigenous musicians and singers, especially if appropriators have already earned enough money that a law firm would be willing to help indigenous artists for a percentage of the compensation. However, at the same time it might make respectful appropriations complicated, while not necessarily guaranteeing that the licensing fees benefit the people who performed on the original recordings, as David Hesmondalgh's account of sample clearing difficulties at Nation Records clearly shows (2000). Such hindrances might demand more resources and effort from artists who aim to develop a sample-based body of work comparable in extent to Bartók's or Kodály's in a manner that is respectful and fair to the original artists. Some of the well-meaning musicians could be discouraged from such appropriations due to the costs imposed by settling collective copyrights. Others with no such ethical concerns could infringe these rights without taking too high risks of persecution, knowing that the copyright owners can do little to stop them, as they (1) might never hear their music, (2) might lack the financial resources to fight a legal battle against music industry giants, (3) might not have clear leadership to represent them, or (4) might not have clear boundaries to be recognized as a group.

Even so, copyright only protects already recorded works from being taken apart and reused as actual samples in new works. If musicians choose to appropriate words or melodies of folk music by writing new arrangements, imitations, or interpretations, they are usually not bound by legal obstacles. They can credit the source of their appropriative works as "traditional"—if they are considerate enough not to claim full authorship for them—since these works are technically in the public domain, and musicians are not obliged to ask for permission or pay compensation for their use.

Shall indigenous groups gain more protection for their musical cultures by extending copyright, introducing the notion of collective folk authorship? Instead of arguing for a copyright-like universal and necessarily inefficient legal means to settle the rules of appropriation of in-

digenous knowledges and cultural forms, Michael F. Brown proposes a case-by-case negotiation between the appropriator and the representatives of the native group. Brown suggests four issues to consider during this negotiation process, in which the involved parties have to come up with solutions they all feel are fair: (1) notions of authority, (2) giving credit, (3) the effect and significance of the new work, and (4) commercial interest. This proposal might read as naive and idealistic in the face of contemporary musical practice if we mistake it for tool or method that would automatically *guarantee protection* against unfair appropriations to powerless indigenous groups. In fact, it is more like a road map, a potential model for appropriators who would like to borrow from other cultures in a manner that is fair and respectful in the moral labyrinth of postmodern/postcolonialist musical fusion. These are flexible guidelines, rather than clear and enforceable laws. And as we will see, they do not even provide an easy, practical solution to resolving the ethical dilemmas that emerge when folk music is reused in some form.

Following Brown's proposal, one way of fair appropriation is sampling from ethnomusicological recordings and then tracking down musicians or their heirs, and talking through the issues. Of course, this might not always be possible, even if we don't consider the often prohibitive costs such attempts might involve. In many cases, the names of the contributing artists are not mentioned on the sleeves of the sampled ethnomusical recordings. Other times, the musicians and singers have been lost without out a trace in the mists of history. Shall a new composition remain unpublished because of these banal reasons? While one tries to locate or credit a sampled artist, the middle man—like a record company—that holds the rights to the sound recordings might appear and demand compensation. Shall we pay licensing fees to these go-betweens if we find out they have never paid the original artists for their efforts and our license fees will most probably never benefit the indigenous performers? After successfully locating the people whose music we would attempt to sample, reaching an agreement with them might still prove impossible. In this case, clearly, the appropriating work shall never be released, but taking this risk is part of trying to be fair and respectful. But what shall we do if the negotiation process runs to a halt because of the unrealistic claims of greedy heirs who might never have had a good relation with the deceased artist?

Instead of entering the legally complicated and ethically troublesome

field of sampling prerecorded music, we can also choose to record ethnic musicians and use the session material as the source for our sample-based productions. This is exactly the path Nation Records artist Muddyman followed:

> Ethically, I do have a problem with sampling. Wherever I go, I meet lots of musicians and I hire them for a session to come and play in my room or whatever. They go away happy, they know what I want to do with them and you know I pay them, because it's impossible to pay royalties on things like that, so if they go away happy, and I'm happy, then there is no problem on either side. And I hope records continue to sell, and I can fund more trips to go away. (quoted in Hesmondalgh 2000: 291)

Instead of fruit brandy or some wine, Muddyman pays the fees he can afford for these sessions; musicians have a chance to listen to his earlier compositions and decide whether they would like their music represented in such a context. Still, in some cases, the über-commodified musical world is so far beyond the horizons of the indigenous musicians that they are not fully aware of even the most immediate consequences that are at stake. Even the people who are the most up-to-date regarding questions of music business and technology might not see how the circumstances could change in the mid and long term. Just like Bartók, Kodály, the Hungarian peasants, Alan Lomax, or Vera Hall, no one knows for sure the fate of Muddyman's recordings: although now unlikely, they can became million-selling hits by accident in two years, licensed for advertising campaigns from Muddyman's heirs fifty years later, or become unauthorized sampler fodder to enter radically different and ever more unpredictable musical contexts.

As Feld's (2000) essay so clearly shows, there is no golden rule, an easy and best way of going about appropriating folk music today. There are only better and worse, careful or less considerate, fair and unfair attempts. Bartók's and Kodály's stories make a strong case that speaks volumes about the potential of new works and ideas that arise from appropriative engagements of folk music. Their legacy suggests that we shall not stop borrowing from the sources of indigenous cultures, only because it is morally so complicated that we most probably never get it perfectly right, and our new works will appear problematic in unforeseen ways in the future. The most important lesson they teach us is that such a decision must not mean a complete neglect of the ethical problems that

we can see today. Those who follow their lead shall try to be as fair and respectful in their engagement with folk music as their current circumstances and understandings of these concepts allow.

Discography

Anima Sound System (1995) *Shalom*, CD, private issue.
Béla Bartók (1930/1992) "Cantata Profana" in Pierre Boulez, (conductor) and the Chicago Symphony Orchestra *Cantata Profana/Wooden Prince*, CD, Deutsche Grammophon.
Enigma (1994) "Return to Innocence" in *The Cross of Changes*, CD, Virgin.
Moby (1999) "Natural Blues" in *Play*, CD, Mute.
Vera Hall (2003) "Trouble So Hard" in Alan Lomax (comp.), *The Blues Song Book*, CD, Rounder Select.
Kuo Ying-Nan and Kuo Hsin-Chu (n.d.) "Jubilant Drinking Song" in Various Artists, *Polyphonies vocals des aborigines de Taïwan*, CD, Francophonie/Alliance Française.
Various Artists (1998–) *The New Patria Series Vo1.1–*, CDs, Fonó.

Notes

1. According to László Dobszay: "Kodály never gave a written summary of his views on the use of folksong in art music, but if one gathers the remarks he made on various occasions, it becomes clear he held similar opinions to those Bartók's expressed in his well-known programme statements" (1982: 303).

2. This expression has first appeared in the lyrics of Bartók's "Cantata Profana" (1930/1992) and was later on picked up by Kodály and others and became the motto of the folk music revivalist movement in Hungary. Of course, such an essentialist imagination of an "authentic" and "pure" folk culture is clearly problematic today. Julie Brown (2000) makes this point looking for traces of colonialist and positivist discourse in Bartók's rather dismissive writing on "gypsy music"—an umbrella term for folkish urban popular music often penned by white Hungarian composers and performed by Roma musicians in restaurants and other places of entertainment—as primitive, wild, corrupted. While the issues she raises are clearly important, the lack of effort in trying to situate and understand Bartók's position on the term of its epistemic possibilities and boundedness makes her criticism troubling. Apart from its retrospective moralizing, Brown's work fails to look at the larger context of Bartók's argument: the relatively contemporary "gipsy music" he attacked was widely believed to be *the* authentic folk music at the time, whereas the peasant music of villages he and

Kodály tried to document and promote was unknown or neglected as primitive or vulgar. Although exoticizing tones and essentialist or purist arguments are clearly present in Bartók's description of the way gypsy musicians perform and transform Hungarian music, Brown shows little if any sympathy for the fact that Bartók talks from the position of the underdog trying to get peasant music recognition as an important part of the nation's cultural treasure. Although her criticism makes the composer look like an uncritical and committed follower of nationalist discourse, it is worth mentioning that he was under constant attack from nationalists from the early 1920s on because of his studies of the musics of other ethnic groups in the Carpathian basin that were seen to have undermined the Hungarian positions when the new boundaries were negotiated with neighboring nations, particularly Romania, after the First World War.

3. The long-lasting influence of Bartók's and Kodály's preservationist insight is clearly indicated in the official description of the Final Hour project that set out to record and document the folk music of Transylvania before it completely vanished. Ethnologist László Kelemen and his colleagues managed to record more than 520 CDs worth of music following the footsteps of Bartók between 1997 and 1999. Some of this music is being released on a series of forty-eight CDs with accompanying booklets. The project description is quick to mention that it is of course debatable that we are in the final hour even now, as they found a vital and living folk music culture in Transylvania almost a century after Bartók's visits.

4. The main argument of this essay—"'racial impurity' has a definitely beneficial effect"—is quoted in the booklet of the first CD by Anima Sound System (1995), a band famous for blending electronica with folk music.

A Day to Sing

Creativity, Diversity, and Freedom of

Expression in the Network Society

Now we can talk about it as the Obama moment: that fever dream of the fall of 2008. After forty years of racialized, reactionary electoral politics—think of how Nixon and Wallace courted the "silent majority" in the 1968 elections, securing 57 percent of the vote and shaping presidential elections hence—a *new* majority of Americans surged to the polls to elect a biracial black man from Hawai'i as their president. After this triumph of diversity over monoculture—and while we can argue over its nature and quality, we cannot deny it was a triumph—the euphoria only seemed to begin. On Barack Obama's inauguration day, Tom Brokaw compared that exhilarating season culminating in his victory to Czechoslavakia's Velvet Revolution of 1989.[1]

Pundits cited anxieties over the deepening economic crisis; John McCain and Sarah Palin's tone-deaf, dissassembling campaign; and Obama's sure-footed electioneering as some of the forces driving the electorate toward its epochal vote. But what about the outpouring of creativity in those shadow-lengthening days? The sudden proliferation of posters prophesying hope and change and progress, the streets full of teens wearing Barack's face on their chests like they had once worn Tupac's, the YouTube videos from celebrities and desk jockeys alike, the tsunami of new songs and mix tapes, even the kitsch—the coffee mugs, the key chains, the candle holders. Corporations could not have concocted a better example of synergy.

Moments of massive social change are feats of collective imagination. They must always be accompanied not just by expressions of unrest and

risk but by explosions of creativity that are both the effect and the cause of further expressions. The Velvet Revolution stretched toward scale after actors, theater workers, writers, musicians, and their organizations crucially joined students in Prague on strike. Of course, the icon of the revolution was Václav Havel, the Velvet Underground fan in whom politics and poetry came together. We must always account for creativity in crafting our visions of freedom.

Creativity is the primary human force that has driven change in and across diverse communities, cultures, and states. Particularly in the past three decades, forms of creativity have played a central role in accelerating the global economy. The rise of the networked communications environment has unleashed creativity and innovation. At the same time, the rise of the neoliberal economic order has concentrated culture industries and increased pressures on the public commons. In the networked world, culture pours through national boundaries, diverts the desires of the body politic, and subdues the urgencies of the state. In the irrationally exuberant market for Chinese art of this past decade, we saw one mood of the boom. Capital from around the world floods auctions for artists barely a generation removed from Maoist centralism. In a short period of time, artistic expression has skipped from artifact to "content" to pure speculative object—and in the process, its value has soared.

At the same time, creativity has been cheapened. The networked world enables more fluid and efficient distribution and exchange of artistic and cultural expression across borders and cultures. New forms of creativity emerge—such as the infinitely pliable form of the mix/remix, a process that in itself can be radical, an act of harnessing networked cultural flows that may pit creativity against commodification. But markets treat arts and culture like "information," the basic unit of the networked world.

Reduced to content to fill the new channels created by technology, creativity's value has largely been left to the marketplace. Markets do a poor job of representing the true value of artistic and cultural expression. Performance-based arts tend to be valued less than forms of art that can be mass-produced. Many cultural expressions have no transactive value at all but are necessary to the functions of a community or people. Culture industries may value a certain amount of diversity of expression; the demand for new sensations never ceases. But in the marketplace, expressions that enhance social status via scarcity or facilitate the sale of other

commodities accrue the most value. Arts and culture are thus reduced to expressions of a lifestyle economy.

Aesthetic production, Fredric Jameson reminds us, is now increasingly important to commodity production (Jameson 1991: 4–5). We have entered a period in which the market-dominant view of arts and culture and the market-dominant view of the networked world have converged. Can global policy balance competing needs? Many, alarmed with the velocity and direction of change, have returned to the right to freedom of expression articulated in Articles 19 and 27 of the Universal Declaration of Human Rights to guide new agendas to address growing inequities between peoples and nations. The important UNESCO report, *Our Creative Diversity* (1995), affirmed culture's central role in national development and strongly warned against understanding development as serving only material improvement. "Culture's role is not exhausted as a servant of ends," Javier Pérez de Cuéllar wrote in the report, "but is the social basis of the ends themselves" (1995: 15). He continues, "Cultural freedom guarantees freedom as a whole. It protects not only the group but also the rights of every individual within it. Cultural freedom, by protecting alternative ways of living, encourages experimentation, diversity, imagination and creativity. Cultural freedom leaves us free to meet the need to define our own needs. This need is now threatened by both global pressures and global neglect" (ibid.).

The cost to peoples and nations of a market-based view of culture may be the homogenization of cultures and the destruction of cultural diversity. Unchecked market power over artistic and cultural expression may undermine the right of self-determination and the basis of social coherence. "Freedom of expression" is often described as a positive right to receive and disseminate information and ideas, as well as a negative right preventing curbs to their flows within society. But freedom of expression may also describe aspects of artistic and cultural expression that encompass their inspiration, production, dissemination, and reception. In light of this, it is important to reaffirm and articulate an expansive notion of freedom of expression that includes foundational rights, such as cultural rights, communication rights, human rights, and moral and legal rights. For instance, how do we view a situation in which a corporation like IKEA has appropriated Native American basket weavers' unique tribal patterns for mass-produced knockoffs? Is IKEA merely "remixing"? Or are

the rights of the Native Americans being abridged and the imperative of cultural diversity being harmed?

Or take the case of "pygmy pop." Steven Feld outlines a process by which field recordings of Central African pygmies have opened up musical possibilities for artists as diverse as Herbie Hancock, Madonna, and Deep Forest.[2] Hancock tells Feld that Bill Summers's introduction to the Headhunters' version of "Watermelon Man," in which Summers imitates a pygmy papaya stem whistle song from a field recording in 1966, is a case of "a brother's kind of thing . . . we're all making African music." Feld recognizes the validity of what he calls "transcultural inspiration," but he cautions that "'taking without asking' is a musical right of the owners of technology, copyrights, and distribution networks" (Feld 1996: 14–15). Once the original recording was made, the expression became "the living mark that every relationship of copy to copied is an icon of unequal power relations" (Feld 1996: 16). Hancock and Harvey Mason get paid when Summers's sounds are sampled by Madonna, not the anonymous pygmy whistler. Feld raises difficult issues around creativity, responsibility, and freedom of expression.

Over the past two decades, consensus has emerged in international circles on the need to assert freedom of expression to protect cultural diversity. In the early 1990s, as transnational media consolidation and free trade agreements began to tie together national markets into a new global system, many began to discuss the need to devise a counterbalancing system of agreements and instruments that would protect and promote cultural diversity at the local, regional, and national levels. In 2005, UNESCO passed the Convention on the Protection and Promotion of the Diversity of Cultural Expressions. The existence of cultural diversity is now widely recognized as crucial to the realization of human rights, minority rights, freedom, and peace. A rich and broad range of artistic and cultural expressions often signals the presence of unfettered creativity and healthy societies.

Clearly, rethinking freedom of expression can converge with this ongoing project of recentering cultural diversity. If we understand artistic and cultural expression in the networked communications environment only as content for the global economy, we apprehend only a part of their true value and misapprehend how market pressures distort, marginalize, or eliminate many kinds of expressions. Although the networked world provides unprecedented opportunities for intercultural understanding

and respect, it may also create more inequities and exacerbate tensions. I argue that our reconsideration of freedom of expression must include a commitment to the fostering, protection, and promotion of the diversity of artistic and cultural expression if we are to realize a brighter future.

Artistic and Cultural Expression in the Networked Environment

By the late 1990s, it became fashionable, even clichéd, to argue that "content is king." Technological change demanded a vast amount of artistic and cultural expression and gave new power to what were formerly considered mere niche markets. In popular music, formerly marginalized genres such as hip-hop and country were suddenly validated, and a wide range of new artists spread into the mainstream.[3] In the arts world, a new flattening of hierarchies and a do-it-yourself aesthetic seemed to proliferate. Visual artists, now given more tools to distribute their work, were more empowered than ever to critique the role of the curator as a career-making or -breaking gatekeeper. At the same time, by affording broader access to artistic expressions than ever before, the networked environment also helped create bullish art markets and reinforced the role of the curator to fabricate new superstars.

Creativity is now seen as the engine of the new global city, the linchpin of twenty-first-century urban economic development. A new body of literature argues that successful cities receive an "artistic dividend" and the multiplier effects of vital culture industries (Markuson and King 2003; Currid 2007). But many suggest the effects go much further. In documenting the rise of what he calls "the creative class" in America, Richard Florida correlated social tolerance with innovation and development. He found that metropolitan areas that allowed gay communities to flourish also tended to boast a strong presence of "creatives" (Florida 2004: xxviii). In other words, a city's cultural diversity spawned expressive diversity that, in turn, bred success in the new global economy. Florida's thesis is now accepted in many policy circles. (It could be argued that this thesis has justified plans and policies that have exacerbated tensions between artists and long-standing poor communities and communities of color. If artists were once the drop-out edge of bohemia, they now are often seen as the leading edge of gentrification [see Solnit and Schwartzenberg 2000].) More research needs to be done on what specific types of poli-

cies are most effective, especially given uneven development around the world. Indeed some have proposed the notion of "creative communities" as a developmental model over Florida's "creative class."[4] But the new literature suggests that policies that foster expression in the networked world hold promise for overturning unjust power structures, empowering marginalized individuals and communities, reinforcing values of tolerance and innovation, and advancing economic development.

Still, the Convention on the Protection and Promotion of the Diversity of Cultural Expressions took care to note that "because they convey identities, values and meanings," arts and culture "must therefore not be treated as solely having commercial value." It stated explicitly "that while the processes of globalization, which have been facilitated by the rapid development of information and communication technologies, afford unprecedented conditions for enhanced interaction between cultures, they also represent a challenge for cultural diversity, namely in view of imbalances between rich and poor countries" (UNESCO 2005). First world media, culture, and entertainment industries reinforce such imbalances. Brazil's film industry, for instance, holds only a 13 percent market share in its own country (Smiers 2003: 190–91, 206–7; Gil 2007a). Despite policies to protect and develop their indigenous film industries, countries such as France, South Korea, and Canada have often been thwarted by Hollywood's size, which affords economies of scale in production and lobbying powers to enforce dominance via international trade agreements (Neil 2006).

Over the past two decades, major trade agreements, at the insistence of France and other nations, have included the so-called cultural exemption, meant to treat artistic and cultural products differently from other trade goods (Beale 2002: 78–85). However, the World Trade Organization has often ruled against protecting countries (Neil 2006). Together, international trade agreements and bodies favor the development of global cultural oligopolies or monopolies over the development of local, national, or regional diversity. In this context, the networked communications environment is not neutral. Market imperatives overpower cultural imperatives. Consider the example of Africa's recent experience with media giant Viacom. For years, many African musicians—particularly younger ones in emerging styles not recognized by the first world catchall category of "world music"—had to leave the continent to be discov-

ered. Africa was largely without a music video network until the arrival of Viacom's MTV Base Africa. A youth-oriented music network that bridged the rich musical scenes across the continent was welcomed. Some spoke of its potential for catalyzing a new form of pan-Africanism. In practice, MTV Base Africa launched in 2005 in fifty African countries with only 30 percent African content. (Executives set merely 50 percent as their long-term goal.)

MTV Base Africa quickly became a staging ground for a number of companies selling consumer goods, especially (and not incidentally) cellular phone companies hoping to tap a large generation of unwired youths. In Nairobi, a British conglomerate swooped in to purchase the city's largest pop music station. Before long, politicized Kenyan hip-hop groups were displaced from the airwaves by the likes of 50 Cent, the American rapper whose name sells not just music but movies, video games, shoes, clothing, and Glaceau Vitamin Water. The rise of MTV Base Africa undoubtedly creates the opportunity for more African music to be heard in the global North. MTV Base UK now receives packaged shows from them. But the overall effect may be one of flattening diversity and difference. Groups like Kalamashaka (Kenya's Public Enemy), who have been displaced in favor of more consumerism-friendly acts from abroad (and indeed, from home, as MTV Base Africa plays more African music), are no better off than they were before.

The growth of the global creative economy has required new regimes of power. Intellectual property—through copyrights or "author's rights"—is the regime by which media-culture-entertainment monopolies and oligopolies exert power over artists, culture producers, communities, and nations. While the networked environment has produced new distribution models—most notably in pay-what-you-like music downloads offered by artists like Radiohead and Saul Williams in 2007—the price of mass distribution for most pop musicians remains their copyright. Even publicly funded organizations, such as university publishers, routinely require an author to turn over a manuscript and copyright without compensation. Universities sometimes also compel scientists to give up rights to patent claims to practice their research there. As such, intellectual property, a terrain where communication rights and cultural rights intersect, has become a primary battleground for freedom of expression activists, particularly those in the first world.

Intellectual property issues turn on fixed assumptions of individuality, originality, and ownership. In hip-hop and other African American popular musics, for instance, U.S. case law on sampling has privileged corporate copyrights over artists' creativity, in no small part due to racialized views of the artists. An alternative reading of the case law might recognize the emergence of American music—blues, jazz, country and bluegrass, rhythm and blues, rock and roll—from out of a flurry of intercultural, intergenerational, and interracial borrowings that Eric Lott has called "love and theft" (a term Bob Dylan—whose artistry he himself acknowledges includes the skill to borrow well—has lifted without ensuing litigation). We now confront the absurd scenario that artists like George Clinton and Public Enemy—mutual admirers who believe strongly in maintaining generational continuities within African American popular music—are unable to share samples because they have been blocked by the publishers and record companies who own the rights to their music.[5] In this instance, companies and courts are not just closing off paths of creativity, they are enclosing cultural legacy. To further complicate Feld's interrogation of Herbie Hancock and the anonymous pygmy whistler, I pose this question: what happens when a community's body of cultural expression is no longer accessible to them?

Stated simply, there is an important difference between the market value for an expression and the nonmarket values embodied in that expression. Market value is preserved for corporate extraction. Over the long run, a market-dominated networked communications environment has an incorporating (not an inclusive) and rationalizing arc. But what of, say, the cultural value of "passing on" between generations of African American musicians (or of African musicians)? Artistic or cultural movements that resist the logic of the marketplace are increasingly difficult to place. Could hip-hop—a movement that developed for almost a decade out of the eye of culture industry capital—emerge these days? Might artists, like Public Enemy, who push aesthetic or ideological boundaries attain the same access to distribution that was possible when the culture industries were less developed? In the most negative reading, it appears that no less than our imagination is being privatized.

Some warn that disturbing new social fissures may be the result. Former U.S. National Endowment for the Arts head Bill Ivey and scholar Steven Tepper argue,

America is facing a growing cultural divide, a divide separating an expressive life that exudes promise and opportunity from one manifesting limited choice and constraint. It is not a gap marked by the common signposts—red versus blue states, conservatives versus liberals, secularists versus orthodox. And it is more embedded than the digital divide that separates citizens from technology. It is a divide based on how and where citizens get information and culture. (Ivey and Tepper 2006: B6)

The cultural elite has the access to the tools and fruits of creativity, whereas a new cultural underclass is locked away from the new economy and its cultural past, while being superserved by niche programming.

The elite minority is offered a dizzying array of cultural choices that bring them into civic engagement, whereas the underclass majority becomes passive cultural and political consumers. Although they speak of the United States specifically, Ivey and Tepper's warning may also force us to rethink the effects of cultural access gaps between nations or communities. Paradoxically, the centrality of arts and culture in the new global economy forces us to reconsider their importance in freedom of expression. Focusing on the nonmarket value of arts and culture helps us think about how to foster, promote, and protect the diversity of cultures. How would it look to have a creative economy balanced toward protecting and promoting the diverse creativity of artists and communities instead of the marketplace values of global oligopolies and monopolies?

The Nonmarket Value of Artistic and Cultural Expression

Although artistic and cultural expression have sometimes been conceived of as projects for political or social change, often, even within those projects, they spill past categories bound by rationality. Indeed, when political movements are exhausted, blocked, or corrupted, social attention and energy may shift to cultural movements that forge new imaginations. The best expressions, of course, carry deep meaning. They may herald a renaissance of a people's traditions. They may give voice to previously inarticulate silences. They may cohere or fragment identity. They may encapsulate the fulfillment of human potential. As Lewis Hyde reminds us in *The Gift* or The Adverts in "One Chord Wonders," artistic and cultural expression creates encounters that are more than mere

transactions. Art and culture grow when shared. Hyde writes, "The gift that is not used will be lost, while the one that is passed along remains abundant" (2007: 26)

By catalyzing reaction, enjoyment, or even disdain, creativity becomes the gift that keeps on giving. Artistic and cultural expression can always be said to be enacted within the space of the commons, autonomous from the logic of economics and politics. Expressions from even the most reclusive of artists become, in fact, acts of community-building. Jonathan Lethem calls these gifts "ghosts in the commercial machine" (2007: 39). In 2003, Gilberto Gil, the legendary bard of *tropicalia* imprisoned thirty-five years by the former authoritarian Brazilian regime for his music, was appointed that country's minister of Culture. On accepting the appointment, he poetically described the primary charge of cultural policy: to locate "the area of experimentation towards new directions," forge "the opening of space for creativity and new popular languages," ensure "the availability of space for adventure and daring," and secure "the space of memory and invention." Freedom of artistic and cultural expression means accounting for the expressions that don't travel well, don't sell much, don't play nice, don't obey rules, don't fit in, and may not even want us, but that we all need, indeed, to reaffirm and advance the very idea of "we."

Indigenous perspectives perhaps most vex dominant conceptions of freedom of expression in the networked world. For instance, at a Freedom of Expression Workshop organized by the Ford Foundation in Indonesia, *kumu hula* Vicky Takamine Holt reframed the intellectual property discussion. In the instance of many Hawaiian chants, authorship is thought to be collective and expression converges with cultural knowledge and spiritual practice. To put it in Western terms, a *mele* (song or chant) is a performance, a database, and a prayer, all at the same time. How can an expanded notion of freedom of expression remove all barriers for the mele to do all of what it needs to do at once? Just as a mele can be considered a database of genealogies, histories, or natural resources, not all lyrics of a mele yield all levels of interpretation. Meanings referring to sacred knowledges may be hidden in plain sight. But those knowledges are not meant for consumption or use by noninitiates. Does freedom of expression also include the freedom not to participate in the networked environment at all?

What about instances in which freedom of cultural expression re-

quires restrictions on flows of information and knowledge? In northern Australia, the Warumungu people recently established a database of early twentieth-century photographs that uses digital rights management to regulate who can see what images. The Warumungu worked with a U.S. designer to design the Mukurtu Wumpurrarni-kari Archive according to their customs and practices. Because Warumungu cultural practices restrict some from viewing the deceased or sacred objects, community members log in to the database through a profile that includes information age, gender, and status; based on their profile, they are granted the appropriate level of access.[6] How do advocates of freedom of expression account for the reality that, especially in the case of some indigenous peoples, not all information wants to be free?[7] This chapter's main focus has been to unpack the key dimensions of artistic and cultural expression. Moving forward, the questions may become: how do we define the freedom part of "freedom of expression"? Whose freedom is it, and what is that freedom for? What freedoms do we protect, and what do we prevent?

Cultural Diversity as a Bulwark
Against Inequity and Violence

Gil's post as Brazil's minister of Culture has been one of the most visionary tenures in cultural policy leadership the world has seen in recent memory. He has been among the most famous champions of ideas such as the Creative Commons license and the UNESCO convention on diversity (which he once memorably framed in terms of his country's richly polycultural pop music heritage). His national policy initiatives have also been notable. One of his programs illustrates the great potential in the networked world. Called Pontos de Cultura—"Culture Points" or "Cultural Hot Spots"—Gil's program made strategic grants of equipment, resources, organizers, and teachers to hundreds of hip-hop education programs in favela and ghetto schools across the country, engaging young people in music, video, and Web production to tell their stories. Some documentaries made in these programs were accepted to air on national television networks. In rural and indigenous communities, Pontos de Cultura grants allowed tribal cultural practitioners to record their music onto audio and video.

"This burst of fresh air is unchaining new vital ideas, new innovative

productions, generating a real empowerment process of an emerging creative society. This process is encouraging and inducing the formation of a network of new cultural multimedia producers in Brazil, a network which will soon be consolidated into a new generation of authors and artists," Gil has said. "We have discovered that it is quite easy for our grassroots communities, those still living in a nineteenth-century reality, to understand the paradigm of the twenty-first century, as they can easily deconstruct the excluding features of the twentieth century culture while they pass through it" (Gil 2007b). Vandana Shiva notes, "The word 'culture' in Sanskrit—*sanskriti*—means activities that hold a society and community together. Violence breaks societies up, it disintegrates instead of integrates. The practice of violence, therefore, cannot be referred to as 'culture.'" She continues, "Living cultures are based on cultural diversity and recognize our universal and common humanity. Killing cultures are based on imperialistic universalism—a violent imposition of the cultural priorities of an imperial power" (2005: 109–19).

I take the primary end of this process of revisiting freedom of expression to be the growth and spread of living cultures. As such, I have tried to elaborate on some of the challenges and opportunities that the networked communications environment offers to artistic and cultural expression. Arts and culture, like information, will benefit from policies that regain the public commons and allow efficient flows through society. Policies ensuring and advancing freedom of expression must also account for the ways arts and culture are not like information. Artistic and cultural expressions possess a crucial but distorting value in the new global economy. Trade agreements, international trade bodies, and media/culture/entertainment company consolidation, on balance, are limiting the diversity of expressions, skewing toward commodifiable forms that expand lifestyle economies. Therefore expressions with strong nonmarket values must also be protected and promoted, and the aim of cultural policy should be to counterbalance market pressures.

Artist rights—individually and collectively—must be reaffirmed against corporate rights. Access to the tools of creativity must be broadened to close new gaps between the cultural elite and the cultural underclass and between rich nations and developing ones. Intellectual property activists should not only pursue remedies for individual creators but recognize how cultural legacies are rapidly being enclosed. In particular, further study is needed to dissect how racism and racialization has impacted

the shaping of intellectual property law in the global North. Those working in arts and culture produce imagination. Artists and cultural workers often work at the margins of society, or better yet, above it on the tightropes. Autonomy is a key value to maintain healthy artistic and cultural expression—not just freedom from state and private censorship but also public pressures to conform. In this kind of environment, artists and cultural workers can breathe life into ideas that help produce necessary social change, not merely reproduce restrictive and outdated structures.

Open circulation of ideas is crucial. As Nixon and Wallace barnstormed the states and the Soviet army rolled into Prague in 1968, against the context of increasing state repression in Brazil, Gil, his compatriot Caetano Veloso, and the artists—visual, musical, and literary—of tropicalia refused to take a position on the margins. That is to say, as Chuck D and Public Enemy did two decades later, they wanted to use the levers of the popular to disseminate an anti-authoritarian art and an egalitarian vision. For this, they suffered imprisonment and then exile. Gil's ascension to the post of minister of Culture is both a repudiation of Brazil's repressive past and a recognition of the social and political centrality of creativity.

Openness is critical for another reason. The tropicalistas were informed by the 1920s modernist avant-garde poet Oswald de Andrade's notion of *antropofagia*, a Brasilocentric "cultural cannibalism." The music of tropicalia, Veloso reminds us, was based on a foundation of bossa nova and Afro-Brazilian folk traditions, especially those from their native north, but nourished by rock, rhythm and blues, jazz, and even French pop and American vaudeville. Veloso's hero Ray Charles once famously disdained bossa nova, yet that did nothing to weaken Veloso's love for Charles's music. Tropicalia, Veloso says, was a reaction against first world musical hegemony that still adopted its fruits, an encounter meant not to reproduce hierarchy but produce mutuality (Veloso 2002: 40–41). Veloso describes the process of riding the kinds of cultural flows that have been taking place for millennia.

If we recognize in his example an analog to our current mix/remix culture, it is only because technology sometimes simply allows us to better do what is ancient. The important thing to remember is not that technology is deterministic. A commitment to freedom and diversity of expression should also respect the right of peoples not to participate or share knowledge deemed sacred. Openness is not the end of freedom

of expression. Cultural diversity, through which communities can move toward equality, is.

As Shiva writes, "Our diversity makes mutuality and a culture of give-and-take possible. Mutuality makes self-organization possible. Deeply autonomous and self-organized, yet deeply connected—with the earth, all species, and each other—humans are creating conditions for their future survival" (2005: 117). By promoting cultural diversity as its end, freedom of expression becomes the mode by which we attain mutuality, connection, and survival. Or, as Gil put it in his first hit, "Louvação" (1965) a song that seemed then to prophesy the tropicalia movement and now feels newly resonant after the Obama moment:

> I'm praising the song that is sung
> To call to life the spring
> I praise those who sing or don't sing
> Because they don't know how or don't recall
> But who will surely sing
> When the certain and precise day for all
> To sing finally does come our way.
> (Translation from Perrone 1989: 94–95)

Notes

Thanks to Roberta Uno, Jenny Toomey, Lisa Horner, Kate Wilkinson, Li Tsin Soon, Andrew Puddephat, Kembrew McLeod, and the anonymous readers for all the support and feedback.

1. See Geoffrey Dickens, "Tom Brokaw Cheers Obama Inauguration Like 'Velvet Revolution,'" January 20, 2009, http://newsbusters.org/.

2. Feld's fine article could also have certainly cited any number of dozens of hip-hop artists who have sampled or rapped over the Headhunters' "Watermelon Man," including Biggie Smalls, P. Diddy, Ultramagnetic MCs, and even Shaquille O'Neal.

3. I describe how the information revolution in the form of Soundscan's data-tracking system transformed the business of pop music in Chang (2005), 415–17.

4. For a different kind of argument around creative communities as opposed to the creative class, Maribel Alvarez's study of the cultural ecology of Silicon Valley in the San Francisco Bay Area appropriately titled *There's Nothing Informal about It* (2005). It should also be noted that all the foregoing research examples pertain to the United States, a fault wholly of the author's recent engagement

with the subject. Studies into diverse cities will certainly yield useful qualifications and suggest different directions that policies should take.

5. This was the substance of a panel discussion I participated in with George Clinton and Public Enemy producer Hank Shocklee at the Future of Music Coalition Summit in 2005.

6. See "Aboriginal Archive Offers New DRM," BBC News Web site, January 29, 2008, accessible at: http://news.bbc.co.uk/2/hi/technology/7214240.stm. See also Kim Christen, "Mukurtu Chatter," On the Long Road: Kimberly Christen's blog, accessible at: http://www.kimberlychristen.com/?p=271.

7. When the story aired on BBC, some "free culture" advocates found the archive design objectionable. They missed the point; the archive functioned by and within the social framework of the community. One commentator remarked, "Unlike copyright-DRM systems, which fall back to the most restrictive state when exporting or communicating with 'unsigned' devices (such as blocking all copying and breaking or lowering playback resolution on high-definition monitors), this one defaults to granting access. It's up to the *people* using the system to determine how new and unknown situations should be handled. Because the Mukurtu protocol-restrictions support community norms, rather than oppose them, the system can trust its users to take objects with them. If a member of the community chooses to show a picture to someone the machine would not have, his or her interpretation prevails—the machine doesn't presume to capture or trump the nuance of the social protocol. Social protocols can be reviewed or broken, and so the human choice to comply gives them strength as community ties." Post from Wendy's Blog, January 11, 2008, "Mukurtu Contextual Archive: Digital Restrictions Done Right." http://wendy.seltzer.org/blog/archives/2008/01/11/mukurtu-contextual-archiving-digital-restrictions-done-right.html (accessed February 5, 2008). In the words of the database designer, Dr. Kimberly Christen, "Many social systems exist that route knowledge differently and understand knowledge not as disembodied or out there for the taking but as part of a human and other relations—so knowledge doesn't exist apart from a set of relations." Post by Kimberly Christen on Icommons e-mail discussion list, "Aboriginal Archive's New DRM: Cultural Solution?" February 1, 2008 (accessed on February 5, 2008), available at: http://lists.ibiblio.org/pipermail/icommons/Week-of-Mon-20080128/001213.html.

Visualizing Copyright, Seeing Hegemony

Toward a Meta-Critique of Intellectual Property

For more than twenty years, scholars in law, cultural studies, history, comparative literature, media and communication studies, anthropology, and political science have dedicated themselves to the historical, political, economic, and cultural significance and impact of copyright. They have done so in a parallel universe to the expansion of intellectual property rights, which has taken place on three fronts. First in *subject matter* (not only is text, music, or film covered, but so are databases, software, DNA sequencing, and potentially also traditional knowledge). Then, *in time* (we have seen a gradual prolongation of the period for which protection is granted), and finally, *in space* (through the formation of post–Second World War international trade institutions, such as the World Trade Organization [WTO] and its Agreement on Trade-related Aspects of Intellectual Property Rights [TRIPS]), intellectual property rights have gone truly global.

Perhaps paradoxically, my favorite description of how we find ourselves in the present quagmire comes from a source that has nothing to do with intellectual property. In his book *Customs in Common: Studies in Traditional Popular Culture*, E. P. Thompson (1991) captures in a nutshell the essence of today's intellectual property system when he speaks of cultural hegemony. While defining the limits of what is possible, and inhibiting the growth of alternative horizons and expectations, there is, he continues,

> nothing determined or automatic about this process. Such hegemony can be sustained by the rulers only by the constant exercise of skill, of theatre and of concession. Such hegemony, even when imposed suc-

cessfully, does not impose an all-embracing view of life; rather, it imposes blinkers, which inhibit vision in certain directions while leaving it clear in others. (Thompson 1991: 86)

Sustained successfully through skill, theater, and concession, intellectual property rights do not impose an all-embracing view of life. What they do, however, especially within the larger context of globalization, is produce a very specific, unequal ordering of the global cultural and political economy, as well as more subtle blinkers like those Thompson envisioned. In this case, the blinkers tend to clear the way for our gaze in the direction of private property, while obscuring and even diverting it away from a closer inspection of an area where certain things are *not* privately owned, or rather, are supposed to be freely accessible: the public domain.

Definitions of the public domain are many and confusing, as are the penumbra of rights and uses that come with the territory in question. Of course, the same can be said for property, an equally bewildering, pliable, and historically contextual category that is "quintessentially and absolutely a social institution" (Underkuffler 2003: 54). Partly as a result of the expansionist tendency already described, the public domain has emerged as the positive other, the unwavering defense against the missiles launched by the blitzkrieg inclined copyright holders, a benevolent Dr. Jekyll to ward off Mr. Hyde's hyperaggression. According to the *New Shorter Oxford English Dictionary*, being in the public domain means "belonging to the public as a whole, esp. not subject to copyright." Jessica Litman, for her part, describes a place that can be "mined by any member of the public" (1990: 975) and Lawrence Lessig a "lawyer-free zone" (2004: 24). The theoretical analysis of the public domain, however, is a lawyer-free zone remarkably filled with attorneys.

Inferred from the foregoing then, Thompson's quote conveys a historic failure to see first the individual needs served by copyright rather than the collective interests of civil society (Rose 2003: 85). In this chapter, however, the metaphorical use of the faculty of seeing, or, as it were, not-seeing in creating and sustaining hegemony, serves a slightly different but related purpose. Elevated to a status of meta-perspective, it helps attempt a critique *of the critique* of intellectual property rights. Insofar that it suggests the possibility of grouping together individual scholarly works on copyright that share no clearly identifiable disciplinary framework or

theoretical/methodological platform, such an undertaking will be speculative to some extent.

The proliferation of approaches on copyright has generated exciting and inspiring results across the humanities and social sciences more generally, yet the disciplinary home base remains in law. Efforts to define an interdisciplinary terrain for copyright bibliographically transcend many disciplinary borders but very few geographical ones, and thus remain narrow in international scope (Vaidhyanathan 2006). Emerging is not so much a clearly identifiable "studies" but the presence of certain dominating discourses made up of recurring key tropes, which operate along the lines of Thompson's blinkers. In the following, I concentrate on two powerful rhetorical devices used in the critique of the current IP system and in the defense of the value of the public domain: creativity and free/dom (or the ideas of free and freedom). These are, in turn, part of a third hegemonic practice that functions on an overall structural level: copyright.

Creativity

One of the most important counterarguments against the current intellectual property "land grab" is that it does not automatically secure an increase in creativity. Backed up by an abundance of evidentiary examples (Boyle 1996, 2008; McLeod 2001, 2005; Lessig 2004, 2008; Vaidhyanathan 2004; Bollier 2005), the dependency on the works of others to create new works is necessary to cultural production. Nobody finds inspiration in a vacuum. The Eurocentric conception of authorship—rewarding individuality and originality through legal regimes of ownership (Foucault 1984)—is counterproductive in recognizing the collective nature of creativity or the many informal ways that allow us to regulate cultural practices. Authorship as we know it is one blinker that lets us see clearly that which we recognize as "correct" expressions of individuality and originality, while hiding from view the significance of artifacts and practices that fall outside this narrow frame. The repercussions of such a propensity are felt most acutely in the problems facing indigenous/native peoples as they navigate the pitfalls of a legal regime that fails to accommodate the specificity and value of traditional, collective knowledge and culture (Coombe 1998; Brown 2004).

Authorship has become, if not the root of all evil, then at least a seri-

ous mental obstacle: both to our appreciation of different forms of cultural production as well as to their inherently collective functions. Within intellectual property critique, creativity is a key concept in fighting back against copyright hardliners. *Copyrights and Copywrongs: The Rise of Intellectual Property and How It Threatens Creativity* (Vaidhyanathan 2001); *Free Culture: How Big Media Uses Technology and the Law to Lock Down Culture and Control Creativity* (Lessig 2004); and *Freedom of Expression®: Overzealous Copyright Bozos and Other Enemies of Creativity* (McLeod 2005) — these titles signal the presence of surrounding enemies targeting an especially valuable attribute: creativity. However, instead of reconceptualizing creativity as a collective, perhaps even "nonoriginal," and extremely culturally diverse activity, the symbolic usage of the idea of creativity as it has taken a foothold in the discourse of intellectual property critique appears not to do away with the old individual, original author. In fact, this usage infuses him with new life.

Disney — meaning both the company owning the mouse that ate the public domain (Sprigman 2002) and the man, Walt — exemplifies both the virtues and vices of creativity. Disney is the ultimate über-crook of the copyright wars, with a corporate appetite of the public domain a bit like Mr. Creosote's in Monty Python's movie *The Meaning of Life* (1983). Superfat and supergreedy, in the end Mr. Creosote exploded of that last, tiny mint chocolate. What will put a stop to Disney's gobbling remains to be seen. Yet there is also a "good" Disney, a role filled by Walt Disney himself, who from the very beginning was designated the artist, whereas Roy, his brother, became known as the businessman (Bryman 1995: 32). Even those who go to great lengths to underscore the cookie-cutter format of the Disney films are equally eager to underline how one should never underestimate Walt's importance as an auteur (Bryman 1995: 26; Shortsleeve 2004: 5). Analytically speaking, the company and the man must part ways; creativity becomes "bad" when corrupted by corporate domination, and "good" when guaranteed by the brilliance and innovation of personality. Disney: on the one hand the killer of creativity, on the other, the very embodiment of it.

When the company emerges as the big, bad, copyright wolf is the same time that it becomes essential to demonstrate that the public domain is what made the genius of Walt Disney possible. Had the misdirected and overzealous Disney IP policies of today been implemented when Walt started out, this might never have occurred at all. One of the world's most

successful miners of public domain material, like *Cinderella* (1950) and *Sleeping Beauty* (1959), Disney's first animated feature, *Snow White and the Seven Dwarfs* (1937), relied on fables whose provenance did not begin with either Disney or the Grimm brothers. These authorless tales were more or less always in the public domain; stories of beautiful princesses, wicked stepmothers, and gallant knights were retold and remobilized through centuries without ever having a remote possibility of locating an individual originator somewhere. Nor was there any real need for such attribution seeking. Fairy tales are prime cross-cultural traveling texts (Zipes 2001).

On the other hand, many Disney movies draw on the public domain works of identifiable authors. For instance *The Jungle Book* (1967) was made from Rudyard Kipling's *The Jungle Book* (1894) and *The Second Jungle Book* (1895). Kipling, in his turn, used stories of wolf-boys that circulated widely in the Anglo-Indian press at the time and drew inspiration from the descriptions of animals in Robert A. Sterndale's *Natural History of the Mammalia of India and Ceylon* (1884) and his father, John Lockwood Kipling's *Beasts and Man in India: A Popular Sketch of Indian Animals in Their Relations with the People* (1891). Edgar Rice Burroughs acknowledged his debt to Kipling in the creation of *Tarzan of the Apes* (1912), and Lord Baden-Powell built his entire Wolf-Cub movement around Kipling's jungle characters and narrative (Hemmungs Wirtén 2008: 109–18).

When Byrne and McQuillan refer to Disney as engaged in "literary vandalism" (1999: 1), theirs is a value judgment emphasizing how Disney constantly simplifies and misrepresents literary texts—predominantly those that have fallen into the public domain—and a viewpoint more or less absent from the field of intellectual property scholarship. From the latter perspective, the problem is not so much Disney's textual uses and abuses but the way the company hinders new interpretations by their litigation culture. This specific form of "market vandalism" forecloses future relations of the kind that made the productive dialogue with Kipling's work, including Disney's own, possible.

The Kipling-Disney trajectory of influence intends to show the value of circulating texts collectively and openly, but it does so, again, by drawing on individual examples. This chain of creativity, this intertextuality of influence, oscillates in a public-private space that not only marks ownership as being in constant flux, but also creativity as driven by individual works and simultaneous collective memory practices and infrastructures.

Even as ideals of uniqueness and originality are resisted, the use of creativity has a tendency to actually reinvent the author by reproducing the core values that were questioned when labeled "authorship."

Even more persistent than relying on the individualization of experience, is the gender, the "him" of these narratives. Few have been as influential in shaping the general awareness of the dangers of an overbloated intellectual property regime as Lawrence Lessig. Read and circulated widely, his 2004 book *Free Culture* is testament to the many ways by which creativity is threatened by the present obsession with control. Not until I reach the final pages do I realize that all those whose creativity is, in one way or the other, so clearly stifled by the wrongdoings of intellectual property rights and who throughout the book represent the virtues of innovation, creativity, and even genius, are men. Is this because women are poor creative role models? I think not. Is it because there are no women who exemplify how challenged innovation and creativity are by the media conglomerates? Hardly. Could it be an insignificant detail, an omission without importance in the larger scale of things? Perhaps.

The kind of creativity sacrificed on the altar of the second enclosure movement is highly gendered, and relies to a substantial degree on recycling the ideology of genius and originality, but now in the innovator/hacker/activist-hero persona. Erected within the framework of intellectual critique is an innovator/creator paradigm that is just as gender-biased as the old author/genius combination, and it could very well turn out to be just as long-lived. The point is not to replace all the *Free Culture* men—the John Seely Browns, Jesse Jordans, Brewster Kahles, Richard Stallmans, and, of course, Eric Eldreds who find their creative endeavors thwarted by copyright—with women. Such gender shuffling changes little (if anything) regarding the fundamentals of either claiming or questioning authorship and creativity.

Rather, in light of how we sustain hegemony by not seeing, is the simple question: what is the potential "for law to reflect upon its foundations and function as an economic and political instrument" (Basalamah 2007: 118), when the presence of exclusionary mechanisms maintain certain established power relations and thereby defuse the wider analytical potential of the critique? Not seeing certain things while foregrounding others is fine, as long as we address the possible consequences of such choices, if only in a footnote. The absence of seeing this lacuna and recognizing its ramifications in theory and in practice is what is important

to discuss. Either way, we are left with a paradox: why is it that the exclusionary narrative of male individuality and originality are part of the problem when it comes to intellectual property and "authorship," and part of the solution when it comes to the public domain and "creativity"?

Free/dom

The representation of creativity outlined previously fits well with the other dominant discursive theme of this chapter: free and freedom. The mission statement of the Electronic Frontier Foundation is nothing if not a full-fledged rallying cry around the U.S. Constitution: "If America's founding fathers had anticipated the digital frontier, there would be a clause in the Constitution protecting your rights online, as well. Instead, a modern group of freedom fighters was necessary to extend the original vision into the digital world" (http://www.eff.org). Freedom fighters in the flesh include Russian hacker Dmitry Sklyarov, arrested for copyright infringement when he wrote a code breaking software to Adobe's Acrobat Reader; Norwegian Jon Lech Johansen (more known as DVD Jon), famous for his release of the DeCSS software, decoding the content-scrambling used for DVD licensing enforcement; and American Edward Felten, who, as part of a contest organized by the Secure Digital Music Initiative broke a digital audio watermark code and found himself threatened with a lawsuit by the industry if he made his findings available in a conference paper. Assisted by the Electronic Frontier Foundation when going to court, all have put a face — a male face — on the opposition against intellectual property expansionism.

"Free" in this context relates foremost to the presumably productive, nonrival nature of information and culture, or the notion that my use does not hinder or preclude your use. The culture to which the notion of free most readily applies is a very specific one, the one of peer-to-peer music downloading and sampling, those very activities that have come to symbolize the misdirected increase in copyright policing. Copyright critique situates this culture as empowering; it is an affirmative place, a bulwark against enclosure's fusillades. The attraction of the freedom position is not surprising, considering the polarization of argument that propels the copyright wars, but it is not without certain problems of its own. The implicit presumption that although there is plenty of outside pressure on the public domain, internally bliss and the reign of consen-

sus is problematic. Not seeing the internal lacerations, rips, and conflicts of interest contained within the public domain is more than counterproductive; it is dangerous.

That is why Anupam Chander and Madhavi Sunder's argument that there now exists a "romance" of the public domain, constructed based on a very specific "kind of libertarianism" for the Information Age, is so crucial. As Chander and Sunder correctly note, "freedom" overshadows the fact that for centuries the public domain "has been a source for exploiting the labor and bodies of the disempowered" (Chander and Sunder 2004: 1334–35). Centuries of takings in the biodiverse regions of the world were made possible by the openness today saluted and heralded as a natural right applicable in all contexts and under all conditions.

It is difficult to argue with words like "free" and "remix." They tap into the wishes of a generation of users for whom any suggestion of discussing rights and obligations, sustainable use, or even the remote possibility that authors/composers/artists might *want* copyright, is archaic at best and treasonous at worst. The universalistic inference of freedom hides the complexities of cultural production and consumption under globalization and digitization. Even if text or information is productive in a sense that natural resources may not be, our uses of them are not without consequences. Culture can be exhausted; it happens every day. Languages disappear and with them alternative ways of interpreting the world, traditional knowledge is wiped out, and cultural artifacts are eradicated with alarming speed. We have an extremely strong faith in the power of technology today—borderline religious zeal, even—to preserve and disseminate cultural expressions *forever*. We should be more skeptical, perhaps, both of the presumption of eternal informational life as well as in surmising that the separation of certain knowledge of use from the resource in question does not have an impact on the information carried by that resource. This argument, however, does not sit easily within the critique against intellectual property expansionism.

There is an underlying assumption that the wider the distribution of an image, a text, or whatever informational resource, the better. In the interesting dialogue with Joy Garnett regarding the "Molotov Man" debacle, Susan Meiselas says, "technology allows us to do many things, but that does not mean we must do them" (Garnett and Meiselas 2007: 58). Quantity rather than quality—which is too complicated a concept, laden with all sorts of elitist detritus—is the benchmark for judging the value

of the digital resource. In certain instances, it is possible that culture is served better by *not* being free, by *not* being subjected to free markets, and by *not* being free from governmental interventions. Not every such not-doing automatically indicates stifled creativity but can be active, even affirmative choices.

In the final section of this contribution, I situate both creativity and freedom as part of a larger and constitutive structural discourse: copyright.

Copyright-Sight

In her book *International Copyright Law and Policy*, Silke von Lewinski asks "whether the prevalence of the English language has . . . given rise to a possibly enhanced influence of 'copyright thinking'" (von Lewinski 2008: vii). From the Berne Convention in 1886 until today's WTO, the World Intellectual Property Organization, and TRIPS framework, international intellectual property rights navigate the actual and imagined borders of the national and the international. The multilateral treaties now in place to govern global cultural production and consumption also result from an ongoing negotiation between civil law and common law. In that historical narrative, *droit d'auteur* and copyright are placeholders for the interpretive possibilities and limitations of two legal systems, where hegemonic power shifts from the French language to the English, and perhaps then even to copyright itself.

Copyright was and still is national law. Copyright was and still is a powerful instrument wielded in the interest of nation-states. "International copyright" is consequently something of an oxymoron. If von Lewinski is right in her claim that the United States has "exercised increased influence on international copyright law and strongly pushed for recognition of elements of the copyright system" (2008: 33–34), is such a tendency explanation not only for the present state of the trade-based intellectual property system but for the scholarly critique of that system as well? Is it, in effect, "copyright thinking" paired with English as the lingua franca of academia that enables the force of both creativity and freedom in the critique against intellectual property expansionism?

My instinctive answer to that question would be yes. The fact that all aspects of intellectual property are global precludes perhaps any one academic predisposition, legal tradition, or critical perspective from gaining

an interpretive upper hand. Yet I argue that a particular kind of understanding of copyright has shaped the way we think about the public domain. The reasons, I suspect, are legislative as well as epistemological. The archetypal public domain defense relies on the Statute of Anne from 1710 as "An Act for the Encouragement of Learning," and even more directly on Article I, paragraph 8, clause 8 of the U.S. Constitution, where the objective of copyrights and patents "To promote the progress of science and useful arts, by securing for limited times to authors and inventors the exclusive right to their respective writings and discoveries," in evidence of Anglo-American copyright as a form of social contract where the public, rather than the author, is the ultimate beneficiary. Safety valves like fair use and fair dealing in the United States and Canada—which do not have codified equivalents in the continental European legal tradition—equally favor an interpretation of the inherent public interest in copyright. The republican view of copyright as serving the greater good of a reading public, rather than the interests of authors, sits well in a contemporary critique where similar goals are highly acclaimed.

Occasionally, it is not difficult to get the impression that international copyright is the same thing as Anglo-Canadian-colonial-Australian-American family relations: that is, a story of the English language in the law, of *copyright's* internationalization. Strangely enough, the imperialist dimensions of this aspect have left few imprints on the theoretical tools used to deconstruct the history of intellectual property. Something like an "anxiety of influence" seems to be at play in copyright scholarship, which partly may account for the relative unease by which lessons from other jurisdictions, the complexity of bi- and multilingualism, and the experience of the other is used to highlight problems in copyright. The nation-state is alive and kicking in the interpretation of intellectual property and the public domain, partly because of how the interpretive possibilities remain bound by the perimeters of law and language. Copyright-sight is successful hegemony, as Thompson argues, not because it strives for complete darkness but because of its "blinkers, which inhibit vision in certain directions while leaving it clear in others."

THIS CHAPTER CONSIDERED how the ideas of creativity and freedom coalesce in copyright and by extension aid in creating a naturalization that has become almost invisible. I have suggested that the very ease with

which we identify with the problem as well as the proposed solutions should leave room for a critical reflexivity to develop on the dominant discourses circulating in copyright critique. Although the trope of creativity and freedom connote values of openness and access, the discourse promoting such values rests on a specific and limited set of assumptions. Transparency and openness are saluted, but as Sweden's Pirate Bay trial showed, to partake in a dialogue on the repercussions of the freedom-versus-control dichotomy requires cracking and mastering the codes and language of technology-speak.

Arguably, for scholars who come from a nonlegal background, common law will make interdisciplinary incursions easier than the civil law tradition prevalent in Sweden or continental Europe. The former is more dynamic and open-ended; the latter is less prone to interdisciplinary or critical entanglements and more focused on black-letter readings of the law. To attempt a critique of copyright's exclusionary practices while anchored in that very tradition might strike someone as contradictory. However, I prefer to see it as evidence of a belief in a self-reflexivity that tries to engage with hegemonic practices that includes and excludes perspectives in your own field, however compounded the problems of defining that field might be.

Several theoretical turns could assist in lowering the blinkers I have tried to identify. A greater commitment to the analytical power of gender is one (for a good example, see Craig 2007). Furthermore, the theoretical instruments developed through cultural theory and comparative literature in translation studies has generated interesting takes on copyright (Venuti 1998; Basamalah 2007, 2008). If combined with the critical perspective of comparative legal studies, for instance in the works of Pierre Legrand (2005, 2009a, 2009b), a new momentum could be brought to the study of copyright also in terms of theory, guiding us through the trajectories of linguistic and cultural difference. If most of copyright history remains (as, indeed, copyright law is) interpreted through the lens of the nation-state and the English language, the comparative approach adds a greater sensitivity to the importance of the relationship between languages and cultures, between legal systems, and between disciplines.

The tension between intellectual property rights and the public domain are global issues and problems. They are also about national laws and nation-state interests, but their ramifications cannot be countered without international mobilization; nor is it possible to move ahead ana-

lytically without such collaboration. Legrand speaks of "an urgent need to appreciate how various legal communities think about the law, why they think about the law as they do, why they would find it difficult to think about the law in any other way, and how their *thought differ from ours*" (Legrand 2005: 34). In doing so, he suggests a transnationally informed "estrangement" strategy that could turn copyright-sight in another direction. To see differently is to think differently, and doing so in respect to copyright critique hopefully expands "the growth of alternative horizons and expectations," rather than contracts them.

DAVID BANASH

Collage as Practice and Metaphor
in Popular Culture

It is ironic that while the products of popular culture provide the raw materials of collage, few popular texts could be properly called collages. While we surf through dozens of screens, are assaulted by cacophonous twists of the radio dial or the randomness of the Web, or are overwhelmed by a profusion of commodities in shop windows, those songs, screens, Web pages, and objects tend to tell remarkably consistent and unified stories. Our phenomenal experience of the mediascape and the marketplace is one of a vast collage, but when we give over to any individual story, object, or image, something else seems to happen.[1] In Marshall McLuhan's terms, our everyday life is an experience of cool media, but we turn our attention to the hot intensities of the individual work. This is particularly pronounced in the themes and reception of recent fiction, especially those works that take popular culture as their subject. Interestingly, while contemporary novelists turn to metaphors of collage to describe our commodified and mediated world, they do so by drawing on some of the oldest and most coherent narrative techniques. To my mind, this suggests a profound play of acknowledgment and repression. Collage-as-metaphor invokes the problems and pains of perception and consumerism but recuperates fragmented realities into narratives that guarantee more comfortable but less modern modes of meaning.

Modern life in consumer cultures is defined by cool styles of fragmentation. In fine art, fragmentation is often a literal practice that performs this experience, yet when popular novelists take fragmentation as their subject they invoke it without performing it.[2] This is particularly true of Janet Fitch's first novel, *White Oleander* (1999), which became an Oprah's Book Club selection and a major motion picture starring both Renée Zell-

weger and Michelle Pfeiffer. The book itself is a frankly polished novel with an essentially nineteenth-century technique employed to construct a typical bildungsroman. The young visual artist Astrid Magnussen is abandoned by her mother, Ingrid—a poet sent to prison for murdering her lover. Shuffled from one disastrous foster home to another, young Astrid seeks to come of age, reconcile the divisive relationship with her mother, and find her voice as an artist. However, what defines her experience is the substitution of styles of consumption for traditional family structures, and through collage and assemblage Astrid makes sense of her life. In pivotal moments, Astrid turns to collage to express her desires, and by the end of the book she becomes something of a pastiche of Joseph Cornell and Marcel Duchamp. Strikingly, Fitch always provides a seamless narrative for the fragmented life of Astrid, thus giving the reader the pleasures of a closely knit tale. The story itself, however, is one of fragmentation and confusion; to convey this, Fitch provides lyrical evocations of collage.

Astrid's final foster home is with Rena Gruschenka, a Russian émigré who makes her living salvaging merchandise from the trash of the rich to sell at swap meets. On her first morning with Rena, Astrid is awakened, put in a van, and taken through the wealthy districts of Los Angeles: "We continued to sift the city's flotsam, rescuing a wine rack and a couple of broken cane-bottom chairs. We took on an aluminum walker, a box of musty books, and a full recycling bin of Rolling Rock empties that sharpened the mold smell in the back" (317). Astrid's apprenticeship in salvage with Rena becomes her final lesson, and the key move through which she becomes an artist. Unlike her mother, a lyric poet, Astrid does not seek to express herself through a unique and unmistakable voice. Turning eighteen and leaving Rena, Astrid thinks, "I had this Raphael sky. I had five hundred dollars and an aquamarine from a dead woman and a future in salvage" (409). To become an artist, Astrid turns to collage under the sign of the commodity. As she says, "Rena stole my pride but gave me back something more, taught me to salvage, glean from the wreckage what could be remade and resold" (437).

Astrid begins to make Cornell-like suitcases assemblages, each representing one of her foster mothers through a selection of lifestyle commodities: "That year, I craved suitcases. I haunted the flea market near the Tiergarten, bargaining and trading for old-fashioned suitcases. . . . I was making altars inside them. Secret portable museums" (438). This descrip-

tion invokes both the sacred and the conservative, the altars suggesting profane illumination and the museum emphasizing the practice of conservation. However, these collages articulate these ends through the logic of the commodity. Like a consumer, Astrid packs each case with the commodities that define the lifestyles of each of the very different women who influenced her. Each suitcase becomes a kind of map of lifestyle, from the religious kitsch of rural poverty to the excesses of suburban sprawl. Thus, while one suitcase is scented with "ma griffe perfume," another has "a little TV screen in the lid, where a decoupaged Miss America beamed" (436). The description of the suitcases continues for almost two pages, and they contain everything from guitar strings and counterfeit money to pearls, rosemary, and barbwire. The contents of each underscores that the differences in the homes are fundamentally communicated though styles of consumption and that Astrid comes to understand her past by reassembling each lifestyle in miniature. Yet if the suitcases are perfect maps of each life, it is because *all* the elements of them are commodities. This suggests that commodity culture has both shattered her life and provided a ground and consistency for its reassembly as she pastes it all back together. That Astrid should turn to collage instead of lyric poetry or other forms of art makes perfect sense. In a way, we might simply see her working through the trauma of her childhood in the very commodified forms she initially experienced. Astrid says, "I would never reach the end of what was in those suitcases" (444).

Fitch's *White Oleander* underscores just how readily the aesthetic of collage communicates the problems of contemporary everyday life in our popular imagination. Indeed, rather than finding collage metaphors threatening or irrational (as they were to audiences in the first decades of the twentieth century), by the end of the century they seem to exist as comfortable metaphors to describe lives ruled by shopping. Yet the practices of collage without the comfortable frame of narrative still have troubling powers, and perhaps Fitch captures a strong sense of this as well.

One of Astrid's first collages emphasizes its most literary and critical mode. Deeply disturbed by a letter from her imprisoned mother, she takes up scissors and paste, cutting up the words of her poet-parent in the hope of escaping her power:

> I went back inside, spread all her letters out on Rena's wobble-legged kitchen table . . . there were enough to drown me forever. The ink of

her writing was a fungus, a malignant spell on birch bark, a twisted rune. I picked up scissors and began cutting, snapping the strings of her words, uncoupling her complicated train of thought car by car. She couldn't stop me now. I refused to see through her eyes any longer. . . . I glued them to sheets of paper. I give them back to you. Your own little slaves. Oh my god they're in revolt. It's Spartacus, Rome is burning. Now sack it, Mother. Take what you can before it all burns to ash. (353–55)

By cutting apart her mother's words, Astrid works through the avant-garde ethos of critique and intervention, creating just the sort of formally challenging and politically charged work one would expect of a Dada. Indeed, she uses her mother's words to create a poem of her own escape. To free herself of her parent's influence, she takes apart her words. This is not an isolated moment in the book, but a consistent theme. A few pages later, Astrid again cuts apart her mother's words: "On the way home from school, I copied the battlefield photograph [an image of the dead at Gettysburg] and sent it to her with four cut-out words, loose in an envelope ['who are you really']" (361). Just after she finishes cutting up Ingrid's letters, she begins another kind of fantastic collage: "I sat on the rug in my room after dinner, cutting old magazine covers into shadow puppets with the X-acto and sewing them onto bamboo skewers I'd saved from Tiny Thai. They were mythical figures, half-animal, half-human" (361). Astrid turns to collage to confront her mother's power with words and to find her own power with images and things. Despite the conventional technique of Fitch's novel, the image of collage becomes a powerful way to understand its own force and possibility as a metaphor, and the kinds of practices Astrid first engages are those that William S. Burroughs and Kathy Acker used to construct entire novels. In his article "Collage as Critique and Invention in the Fiction of William S. Burroughs and Kathy Acker," Robert Latham suggests that

> at the heart of discourse itself is an anti-Oedipal dynamic. Collage is a system of writing that denies paternity, asserting—in the violent act of *decoupage* that inaugurates it—a castrating prerogative over the texts constituting official culture. The collage text is the issue of a promiscuous mingling of materials that makes its authorship radically problematic; it is impossible to know who fathered it. (1993: 32)

In the context of *White Oleander*, Latham's account of the critical desire of collage makes a great deal of sense. Astrid frees the words her mother has written from their rhetorical and semantic context. She quite literally unhooks her train of thought. She denies her mother's intention, her lyric sensibility, and thus frees herself from her influence. This act of rebellion is coextensive with Astrid's response to images of femininity in popular culture. In this second moment, she turns to her pile of magazines, using these ready-made images to create a mythical world. Nonetheless, in each case there is a recuperation of the castrating prerogatives of collage techniques. Though she cuts apart her mother Ingrid's words, her mother Fitch is there to envelop her and guarantee her meaning in yet more smooth lyrical words, and we readers, not subjected to the fragmentation and frustration, are given instead a gorgeous and lyrical ekphrastic substitute. Similarly, the mythical world created from the pages of fashion magazines finds a ground and consistency with those magazines themselves, as both remain comfortably within the world of the commodity fetish, the selection and arrangement of ready-mades. In novels like *White Oleander*, collage practices become metaphors to understand the profoundly fragmented experiences of modern life, but the difficulty and power of fragmentation is always differed. This is just as true of the film adaptation, in which continuity editing and a lyrical camera make smooth the fragments of the world, passing lovingly over Astrid's works but never using montages or found footage in the editing that would more forcefully but disturbingly perform the fragmentation at the heart of the narrative.

White Oleander is at one with critical commentary on collage that begins in the 1930s and continues today, explaining the importance of fine art collage in terms of commodity culture. Perhaps the most important figure in this remains Walter Benjamin's *Arcades Project* (1999). What is fascinating about Benjamin is a strident emphasis on the object in almost all his work, and the almost total absence of people from his interests. For him, the critic confronts the object, more often than not in the commodity form, to make sense of the world. Though one might turn to almost any of his essays to see this, the importance of the object to his seminal allegory, the "angel of history" from the "Theses on the Philosophy of History" is a most shocking instance. Benjamin writes,

> A Klee painting named "Angelus Novus" shows an angel looking as though he is about to move away from something he is fixedly contem-

plating. His eyes are staring, his mouth is open, his wings are spread. This is how one pictures the angel of history. His face is turned toward the past. Where we perceive a chain of events, he sees one single catastrophe which keeps piling wreckage upon wreckage and hurls it in front of his feet. The angel would like to stay, awaken the dead, and make whole what has been smashed. But a storm is blowing from Paradise; it has got caught in his wings with such violence that the angel can no longer close them. This storm irresistibly propels him into the future to which his back is turned, while the pile of debris before him grows skyward. This storm is what we call progress. (1969: 258)

The Klee artwork shows only the angel, and Benjamin provides the very concrete details. Like many other critics of modernity, he chooses to emphasize the fragmentation of consumer culture through the metaphor of "debris." Benjamin's image makes a metonymic shift from the totality of time itself to that image of "wreckage," emphasizing the detritus of material culture so absent from the drawing. In his ekphrasis, the angel regards the past less as a temporal category than as an accumulation of *things*, in which all time is simultaneously present. Indeed, this is a powerful image of visual collage, with its emphasis on both fragmentation and simultaneity. The angel (ostensibly the critic) would like to reassemble these fragments, redeeming past moments, but those moments are objects, and one cannot help but read here a deep allegory not of history but of commodity culture that so values the object. This very project, to take the cast-off ready-mades of the past and assemble out of them some sense of order and history, is a key metaphor in two bestselling novels that invoke the same matrix of collage forms, ready-mades, and commodities that Fitch so adroitly dramatized.

Douglas Coupland's novel *Shampoo Planet* (1992) is not a work of collage. Indeed, for all the reviews that greeted Coupland as the voice of a new generation, one could not imagine a more formally conventional novel. Although the themes are those of postmodern consumer culture, the novel itself hardly deviates from the most staid techniques of nineteenth-century realism. The novel's first-person narrator is Tyler Johnson, a young twenty-something working-class youth with executive ambitions. Though *Shampoo Planet* makes no reference to Benjamin's allegory, one wonders if it might not have served as an ironic counterpoint to Tyler's proposal to Bechtol's CEO, Frank Miller. Seeking access to the cor-

porate fast track, Tyler writes a letter to the growing company, suggesting a business plan that literalizes and commodifies Benjamin's allegory:

> Well, to business, Mr. Miller: I have an idea for Bechtol that could net good profit for your company. I will be brief. To wit: I think our country is having a shortage of historical objects — there are not enough old things for people to own. As well, we have too many landfills, plus an ever-looming fuel shortage. So I therefore say, Mr. Miller, "Why not combine these three factors with our country's love of theme parks and come out a winner?" I suggest, Mr. Miller, that Bechtol develop a national chain of theme parks called *HistoryWorld*™ in which visitors (wearing respirators and outfits furnished by Bechtol's military division) dig through landfill sites abandoned decades ago (and purchased by Bechtol for next to nothing) in search of historical objects like pop bottles, old telephones, and furniture. The deeper visitors dig, the further visitors travel back in time, and hence the more they would pay. *HistoryWorld's*™ motto: INSTANT HISTORY. (200)

This is Tyler's fantasy of redeeming the past by gathering together the wreckage and debris of consumer culture. He hopes to put right the failings of modernity. However, far from the more nuanced vision of Benjamin, this is a fantasy without critical force. Unlike Benjamin's angel who would "awaken the dead," Tyler imagines instead "Profit Ahoy!" (201). Amusingly enough, his letter secures an interview with Miller who has a single question for Tyler, ironically asking how he feels about the future. Tyler replies, "Well Sir . . . I think in order to be happy — in order to deal with the future in a correct and positive manner — one shouldn't go around thinking life isn't as good as it used to be. Life must be *better* now than it ever was before, and life is only going to become better and better in the future" (272). Not surprisingly, Miller replies with the repetition of a single word: "Exactly. Exactly" (272). Tyler and Miller are not facing the past like Benjamin's angel, but blowing the unwilling angel into the future. Yet Tyler is able to mobilize something of the same logic of collage that coordinates Benjamin's allegory and his literal collage, *The Arcades Project. HistoryWorld*™ is no less compelling (and perhaps less utopian and more accurate) an allegory of modernity than the angel of history, with the same logic of fragmentation and selection, cutting and pasting. Though Tyler's allegory adds a particular element that highlights its difference from Benjamin: "Landfills are bursting with fuel: newspapers and

wood in particular. *HistoryWorld*™ visitors would not only be excavating for exciting historical artifacts, but *helping contribute to alternative fuel sources, too*" (200). Rather than waking the dead, the wreckage of the past fuels the storm.

Tyler's identity is defined by the commodities he chooses, ready-made from the pages of catalogs, and he differentiates himself from his mother by contrasting her "depressing" hippie choices with his own "tasteful" selections. In fact, the performance of identity through consumption is the theme of the novel, communicated even in the title: *Shampoo Planet*. As Tyler says, "I have a good car and wide assortment of excellent hair-care products. I know what I want from life; I have ambition" (13). Because he lives in a world of ready-made commodities and defines himself through them, his dream of *HistoryWorld*™ makes sense. For Tyler, to know the past is only possible, as it was for Benjamin, by redeeming the debris of cast-off commodities through which that world lived, but whereas Benjamin believed a profane illumination might awaken the critic from nightmares of exploitation that made commodity culture, Tyler simply extends the logic of commodification over that history. In both paradigms, the logic of the commodity is reflected and contested through the practice of collage. Artists and critics mirror consumers, choosing and arranging ready-made materials, and this fact explains why collage is important not only as a practice of artists but also as a co-ordinating metaphor to grasp the struggles and problems of identity and everyday life in popular literature.

If both artists and critics are rummaging through the trash of commodity culture, the objects all around us—many things that were once trash or existed as something other than commodities (stories or melodies, genomes or images)—are now commodities in their own right. While Benjamin sees the storm of progress giving the angel the possibility of choosing any object, a way to "seize hold of a memory as it flashes up at a moment of danger," those objectified memories are now themselves commodities, and subject to control and exchange, valorized just as Tyler envisions it. The whole shared cultural past is being repackaged, the trash hauled back in, as it were, to be sold again, and this has created a crisis for artists now that even business seems to be taking the ready-made seriously, turning and eating its own tail. Today the Dada appropriation of images and words in collages would be possible only if Hannah Höch and Raoul Hausmann could afford the images, and only if the owners

were willing to sell. It is the commodifiction of trash, the whole spectacularization of our object world by corporations that is at the heart of Don DeLillo. In his bestselling epic *Underworld* (1998), DeLillo invokes the landfills of Coupland's fantasy theme park, and waste management executive Nick Shay muses that "the landfill showed him smack-on how the waste stream ended, where all the appetites and hankerings, the sodden second thoughts came runneling out, the things you wanted ardently and then did not" (184–85). The waste managers are thus the "seers" and "adepts" of the waste world who want to "make a park one day out of every kind of used and lost and eroded object of desire" (185), or, better and more accurately, they will also commodify the trash itself. Another waste executive goes further, arguing that landfills themselves are the attraction: "The scenery of the future. Eventually the only scenery left. The more toxic the waste, the greater the effort and expense a tourist will be willing to tolerate in order to visit the site" (286). The two key characters of *Underworld* are the waste management executive and an artist of collage and assemblage named Klara Sax. While Nick Shay manages the waste, Klara turns it into collaged assemblages and installations.

First a painter in the 1950s, Klara, much like Robert Rauschenberg, begins to incorporate objects and ephemera into her canvases until they are something like combines or outright assemblages. Gesturing at the assemblage and found object movements of the 1960s and '70s, Klara explains "there were a few of us then. We took junk and saved it for art. Which sounds nobler than it was" (393). If the waste dump is the underworld of consumer culture, the collage is its mirror, a perfect synecdoche, a dialectical image of the shopper and the wasteful consumer, the work of art encoding both the process of selection and enshrining the cast-off status of disposable objects in a world of planned obsolescence. Klara sums up her work at one point: "What I really want to get at is the ordinary thing, the ordinary life behind the thing" (77), but of course the thing is not so readily available, enmeshed in a complex matrix of ideology and desire caught in the maw of commodity fetishism. To evoke this world, DeLillo, like Fitch and Coupland, gives us the image of the readymade and the metaphor of the collage artist.

That popular, widely read novelists do not perform the practices of collage that are such central metaphors to their work might seem somewhat puzzling since collage is such an important metaphor. To grasp this more clearly, I turn to *The Third Mind* (1978), in which coauthors William S. Bur-

roughs and Brion Gysin connect the cut-up forms of collage to the experience of everyday life. They write that "because cut-ups make explicit a psychosensory process that is going on all the time anyway. Somebody is reading a newspaper . . . but subliminally he is reading the columns on either side and is aware of the person sitting next to him. That's a cut-up" (5).

For Burroughs, simply walking down the street was to be assaulted by a constant influx of images, "a juxtaposition of what's happening outside and what you're thinking of" (5). For him, the cut-up was a way to present this, but it cuts against the idea of art as a shaping of the external chaos of the world into meaningful form. As Jean-Paul Sartre says in *What Is Literature?*, "If I fix on canvas or in writing a certain aspect of the fields or the sea or a look on someone's face I have disclosed, I am conscious of having produced them by condensing relationships, by introducing order where there was none, by imposing the unity of mind on the diversity of things" (1949: 39). Burroughs eschews this formal desire, suggesting in part that one power of collage is to provide an almost unmediated version of the raw experience of perception in a mediascape without the forms of art that condense, order, and unify, to quite literally revel in the diversity of things.

In collages, the things themselves often remain in an undecidable chaos, demanding of the audience something much like the work of the artist to unify and order. Though Burroughs offers a utopian vision, his experiment suggests that the images, sounds, and inchoate mediascape is caught up with our own perception, and it is how we make meaning: "I'll say, when I got to here I was at that sign, I was thinking this, and when I return to the house I'll type these up" (1978: 5). Thus the commercial sign, the walk, and the thought are cut up together. There are two problems with this. Formally, we have traditionally called on artists to filter and form the chaos of perception for us. While we have a sense of chaos as the condition of our lives, we long for the simplifications and intensifications that hot media as narrative, melodies, perspectives, or frames bring to simplify and unify it. More troubling, since almost every color, note, and letter of our media is now owned outright, the meanings we make in our cut-up perceptions are no longer our own. Of course the novel hardly seems the most relevant form to capture and work through the fragmentation of contemporary life, so I conclude by turning to the now all but ubiquitous world of films. Curiously, like the novel, most popular films

are not collages but, much like the novels I've been discussing, they in fact invoke the ready-made and the practices of collage as metaphor.

Even a casual filmgoer could point out that many popular films contain radically disjunctive montages, but these are quite unlike found footage films that are based entirely on ready-mades, nor are these films consistently disjunctive. Instead, the collages so important in these films are carefully framed and narrativized within strong continuity editing. One need only think of *A Clockwork Orange* (1971) with its terrifying disjunctive montage of violence that is Alex's "cure," or the multiple screens in *Network* (1976) or, more recently, *Minority Report* (2002). These visual collages invoke the mediascape, but they also narrativize it in very traditional modes, invoking it as image or substance while also framing and containing it.

In *Postmodernism, or, The Cultural Logic of Late Capitalism* (1991), Fredric Jameson speculates about living in a world of ubiquitous, demanding, and overwhelming screen images. He celebrates the avant-garde video installations of Nam June Paik, who scatters dozens of TV screens in incongruous environments, all showing asynchronous image loops. How, Jameson wonders, are we to make sense of this? He writes,

> The postmodernist viewer, however, is called upon to do the impossible, namely, to see all the screens at once, in their radical and random difference; such a viewer is asked to follow the evolutionary mutation of David Bowie in *The Man Who Fell to Earth* (who watches fifty-seven television screens simultaneously) and to rise somehow to a level at which the vivid perception of radical difference is in and of itself a new mode of grasping what used to be called relationship: something for which the *collage* is still only a very feeble name. (1991: 31)

Although Nam June Paik may demand that we directly confront the impossibility or horror of our mediascape in relation to our perceptual limits (or perhaps give us the means for mutation of new perceptual powers), popular culture still thinks of relationship in those older modes of narrative and unity. We do not have to watch and understand the fifty-seven screens in *The Man Who Fell to Earth*, we watch an image of Bowie watching, and we understand that metaphorically this alien power is an apt one for our world.

The profound reactions popular audiences have to avant-garde difficulty, and the deep pleasure they take in framed, narrativized collage

texts is analogous to our relationship to horror, our desire to confront the abject, indeed, our need to confront it as an essential aspect of our world, but only within the frames and narratives that will provide distance and clarity, unity and meaning. There is a horror of sorts in a mediascape that demands perceptual abilities possessed only by space aliens like David Bowie, and there is another kind of horror in commodities that seem to act on their own "grotesque ideas," as Marx puts it (1906: 82). Still unable to think of Jameson's "radical difference in and of itself," we confront our mediated, ready-made monsters only in mirrors, counting on metaphors and frames to provide meaningful ground while putting us in touch with a reality beyond our perceptual and psychic abilities to fully acknowledge.

Notes

1. Despite the critical celebration of avant-garde collage, radical ready-made forms have generally not existed in the popular, and where they do they are carefully framed or narrativized. The disjunctive montages of Soviet cinema were turned into the Hollywood continuity, the Dada politics of photomontage is emptied of its critical force while its visual styles find their way back into the montages of the advertising layouts that first inspired them, and even the jarring and dissonant samples and cutups of *musique concrète* and early hip-hop have given way to the more unified, less layered, and generally more melodic electronica and hip-hop of our present moment. Much the same movement could be tracked in contemporary media technologies and the Internet, where the experience of browsing the Web is becoming far more carefully framed and smoothly narrativized in recent years.

2. Collage is most often considered a technique of visual artists, painters like Pablo Picasso, or artists of assemblage like Joseph Cornell. However, a surprising number of writers also work in collage, and a very incomplete list includes works by T. S. Eliot, Ezra Pound, James Joyce, William Burroughs, Kathy Acker, Harold Jaffe, and Steve Tomasula. Collage in this literary sense means something a bit different but still rests on the use of ready-made fragments. For a fuller discussion of literary collage, see Banash (2004).

Assassination Weapons

The Visual Culture of New Wave Science Fiction

As both a literary technique and a political instrument, collage was cen-
tral to the writings of New Wave science fiction (SF) during the 1960s.
Using collage strategies as alternatives to the mimetic representation
that had characterized the pulp SF tradition, New Wave authors mounted
an attack on what Raymond Federman has identified as the dullness of
standard modes of reading: "the whole traditional, conventional, fixed,
and boring method of reading a book must be questioned, challenged,
demolished. . . . The writer . . . must, through innovations in the writing
itself—in the typography and topology of his writing—renew our sys-
tem of reading" (1981: 9). This refreshment of reading involves not merely
a formal strategy, according to Federman, but also a critical animus di-
rected against the ideological biases of conventional literary forms, seek-
ing to provoke attention to their subconscious channeling of perception
and desire: "Discourses impregnate us, traverse us, guide us, influence
us, determine us, confuse us—willingly or unwillingly. . . . Therefore, the
importance of always questioning, always doubting, always challenging
these discourses . . . to find out how they function, how they are consti-
tuted" (1976: 563). Collage remotivates extant materials in a critical fash-
ion, forcing readers "to participate, to finish the work" (576).

Federman's argument links traditional formalist concerns with
social-critical ones, an extrapolation that has also been made by Walter
Benjamin, who has defended collage/montage (in a discussion of Bertolt
Brecht's "epic theater") as a radical political tool. In montage, "the super-
imposed element disrupts the context in which it is inserted," and this
disruption forces the audience "to adopt an attitude vis-à-vis the process"
rather than passively imbibing a realistic illusion (1986, 234–35). Epic the-

ater "is less concerned with filling the public with feeling, even seditious ones, than with alienating it, in an enduring manner, through thinking, from the conditions in which it lives" (1986, 236). This is Brecht's famous "V-effect"—a technique of formal defamiliarization that subtends a social estrangement. New Wave SF writers of the 1960s were similarly driven by a conviction that overturning conventional modes of discourse, within and outside the genre, would have profound sociopolitical repercussions.

As in so many areas of society, the 1960s were a period of significant conflict and change within the SF genre. The so-called New Wave movement brought not only a greater degree of literary sophistication to the field but also a more militant ideological posture. During this decade, science fiction shed its earlier, almost missionary zeal for the popularization of science and scientific literacy and adopted a series of critical perspectives that arraigned not only technocratic institutions and values but SF's own status as their literary mouthpiece. New Wave SF undertook a powerful diagnostic self-analysis designed to lay bare the complicities and lines of influence that linked the genre with the technocratic state— a self-analysis that at times seemed to call for the liquidation of SF as the only possible escape from ideological co-optation, while at other times suggesting that the genre, with its powerful vocabulary of imagery and metaphor, was uniquely positioned to expose the depredations of modern technocracy. Ultimately, New Wave SF did not so much reject its position as a popular mediator of postwar technoculture as infuse this sometimes dubious role with a more encompassing ethical-political agenda and a more sophisticated aesthetic approach.

During this period, many SF authors began to question if not the core values of scientific inquiry then the larger social processes to which they had been conjoined in the service of state and corporate power. In their extrapolation of fictional futures, younger writers in particular began to be guided by influential critiques of technocracy emanating from modern philosophy (Theodor Adorno, Herbert Marcuse) and sociology (C. Wright Mills, Jacques Ellul, Theodore Roszak). The New Wave critique of technocracy began to align itself with other ideological programs seeking to reform or revolutionize social relations, such as Second Wave feminism (in the fiction of Joanna Russ), gay liberation (in the work of Samuel R. Delany), and anti-colonial movements (in stories by Ursula K. Le Guin and Michael Bishop), generating a committed brand of SF that used the

resources of the genre for politically progressive purposes. At the same time, these writers brought a set of aesthetic concerns molded less by a nostalgia for the pulps than by a fascination for the strategies of the historical avant-garde, from Surrealism to the *nouveau roman*. The New Wave thus marked the emergence and consolidation of a sophisticated *literary* mode, whose formal techniques rivaled those of contemporary postmodern fiction in its subversion of narrative linearity, its resistance to teleology and closure, and its experiments with fragmented and dissonant prose structures (strategies far removed from the straightforward methods of traditional pulp SF).

Indeed, these twin "revolutionary" impulses—ideological and formal—were intimately entwined in the best 1960s SF, showing how the critique of technocratic values required a thoroughgoing revision of the forms of representation through which the genre evoked the coming future. As a political and an aesthetic formation, the New Wave thus represented an unprecedented moment in the history of popular genres when social-critical and literary-experimental impulses converged, often to provocative and occasionally profound effect. Rather than endorsing a tacit consensus regarding the outcome of technoscientific progress, SF began to explore visions of alterity rooted in contemporary anthropological, psychoanalytic, and gender theory, visions frequently elaborated through experimental narrative techniques (such as the time-slipping four-part montage of Russ's novel *The Female Man* [1975]). This diversification of technocultural possibilities tempered if not undid pulp SF's quasi-imperialist vision of straight men conquering the stars in the name of science, substituting instead a psychedelic exploration of the domains of what J. G. Ballard famously dubbed "inner space." This exploration drew not on the pulp tradition but on eclectically borrowed theoretical and avant-garde resources, such as Marshall McLuhan's vision of modern media as a prosthetic formation, William Burroughs's cut-up technique of resistance to propagandistic control systems, and Pop Art's ironic celebration-cum-critique of industrial mass production.

While the major narrative experiments of the period have received substantial coverage in the critical literature (see, e.g., Greenland 1983), insufficient attention has been paid to the innovations in visual art, magazine design, and illustration that accompanied the advent of the New Wave movement. Although a few SF artists, such as Richard Powers, had dabbled in avant-garde styles during the 1950s, the 1960s saw an

explosion of such strategies. The use of collage by New Wave writers—such as J. G. Ballard, whose debt to Surrealism he frequently and proudly acknowledged—has received sustained attention, but this chapter proposes to consider, alongside these literary experiments, the deployment of photomontage and other collage techniques by SF illustrators during the 1960s. I focus in particular on the visual evolution of *New Worlds*, the flagship of the New Wave movement, as it mutated from a traditional SF digest into a large-format glossy magazine featuring widespread coverage of the contemporary arts, with illustrated essays on the likes of Salvador Dalí, M. C. Escher, and Eduardo Paolozzi. My main point is to show that the New Wave's aesthetic and ideological renovation of SF was not purely a literary phenomenon but also encompassed radical transformations in the genre's visual culture.

Founded in 1946 on the model of John W. Campbell's Golden Age hard SF pulp *Astounding Stories*, *New Worlds* was for two decades the principal British outlet for serious science fiction. Over the years, its editor, John Carnell, cultivated a reliable stable of native talent whose work was generally competent if not exactly trailblazing. The exception to this stricture was J. G. Ballard, who began placing stories with Carnell in 1956, and by the early 1960s was widely seen as the most original young talent in British SF. His fiction was distinctive in its range of reference to modern literature and culture, from Kafka and Freud to the Surrealists, whose psychological insights often formed the speculative core of his tales (as opposed to the physical and sociological sciences that had dominated SF's modes of extrapolation to that time). Witty, lyrical, and evocative, his early stories were propelled by a powerful undercurrent of obsession, often featuring haunted or half-mad characters struggling with internal demons in near-future settings marked by social breakdown and spiritual malaise. A clutching sense of entropic dissolution prevailed, with his protagonists obscurely complicit in their own ruination—brooding anti-heroes far removed from the stolid rocket jockeys of American pulp SF.

In fact, these tales were intended as ironic comment on the genre's cherished vision of space flight as humanity's high destiny, as Ballard made clear in the guest editorial he penned for *New Worlds* in May 1962, titled "Which Way to Inner Space?" Baldly asserting that "space fiction can no longer provide the main wellspring of ideas for s-f," not only because the result was "invariably juvenile" (3) but also because the actual achievements of the space program had eclipsed the genre's fantasies,

Ballard called for a turn inward, toward the realms of experimental and aberrant psychology: "I'd like to see more psycho-literary ideas, more meta-biological and meta-chemical concepts, private time-systems, synthetic psychologies and space-times, more of the sombre half-worlds one glimpses in the paintings of schizophrenics, all in all a complete speculative poetry and fantasy of science" (118). The goal, he made clear, was not merely to update the genre's corpus of available themes, but to improve its literary quality, bringing SF in line with the avant-garde impulses of "painting, music and the cinema . . . , particularly as these have become wholeheartedly speculative, more and more concerned with the creation of new states of mind, new levels of awareness." To accomplish this, SF would have to "jettison its present narrative forms and plots" (117), inherited from the pulp-fiction past, and become instead a truly mature and *modern* genre in sync with the changing times.

Ballard's essay provided the first glimmerings of a topical and aesthetic approach that soon crystallized as the New Wave movement, a program of renovation that shifted the genre's focus from the soaring vistas of interstellar space to the psychosocial landscapes of an encroaching technocratic modernity. In 1963, Ballard produced what is often seen as the first real New Wave story, "The Terminal Beach." A brilliantly disturbing montage of subtitled fragments geared to capture the disintegrating mind of its protagonist, the story follows an erstwhile Second World War pilot who has become a starving squatter haunting the abandoned atomic testing site at Eniwetok in a desperate effort to come to grips with his own complicity in mechanized death. The story was hugely controversial among SF writers and fans not only because of its apparent anti-technological bias but also due to its unusual form, its juxtaposition of disparate images that fused objective and subjective worlds in a Surrealist labyrinth of blasted bunkers, half-buried jukeboxes, and huge B-29s rusting "like dead reptile birds." Carnell hated the story and almost refused to publish it; certainly, its pugnacious experimentalism was unique in early 1960s SF (see Latham 2005). Yet as Ballard's work began to be reprinted in the United States, he developed a substantial following, especially among younger writers—such as Thomas M. Disch and Norman Spinrad—who were searching for more complex modes of storytelling than the U.S. pulp tradition generally offered.

In 1964, a change in *New World*'s ownership prompted Carnell to hand the magazine over to a young, energetic successor named Michael Moor-

cock, who soon made it clear that Ballard's "Terminal Beach" was to be not the exception but the norm. Moorcock's editorial in the first issue, titled "A New Literature for the Space Age" (1964) boldly called for "a kind of SF which is unconventional in every sense" and thus appropriate for "our ad-saturated, Bomb-dominated, power-corrupted times" (3). The issue also featured an essay by Ballard on the novels of William S. Burroughs, which hailed that author's controversial cut-up method as the ideal formal paradigm for a new brand of serious SF. Like Surrealism, the cut-up was a "technique for the marriage of opposites, underlining the role of recurrent images in all communication, fixed at the points of contact in the webs of language linking everything in our lives, from nostalgic reveries . . . to sinister bureaucratic memos and medicalese" (Ballard 1964: 123). It was thus the perfect method for exploring inner space, "fashion[ing] from our dreams and nightmares the first authentic mythology of the age of Cape Canaveral, Hiroshima and Belsen" (127).

Over the next several years, *New Worlds* began to stake out terrain that brought SF more and more into conversation with the historical avant-garde, with Ballard usually leading the way as practitioner and polemicist. His essay "The Coming of the Unconscious" (1966) defended Surrealism as a cognitive-aesthetic mode uniquely well suited to analyze a postwar world where reality and fantasy were inextricably conjoined. Like the paintings of Dalí and Max Ernst, Ballard's fiction of this period explored "the juxtaposition of the bizarre and familiar" (141) — in Ballard's case, not Dalí's wrist-watches and fried eggs but those elements more clearly linked with the technological and media landscapes: automobiles, movie stars, atrocity footage, astronauts. In his approach to this material, Ballard, like Dalí, wed an attitude of naive innocence — an embrace of this vulgar material as the inescapable common stratum of our lives — with a paranoid conviction that there was something obscurely awry beneath its bland, settled surfaces. *New Worlds*'s bold experiments had powerful reverberations in the United States starting in 1965, when Berkeley Books initiated an anthology series reprinting the most challenging of the magazine's offerings. Although the American New Wave never fully embraced the more radical methods pioneered by the British cohort, there is little doubt that, during its mid- to late 1960s heyday, *New Worlds* was widely perceived as an invaluable incubator of new techniques that the genre needed to confront and assimilate.

Ballard's main contribution to *New Worlds* from 1966 to 1969 was a

series of bleak and brilliant "condensed novels" (as he called them), which drew heavily on Dalí in their bold juxtaposition of iconic images and on Burroughs in their embrace of fragmented seriality over linear narrative. In 1970, these works were eventually collected into an anti-novel titled *The Atrocity Exhibition*, a book that perfectly exemplified the New Wave synthesis of formal innovation and ideological critique. A potent collage drawing on the image archive of postwar political and celebrity culture, *The Atrocity Exhibition* arraigned modern technocracy and its instrumentalized communications media as a pathological psychosocial formation. Its continuous global projection of stereotyped images had attained a reified autonomy: blown-up photos of politicians and film stars loomed over the contemporary landscape like vast dream visions, providing for individual consumers "a set of operating formulae for their passage through consciousness" (Ballard 1979: 18) and, for the mysterious power elite manipulating the images, a system of modular codes "as unreal as the war the film companies had restarted in Vietnam" (9). In Ballard's analysis, public figures and events—from Elizabeth Taylor to the Vietnam War—were simulations arranged by shadowy experts and designed to channel human desire into programmed outlets of fantasy and aggression.

Though this analysis might seem wholly negative in its vision of a power-mad technocracy contriving unreal mass-mediated events, Ballard's work also celebrated the inability of the system fully to recuperate its effects. The fake newsreels, the seductive images of fashion models and presidential candidates, while quantified to achieve predictable results, occasionally derailed when obsessed individuals appropriated and remotivated them in obscure symbologies and patterns all their own. Random fragments of the technological and media landscape, when filtered by a visionary consciousness, achieved the status of "psychic totems"—"assassination weapons" that violently broke the spell of power. Moreover, the sudden deaths of iconic celebrities—from the ambiguous murder of JFK to the legendary suicide of Marilyn Monroe—took on an impenetrable yet potent mystery, becoming the object of rapt fantasies that could not be entirely controlled. This vision was realized at the level of form itself: the random violence of decoupage—the radical reappropriation achieved by the collage effect—was, in *The Atrocity Exhibition*, a source of potential liberation from the calibrated violence of a militarist technocracy. As Roger Luckhurst has observed, "Ballard's

devices of collage, the subversion of found texts, and refunctioning of allegedly 'objective' professional discourses" (2005: 153) were the equivalent of politicized theoretical strategies such as Situationism, and indeed the "Society of the Spectacle" has achieved few more potent resolutions than in these harsh, dissonant, hallucinatory fictions.

Yet Luckhurst, like most critics of the New Wave movement, limited his focus to the fiction itself, and thus largely ignored the evolving and growingly experimental visual medium through which it was originally transmitted. When Moorcock took over *New Worlds* in the spring of 1964, he envisioned a radical revamping that would convert a standard SF magazine into a publication "speciali[zing] in experimental work by writers like Burroughs and artists like Paolozzi," and thus attempting a "cross-fertilisation of popular sf, science and the work of the literary and artistic avant garde" (1983: 11). Yet for the first three years, he was hamstrung by a pocketbook format enforced by the new publisher and a rapidly declining subscription base, as old guard readers deserted the magazine in droves. The operation was very close to folding when it was saved by a last-minute infusion of funds from the British Arts Council, which had taken an interest in Moorcock's ambitious editorial program. This subvention allowed him to realize his original vision for the journal, and the July 1967 issue saw an increase in size, a switch to glossy paper, and the inclusion of a range of challenging content, from Ballard's newest condensed novel "The Death Module" to Pamela Zoline's feminist collage story "The Heat Death of the Universe" to an illustrated essay on the drawings of Dutch Surrealist M. C. Escher. Over the next three years, before the magazine eventually folded in the spring of 1970, Moorcock continuously experimented not just with the styles of fiction he published but also with the magazine's design and layout, so that by the late 1960s it had totally morphed from a genre-based publication with roots in the SF pulps into an avant-garde journal with a strong countercultural vision.

As noted, this transformation was ideological as well as formal, reflecting a critical interrogation of the technocratic values that SF as a genre had been partially responsible for disseminating. Collage strategies were particularly useful in this regard because, as Benjamin has argued, their "use of elements of reality in experimental rearrangements" (1986: 235) had the effect of interrupting settled readings, defamiliarizing habituated modes of perception, and prompting, at least potentially, a posture of cognitive reflection. It is difficult to imagine anything more

alienating for the traditional SF reader than the large-format *New Worlds*, which radically defamiliarized what an SF publication should look like and do. Gone were the mimetic illustrations, the linear narratives, the technophiliac tone of the conventional SF magazine, replaced by striking photomontages, aggressive collage fictions, and a militant critique of technocratic society.

The first several issues of the revamped *New Worlds* made clear the agenda the journal was staking out in large part through the photoessays it ran on major graphic artists, thus indicating the importance of visual elements in defining the New Wave aesthetic. The article on Escher by Charles Platt, titled "Expressing the Abstract" (1967), makes the link clear at the outset: "Speculative fiction has in the last five years become a form involving greater abstraction of idea and vision. Consequently, art concerned principally with the visual interpretation of such subtleties is particularly relevant to the form" (44). Escher's skillful deployment of visual paradox, his intricate confusions of microcosm and macrocosm, held a key for SF writers seeking "new means of expression to convey the complex qualities of a mental image" (49). Platt was particularly well placed to explore this linkage because Moorcock had appointed him designer of the magazine, and over the next few years his layouts explored delirious fusions of word and image. The essay on Paolozzi in the subsequent issue, written by Christopher Finch (1967), went even further in urging a connection between avant-garde visual art and New Wave fiction, arguing that the Italian artist's sculptures and collages deserved to be seen as "language mechanisms" built out of iconic pop culture elements plundered from the technological and media landscapes. In short, they were the "paraliterary" equivalents of Ballard's condensed novels, "devis[ing] a basic system of syntax" from the detritus of postmodern life and using it to express a "comprehensive grasp of the constantly evolving situation" (30).

On one hand, this sort of argument for an alliance between speculative fiction and avant-garde art simply carried forward Ballard's championing of Surrealists like Dalí and Ernst as founders of "the iconography of inner space" (1966: 141). On the other hand, the fact that the magazine now possessed the financial and intellectual resources to explore this alliance in detail issue by issue made the overall argument much more compelling. No longer did the imputed connection rely solely on Ballard's (admittedly considerable) powers as a polemicist; it could be di-

rectly seen by readers as they turned the pages. Paolozzi in particular became something of an aesthetic touchstone for the large-format *New Worlds*: not only was he listed for several years on the masthead as the magazine's "aeronautics advisor," but his pioneering montages of found images plucked from the pop culture archive (including occasional borrowings from the SF pulps) provided a model for the photomontage illustrations produced by in-house artists such as Platt, Vivienne Young, and Mal Dean.

The appointment of Finch as the arts editor in September 1967 ensured ongoing coverage of contemporary artists whose work converged with the anti-technocratic bent of the magazine's fiction. Finch's profiles of British collage artists Richard Hamilton (October 1967) and Colin Self (November 1967), for example, provocatively examined the erotics of high-tech imagery, the hypnotic beauty of weapons systems, the compulsive glamour of consumer objects—themes also treated, with growing sophistication, in the magazine's published fiction. The effect of perusing these issues is a full-body immersion in the New Wave aesthetic, a frontal confrontation with a pugnacious SF counterculture. The illustrations accompanying stories in Brian Aldiss's "Acid Head Wars" series or the serialized installments of Norman Spinrad's novel *Bug Jack Barron* at once captured the fiction's psychedelic imagery and contributed an element of potent strangeness to the general mixture. Langdon Jones's collage story "The Eye of the Lens," in the March 1968 issue, featured a concrete poem entwining passages from the text around a lens-like flaring sun or blooming flower. In the same issue, Platt contributed a visual essay titled "Fun Palace—Not a Freakout" that took the form of a series of caustic captions and word balloons accompanying feverish photomontages of Jimi Hendrix, Marshall McLuhan, and the Maharishi Mahesh Yogi, the general purpose of which was to mock hippie youth's pretensions to originality by linking their lifestyle experiments with the "bigger-better, new-improved" ethos of contemporary consumer culture (1968: 37). (See figure 1.)

Ballard's manifestoes and hallucinatory fictions continued to provide a kind of backbone for the various collage experiments. The January 1969 issue ran his latest condensed novel, *The Summer Cannibals*, illustrated with photos of wrecked cars, crash test dummies, and fragments of a woman's face. (See figure 2.) Other issues ran, as parody advertisements,

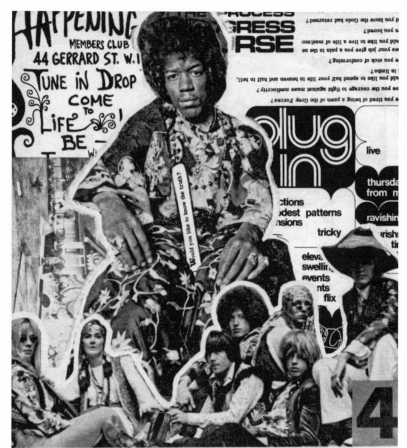

DROPOUT MEDIOCRITY: Hippies renounced materialism but despite themselves retained its attitude that bigger-is-better, new-outdates-old. Get a kick from Beardsley? Then copy him, even more grotesquely. Colours are mind-blowing, so make them brighter. If it doesn't work any more then try something stronger -- if 1000 watt guitar feedback doesn't make them freak out, add stroboscopes, colour slides, bright lights. The appeal of hippie music and art is inevitably transitory, being trapped in the same bigger-better, new-improved rut. Lacking true talent or imagination, they can't hope to produce anything lasting, even if they wanted to. A new trend will always outdate last month's rave. There's always a bigger freakout.

Page 37

1. "Fun Palace—Not a Freakout."

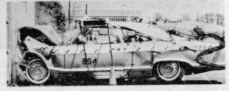

pulled at the damp crutch of his trousers. On an impulse, as they lay in the small room near the car park, he had dressed and taken her down to the cafe, fed up with her chronic cystitis and sore urethra. For hours his hands had searched her passive flesh, hunting for some concealed key to their sexuality. He traced the contours of breast and pelvis inside the yellow linen dress, then looked round as a young man walked towards them through the empty tables.

Imaginary Perversions

He tipped the warm swill from his glass on to the ash-stained sand. ". . . it's an interesting question—in *what* way is intercourse per vagina more stimulating than with this ashtray, say, or with the angle between two walls? Sex is now a conceptual act, it's probably only in terms of the perversions that we can make contact with each other at all. The perversions are completely neutral, cut off from any suggestion of psychopathology—in fact, most of the ones I've tried are out of date. We need to invent a series of imaginary sexual perversions just to keep the activity alive . . ." The girl's attention strayed to her magazine and then to the young man's sunburned wrist. The handsome loop of

his gold bracelet swung above her knee. As he listened, the young man's uncritical eyes were sharpened by moments of humour and curiosity. An hour later, when she had left him, he saw them talking together by the kiosk of the open air cinema.

An Erotic Game

"Have we stopped?" Waving at the dust that filled the cabin, she waited patiently as he worked away at the steering wheel. The road had come to a dead end among the ashy dunes. On the rear window ledge the novel had opened and begun to curl again in the heat like a Japanese flower. Around them lay portions of the drained river, hollows filled with pebbles and garbage, the remains of steel scaffolding. Yet their position in relation to the river was uncertain. All afternoon they had been following this absurd sexual whim of his, plunging in and out of basins of dust, tracking across beds of cracked mud like nightmare chessboards. Overhead was the concrete span of the motor bridge, its arch as ambiguously placed as a rainbow's. She looked up wearily from her compact as he spoke. "You drive."

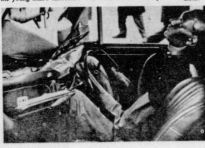

2. *The Summer Cannibals.*

3. "Alien Territory."

Ballard's photographs of his current girlfriend with superimposed quotations from his stories. In the February 1969 issue, Ballard provided a strident profile of Dalí, once again defending Surrealism as the "main visual tradition of the 20th century," just as SF was its "main literary tradition" (27). The 1969 issues particularly were seamless fusions of verbal and visual content, with every short story coming equipped with drawings, collages, or photographs designed to heighten the defamiliarizing effect. Some stories, such as Michael Butterworth's "Circularisation of Condensed Conventional Straight-Line Word-Image Structures (Radial-Planographic Condensed Word-Image Structures, Rotation about a Point)," in the July 1969 issue, incorporated the illustrations directly into the text as quirky charts and diagrams. At the same time, poetry by D. M. Thomas and Mervyn Peake persistently toyed with page layout,

using rows and columns as structural features. Similarly, John Sladek's story "Alien Territory," in the November 1969 issue, included instructions on how to decode a story that featured braided narratives, one reading top to bottom and another reading left to right. (See figure 3.)

The overall effect was of a ludic subversion of technocratic ideology, since the layout of these pieces appeared at once highly rationalized and oddly playful, regimented and insane. In short, the iconography and design of *New Worlds* mounted a critique similar to that contained in its fiction: an exposure of high-tech military-industrial society as a world of surface calm screening depths of seething violence and corruption. Photomontages of technological instruments fissured with organic apertures, for example, amounted to a powerful indictment of reification, of machines assuming lifelike properties while human beings were assimilated into a monolithic apparatus. In sum, the New Wave, especially the editorial coterie at *New Worlds*, made use of collage techniques in a methodical and multifaceted way in works of fiction that challenged SF orthodoxies and in visual materials that held up to postwar culture a series of distorting mirrors, reflecting back its incipient rage and anomie.

As a result, SF has become a more complex and sophisticated literary mode. Even as the more radical technical experiments gradually ebbed, the militant ideological postures they bequeathed to the genre were absorbed and extended in subsequent decades, by feminist SF in the 1970s, cyberpunk SF in the 1980s, and the New Space Opera in the 1990s. At the same time, major New Wave writers, especially Ballard, have been celebrated by mainstream literary critics as uniquely powerful visionaries. It was in large part through the incorporation of collage strategies that SF morphed from the juvenile space adventures of the 1950s pulps to a vital discourse of postmodern technoculture in the late twentieth and early twenty-first centuries.

Free Culture

A Conversation with Jonathan Lethem

I have long been a fan of Jonathan Lethem—author of, among many other books, the bestsellers *Motherless Brooklyn* and *The Fortress of Solitude*. He is also the author of "The Ecstasy of Influence: A Plagiarism," his well-received essay published by *Harper's* in early 2007, which we are honored to reprint in the next, final chapter. In it, Lethem used the words of other writers, including some of mine, to craft what he refers to as "a giant piece of appropriation art." Not long after his essay was published, on April 4, 2007, I sat down with him for a long and winding exchange about rock 'n' roll, collage, Kathy Acker, comic books, Pop Art, painting, and fair use, to name just a few of the disparate subjects we covered. At the end of our talk, I had him sign my copy of his book *You Don't Love Me Yet*.

Later, when I opened it, I was amused to read his inscription, which he borrowed from Abbie Hoffman. "For Kembrew, Steal This Book!" It seemed appropriate, given the nature of the following conversation.

On the Ecstasy of Influence

Kembrew McLeod: What led you to write "The Ecstasy of Influence"?

Jonathan Lethem: Well, I can trace it very specifically, but it begins in the farthest reaches of my own interest in art and culture. To begin with, I've always liked and responded to collage art, and sampled music, and to openly brandished influences in art, generally. Quotations and appropriations have always resonated with me. It began as a taste, as an appetite in cultural materials, not as a kind of political position in any sense. I grew up with a father [who was] a painter and going to museums and

galleries and looking at art a lot. I always responded to it. I sensed a recognition and enthusiasm the Pop artists had in their appropriations of comic books, or the Dadas and their collages, and I always knew I wanted to make work that had this element or that reflected this tendency. Back when I thought I was going to be a visual artist—and I did in fact make work that had collage elements and lots of quotation in it when I was a painter and a sculptor—I was always fascinated by music that was recognizably appropriated or transmuted from other music.

I've always liked tracing the lineage of the bluesmen into the rock and roll music that followed, understanding how Bob Dylan sourced these folk traditions. Everything about that always struck me as lovely, and I never felt any resistance to believing that the art that I found most exciting and original was also frequently and plainly indebted, or sourced, in other art. I took this for granted and was always disconcerted by the opposite reaction, by the tendency for people to want to denounce appropriation or borrowing—or to overstate the originality of something that they admired, or be disconcerted if you point out, "Well, this quite lovely thing that you like, that song, or that painting, or that book—I can think of several precedents for it." And people would become disappointed or confused.

Of course, I feel both ways. I feel aware of the opposite tendency in me, but it is very weak and the other is very strong, and so I was always very curious about these questions. I resented the idea that a word that had come to me in common usage, like Band-Aid, was somehow private property. I never liked it, and when I began to write and would use certain words in lowercase and my copy editors would try to capitalize, I always fought them on it because it seemed unprincipled to me. In other words, I was a "free culture" advocate waiting to happen because of a predisposition in me towards that kind of cultural activity.

On Copyright and Illegal Art

Kembrew McLeod: What gave you the idea to do an appropriation-driven essay? Can you tell me about how you put it together? For instance, when I met you in early 2006, you were in the middle of writing "Ecstasy of Influence." You showed me a copy of my own book, *Freedom of Expression®*, that you'd been reading and there were all these sticky notes sticking

out of the book's pages. I'd imagine the same is true with all these other books you borrowed from.

Jonathan Lethem: Yeah, I had this whole pile of books that transformed in this effort into a pile of sources. I'm not sure exactly when I had the idea, I can't recall, but of course now it seems so fundamental. It comes partly from the fact that I'm not ordinarily a very good or very comfortable thinker or writer in what you might call ideological or political language. I tend to think and write in metaphors and imagery. I make up characters and scenes and situations and notions and symbols. And of course you—and Siva Vaidhyanathan and Lawrence Lessig—so knocked me out when I began to suddenly realize that there is this vein of very articulate, very persuasive advocacy that interests me. I would be hard pressed to do anything but just kind of a thin restatement of some of your basic premises. At the same time I felt there was sort of a place for another voice in this conversation.

One of the things that struck me, as much as I admired the work of the three of you, is that there is this whole other realm. So there is this very strong public advocacy from you guys, and then there's this other realm of provocation, you might say, from fringe culture, the kind of willfully illegal art that you see in the Illegal Art exhibition, or that Negativland propagates. I was also conscious that there has been a lot of stuff, and I was very interested in it and liked it very much—often from the Web-based cultural creators who were not for the most part very well remunerated for their work. They didn't have a large stake in the copyright system as such and they wanted to kind of throw a wrench in the works. But what's desperately absent is the ordinary working artist, mid-career, contemplating these things from within a more traditional art form and with a stake in copyright. Because the truth is that I make my living by licensing my copyrights, and there really is this total vacancy in the middle where the people whose stuff is being argued over have abdicated the conversation.

In their place, unfortunately I think, we have agents and guilds hammering away mostly on the side of corporate expansion of the domains of intellectual property and copyright—with no particular regard for either the fragile, elusive idea of a healthy public domain. There's no sensitivity to the fundamental ways in which individual artists are nourished by their participation in free cultural exchange. So there might be

something very much at stake for even someone with the privileges that I enjoy; besides, just how long can I cling to my copyright protections? But the authors' guilds and the publishers' associations and the agents' associations don't think along those lines, though it's not their job to. So I thought, "This is what I want to describe. I have no particular insight to offer Siva, or Kembrew, or Lessig, they know what's wrong with the present situation." But what I can do is talk as an artist in a way that might be persuasive and resonant with other artists and with people who read and appreciate our work.

I also wanted the essay to be something that would be undeniable; it would have the force of all of the arguments that I've absorbed and liked so much. So it became a very natural choice to say, "Let's go ahead and make it a giant piece of appropriation art." I'm so rarely in the position to align myself with illegal artists. The funny thing about being a novelist—one reason I think very few novelists have tended to be active on this front—is that we can get away with so much. If I wanted to write a short story where I talked about a character that the reader would understand as Homer Simpson from *The Simpsons*, I could do it. No one would ever be able to stop me. But if the equivalent piece of art was made by a painter—or let alone a digital sampling video artist or a musician who uses and captures the grain of Homer Simpson's voice and puts it in a song—all of those people would be in trouble instantly. But I could bring the character to mind in my readers understanding without violating any law.

Kembrew McLeod: One of the interesting things about reading your *Harper's* essay, for me, was trying to guess when you were using my sentences, when you were using the words of others—like Lewis Hyde, Siva Vaidhyanathan, Lawrence Lessig, and others you appropriated—and when you were crafting your own sentences. It was like a game, trying to connect the dots in my head. That moment reminded me of the times when I've heard a sample of music from one song within another song, or when someone makes a pop culture reference in everyday conversation.

Jonathan Lethem: I'm really glad you drew attention to it because it was a very interesting piece to edit. The editors at *Harper's*, with whom I've worked before—and *Harper's* being a place where things are usually taken to a pretty high degree of editorial refinement—they would point out to me places where there was still a disjunction at some level. Where I moved from, let's say a sentence spoken by Harry S. Truman to my own

writing, and they'd say, "This sounds a little weird, are you comfortable—you Jonathan Lethem with your reputation as a prose writer on the line—comfortable with not resolving this further?" And I thought, "Well, this is a mashup, and one of the things that turns me on about mashups is the disjunctive quality." Or if you think of a collage, the places where the seam of torn paper is in evidence, and I thought, "This is okay. This is good. This is reproducing the means of its own expression."

It's saying appropriated culture has an energy that comes from the surprise and awkwardness, the disconcerting quality that comes from seeing things moved in and out of other contexts, especially across years. When you think of the power of a Delta blues singer's voice put into a piece of house music, techno beat, it's partly that time travel is occurring. One of the things that this essay did was, when I smashed Roland Barthes's sentence up against Mark Twain's sentence, there was—along with other things that were going on—time travel. That's something that is a very remarkable experience for art to be able to provide. So I didn't want to smooth every rough edge down and turn every voice into a version of my own. I like that, as in a good piece of sampled music, there were moments when you were sure it was from one place, and other times you were really confused about where it was from.

On Art and Appropriation

Kembrew McLeod: I was recently rereading *Fortress of Solitude*. As the novel progresses, you write about soul and hip-hop as a kind of the soundtrack, as the narrative's background noise. Growing up in New York in the 1970s and 1980s, do you see hip-hop as influencing your thinking about the appropriation practices you are now writing about?

Jonathan Lethem: Sure, I think that of course I was witness to a fundamental kind of appropriation art culture that was a nativist one. Hip-hop sampling and scratching—DJs mixing up records—didn't come from any theory. It came from an intuition, a pleasure principle, and I was pretty responsive to that. But I would also say that the generation of music fan I am, by the time I got to have a kind of rock and roll of my own, it is punk that claims itself as a kind of original, fresh turn in the history of rock and roll, though it's also a reclaiming of certain kinds of 1950s energies. I think one of the first things I liked figuring out was that those same

three chords that run through all the great trashy rock songs—the fact that all these great songs were kind of the same song—gave me a thrill. I also grew up on other art forms that point in this direction in interesting, sometimes contradictory ways, like comic books. One of the whole things about loving Marvel Comics that's quite confusing is that the writer or artist you always identify with on a given comic book gets taken off that comic book and someone else takes up the story.

So it's this giant collective tapestry of different artists and writers and sometimes you feel with great distress, "Oh wait, how can someone other than Jim Starlin draw [Adam] Warlock? That doesn't make any sense." But other times you like Warlock so much that you go ahead and you shift to the next phase in his identity drawn and written by someone else, whoever it may be. "How can anyone but Jack Kirby draw the Fantastic Four?" Well, comic books school you in this kind of confusing maelstrom of different styles and expressions all applied to the same universe; it's like this toppled-together mosaic. It also is this highly bastardized form where artists and writers, as it turned out, were often quite resentful and felt disenfranchised with their own creator's rights in many ways. It raised those issues from another perspective. So many of the creators in that realm have had so little protection, they've had so little in the way of creator's rights that they are kind of desperados on the other side of the fence. They really only recently gained any ability to copyright their own material at all.

Most of the great anti-corporate battles in that world have had to do with creators establishing themselves as having any rights to the material they made under work-for-hire contracts, and so for that reason they are pulling in the opposite direction. You can't really blame them, and yet it's quite strange because they work in this medium that has this fundamental collaborative quality. Science fiction, which was a great appetite of mine in my teenage years, also had some of this quality. All the great American pulp science fiction writers were all writing in a kind of conversation with one another. You couldn't write an articulate, impressive science fiction story without having read all the other ones, because they were all upping the ante on each other all the time. So again it had a kind of folk-mosaic quality to it, which maybe also points in this direction. It certainly is different from the image of the solitary, iconic, classic, absolute, unique authoritative creator that one associates with literature.

On Literary Appropriation

Kembrew McLeod: One of the things that I've never been able to answer myself (and I've spent years thinking about it) is the following question: "What is it that is different about the medium of writing when it comes to rights clearance?" I'm thinking about T. S. Eliot and his literary appropriations, or Kathy Acker. That is, when a novelist or a writer is appropriating from other writing, it doesn't really seem to set off any red flags. However, if you want to quote six lines of a song lyric, you're moving from the medium of print to music, and that's when the red flags fly.

Jonathan Lethem: Well it's interesting. Every medium has its own extremely specific set of folkways and mores. Because you're right, with T. S. Eliot and Kathy Acker, or William Burroughs, the avant-garde license is very freely awarded in writing. "Oh, well, that gesture is understood. It's not plagiarism, and it's also not copyright infringement, or not in any way that anybody's going to get excited about." The truth has mostly to do with the cash on the barrelhead. The reason someone taking a little bit of another song has been turned into this great offense is because people feel that someone can make a lot of money from a song. But when Kathy Acker grabs a piece of—well, usually she grabbed Melville or Dickens, first of all, that stuff is in the public domain—but even if she borrowed a writer who was technically still copyrighted, there's not a lot at stake financially. A publisher is not going to think, "We're selling fewer of X because she borrowed Y for her odd little avant-garde novel."

She's not making a lot of money. Probably the person she was borrowing from isn't John Grisham, and it just sort of flies under that business radar. It's seen as an avant-garde gesture that a few people get to do, and then we all go, "Ho ho ho, that was a very interesting avant-garde gesture, but real writers are always totally original." I think, in another sense, writing is very reactionary and very conservative. The great preponderance of writers are understood to be necessarily originating every word they put on the page, and if they dare to violate it we're actually very quick to call them plagiarists, whereas a comparable amount of normal quotation or borrowing in painting is seen as very typical. In writing it's only a very small handful of avant-gardists working in a very self-conscious posture who have been congratulated for it. Everyone else is a plagiarist if they are revealed to have done something like that. But in

painting, if you think about it, almost every art movement—with the sole exception of the pure Abstract painters—they quote imagery, quote other paintings, quote the history of art, and rework it constantly everywhere. It's very typical. It's central to painting.

I don't think the same gesture is seen as central to writing. It's seen as marginal. It's a special case. And I also think that writing has this very confusing overlap, because it exists in the same medium as journalism and the papers that students write. So here are these areas where—for local reasons, and I don't mean that in a dismissive way—it's quite important that teachers get their students to try to write original essays and not just print out stuff they find on Wikipedia or whatever. That's important for teaching because it's an important way for people to study and learn. It's maybe less urgent that journalists not cut and paste their pieces, and it maybe seems a little hysterical to me the way journalists are constantly tearing each other down for this practice.

Anyway, because the neighboring realms of academic and journalistic writing are viewed in that context—rather than in a pure, let's say "arts" context—you get very ridiculous accusations of plagiarism in the literary realm. Like the one that recently flew out against Ian McEwan. It's just a laughably pointless accusation, but it's one that I suppose would have excited someone in academia or journalism. I mean, if that's plagiarism, then we're all in a great load of trouble because novelists build their words out of pieces of everything, of things they observe, things they overhear, things they read. This is how it's done. The work doesn't just arise out of some great void. So I think it's very interesting. You could make a similar analysis regarding the strange paradoxes of how plagiarism and borrowing are regarded in each and every different artistic realm. It's quite striking.

The Ecstasy of Influence

A Plagiarism

All mankind is of one author, and is one volume; when one man
dies, one chapter is not torn out of the book, but translated into
a better language; and every chapter must be so translated.
—**John Donne**

Love and Theft

Consider this tale: a cultivated man of middle age looks back on the story
of an *amour fou*, one beginning when, traveling abroad, he takes a room as
a lodger. The moment he sees the daughter of the house, he is lost. She is a
preteen, whose charms instantly enslave him. Heedless of her age, he be-
comes intimate with her. In the end she dies, and the narrator—marked
by her forever—remains alone. The name of the girl supplies the title of
the story: *Lolita*.

The author of the story I've described, Heinz von Lichberg, published
his tale of Lolita in 1916, forty years before Vladimir Nabokov's novel.
Lichberg later became a prominent journalist in the Nazi era, and his
youthful works faded from view. Did Nabokov, who remained in Berlin
until 1937, adopt Lichberg's tale consciously? Or did the earlier tale exist
for Nabokov as a hidden, unacknowledged memory? The history of litera-
ture is not without examples of this phenomenon, called cryptomnesia.
Another hypothesis is that Nabokov, knowing Lichberg's tale perfectly
well, had set himself to that art of quotation that Thomas Mann, himself
a master of it, called "higher cribbing." Literature has always been a cru-
cible in which familiar themes are continually recast. Little of what we

admire in Nabokov's *Lolita* is to be found in its predecessor; the former is in no way deducible from the latter. Still, did Nabokov consciously borrow and quote?

"When you live outside the law, you have to eliminate dishonesty." The line comes from Don Siegel's film noir, *The Lineup* (1958), written by Stirling Silliphant. The film still haunts revival houses, likely thanks to Eli Wallach's blazing portrayal of a sociopathic hit man and to Siegel's long, sturdy auteurist career. Yet what were those words worth—to Siegel, or Silliphant, or their audience—in 1958? And again: what was the line worth when Bob Dylan heard it (presumably in some Greenwich Village repertory cinema), cleaned it up a little, and inserted it into "Absolutely Sweet Marie"? What are they worth now, to the culture at large?

Appropriation has always played a key role in Dylan's music. The songwriter has grabbed not only from a panoply of vintage Hollywood films but from Shakespeare and F. Scott Fitzgerald and Junichi Saga's *Confessions of a Yakuza*. He also nabbed the title of Eric Lott's study of minstrelsy for his album *Love and Theft* (2001). One imagines Dylan liked the general resonance of the title, in which emotional misdemeanors stalk the sweetness of love, as they do so often in his songs. Lott's title is, of course, itself a riff on Leslie Fiedler's *Love and Death in the American Novel*, which famously identifies the literary motif of the interdependence of a white man and a dark man, like Huck and Jim or Ishmael and Queequeg—a series of nested references to Dylan's own appropriating, minstrel-boy self. Dylan's art offers a paradox: while it famously urges us not to look back, it also encodes a knowledge of past sources that might otherwise have little home in contemporary culture, like the Civil War poetry of the Confederate bard Henry Timrod, resuscitated in lyrics on Dylan's newest record, *Modern Times* (2006). Dylan's originality and his appropriations are as one.

The same might be said of *all* art. I realized this forcefully when one day I went looking for the John Donne passage quoted in the epigraph. I know the lines, I confess, not from a college course but from the movie version of *84 Charing Cross Road* with Anthony Hopkins and Anne Bancroft. I checked out *84 Charing Cross Road* from the library in the hope of finding the Donne passage, but it wasn't in the book. It's alluded to in the play that was adapted from the book, but it isn't reprinted. So I rented the movie again, and there was the passage, read in voice-over by Hop-

kins but without attribution. Unfortunately, the line was also abridged so that, when I finally turned to the Web, I found myself searching for the line "all mankind is of one volume" instead of "all mankind is of one author, and is one volume."

My Internet search was initially no more successful than my library search. I had thought that summoning books from the vast deep was a matter of a few keystrokes, but when I visited the Web site of the Yale library, I found that most of its books do not yet exist as computer text. As a last-ditch effort I searched the seemingly more obscure phrase "every chapter must be so translated." The passage I wanted finally came to me, as it turns out, not as part of a scholarly library collection but simply because someone who loves Donne had posted it on his homepage. The lines I sought were from Meditation 17 in *Devotions upon Emergent Occasions*, which happens to be the most famous thing Donne ever wrote, containing as it does the line "never send to know for whom the bell tolls; it tolls for thee." My search had led me from a movie to a book to a play to a Web site and back to a book. Then again, those words may be as famous as they are only because Hemingway lifted them for his book title.

Literature has been in a plundered, fragmentary state for a long time. When I was thirteen I purchased an anthology of Beat writing. Immediately, and to my very great excitement, I discovered William S. Burroughs, author of something called *Naked Lunch*, excerpted there in all its coruscating brilliance. Burroughs was then as radical a literary man as the world had to offer. Nothing, in all my experience of literature since, has ever had as strong an effect on my sense of the sheer possibilities of writing. Later, attempting to understand this impact, I discovered that Burroughs had incorporated snippets of other writers' texts into his work, an action I knew my teachers would have called plagiarism. Some of these borrowings had been lifted from American science fiction of the forties and fifties, adding a secondary shock of recognition for me. By then I knew that this "cut-up method," as Burroughs called it, was central to whatever he thought he was doing, and that he quite literally believed it to be akin to magic. When he wrote about his process, the hairs on my neck stood up, so palpable was the excitement. Burroughs was interrogating the universe with scissors and a paste pot, and the least imitative of authors was no plagiarist at all.

Contamination Anxiety

In 1941, on his front porch, Muddy Waters recorded a song for the folklorist Alan Lomax. After singing the song, which he told Lomax was titled "Country Blues," Waters described how he came to write it. "I made it on about the eighth of October '38," Waters said. "I was fixin' a puncture on a car. I had been mistreated by a girl. I just felt blue, and the song fell into my mind and it come to me just like that and I started singing." Then Lomax, who knew of the Robert Johnson recording called "Walkin' Blues," asked Waters if there were any other songs that used the same tune. "There's been some blues played like that," Waters replied. "This song comes from the cotton field and a boy once put a record out—Robert Johnson. He put it out as named 'Walkin' Blues.' I heard the tune before I heard it on the record. I learned it from Son House." In nearly one breath, Waters offers five accounts: his own active authorship: he "made it" on a specific date. Then the "passive" explanation: "it come to me just like that." After Lomax raises the question of influence, Waters, without shame, misgivings, or trepidation, says that he heard a version by Johnson, but that his mentor, Son House, taught it to him. In the middle of that complex genealogy, Waters declares that "this song comes from the cotton field."

Blues and jazz musicians have long been enabled by a kind of "open source" culture, in which pre-existing melodic fragments and larger musical frameworks are freely reworked. Technology has only multiplied the possibilities; musicians have gained the power to *duplicate* sounds literally rather than simply approximate them through allusion. In seventies Jamaica, King Tubby and Lee "Scratch" Perry deconstructed recorded music, using astonishingly primitive predigital hardware, creating what they called "versions." The recombinant nature of their means of production quickly spread to DJs in New York and London. Today an endless, gloriously impure, and fundamentally social process generates countless hours of music.

Visual, sound, and text collage—which for many centuries were relatively fugitive traditions (a cento here, a folk pastiche there)—became explosively central to a series of movements in the twentieth century: futurism, Cubism, Dada, *musique concrète*, Situationism, Pop Art, and appropriationism. In fact, collage, the common denominator in that

list, might be called *the* art form of the twentieth century, never mind the twenty-first. But forget, for the moment, chronologies, schools, or even centuries. As examples accumulate—Igor Stravinsky's music and Daniel Johnston's, Francis Bacon's paintings and Henry Darger's, the novels of the Oulipo group and of Hannah Crafts (the author who pillaged Dickens's *Bleak House* to write *The Bondwoman's Narrative*), as well as cherished texts that become troubling to their admirers after the discovery of their "plagiarized" elements, like Richard Condon's novels or Martin Luther King Jr.'s sermons—it becomes apparent that appropriation, mimicry, quotation, allusion, and sublimated collaboration consist of a kind of sine qua non of the creative act, cutting across all forms and genres in the realm of cultural production.

In a courtroom scene from *The Simpsons* that has since entered into the television canon, an argument over the ownership of the animated characters Itchy and Scratchy rapidly escalates into an existential debate on the very nature of cartoons. "Animation is built on plagiarism!" declares the show's hot-tempered cartoon-producer-within-a-cartoon, Roger Meyers Jr. "You take away our right to steal ideas, where are they going to come from?" If nostalgic cartoonists had never borrowed from *Fritz the Cat*, there would be no *Ren & Stimpy Show*; without the Rankin/Bass and Charlie Brown Christmas specials, there would be no *South Park*; and without *The Flintstones*—more or less *The Honeymooners* in cartoon loincloths—*The Simpsons* would cease to exist. If those don't strike you as essential losses, then consider the remarkable series of "plagiarisms" that link Ovid's "Pyramus and Thisbe" with Shakespeare's *Romeo and Juliet* and Leonard Bernstein's *West Side Story*, or Shakespeare's description of Cleopatra, copied nearly verbatim from Plutarch's life of Mark Antony and also later nicked by T. S. Eliot for *The Waste Land*. If these are examples of plagiarism, then we want more plagiarism.

Most artists are brought to their vocation when their own nascent gifts are awakened by the work of a master. That is to say, most artists are converted to art by art itself. Finding one's voice isn't just an emptying and purifying oneself of the words of others but an adopting and embracing of filiations, communities, and discourses. Inspiration could be called inhaling the memory of an act never experienced. Invention, it must be humbly admitted, does not consist in creating out of void but out of chaos. Any artist knows these truths, no matter how deeply he or she submerges that knowing.

What happens when an allusion goes unrecognized? A closer look at *The Waste Land* may help make this point. The body of Eliot's poem is a vertiginous mélange of quotation, allusion, and "original" writing. When Eliot alludes to Edmund Spenser's *Prothalamion* with the line "Sweet Thames, run softly, till I end my song," what of readers to whom the poem, never one of Spenser's most popular, is unfamiliar? (Indeed, the Spenser piece is now known largely because of Eliot's use of it.) Two responses are possible: grant the line to Eliot, or later discover the source and understand the line as plagiarism. Eliot evidenced no small anxiety about these matters; the notes he so carefully added to *The Waste Land* can be read as a symptom of modernism's contamination anxiety. Taken from this angle, what exactly is postmodernism, except modernism without the anxiety?

Surrounded by Signs

The Surrealists believed that objects in the world possess a certain but unspecifiable intensity that had been dulled by everyday use and utility. They meant to reanimate this dormant intensity, to bring their minds once again into close contact with the matter that made up their world. André Breton's maxim "Beautiful as the chance encounter of a sewing machine and an umbrella on an operating table" is an expression of the belief that simply placing objects in an unexpected context reinvigorates their mysterious qualities.

This "crisis" the Surrealists identified was being simultaneously diagnosed by others. Martin Heidegger held that the essence of modernity was found in a certain technological orientation he called "enframing." This tendency encourages us to see the objects in our world only in terms of how they can serve us or be used by us. The task he identified was to find ways to resituate ourselves vis-à-vis these "objects," so that we may see them as "things" pulled into relief against the ground of their functionality. Heidegger believed that art had the great potential to reveal the "thingness" of objects.

The Surrealists understood that photography and cinema could carry out this reanimating process automatically; the process of framing objects in a lens was often enough to create the charge they sought. Describing the effect, Walter Benjamin drew a comparison between the photographic apparatus and Freud's psychoanalytic methods. Just as Freud's

theories "isolated and made analyzable things which had heretofore floated along unnoticed in the broad stream of perception," the photographic apparatus focuses on "hidden details of familiar objects," revealing "entirely new structural formations of the subject."

It is worth noting, then, that early in the history of photography a series of judicial decisions could well have changed the course of that art: courts were asked whether the photographer, amateur or professional, required permission before he could capture and print an image. Was the photographer *stealing* from the person or building whose photograph he shot, pirating something of private and certifiable value? Those early decisions went in favor of the pirates. Just as Walt Disney could take inspiration from Buster Keaton's *Steamboat Bill, Jr.*, the Brothers Grimm, or the existence of real mice, the photographer should be free to capture an image without compensating the source. The world that meets our eye through the lens of a camera was judged to be, with minor exceptions, a sort of public commons, where a cat may look at a king.

Novelists may glance at the stuff of the world, too, but we sometimes get called to task for it. For those whose ganglia were formed pre-TV, the mimetic deployment of pop culture icons seems at best an annoying tic and at worst a dangerous vapidity that compromises fiction's seriousness by dating it out of the Platonic Always, where it ought to reside. In a graduate workshop I briefly passed through, a certain gray eminence tried to convince us that a literary story should always eschew "any feature which serves to date it" because "serious fiction must be timeless." When we protested that, in his own well-known work, characters moved about electrically lit rooms, drove cars, and spoke not Anglo-Saxon but postwar English—and further, that fiction he had himself ratified as great, such as Dickens, was liberally strewn with innately topical, commercial, and timebound references—he impatiently amended his proscription to those explicit references that would date a story in the "frivolous now." When pressed, he said of course he meant the "trendy mass-popular-media" reference. Here, transgenerational discourse broke down.

I was born in 1964; I grew up watching Captain Kangaroo, moon landings, zillions of TV ads, the Banana Splits, M*A*S*H, and *The Mary Tyler Moore Show*. I was born with words in my mouth—"Band-Aid," "Q-tip," "Xerox"—object names as fixed and eternal in my logosphere as "taxicab" and "toothbrush." The world is a home littered with pop culture products

and their emblems. I also came of age swamped by parodies that stood for originals yet mysterious to me—I knew the Monkees before the Beatles, Belmondo before Bogart, and "remember" the movie *Summer of '42* from a *Mad* magazine satire, though I've still never seen the film itself. I'm not alone in having been born backward into an incoherent realm of texts, products, and images, the commercial and cultural environment with which we've both supplemented and blotted out our natural world. I can no more claim it as "mine" than the sidewalks and forests of the world, yet I do dwell in it, and for me to stand a chance as either artist or citizen, I'd probably better be permitted to name it.

Consider Walker Percy's *The Moviegoer*:

> Other people, so I have read, treasure memorable moments in their lives: the time one climbed the Parthenon at sunrise, the summer night one met a lonely girl in Central Park and achieved with her a sweet and natural relationship, as they say in books. I too once met a girl in Central Park, but it is not much to remember. What I remember is the time John Wayne killed three men with a carbine as he was falling to the dusty street in *Stagecoach*, and the time the kitten found Orson Welles in the doorway in *The Third Man*. (1961: 7)

Today, when we can eat Tex-Mex with chopsticks while listening to reggae and watching a YouTube rebroadcast of the Berlin Wall's fall— that is, when damn near *everything* presents itself as familiar—it's not a surprise that some of today's most ambitious art is going about trying to *make the familiar strange*. In so doing, in reimagining what human life might truly be like over there across the chasms of illusion, mediation, demographics, marketing, imago, and appearance, artists are paradoxically trying to restore what's taken for "real" to three whole dimensions, to reconstruct a univocally round world out of disparate streams of flat sights.

Whatever charge of tastelessness or trademark violation may be attached to the artistic appropriation of the media environment in which we swim, the alternative—to flinch, or tiptoe away into some ivory tower of irrelevance—is far worse. We are surrounded by signs; our imperative is to ignore none of them.

Usemonopoly

The idea that culture can be property—*intellectual* property—is used to justify everything from attempts to force the Girl Scouts to pay royalties for singing songs around campfires to the infringement suit brought by the estate of Margaret Mitchell against the publishers of Alice Randall's *The Wind Done Gone*. Corporations like Celera have filed for patents for human genes, while the Recording Industry Association of America has sued music downloaders for copyright infringement, reaching out-of-court settlements for thousands of dollars with defendants as young as twelve. ASCAP bleeds fees from shop owners who play background music in their stores; students and scholars are shamed from placing texts face-down on photocopy machines. At the same time, copyright is revered by most established writers and artists as a birthright and bulwark, the source of nurture for their infinitely fragile practices in a rapacious world. Plagiarism and piracy, after all, are the monsters we working artists are taught to dread, as they roam the woods surrounding our tiny preserves of regard and remuneration.

A time is marked not so much by ideas that are argued about as by ideas that are taken for granted. The character of an era hangs upon what needs no defense. In this regard, few of us question the contemporary construction of copyright. It is taken as a law, both in the sense of a universally recognizable moral absolute, like the law against murder, and as naturally inherent in our world, like the law of gravity. In fact, it is neither. Rather, copyright is an ongoing social negotiation, tenuously forged, endlessly revised, and imperfect in its every incarnation.

Thomas Jefferson, for one, considered copyright a necessary evil: he favored providing just enough incentive to create, nothing more, and thereafter allowing ideas to flow freely, as nature intended. His conception of copyright was enshrined in the U.S. Constitution, which gives Congress the authority to "promote the Progress of Science and useful Arts, by securing for limited Times to Authors and Inventors the exclusive Right to their respective Writings and Discoveries." This was a balancing act between creators and society as a whole; second comers might do a much better job than the originator with the original idea.

But Jefferson's vision has not fared well, has in fact been steadily eroded by those who view the culture as a market in which everything of value should be owned by someone or other. The distinctive feature of

modern American copyright law is its almost limitless bloating—its expansion in both scope and duration. With no registration requirement, every creative act in a tangible medium is now subject to copyright protection: your email to your child or your child's finger painting, both are automatically protected. The first Congress to grant copyright gave authors an initial term of fourteen years, which could be renewed for another fourteen if the author still lived. The current term is the life of the author plus seventy years. It's only a slight exaggeration to say that each time Mickey Mouse is about to fall into the public domain, the mouse's copyright term is extended.

Even as the law becomes more restrictive, technology is exposing those restrictions as bizarre and arbitrary. When old laws fixed on reproduction as the compensable (or actionable) unit, it wasn't because there was anything fundamentally invasive of an author's rights in the making of a copy. Rather, it was because copies were once easy to find and count, so they made a useful benchmark for deciding when an owner's rights had been invaded. In the contemporary world, though, the act of "copying" is in no meaningful sense equivalent to an infringement—we make a copy every time we accept an emailed text, or send or forward one—and is impossible anymore to regulate or even describe.

At the movies, my entertainment is sometimes lately preceded by a dire trailer, produced by the lobbying group called the Motion Picture Association of America (MPAA), in which the purchasing of a bootleg copy of a Hollywood film is compared to the theft of a car or a handbag—and, as the bullying supertitles remind us, "You wouldn't steal a handbag!" This conflation forms an incitement to quit thinking. If I were to tell you that pirating DVDs or downloading music is in no way different from loaning a friend a book, my own arguments would be as ethically bankrupt as the MPAA's. The truth lies somewhere in the vast gray area between these two overstated positions. For a car or a handbag, once stolen, no longer is available to its owner, while the appropriation of an article of "intellectual property" leaves the original untouched. As Jefferson wrote, "He who receives an idea from me, receives instruction himself without lessening mine; as he who lights his taper at mine, receives light without darkening me."

Yet industries of cultural capital, who profit not from creating but from distributing, see the sale of culture as a zero-sum game. The piano roll publishers fear the record companies, who fear the cassette tape manu-

facturers, who fear the online vendors, who fear whoever else is next in line to profit most quickly from the intangible and infinitely reproducible fruits of an artist's labor. It has been the same in every industry and with every technological innovation. Jack Valenti, speaking for the MPAA: "I say to you that the VCR is to the American film producer and the American public as the Boston Strangler is to the woman home alone."

Thinking clearly sometimes requires unbraiding our language. The word "copyright" may eventually seem as dubious in its embedded purposes as "family values," "globalization," and, sure, "intellectual property." Copyright is a "right" in no absolute sense; it is a government-granted monopoly on the use of creative results. So let's try calling it that—not a right but a *monopoly on use*, a "usemonopoly"—and then consider how the rapacious expansion of monopoly rights has always been counter to the public interest, no matter if it is Andrew Carnegie controlling the price of steel or Walt Disney managing the fate of his mouse. Whether the monopolizing beneficiary is a living artist or some artist's heirs or some corporation's shareholders, the loser is the community, including living artists who might make splendid use of a healthy public domain.

The Beauty of Second Use

A few years ago someone brought me a strange gift, purchased at the Museum of Modern Art's downtown design store: a copy of my own first novel, *Gun, with Occasional Music*, expertly cut into the contours of a pistol. The object was the work of Robert The, an artist whose specialty is the reincarnation of everyday materials. I regard my first book as an old friend, one who never fails to remind me of the spirit with which I entered into this game of art and commerce—that to be allowed to insert the materials of my imagination onto the shelves of bookstores and into the minds of readers (if only a handful) was a wild privilege. I was paid $6,000 for three years of writing, but at the time I'd have happily published the results for nothing. Now my old friend had come home in a new form, one I was unlikely to have imagined for it myself. The gun-book wasn't readable, exactly, but I couldn't take offense at that. The fertile spirit of stray connection this appropriated object conveyed back to me—the strange beauty of its second use—was a reward for being a published writer I could never have fathomed in advance. And the world

makes room for both my novel and Robert The's gun-book. There's no need to choose between the two.

In the first life of creative property, if the creator is lucky, the content is sold. After the commercial life has ended, our tradition supports a second life as well. A newspaper is delivered to a doorstep, and the next day wraps fish or builds an archive. Most books fall out of print after one year, yet even within that period they can be sold in used bookstores and stored in libraries, quoted in reviews, parodied in magazines, described in conversations, and plundered for costumes for kids to wear on Halloween. The demarcation between various possible uses is beautifully graded and hard to define, the more so as artifacts distill into and repercuss through the realm of culture into which they have been entered, the more so as they engage the receptive minds for whom they were presumably intended.

Active reading is an impertinent raid on the literary preserve. Readers are like nomads, poaching their way across fields they do not own—artists are no more able to control the imaginations of their audiences than the culture industry is able to control second uses of its artifacts. In the children's classic *The Velveteen Rabbit*, the old Skin Horse offers the Rabbit a lecture on the practice of textual poaching. The value of a new toy lies not in its material qualities (not "having things that buzz inside you and a stick-out handle"), the Skin Horse explains, but rather in how the toy is used. "Real isn't how you are made. . . . It's a thing that happens to you. When a child loves you for a long, long time, not just to play with, but REALLY loves you, then you become Real." The Rabbit is fearful, recognizing that consumer goods don't become "real" without being actively reworked: "Does it hurt?" Reassuring him, the Skin Horse says: "It doesn't happen all at once. . . . You become. It takes a long time. . . . Generally, by the time you are Real, most of your hair has been loved off, and your eyes drop out and you get loose in the joints and very shabby." Seen from the perspective of the toymaker, the Velveteen Rabbit's loose joints and missing eyes represent vandalism, signs of misuse and rough treatment; for others, these are marks of its loving use.

Artists and their surrogates who fall into the trap of seeking recompense for every possible second use end up attacking their own best audience members for the crime of exalting and enshrining their work. The Recording Industry Association of America prosecuting their own record-

buying public makes as little sense as the novelists who bristle at auto-graphing used copies of their books for collectors. And artists, or their heirs, who fall into the trap of attacking the collagists and satirists and digital samplers of their work are attacking the next generation of creators for the crime of being influenced, for the crime of responding with the same mixture of intoxication, resentment, lust, and glee that characterizes all artistic successors. By doing so they make the world smaller, betraying what seems to me the primary motivation for participating in the world of culture in the first place: to make the world larger.

Source Hypocrisy, or Disnial

The Walt Disney Company has drawn an astonishing catalog from the work of others: *Snow White and the Seven Dwarfs, Fantasia, Pinocchio, Dumbo, Bambi, Song of the South, Cinderella, Alice in Wonderland, Robin Hood, Peter Pan, Lady and the Tramp, Mulan, Sleeping Beauty, The Sword in the Stone, The Jungle Book,* and, alas, *Treasure Planet,* a legacy of cultural sampling that Shakespeare, or De La Soul, could get behind. Yet Disney's protectorate of lobbyists has policed the resulting cache of cultural materials as vigilantly as if it were Fort Knox—threatening legal action, for instance, against the artist Dennis Oppenheim for the use of Disney characters in a sculpture, and prohibiting the scholar Holly Crawford from using any Disney-related images—including artwork by Lichtenstein, Warhol, Oldenburg, and others—in her monograph *Attached to the Mouse: Disney and Contemporary Art.*

This peculiar and specific act—the enclosure of commonwealth culture for the benefit of a sole or corporate owner—is close kin to what could be called *imperial plagiarism*, the free use of third world or "primitive" artworks and styles by more privileged (and better-paid) artists. Think of Picasso's *Les Demoiselles d'Avignon*, or some of the albums of Paul Simon or David Byrne: even without violating copyright, those creators have sometimes come in for a certain skepticism when the extent of their outsourcing became evident. And, as when Led Zeppelin found themselves sued for back royalties by the bluesman Willie Dixon, the act can occasionally be an expensive one. *To live outside the law, you must be honest*: perhaps it was this, in part, that spurred David Byrne and Brian Eno to recently launch a "remix" Web site, where anyone can download easily disassembled versions of two songs from *My Life in the Bush of Ghosts,*

an album reliant on vernacular speech sampled from a host of sources. Perhaps it also explains why Bob Dylan has never refused a request for a sample.

Kenneth Koch once said, "I'm a writer who likes to be influenced." It was a charming confession, and a rare one. For so many artists, the act of creativity is intended as a Napoleonic imposition of one's uniqueness upon the universe—*après moi le déluge* of copycats! For every James Joyce or Woody Guthrie or Martin Luther King Jr., or Walt Disney, who gathered a constellation of voices in his work, there may seem to be some corporation or literary estate eager to stopper the bottle: cultural debts flow in, but they don't flow out. We might call this tendency "source hypocrisy." Or we could name it after the most pernicious source hypocrites of all time: Disnial.

You Can't Steal a Gift

My reader may, understandably, be on the verge of crying, "Communist!" A large, diverse society cannot survive without property; a large, diverse, and modern society cannot flourish without some form of intellectual property. But it takes little reflection to grasp that there is ample value that the term "property" doesn't capture. And works of art exist simultaneously in two economies, a market economy and a *gift economy*.

The cardinal difference between gift and commodity exchange is that a gift establishes a feeling-bond between two people, whereas the sale of a commodity leaves no necessary connection. I go into a hardware store, pay the man for a hacksaw blade, and walk out. I may never see him again. The disconnectedness is, in fact, a virtue of the commodity mode. We don't want to be bothered, and if the clerk always wants to chat about the family, I'll shop elsewhere. I just want a hacksaw blade. But a gift makes a connection. There are many examples, the candy or cigarette offered to a stranger who shares a seat on the plane, the few words that indicate goodwill between passengers on the late-night bus. These tokens establish the simplest bonds of social life, but the model they offer may be extended to the most complicated of unions—marriage, parenthood, mentorship. If a value is placed on these (often essentially unequal) exchanges, they degenerate into something else.

Yet one of the more difficult things to comprehend is that the gift economies—like those that sustain open-source software—coexist so

naturally with the market. It is precisely this doubleness in art practices that we must identify, ratify, and enshrine in our lives as participants in culture, either as "producers" or "consumers." Art that matters to us — which moves the heart, or revives the soul, or delights the senses, or offers courage for living, however we choose to describe the experience — is received as a gift is received. Even if we've paid a fee at the door of the museum or concert hall, when we are touched by a work of art something comes to us that has nothing to do with the price. The daily commerce of our lives proceeds at its own constant level, but a gift conveys an uncommodifiable surplus of inspiration.

The way we treat a thing can change its nature, though. Religions often prohibit the sale of sacred objects, the implication being that their sanctity is lost if they are bought and sold. We consider it unacceptable to sell sex, babies, body organs, legal rights, and votes. The idea that something should never be commodified is generally known as *inalienability* or *unalienability* — a concept most famously expressed by Thomas Jefferson in the phrase "endowed by their Creator with certain unalienable Rights." A work of art seems to be a hardier breed; it can be sold in the market and still emerge a work of art. But if it is true that in the essential commerce of art a gift is carried by the work from the artist to his audience, if I am right to say that where there is no gift there is no art, then it may be possible to destroy a work of art by converting it into a pure commodity. I don't maintain that art can't be bought and sold, but that the gift portion of the work places a constraint upon our merchandising. This is the reason why even a really beautiful, ingenious, powerful ad (of which there are a lot) can never be any kind of real art: an ad has no status as gift; that is, it's never really *for* the person it's directed at.

The power of a gift economy remains difficult for the empiricists of our market culture to understand. In our times, the rhetoric of the market presumes that everything should be and can be appropriately bought, sold, and owned — a tide of alienation lapping daily at the dwindling redoubt of the unalienable. In free market theory, an intervention to halt propertization is considered "paternalistic," because it inhibits the free action of the citizen, now reposited as a "potential entrepreneur." Of course, in the real world, we know that child-rearing, family life, education, socialization, sexuality, political life, and many other basic human activities require insulation from market forces. In fact, paying for many of these things can ruin them. We may be willing to peek at *Who Wants to*

Marry a Millionaire or an eBay auction of the ova of fashion models, but only to reassure ourselves that some things are still beneath our standards of dignity.

What's remarkable about gift economies is that they can flourish in the most unlikely places—in run-down neighborhoods, on the Internet, in scientific communities, and among members of Alcoholics Anonymous. A classic example is commercial blood systems, which generally produce blood supplies of lower safety, purity, and potency than volunteer systems. A gift economy may be superior when it comes to maintaining a group's commitment to certain extra-market values.

The Commons

Another way of understanding the presence of gift economies—which dwell like ghosts in the commercial machine—is in the sense of a *public commons*. A commons, of course, is anything like the streets over which we drive, the skies through which we pilot airplanes, or the public parks or beaches on which we dally. A commons belongs to everyone and no one, and its use is controlled only by common consent. A commons describes resources like the body of ancient music drawn on by composers and folk musicians alike, rather than the commodities, like "Happy Birthday to You," for which ASCAP, 114 years after it was written, continues to collect a fee. Einstein's theory of relativity is a commons. Writings in the public domain are a commons. Gossip about celebrities is a commons. The silence in a movie theater is a transitory commons, impossibly fragile, treasured by those who crave it, and constructed as a mutual gift by those who compose it.

The world of art and culture is a vast commons, one that is salted through with zones of utter commerce yet remains gloriously immune to any overall commodification. The closest resemblance is to the commons of a *language*: altered by every contributor, expanded by even the most passive user. That a language is a commons doesn't mean that the community owns it; rather, it belongs between people, possessed by no one, not even by society as a whole.

Nearly any commons, though, can be encroached upon, partitioned, enclosed. The American commons include tangible assets such as public forests and minerals, intangible wealth such as copyrights and patents, critical infrastructures such as the Internet and government research,

and cultural resources such as the broadcast airwaves and public spaces. They include resources we've paid for as taxpayers and inherited from previous generations. They're not just an inventory of marketable assets; they're social institutions and cultural traditions that define us as Americans and enliven us as human beings. Some invasions of the commons are sanctioned because we can no longer muster a spirited commitment to the public sector. The abuse goes unnoticed because the theft of the commons is seen in glimpses, not in panorama. We may occasionally see a former wetland paved; we may hear about the breakthrough cancer drug that tax dollars helped develop, the rights to which pharmaceutical companies acquired for a song. The larger movement goes too much unremarked. The notion of a *commons of cultural materials* goes more or less unnamed.

Honoring the commons is not a matter of moral exhortation. It is a practical necessity. We in Western society are going through a period of intensifying belief in private ownership, to the detriment of the public good. We have to remain constantly vigilant to prevent raids by those who would selfishly exploit our common heritage for their private gain. Such raids on our natural resources are not examples of enterprise and initiative. They are attempts to take from all the people just for the benefit of a few.

Undiscovered Public Knowledge

Artists and intellectuals despondent over the prospects for originality can take heart from a phenomenon identified about twenty years ago by Don Swanson, a library scientist at the University of Chicago. He called it "undiscovered public knowledge." Swanson showed that standing problems in medical research may be significantly addressed, perhaps even solved, simply by systematically surveying the scientific literature. Left to its own devices, research tends to become more specialized and abstracted from the real-world problems that motivated it and to which it remains relevant. This suggests that such a problem may be tackled effectively not by commissioning more research but by assuming that most or all of the solution can already be found in various scientific journals, waiting to be assembled by someone willing to read across specialties. Swanson himself did this in the case of Raynaud's syndrome, a disease that causes the fingers to become numb. His finding is especially

striking—perhaps even scandalous—because it happened in the ever-expanding biomedical sciences.

Undiscovered public knowledge emboldens us to question the extreme claims to originality made in press releases and publishers' notices: is an intellectual or creative offering truly novel, or have we just forgotten a worthy precursor? Does solving certain scientific problems really require massive additional funding, or could a computerized search engine, creatively deployed, do the same job more quickly and cheaply? Last, does our appetite for creative vitality require the violence and exasperation of another avant-garde, with its wearisome killing-the-father imperatives, or might we be better off ratifying the *ecstasy of influence*—and deepening our willingness to understand the commonality and timelessness of the methods and motifs available to artists?

Give All

A few years ago, the Film Society of Lincoln Center announced a retrospective of the works of Dariush Mehrjui, then a fresh enthusiasm of mine. Mehrjui is one of Iran's finest filmmakers, and the only one whose subject was personal relationships among the upper-middle-class intelligentsia. Needless to say, opportunities to view his films were—and remain—rare indeed. I headed uptown for one, an adaptation of J. D. Salinger's *Franny and Zooey*, titled *Pari*, only to discover at the door of the Walter Reade Theater that the screening had been canceled: its announcement had brought threat of a lawsuit down on the Film Society. True, these were Salinger's rights under the law. Yet why would he care that some obscure Iranian filmmaker had paid him homage with a meditation on his heroine? Would it have damaged his book or robbed him of some crucial remuneration had the screening been permitted? The fertile spirit of stray connection—one stretching across what is presently seen as the direst of international breaches—had in this case been snuffed out. The cold, undead hand of one of my childhood literary heroes had reached out from its New Hampshire redoubt to arrest my present-day curiosity.

A few assertions, then.

Any text that has infiltrated the common mind to the extent of *Gone with the Wind* or *Lolita* or *Ulysses* inexorably joins the language of culture. A map-turned-to-landscape, it has moved to a place beyond enclosure or control. The authors and their heirs should consider the subsequent paro-

dies, refractions, quotations, and revisions an honor, or at least the price of a rare success.

A corporation that has imposed an inescapable notion—Mickey Mouse, Band-Aid—on the cultural language should pay a similar price.

The primary objective of copyright is not to reward the labor of authors but "to promote the Progress of Science and useful Arts." To this end, copyright assures authors the right to their original expression, but encourages others to build freely upon the ideas and information conveyed by a work. This result is neither unfair nor unfortunate.

Contemporary copyright, trademark, and patent law is presently corrupted. The case for perpetual copyright is a denial of the essential gift aspect of the creative act. Arguments in its favor are as un-American as those for the repeal of the estate tax.

Art is sourced. Apprentices graze in the field of culture.

Digital sampling is an art method like any other, neutral in itself.

Despite hand-wringing at each technological turn—radio, the Internet—the future will be much like the past. Artists will sell some things but also give some things away. Change may be troubling for those who crave less ambiguity, but the life of an artist has never been filled with certainty.

The dream of a perfect systematic remuneration is nonsense. I pay rent with the price my words bring when published in glossy magazines and at the same moment offer them for almost nothing to impoverished literary quarterlies, or speak them for free into the air in a radio interview. So what are they worth? What would they be worth if some future Dylan worked them into a song? Should I care to make such a thing impossible?

Any text is woven entirely with citations, references, echoes, cultural languages, which cut across it through and through in a vast stereophony. The citations that go to make up a text are anonymous, untraceable, and yet *already read*; they are quotations without quotation marks. The kernel, the soul—let us go further and say the substance, the bulk, the actual and valuable material of all human utterances—is plagiarism. For substantially all ideas are secondhand, consciously and unconsciously drawn from a million outside sources, and daily used by the garnerer with a pride and satisfaction born of the superstition that he originated them; whereas there is not a rag of originality about them anywhere except the little discoloration they get from his mental and moral caliber and his

temperament, and which is revealed in characteristics of phrasing. Old and new make the warp and woof of every moment. There is no thread that is not a twist of these two strands. By necessity, by proclivity, and by delight, we all quote. Neurological study has lately shown that memory, imagination, and consciousness itself is stitched, quilted, pastiched. If we cut and paste our selves, might we not forgive it of our artworks?

Artists and writers—and our advocates, our guilds and agents—too often subscribe to implicit claims of originality that do injury to these truths. And we too often, as hucksters and bean counters in the tiny enterprises of our selves, act to spite the gift portion of our privileged roles. People live differently who treat a portion of their wealth as a gift. If we devalue and obscure the gift-economy function of our art practices, we turn our works into nothing more than advertisements for themselves. We may console ourselves that our lust for subsidiary rights in virtual perpetuity is some heroic counter to rapacious corporate interests. But the truth is that with artists pulling on one side and corporations pulling on the other, the loser is the collective public imagination from which we were nourished in the first place, and whose existence as the ultimate repository of our offerings makes the work worth doing in the first place.

As a novelist, I am a cork on the ocean of story, a leaf on a windy day. Pretty soon I'll be blown away. For the moment I'm grateful to be making a living, and so must ask that for a limited time (in the Thomas Jefferson sense) you please respect my small, treasured usemonopolies. Don't pirate my editions; do plunder my visions. The name of the game is Give All. You, reader, are welcome to my stories. They were never mine in the first place, but I gave them to you. If you have the inclination to pick them up, take them with my blessing.

•••

Key: I is Another

This key to the preceding chapter names the source of every line I stole, warped, and cobbled together as I "wrote" (except, alas, those sources I forgot along the way). First uses of a given author or speaker are *italicized*. Nearly every sentence I culled I also revised, at least slightly—for necessities of space, in order to produce a more consistent tone, or simply because I felt like it.

Title

The phrase "the ecstasy of influence," which embeds a rebuking play on Harold Bloom's "anxiety of influence," is lifted from spoken remarks by Professor *Richard Dienst* of Rutgers.

Love and Theft

"A cultivated man of middle age" to "hidden, unacknowledged memory?" These lines, with some adjustments for tone, belong to the *anonymous editor* or *assistant* who wrote the dust-flap copy of Michael Maar's *The Two Lolitas*. Of course, in my own experience, dust-flap copy is often a collaboration between author and editor. Perhaps this was also true for Maar.

"The history of literature" to "borrow and quote?" comes from Maar's book itself.

"Appropriation has always" to "Ishmael and Queequeg." This paragraph makes a hash of remarks from an interview with *Eric Lott* conducted by *David McNair* and *Jayson Whitehead*, and incorporates both interviewers' and interviewee's observations. (The text-interview form can be seen as a commonly accepted form of multivocal writing. Most interviewers prime their subjects with remarks of their own—leading the witness, so to speak—and gently refine their subjects' statements in the final printed transcript.)

"I realized this" to "for a long time." The anecdote is cribbed, with an elision to avoid appropriating a dead grandmother, from *Jonathan Rosen's The Talmud and the Internet*. I've never seen *84 Charing Cross Road*, nor searched the Web for a Donne quote. For me it was through Rosen to Donne, Hemingway, Web site, et al.

"When I was thirteen" to "no plagiarist at all." This is from *William Gibson's* "God's Little Toys," in *Wired* magazine. My own first encounter with William Burroughs, also at age thirteen, was less epiphanic. Having grown up with a painter father who, during family visits to galleries or museums, approvingly noted collage and appropriation techniques in the visual arts (Picasso, Claes Oldenburg, Stuart Davis), I was gratified, but not surprised, to learn that literature could encompass the same methods.

Contamination Anxiety

"In 1941, on his front porch" to "'this song comes from the cotton field.'" *Siva Vaidhyanathan, Copyrights and Copywrongs* (2001).

"Enabled by a kind . . . freely reworked." *Kembrew McLeod, Freedom of Expression*. In *Owning Culture* (2001), McLeod notes that, as he was writing, he

> happened to be listening to a lot of old country music, and in my casual listening I noticed that six country songs shared *exactly* the same vocal melody, including Hank Thompson's "Wild Side of Life," the Carter Family's "I'm Thinking Tonight of My Blue Eyes," Roy Acuff's "Great Speckled Bird," Kitty Wells's "It Wasn't God Who Made Honky Tonk Angels," Reno & Smiley's "I'm Using My Bible for a Roadmap," and Townes Van Zandt's "Heavenly Houseboat Blues." . . . In his extensively researched book, *Country: The Twisted Roots of Rock 'n' Roll*, Nick Tosches documents that the melody these songs share is both "ancient and British." There were no recorded lawsuits stemming from these appropriations.

"Musicians have gained . . . through allusion." *Joanna Demers, Steal This Music*.

"In Seventies Jamaica" to "hours of music." Gibson.

"Visual, sound, and text collage" to "realm of cultural production." This plunders, rewrites, and amplifies paragraphs from McLeod's *Owning Culture*, except for the line about collage being the art form of the twentieth and twenty-first centuries, which I heard filmmaker *Craig Baldwin* say, in defense of sampling, in the trailer for a documentary, *Copyright Criminals* (2009).

"In a courtroom scene" to "would cease to exist." *Dave Itzkoff, New York Times*.

"The remarkable series of 'plagiarisms'" to "we want more plagiarism." *Richard Posner*, combined from The Becker-Posner Blog and the *Atlantic Monthly*.

"Most artists are brought" to "by art itself." These words, and many more to follow, come from *Lewis Hyde*'s *The Gift* (2007). Above any other book I've here plagiarized, I commend *The Gift* to your attention.

"Finding one's voice . . . filiations, communities, and discourses." Semanticist *George L. Dillon*, quoted in *Rebecca Moore Howard*'s "The New Abolitionism Comes to Plagiarism."

"Inspiration could be . . . act never experienced." *Ned Rorem*, found on several "great quotations" sites on the Internet.

"Invention, it must be humbly admitted . . . out of chaos." *Mary Shelley*, from her introduction to *Frankenstein*.

"What happens" to "contamination anxiety." *Kevin J. H. Dettmar*, from "The Illusion of Modernist Allusion and the Politics of Postmodern Plagiarism."

Surrounded by Signs

"The surrealists believed" to the Walter Benjamin quote. *Christian Keathley*'s *Cinephilia and History, or the Wind in the Trees*, a book that treats fannish fetishism as the secret at the heart of film scholarship. Keathley notes, for instance, Joseph Cornell's surrealist-influenced film *Rose Hobart* (1936), which simply records "the way in which Cornell himself watched the 1931 Hollywood potboiler *East of Borneo*, fascinated and distracted as he was by its B-grade star"—the star, of course, being Rose Hobart herself. This, I suppose, makes Cornell a sort of father to computer-enabled fan-creator reworkings of Hollywood product, like the version of George Lucas's *The Phantom Menace* from which the noxious Jar Jar Binks character was purged; both incorporate a viewer's subjective preferences into a revision of a filmmaker's work.

"Early in the history of photography" to "without compensating the source." From *Free Culture*, by *Lawrence Lessig* (2004), the greatest of public advocates for copyright reform, and the best source if you want to get radicalized in a hurry.

"For those whose ganglia" to "discourse broke down." From *David Foster Wallace*'s essay "E Unibus Pluram," reprinted in *A Supposedly Fun Thing I'll Never Do Again*. I have no idea who Wallace's "gray eminence" is or was. I inserted the example of Dickens into the paragraph; he strikes me as overlooked in the lineage of authors of "brand-name" fiction.

"I was born . . . *Mary Tyler Moore Show*." These are the reminiscences of *Mark Hosler* from Negativland, a collaging musical collective that was sued by U2's record label for their appropriation of "I Still Haven't Found What I'm Looking For." Although I had to adjust the birth date, Hosler's cultural menu fits me like a glove.

"The world is a home . . . pop-culture products." McLeod.

"Today, when we can eat" to "flat sights." Wallace.

"We're surrounded by signs, ignore none of them." This phrase, which I unfortunately rendered somewhat leaden with the word "imperative," comes from *Steve Erickson's* novel *Our Ecstatic Days*.

Usemonopoly

"Everything from attempts" to "defendants as young as twelve." *Robert Boynton, New York Times Magazine*, "The Tyranny of Copyright?"

"A time is marked" to "what needs no defense." Lessig, this time from *The Future of Ideas*.

"Thomas Jefferson, for one" to "'respective Writings and Discoveries.'" Boynton.

"Second comers might do a much better job than the originator." I found this phrase in Lessig, who is quoting Vaidhyanathan, who himself is characterizing a judgment written by *Learned Hand*.

"But Jefferson's vision . . . owned by someone or other." Boynton.

"The distinctive feature" to "term is extended." Lessig, again from *The Future of Ideas*.

"When old laws" to "had been invaded." *Jessica Litman, Digital Copyright* (2001).

"'I say to you . . . woman home alone.'" I found the Valenti quote in McLeod. Now fill in the blank: Jack Valenti is to the public domain as _____ is to _____.

The Beauty of Second Use

"In the first" to "builds an archive." Lessig.

"Most books . . . one year." Lessig.

"Active reading is" to "do not own." This is a mashup of *Henry Jenkins*, from his *Textual Poachers: Television Fans and Participatory Culture*, and *Michel de Certeau*, whom Jenkins quotes.

"In the children's classic" to "its loving use." Jenkins. (Incidentally, have the holders of the copyright to *The Velveteen Rabbit* had a close look at *Toy Story*? There could be a lawsuit there.)

Source Hypocrisy, or Disnial

"The Walt Disney Company . . . alas, *Treasure Planet*." Lessig.

"Imperial Plagiarism" is the title of an essay by *Marilyn Randall*.

"Spurred David Byrne . . . *My Life in the Bush of Ghosts*." Chris Dah-

len, Pitchfork—though in truth by the time I'd finished, his words were so utterly dissolved within my own that had I been an ordinary cutting-and-pasting journalist it never would have occurred to me to give Dahlen a citation. The effort of preserving another's distinctive phrases as I worked on this essay was sometimes beyond my capacities; this form of plagiarism was oddly hard work.

"Kenneth Koch" to "*déluge* of copycats!" *Emily Nussbaum, New York Times Book Review.*

You Can't Steal a Gift

"You can't steal a gift." *Dizzy Gillespie,* defending another player who had been accused of poaching Charlie Parker's style: "You can't steal a gift. Bird gave the world his music, and if you can hear it you can have it."

"A large, diverse society . . . intellectual property." Lessig.

"And works of art" to "marriage, parenthood, mentorship." Hyde.

"Yet one . . . so naturally with the market." David Bollier, *Silent Theft*.

"Art that matters" to "bought and sold." Hyde.

"We consider it unacceptable" to "'certain unalienable Rights'." Bollier, paraphrasing Margaret Jane Radin's *Contested Commodities*.

"A work of art" to "constraint upon our merchandising." Hyde.

"This is the reason . . . person it's directed at." Wallace.

"The power of a gift" to "certain extra-market values." Bollier, and also the sociologist Warren O. Hagstrom, whom Bollier is paraphrasing.

The Commons

"Einstein's theory" to "public domain are a commons." Lessig.

"That a language is a commons . . . society as a whole." Michael Newton, in the *London Review of Books*, reviewing a book called *Echolalias: On the Forgetting of Language* by Daniel Heller-Roazen. The paraphrases of book reviewers are another covert form of collaborative culture; as an avid reader of reviews, I know much about books I've never read. To quote Yann Martel on how he came to be accused of imperial plagiarism in his Booker Prize–winning novel *Life of Pi*,

> Ten or so years ago, I read a review by John Updike in the *New York Times Review of Books* [*sic*]. It was of a novel by a Brazilian writer, Moacyr Scliar. I forget the title, and John Updike did worse: he clearly thought the book as a whole was forgettable. His review—one of those

that makes you suspicious by being mostly descriptive . . . oozed in-
difference. But one thing about it struck me: the premise. . . . Oh, the
wondrous things I could do with this premise.

Unfortunately, no one was ever able to locate the Updike review in ques-
tion.

"The American commons" to "for a song." Bollier.

"Honoring the commons" to "practical necessity." Bollier.

"We in Western . . . public good." John Sulston, Nobel Prize–winner
and co-mapper of the human genome.

"We have to remain" to "benefit of a few." Harry S Truman, at the open-
ing of the Everglades National Park. Although it may seem the height of
presumption to rip off a president—I found claiming Truman's stolid ad-
vocacy as my own embarrassing in the extreme—I didn't rewrite him at
all. As the poet Marianne Moore said, "If a thing had been said in the best
way, how can you say it better?" Moore confessed her penchant for incor-
porating lines from others' work, explaining, "I have not yet been able to
outgrow this hybrid method of composition."

Undiscovered Public Knowledge

"Intellectuals despondent" to "quickly and cheaply?" Steve Fuller,
The Intellectual. There's something of Borges in Fuller's insight here; the
notion of a storehouse of knowledge waiting passively to be assembled by
future users is suggestive of both "The Library of Babel" and "Kafka and
his Precursors."

Give All

"One of Iran's finest" to "meditation on his heroine?" Amy Taubin, *Vil-
lage Voice*, although it was me who was disappointed at the door of the
Walter Reade Theater.

"The primary objective" to "unfair nor unfortunate." Sandra Day
O'Connor, 1991.

"The future will be much like the past" to "give some things away."
Open-source film archivist Rick Prelinger, quoted in McLeod.

"Change may be troubling . . . with certainty." McLeod.

"Woven entirely" to "without inverted commas." Roland Barthes.

"The kernel, the soul" to "characteristics of phrasing." Mark Twain,
from a consoling letter to Helen Keller, who had suffered distressing

accusations of plagiarism (!). In fact, her work included unconsciously memorized phrases; under Keller's particular circumstances, her writing could be understood as a kind of allegory of the "constructed" nature of artistic perception. I found the Twain quote in the aforementioned *Copyrights and Copywrongs*, by Siva Vaidhyanathan.

"Old and new" to "we all quote." Ralph Waldo Emerson. These guys all sound alike!

"People live differently . . . wealth as a gift." Hyde.

"I'm a cork" to "blown away." This is adapted from The Beach Boys song "'Til I Die," written by Brian Wilson. My own first adventure with song lyric permissions came when I tried to have a character in my second novel quote the lyrics "There's a world where I can go and / Tell my secrets to / In my room / In my room." After learning the likely expense, at my editor's suggestion I replaced those with "You take the high road / I'll take the low road / I'll be in Scotland before you," a lyric in the public domain. This capitulation always bugged me, and in the subsequent British publication of the same book I restored the Brian Wilson lyric, without permission. *Ocean of Story* is the title of a collection of *Christina Stead*'s short fiction.

Saul Bellow, writing to a friend who had taken offense at Bellow's fictional use of certain personal facts, said: "The name of the game is Give All. You are welcome to all my facts. You know them, I give them to you. If you have the strength to pick them up, take them with my blessing." I couldn't bring myself to retain Bellow's "strength," which seemed presumptuous in my new context, though it is surely the more elegant phrase. On the other hand, I was pleased to invite the suggestion that the gifts in question may actually be light and easily lifted.

Key to the Key

The notion of a collage text is, of course, not original to me. *Walter Benjamin*'s incomplete *Arcades Project* (1999) seemingly would have featured extensive interlaced quotations. Other precedents include *Graham Rawle*'s novel *Diary of an Amateur Photographer*, its text harvested from photography magazines, and *Eduardo Paolozzi*'s collage-novel *Kex*, cobbled from crime novels and newspaper clippings. Closer to home, my efforts owe a great deal to the recent essays of *David Shields*, in which diverse quotes are made to closely intertwine and reverberate, and to conversations with editor *Sean Howe* and archivist *Pamela Jackson*. Last year

David Edelstein, in *New York* magazine, satirized the Kaavya Viswanathan plagiarism case by creating an almost completely plagiarized column denouncing her actions. Edelstein intended to demonstrate, through ironic example, how bricolage such as his own was ipso facto facile and unworthy. Although Viswanathan's version of "creative copying" was a pitiable one, I differ with Edelstein's conclusions.

The phrase "Je est un autre," with its deliberately awkward syntax, belongs to *Arthur Rimbaud*. It has been translated both as "I is another" and "I is someone else," as in this excerpt from Rimbaud's letters:

> For I is someone else. If brass wakes up a trumpet, it is not its fault. To me this is obvious: I witness the unfolding of my own thought: I watch it, I listen to it: I make a stroke of the bow: the symphony begins to stir in the depths, or springs on to the stage.
>
> If the old fools had not discovered only the false significance of the Ego, we should not now be having to sweep away those millions of skeletons which, since time immemorial, have been piling up the fruits of their one-eyed intellects, and claiming to be, themselves, the authors!

This essay was originally published in *Harper's Magazine*, February 2007. Because of the unusual nature of this self-contained appropriation essay, with its unique citation format, the editors chose to leave the citations out of *Cutting Across Media*'s bibliography.

Allen, Joe. "Backspinning Signifying." *to.the.quick* 2 (1999). Available at http://to-the-quick.binghamton.edu/issue%202/sampling.html.

Alvarez, Maribel. *There's Nothing Informal about It.* Cultural Initiatives Silicon Valley, 2005. Available at http://www.ci-sv.org/pdf/MAlvarez_PA_study.pdf.

Antin, David. "Modernism and Postmodernism: Approaching the Present in American Poetry." *boundary 2* 1 (1972): 98–133.

Arnett, William, and Paul Arnett, eds. *Gee's Bend: The Women and Their Quilts.* Atlanta: Tinwood Books, 2002.

Badiou, Alain. *Being and Event.* Trans. Oliver Feltham. London: Continuum, 2005.

———. *Metapolitics.* Trans. Jason Barker. London: Verso, 2006.

———. *The Century.* Trans. Alberto Toscano. Cambridge: Polity, 2007.

Bakhtin, Mikhail. *Rabelais and His World.* Trans. Hélène Iswolsky. Bloomington: Indiana University Press, 1984.

Ballard, J. G. "Which Way to Inner Space?" *New Worlds* 118 (May 1962): 2–3, 116–18.

———. "Myth-Maker of the 20th Century." *New Worlds* 142 (May–June 1964): 121–27.

———. "The Coming of the Unconscious." *New Worlds* 164 (July 1966): 141–46.

———. "Salvador Dali: The Innocent as Paranoid." *New Worlds* 187 (February 1969): 25–31.

———. *The Atrocity Exhibition.* London: Triad/Panther, 1979.

Banash, David. "From Advertising to the Avant-Garde: Rethinking the Invention of Collage." *Postmodern Culture* 14:2 (2004).

Bartók, Béla. "Magyar népzene és új magyar zene [Hungarian folk music and new Hungarian music]." *Bartók válogatott zenei írásai.* Budapest: Magyar Kórus, 1948a. (Available in English in: Bartók, Béla. *Essays.* Ed. Benjamin Suchof. Lincoln: University of Nebraska Press, 1992.)

———. "A parasztzene hatása az újabb magyar műzenére [The influence of peasant music on later Hungarian art music]." *Bartók válogatott zenei írásai.* Budapest: Magyar Kórus, 1948b. (Available in English in: Bartók, Béla. *Essays.* Ed. Benjamin Suchof. Lincoln: University of Nebraska Press, 1992.)

————. "Faji tisztaság a zenében [Race purity in music]." *Bartók Béla Összegyűjtött Írásai*. Ed. András Szőllősy. Budapest: Zeneműkiadó, 1966. (Available in English in: Bartók, Béla. *Essays*. Ed. Benjamin Suchof. Lincoln: University of Nebraska Press, 1992.)

Basalamah, Salah. "Translation Rights and the Philosophy of Translation. Remembering the Debts of the Original." In *In Translation: Reflections, Refractions, Transformations*, ed. Paul St-Pierre and Prafulla C. Kar. Amsterdam: John Benjamins Publishing, 2007, 117–32.

————. "Aux sources des normes du droit de la traduction." In *Beyond Descriptive Translation Studies. Investigations in Homage to Gideon Toury*, ed. Anthony Pym, Miriam Schlesinger, and Daniel Simeoni. Amsterdam: John Benjamins Publishing, 2008, 247–64.

BBC News. "KLF Frontman Marks 'No Music Day.'" *BBC News*, November 21, 2007.

Beale, Alison. "Identifying A Policy Hierarchy: Communications Policy, Media Industries and Globalization." In *Global Culture: Media, Arts, Policy, and Globalization*, ed. Diana Crane, Nobuko Kawashima, Ken'ichi Kawasaki. New York: Routledge, 2002, 78–85.

Benjamin, Walter. *Illuminations: Essays and Reflections*. Ed. H. Arendt, trans. H. Zohn. New York: Schocken Books, 1969.

————. "The Author as Producer." In *Reflections: Essays, Aphorisms, Autobiographical Writings*, edited by Peter Demetz. New York: Schocken, 1986, 220–38.

————. "138: To Gerhard Scholem." In *The Correspondence of Walter Benjamin*, ed. G. Scholem and T. Adorno, trans. M. R. Jacobsen and E. M. Jacobsen. Chicago: University of Chicago Press, 1994, 255–59.

————. *The Arcades Project*. Trans. H. E. Eiland and K. McLaughlin. Cambridge: Harvard University Press, 1999.

Bernstein, Charles. "Semblance." In *The L=A=N=G=U=A=G=E Book*, edited by Bruce Andrews and Charles Bernstein. Carbondale: Southern Illinois University Press, 1984, 115–18.

————. *Rough Trades*. Los Angeles: Sun and Moon, 1991.

Böll, Heinrich. "Murke's Collected Silences." In *Heinrich Böll: Eighteen Stories*. New York: McGraw-Hill, 1966.

Bollier, David. *Brand-Name Bullies: The Quest to Own and Control Culture*. Hoboken, N.J.: John Wiley, 2005.

Bónis, Ferenc. "Zoltán Kodály, a Hungarian Master of Neoclassicism." *Studia Musicologica Academiae Scientiarum Hungaricae* 25:1 (1983): 73–91.

Boyle, James. *Shamans, Software, and Spleens: Law and the Construction of the Information Society*. Cambridge: Harvard University Press, 1996.

————. *The Public Domain: Enclosing the Commons of the Mind*. New Haven: Yale University Press, 2008.

Brown, Julie. "Bartók, the Gypsies, and Hybridity in Music." In *Western Music and its Others. Difference, Representation and Appropriation in Music*, ed. Georgina Born and David Hesmondhalgh. Berkeley: University of California Press, 2000, 119–43.

Brown, Michael F. *Who Owns Native Culture?* Cambridge: Harvard University Press, 2004.

Bryman, Alan. *Disney and His Worlds*. London: Routledge, 1995.

Buck-Morss, Susan. *The Dialectics of Seeing: Walter Benjamin and the Arcades Project*. Cambridge: MIT Press, 1991.

Bunn, Austin. "Machine Age." *Village Voice*. February 25. 1998. Available at http://www.villagevoice.com/columns/9809/bunn.shtml.

Burroughs, William S. "The Invisible Generation." In *The Ticket That Exploded*. New York: Grove Press, 1966.

———. *Electronic Revolution*. West Germany: Expanded Media Editions, 1982.

———. *The Adding Machine: Selected Essays*. London: Calder, 1985.

———. "Preface." In *Here to Go*. London: Creation Books, 2001.

Burroughs, William S., and Brion Gysin. *The Third Mind*. New York: Seaver Books/ Viking, 1978.

Burroughs, William S., et al. *Minutes to Go*. Paris: Two Cities Editions, 1960.

Butler, Ben. "Interview: The KLF's James Cauty." *Rocknerd.org*, June 18, 2003. Accessed December 29, 2007 at http://rocknerd.org/article.pl?sid=03/06/ 18/0539252.

Byrne, Eleanor, and Martin McQuillan. *Deconstructing Disney*. London: Pluto Press, 1999.

Chander, Anupam, and Madhavi Sunder. "The Romance of the Public Domain." *California Law Review* 92 (2004): 1331–74.

Chang, Jeff. *Can't Stop Won't Stop: A History of the Hip-Hop Generation*. New York: St. Martin's, 2005.

Clarke, Tim. *The Revolution of Modern Art and the Modern Art of Revolution*. London: Chronos, 1994.

Coleman, Stephen. *Stilled Tongues: From Soapbox to Soundbite*. London: Porcupine Press, 1997.

Coombe, Rosemary J. *The Cultural Life of Intellectual Properties: Authorship, Appropriation, and the Law*. Durham: Duke University Press, 1998.

Coupland, Douglas. *Shampoo Planet*. New York: Pocket, 1992.

Craig, Carys. "Reconstructing the Author-Self: Some Feminist Lessons for Copyright Law." *Journal of Gender, Social Policy and the Law* 15:2 (2007): 207–68.

Crawford, Holly. *Attached to the Mouse: Disney and Contemporary Art*. Lanham, Md.: University Press of America, 2006.

Currid, Elizabeth. *The Warhol Economy: How Fashion, Art and Music Drive New York City*. Princeton: Princeton University Press, 2007.

Dannen, Frederic. *Hit Men: Powerbrokers and Fast Money Inside the Music Business*, 3rd ed. London: Helter Skelter, 2008.

deAk, Edit, and Rammellzee. "Train as Book: Culture Is the Most Fertilized Substance." *Artforum* (May 1983): 88–93.

Deleuze, Gilles. *Difference and Repetition*. New York: Columbia University Press, 1994.

Deleuze, Gilles, and Félix Guattari. *A Thousand Plateaus*. Minneapolis: University of Minnesota Press, 1987.

DeLillo, Don. *Underworld*. New York: Scribner, 1998.

De Man, Paul. *Blindness and Insight: Essays in the Rhetoric of Contemporary Criticism*. Minneapolis: University of Minnesota Press, 1983.

Derrida, Jacques. *Marges de la philosophie*. Paris: Minuit, 1972.

———. *Glas*. Paris: Denoël/Gonthier, 1981.

———. *Points. . . .* Stanford: Stanford University Press, 1995.

———. *Acts of Religion*. New York: Routledge, 2002.

Dibbell, Julian. "We Pledge Allegiance. . . . Welcome to Brazil!" *Wired* (November 2004): 191–97.

Dick, Philip K. *The Three Stigmata of Palmer Eldritch*. New York: Vintage, 1991.

———. *VALIS*. New York: Vintage, 1991.

Dobszay, László. "The Absorption of Folksong in Bartók's Composition." *Studia Musicologica Academiae Scientiarum Hungaricae* 24:3 (1982): 303–13.

Drummond, Bill. *45*. London: Abacus, 2002.

———. *The 17*. London: Beautiful Books, 2008.

Drummond, Bill, and J. Cauty. *The Manual (How to Have a Number One the Easy Way)*. London: KLF Publications, 1989.

Enns, Anthony. "Burroughs's Writing Machines." In *Retaking the Universe: William S. Burroughs in the Age of Globalization*, ed. Davis Schneiderman and Philip Walsh. Sterling, Va.: Pluto Press, 2004. 95–115.

Eősze, László. *Kodály Zoltán élete és munkássága* [The life and work of Zoltán Kodály]. Budapest: Zeneműkiadó, 1956. (Available in English in: Eősze, László. *Zoltán Kodály: His Life and Work*. New York: Taplinger.)

Falconer, Delia. "The Eloquence of Fragments: Delia Falconer on the World of W.G. Sebald." *Eureka Street Online* (December 2001). Accessed Mar 2, 2005 at http://www.eurekastreet.com.au/pages/111/111falconer.html.

Federman, Raymond. "Imagination as Plagiarism [an unfinished paper . . .]." *New Literary History* 7:3 (spring 1976): 563–78.

———. "Surfiction—Four Propositions in Form of an Introduction." In *Surfiction: Fiction Now . . . and Tomorrow*, 2nd ed. Chicago: Swallow, 1981, 5–15.

Feld, Steven. "A Genealogy of Schizophonic Mimesis." *Yearbook for Traditional Music* 28 (1996): 14–15.

———. "The Poetics and Politics of Pygmy Pop." In *Western Music and its Others*.

Difference, Representation and Appropriation in Music, ed. Georgina Born and David Hesmondhalgh. Berkeley: University of California Press, 2000, 254–79.

Feuer, Alan. "Giuliani Dropping His Bitter Battle with Art Museum." *The New York Times*, March 28, 2000, 1:6.

Finch, Christopher. "Eduardo Paolozzi." *New Worlds* 174 (August 1967): 28–35.

Fitch, Janet. *White Oleander*. New York: Little, Brown, 1999.

Fisher, Allen. *Ideas on the Culture Dreamed Of*. London: Spanner Editions, 1982.

———. *Traps or Tools and Damage*. Surrey: Roehampton University, 2002.

———. *Gravity*. Cambridge: Cambridge University Press, 2004a.

———. *Entanglement*. Toronto: The Gig, 2004b.

———. *Place*. London: Reality Street Editions, 2005.

Florida, Richard. *The Rise of the Creative Class*. New York: Basic Books, 2004.

Flynt, Henry. "The Meaning of My Avant-Garde Hillbilly and Blues Music." *Henry Flynt "Philosophy,"* 2002. Available at http://www.henryflynt.org/aesthetics/meaning_of_my_music.htm.

Foucault, Michel. "What Is an Author?" In *The Foucault Reader*, ed. Paul Rabinow. New York: Pantheon, 1984.

Freedman, Morris. "The Persistence of Plagiarism, the Riddle of Originality." *Virginia Quarterly Review: A National Journal of Literature and Discussion* 70 (1994): 504–17.

Fricke, Jim, and Charlie Ahearn, eds. *Yes Yes Y'all: The Experience Music Project Oral History of Hip-Hop's First Decade*. Cambridge: Da Capo, 2002.

Frith, S. *Music and Copyright*. Edinburgh: Edinburgh University Press, 1993.

Fusco, Coco. *The Bodies That Were Not Ours*. London: Routledge, 2001.

Garnett, Joy, and Susan Meiselas. "On the Rights of Molotov Man: Appropriation and the Art of Context." *Harper's Magazine* (February 2007): 53–58.

Gates, Henry Louis Jr. *The Signifying Monkey: A Theory of Afro-American Literary Criticism*. New York: Oxford University Press, 1988.

Gayford, Martin. "Triumph of the Elephant Man." *art.telegraph* (March 7, 2002). Accessed Mar 15, 2005, at http://www.telegraph.co.uk/arts/main.jhtml?xml=/arts/2002/07/03/bagayfo3.xml.

Gil, Gilberto. "Discurso do ministro Gilberto Gil na solenidade de transmissão do cargo." Speech at Brasilia, January 2, 2003. Available at http://www.cultura.gov.br/site/?p=1165.

———. "Speech of Minister Gilberto Gil at the First Session of the Intergovernmental Committee of the Convention on the Protection and Promotion of the Diversity of Cultural Expressions." Ottawa, Canada, December 11, 2007a. Available at http://www.cultura.gov.br/site/?p=9145.

———. "Discurso do ministro da Cultura, Gilberto Gil, em seminário sobre experiências acerca do tema Cultura Digital." Speech in San Francisco,

California, December 14, 2007b. Available at http://www.cultura.gov.br/
site/?p=9320.

Gilroy, Paul. *There Ain't No Black in the Union Jack.* London: Routlege Classics, 2002.

Ginsberg, Allen. "Literary History of the Beat Generation," Lecture 1, Naropa Institute. N.p.: June 9, 1977.

Goffman, Erving. *Forms of Talk*, 2nd ed. Philadelphia: University of Pennsylvania Press, 1981.

Greenberg, Lynne A. "The Art of Appropriation: Puppies, Piracy, and Post-Modernism." *Cardozo Arts and Entertainment Law Journal* 11 (1992): 1–33.

Greenland, Colin. *The Entropy Exhibition: Michael Moorcock and the British "New Wave" in Science Fiction.* London: Routledge and Kegan Paul, 1983.

Greenman, Ben. "The Mouse that Remixed." *NewYorker.com* (February 9, 2004). Accessed March 8, 2005, at http://newyorker.com/talk/content/?040209ta_talk_greenman.

Greetham, David. "Rights to Copy." *Text: Transactions of the Society for Textual Scholarship* 10 (1997): 135–44.

Guthrie, Woody. *Pastures of Plenty: A Self-Portrait.* Ed. D. Marsh and H. Leventhal. New York: Harper Perennial, 1990.

Gysin, Brion. "Dreamachine." In *Back in No Time: The Brion Gysin Reader*. Middletown, Conn.: Wesleyan University Press, 2001.

Harris, Michael. *Colored Pictures: Race and Visual Representation.* Chapel Hill: University of North Carolina Press, 2003.

Harris, Oliver. "Cutting Up Politics." In *Retaking the Universe: William S. Burroughs in the Age of Globalization*, ed. Davis Schneiderman and Philip Walsh. Sterling, Va.: Pluto Press, 2004, 175–200.

———. "Cutting Up the Corpse." In *The Exquisite Corpse: Creativity, Collaboration, and the World's Most Popular Parlor Game*, ed. Kanta Kochhar-Lindgren, Davis Schneiderman, and Tom Denlinger. Lincoln: University of Nebraska Press, 2009.

Haygood, Will. "Why Negro Humor Is so Black." *American Prospect* (December 18, 2000): 31–33.

Hegel, Georg Wilhelm Friedrich. *The Encyclopaedia Logic*, trans. T. F. Geraets, W. A. Suchting, and H. S. Harris. Indianapolis: Hackett, 1991.

Hemmungs Wirtén, Eva. *Terms of Use: Negotiating the Jungle of the Intellectual Commons.* Toronto: University of Toronto Press, 2008.

Hesmondalgh, David. "International Times: Fusions, Exoticism, and Antiracism in Electronic Dance Music." In *Western Music and its Others. Difference, Representation and Appropriation in Music*, ed. Georgina Born and David Hesmondhalgh. Berkeley: University of California Press, 2000, 280–304.

Hill, Napoleon. *Think and Grow Rich.* New York: Hawthorn Books, 1966.

Hoffman, Katherine, ed. *Collage: Critical Views*. Ann Arbor: UMI Research Press, 1989.

Hogenkamp, Bert. "Workers' Newsreels in the Netherlands (1930–1931)." In *Communication and Class Struggle*, ed. by Armand Mattelart and Seth Siegelaub. New York: International General, 1983.

Hopkins, Budd. "Modernism and the Collage Aesthetic." *New England Review* 18:2 (1997): 5–12.

Howard-Spink, Sam. "Grey Tuesday, Online Cultural Activism and the Mash-up of Music and Politics." *First Monday* 9:10 (September 30, 2004). Accessed February 5, 2005, at http://firstmonday.org/issues/issue9_10/howard/index .html.

Hyde, Lewis. *The Gift: Creativity and the Artist in the Modern World: 25th Anniversary Edition*. New York: Vintage, 2007.

Ivens, Joris. *The Camera and I*. New York: International Publishers, 1969.

Ivey, Bill, and Steven Tepper. "Cultural Renaissance or Cultural Divide?" *Chronicle of Higher Education: The Chronicle Review* 52:37 (May 19, 2006): B6.

Jameson, Fredric. *Postmodernism, or, The Cultural Logic of Late Capitalism*. Durham: Duke University Press, 1991.

Johnston, Nicole. "Artist Wins Case against Makers of Barbie doll." *World Today* (February 27, 2001). Accessed July 5, 2006, at http://www.abc.net.au/worldtoday/stories/s252386.htm.

Joris, Pierre. *A Nomad Poetics*. Middleton, Conn.: Wesleyan University Press, 2003.

Klein, Joe. *Woody Guthrie: A Life*. New York: Delta Trade Paperbacks, 1980.

Klein, Naomi. *No Logo: Taking Aim at the Brand Bullies*. New York: Picador, 1999.

KLF Communications. "The KLF Biography as of 20th July 1990 (KLF BIOG 012)." *Library of Mu* (1990). Accessed December 27, 2007, at http://www .libraryofmu.org/display-resource.php?id=512.

———. "KLF Info Sheet (January 22)." *Library of Mu* (1998). Accessed December 29, 2007, at http://www.libraryofmu.org/display-resource.php?id=501.

Kodály, Zoltán. "Magyar témák a külföldi zenében. Előszó Prahács Margit Könyvéhez [Hungarian themes in foreign music. Preface to Margit Prahács's book]." In *Visszatekintés. Összegyűjtött írások, beszédek, nyilatkozatok Vol. 2*, ed. Ferenc Bónis. Budapest: Zeneműkiadó, 1974a.

———. "Bartókról és a népdalgyűjtésről. Nyilatkozat [On Bartók and folk song collecting. Interview]." In *Visszatekintés. Összegyűjtött írások, beszédek, nyilatkozatok Vol. 2*, ed. Ferenc Bónis. Budapest: Zeneműkiadó, 1974b. (Available in English in: Kodály, Zoltán. *Selected Writings of Zoltán Kodály*, ed. Ferenc Bónis. London: Boosey and Hawkes, 1974.)

Lampert, Vera. "Bartók's Choice of Theme for Folksong Arrangement: Some Les-

sons of the Folk-Music Sources of Bartók's Works." *Studia Musicologica Academiae Scientiarum Hungaricae* 24:3 (1982): 401–9.

Latham, Robert. "Collage as Critique and Invention in the Fiction of William S. Burroughs and Kathy Acker." *Journal of the Fantastic in the Arts* 5:3 (1993).

———. "*New Worlds* and the New Wave in Fandom: Fan Culture and the Reshaping of Science Fiction in the Sixties." *Vector: The Critical Journal of the British Science Fiction Association* 242 (July/August 2005): 4–12.

Legrand, Pierre. "Issues in the Translatability of Law." In *Nation, Language, and the Ethics of Translation*, ed. Sandra Bermann and Michael Wood. Princeton: Princeton University Press, 2005, 30–50.

———. *Le Droit Comparé.* Paris: Presses Universitaires de France, 2009a.

Legrand, Pierre, ed. *Comparer les droits, résolument.* Paris: Presses Universitaires de France, 2009b.

Leiby, Richard. "Moby's Remixes of the Blues Make the Ads. While the Originals Don't Make a Cent." *Washington Post*, August 9, 2000. Available at http://www.blues.co.nz/news/article.php?id=341.

Lessig, Lawrence. *Free Culture: How Big Media Uses Technology and the Law to Lock Down Culture and Control Creativity.* New York: Penguin, 2004.

———. *Remix: Making Art and Commerce Thrive in the Hybrid Economy.* New York: Penguin, 2008.

Lethem, Jonathan. "The Ecstasy of Influence: A Plagiarism." *Harper's Magazine*, February, 2007. Available at http://www.harpers.org/archive/2007/02/0081387.

Lindenbaum, John. *Music Sampling and Copyright Law.* Unpublished thesis, 1999. Available at http://www.princeton.edu/~artspol/studentpap/undergrad%20thesis1%20JLind.pdf.

Litman, Jessica. "The Public Domain." *Emory Law Journal* 39 (1990): 965–1023.

———. *Digital Copyright.* Amherst, Mass.: Prometheus Books, 2001.

Luckhurst, Roger. *Science Fiction.* London: Polity, 2005.

Markusen, Ann, and David King. "The Artistic Dividend: The Arts' Hidden Contributions to Regional Development." University of Minnesota, Project on Regional and Industrial Economics, Humphrey Institute of Public Affairs. July 2003. Accessible at: www.hhh.umn.edu/img/assets/6158/artistic_dividend_revisited.pdf.

Marx, Karl. *Capital.* Trans. Samuel Moore and Edward Aveling. New York: Modern Library, 1906.

Mattel v. Forsythe. CV 99–8543 RSWL. US District Ct. of California. June 21, 2004.

Mauss, Marcel. *A General Theory of Magic.* New York: Routledge, 2001.

McLeod, Kembrew. *Owning Culture: Authorship, Ownership, and Intellectual Property Law.* New York: Peter Lang, 2001.

————. *Freedom of Expression®: Overzealous Copyright Bozos and Other Enemies of Creativity*. New York: Doubleday, 2005.

————. *Freedom of Expression®: Resistance and Repression in the Age of Intellectual Property*. Minneapolis: University of Minnesota Press, 2007.

Meikle, Graham. *Future Active: Media Activism and the Internet*. New York: Routledge, 2002.

Miles, Barry. *The Beat Hotel: Ginsberg, Burroughs, and Corso in Paris, 1958–1963*. New York: Grove Press, 2000.

————. *William Burroughs: El Hombre Invisible*. London: Virgin, 2002.

Miller, Paul D. *Rhythm Science*. Cambridge: MIT Press, 2004.

Moorcock, Michael. "A New Literature for the Space Age." *New Worlds* 142 (May–June 1964): 2–3.

————. "Introduction." In *New Worlds: An Anthology*, ed. Michael Moorcock. London: Flamingo, 1983, 9–26.

Morgan, Ted. *Literary Outlaw: The Life and Times of William S. Burroughs*. New York: Avon Books, 1990.

Muchnic, Suzanne. "Disney Demands Removal of Sculpture." *Los Angeles Times*, October 16, 1992: B1.

Neal, Mark Anthony, and Murray Forman, eds. *That's the Joint!: The Hip-Hop Studies Reader*. New York: Routledge, 2004.

Nebulose.net. "Grey Tuesday." Mar 10, 2005. Available at http://nebulose.net/blog/archives/cat_music.html.

Negativland. *Fair Use: The Story of the Letter U & the Numeral 2*. San Francisco: Seeland-Negativland, 1995.

Neil, Garry. "The Convention as a Response to the Cultural Challenges of Economic Globalization." In *UNESCO's Convention on the Protection and Promotion of the Diversity of Cultural Expressions: Making it Work*, ed. Nina Obuljen and Joost Smiers. Zagreb: Institute for International Relations, 2006. Culturelink Joint Publication Series no. 9, 1–49. Available at http://www.culturelink.org/publics/joint/diversity01/Obuljen_Unesco_Diversity.pdf.

Nelson, Cary. *Repression and Recovery: Modern American Poetry and the Politics of Cultural Memory, 1910–1945*. Madison: University of Wisconsin Press, 1989.

"New Espionage American Style." *Newsweek*, November 22, 1971, 28–40.

New Musical Express. "Timelords, Gentlemen Please!" *New Musical Express* (May 16, 1992).

Orlans, Harold. "Current Copyright Law and Fair Use: The Council of Editors of Learned Journals, Keynote Address, MLA Convention 2000." *Journal of Scholarly Publishing* 33:3 (2002): 125–47.

Osborne, Richard. "Blackface Minstrelsy from Melville to Moby." *Critical Quarterly* 48:1 (2006): 14–25.

Oswald, John. "Plunderphonics, or Audio Piracy as a Compositional Prerogative."

In *Casette Mythos*. Autonomedia, 1990. Available at http://www.halcyon.com/ robinja/ mythos/Plunderphonics.html.

Percy, Walker. *The Moviegoer*. New York: Knopf, 1961.

Pérez de Cuéllar, Javier. *Our Creative Diversity: Report of the World Commission on Culture and Development*. Paris: UNESCO, 1995.

Perloff, Marjorie. *The Futurist Moment*. Chicago: University of Chicago Press, 1986.

Perrone, Charles. *Masters of Contemporary Brazilian Song*. Austin: University of Texas Press, 1989.

Picasso, Pablo. *The Burial of the Count of Orgaz and Other Writings of Pablo Picasso*. Ed. Pierre Joris and Jerome Rothenberg. Boston: Exact Change, 2004.

Piché, Thomas Jr. "Collage: Half Explained and Almost Grasped." In *Collage: Signs and Symbols*. Pavel Zoebok Gallery. April 21–May 21, 2005.

Pinney, Christopher, and Nicholas Peterson, eds. *Photography's Other Histories*. Durham: Duke University Press, 2003.

Plant, Sadie. *The Most Radical Gesture: The Situationist International in a Postmodern Age*. New York: Routledge, 1992.

Platt, Charles. "Expressing the Abstract." *New Worlds* 173 (July 1967): 44–49.

———. "Fun Palace—Not a Freakout." *New Worlds* 180 (March 1968): 31–41.

Rambuss, Richard. "Sacred Subjects and the Aversive Metaphysical Conceit: Crashaw, Serrano, Ofili." *English Literary History* 71:2 (summer 2004): 497.

Rantings and Ravings 3.0. February 23, 2004. Accessed Mar 10, 2005 at http:// rantings.shaghaghi.net/ archives/a_letter_a_day_early.html.

Raymond, E. S. *The New Hacker's Dictionary*. Cambridge: MIT Press, 1996.

Read, Alan. *The Fact of Blackness*. Seattle: Bay Press and Iniva, 1996.

Reid, J. "Money to Burn." *Observer*, September 25, 1994.

"Review: Jay-Z/Linkin Park's 'Collision Course.'" *About.com*. Accessed March 10, 2005.

Rose, Mark. *Authors and Owners: The Invention of Copyright*. Cambridge: Harvard University Press, 1993.

———. "Nine-Tenths of the Law: The English Copyright Debate and the Rhetoric of the Public Domain." *Law and Contemporary Problems* 66 (2003): 75–87.

Saint-Amour, Paul K. *The Copywrights: Intellectual Property and the Literary Imagination*. Ithaca: Cornell University Press, 2003.

Sanjek, David. "'Don't Have to DJ No More': Sampling and the 'Autonomous' Creator." In *Popular Culture: Production and Consumption*. ed. C. Lee Harrington and Denise D. Bielby. London: Blackwell, 2001. Available at http:// www.law.duke.edu/curriculum/courseHomepages/spring2002/724_02/ samplingreading.doc.

"San Jose Law Firm Assists Elderly Taiwanese Couple Whose Work Gained Fame But Not Compensation." *Business Wire*, December 28, 1998.

Sartre, Jean-Paul. *What Is Literature?* Trans. Bernard Frechtman. New York: Philosophical Library, 1949.

Seger, Anthony. "Ethnomusicology and Music Law." In *Borrowed Power. Essays on Cultural Appropriation*, ed. Bruce Ziff and Pratima V. Rao. New Brunswick: Rutgers University Press, 1997.

Sharkey, Alix. "Trash Art and Kreation." *Guardian*, May 21, 1994.

Shaw, William. "Who Killed the KLF?" *Select* (July 1992).

Sheppard, Robert. "The Necessary Business of Allen Fisher." In *Future Exiles: 3 London Poets*. London: Paladin, 1992.

Shiva, Vandana. *Earth Democracy*. Cambridge: South End Press, 2005.

Shortsleeve, Kevin. "The Wonderful World of the Depression: Disney, Despotism, and the 1930s. Or, Why Disney Scares Us." *Lion and the Unicorn* 28:1 (2004): 1–30.

Simpson, Paul. *The Rough Guide to Cult Pop*. London: Rough Guides, 2003.

Smiers, Joost. *Arts under Pressure: Promoting Cultural Diversity in the Age of Globalisation*. London: Zed Books, 2003.

Smith, M. "The Great TUNE Robbery." *Melody Make*, December 12, 1987.

Sobieszek, R. A. *Ports of Entry: William S. Burroughs and the Arts*. London: Thames and Hudson, 1996.

Solnit, Rebecca, and Susan Schwartzenberg. "A Real Estate History of the Avant-Garde." In *Hollow City: The Siege of San Francisco and the Crisis of American Urbanism*. New York: Verso, 2000.

Sprigman, Chris. "The Mouse that Ate the Public Domain: Disney, the Copyright Term Extension Act, and *Eldred v. Ashcroft*." *Find Law*. Accessed March 5, 2002, at http://writ.news.findlaw.com/commentary/20020305_sprigman .html.

Steuer, Eric. ":14: Danger Mouse & Jemini/What U Sittin' On? (sidebar)." *Wired* (November 2004): 196.

Striphas, Ted, and Kembrew McLeod. "Strategic Improprieties: Cultural Studies, the Everyday, and the Politics of Intellectual Property." *Cultural Studies* 2–3 (March/May 2006): 119–44.

Strugatsky, Arkady, and Boris Strugatsky. *Roadside Picnic/Tale of the Troika*. New York: Pocket Books, 1977.

Summers, Rod. "VEC Audio Exchange." In *Sound by Artists*, ed. Dan Lander and Micah Lexier. Toronto: Art Metropole, 1990, 235–40.

"Taiwanese Settle Lawsuit Claiming Their Original Composition Was Stolen; They Will Now Set Up Foundation." *Business Wire*, June 23, 1999.

Taylor, Brandon. *Collage: The Making of Modern Art*. New York: Thames and Hudson, 2004.

Taylor, Timothy D. *Strange Sounds: Music, Technology and Culture*. New York: Routledge, 2001.

Theado, Matt, ed. *The Beats: A Literary Reference*. New York: Carroll & Graff, 2002.

Thompson, E. P. *Customs in Common: Studies in Traditional Popular Culture*. London: Merlin Press, 1991.

Thompson, Robert Farris. *Flash of the Spirit: African and Afro-American Art and Philosophy*. New York: Vintage, 1984.

Timelords. "Doctorin' the Tardis." *Discogs.com* (1988). Accessed December 27, 2007, at http://www.discogs.com/release/494935.

Tomasula, Steve. *The Book of Portraiture*. Normal/Tallahassee: FC2, 2006.

Ulmer, Gregory. *Applied Grammatology: Post(e)-Pedagogy from Jacques Derrida to Joseph Beuys*. Baltimore: Johns Hopkins University Press, 1985.

Underkuffler, Laura S. *The Idea of Property: Its Meaning and Power*. Cambridge: Cambridge University Press, 2003.

UNESCO. Convention on the Protection and Promotion of the Diversity of Cultural Expressions 2005. Passed October 20, 2005, in Paris. Available at http://portal.unesco.org/en/ev.php-URL_ID=31038&URL_DO=DO_TOPIC&URL_SECTION=201.html.

Vaidhyanathan, Siva. *Copyrights and Copywrongs: The Rise of Intellectual Property and How It Threatens Creativity*. New York: New York University Press, 2001.

———. *The Anarchist in the Library: How the Clash between Freedom and Control Is Hacking the Real World and Crashing the System*. New York: Basic Books, 2004.

———. "Afterword: Critical Information Studies. A Bibliographic Manifesto." *Cultural Studies* 2–3 (March/May 2006): 292–315.

Veloso, Caetano. *Tropical Truth: A Story of Music and Revolution in Brazil*. Trans. Isabel De Sena. New York: Knopf, 2002.

Venuti, Lawrence. *The Scandals of Translation: Towards an Ethics of Difference*. London: Routledge, 1998.

Verzola, Roberto. "Cyberlords: The Rentier Class of the Information Sector." *nettime.org*, March 15, 1998. Accessed July 5, 2006, at http://www.nettime.org/Lists-Archives/nettime-1-9803/msg00079.html.

Vinge, Vernor. *True Names . . . and Other Dangers*. New York: Baen, 1987.

Vogel, Carol. "Chris Ofili: British Artist Holds Fast to His Inspiration." *New York Times.com*, September 28, 1999. Available at http://partners.nytimes.com/library/arts/092899ofili-brooklyn-museum.html.

Von Lewinski, Silke. *International Copyright Law and Policy*. Cambridge: Cambridge University Press, 2008.

Waldrop, Rosmarie. *The Reproduction of Profiles*. New York: New Directions, 1987.

Watson, Ben. "King Boy D." *Wire* (March 1997).

Webb, Robert. "Pop: It's in the Mix—Tammy Wynette and the KLF Justified and Ancient (Stand by the Jams); the Independent's Guide to Pop's Unlikeliest Collaborations." *Independent*, November 3, 2000.

Weiss, Brad. "Thug Realism: Inhabiting Fantasy in Urban Tanzania." *Cultural Anthropology* 17:1 (February 2002): 93–124.

Wilson, R. A., and R. Shea. *The Illuminatus! Trilogy*. New York: Dell, 1984.

Wilson, Terry, and Brion Gysin. *Here to Go: Brion Gysin*. United Kingdom: Creation Books, 2001.

Woodmansee, Martha, and Mark Osteen. *The New Economic Criticism: Studies at the Intersection of Literature and Economics*. London: Routledge, 1999.

Worsdale, Godfrey, and Lisa G. Corrin. *Chris Ofili*. London: Serpentine Gallery and Southampton City Art Gallery, 1998.

Young, Stewart. "The KLF & Illuminatus!" *Easyweb* (1994). Accessed December 30, 2007, at http://easyweb.easynet.co.uk/~stuey/klf/23.htm.

Zipes, Jack. "Cross-Cultural Connections and the Contamination of the Classical Fairy Tale." In *The Great Fairy Tale Tradition: From Straparola and Basile to the Brothers Grimm*, ed. Jack Zipes. New York: W. W. Norton, 2001, 845–69.

CONTRIBUTORS

Craig Baldwin is a California filmmaker, publisher, and educator whose work in part reflects the Funk or Neo-Dada aesthetic that threads through Bay Area artwork of the past half-century, as well as Situationist strategies of détournement and media intervention. Over the past two decades, Baldwin has also been curating and screening thematic programs of radical documentary and experimental work in his weekly Other Cinema showcase. Baldwin is currently an adjunct faculty member of both the San Francisco Art Institute and California College of the Arts.

David Banash is an associate professor of English at Western Illinois University where he teaches courses in contemporary literature, film, and popular culture. His essays and reviews have appeared in *Bad Subjects: Political Education for Everyday Life*, *Paradoxa*, *PopMatters*, *Postmodern Culture*, *Reconstruction*, *Science Fiction Studies*, *Trickhouse*, and *Utopian Studies*.

Marcus Boon is an associate professor of English at York University, Toronto. He is the author of *The Road of Excess: A History of Writers on Drugs* and *In Praise of Copying* and the editor of *Subduing Demons in America: Selected Poems of John Giorno* and *America: A Prophecy! The Sparrow Reader*, both from Soft Skull. He writes about music for *The Wire*.

Jeff Chang was a U.S.A. Ford Fellow in Literature and a winner of the North Star News Prize. His first book, *Can't Stop Won't Stop*, garnered many honors, including the American Book Award and the Asian American Literary Award. He is the editor of *Total Chaos: The Art and Aesthetics of Hip-Hop*. He is currently writing two new books, *Who We Be: The Colorization of America* and *Youth*. In 1993, he co-founded and ran the influential hip-hop indie label, SoleSides, now Quannum Projects.

Joshua Clover is a scholar, poet, and journalist. His first collection of poems, *Madonna anno domini*, won the Walt Whitman Award from the Academy of American Poets. His most recent books include *The Matrix*, a book of film

criticism, and *1989: Bob Dylan Didn't Have This to Sing About*. He is currently a professor of Poetry and Poetics at the University of California, Davis.

Lorraine Morales Cox is an associate professor of Contemporary Art and Theory at Union College in Schenectady, New York. Her research centers largely on contemporary artists of color and transnational artists working in the United States, who create critically engaging work that confronts issues such as racism, sexism, homophobia, classism, and other forms of oppression. Her publications have appeared in *Women and Performance: A Journal of Feminist Theory* and in *Representation and Decoration in a Postmodern Age* and has written on the artists Ben Shahn, Jörg Immendorff, and Jonathan Calm.

Lloyd Dunn is a multimedia artist whose work includes video, film, sound, and graphic design. Beginning in 1983, he edited *PhotoStatic Magazine*, a zine devoted to photocopy art that brought together many threads from the burgeoning zine undergrounds of the 80s and 90s. In 1987, he co-founded The Tape-beatles, a group which helped pave the way for new music and sound art based on collage and sampling techniques. During the 2000s, he became increasingly involved in the ww and currently works as a freelance developer in Prague. In 2009, Dunn started a series of filecasts called Nula at http://nula.cc.

Philo T. Farnsworth launched the record label Illegal Art in 1998, and it has released records by Girl Talk, Steinski, Wobbly, People Like Us, and several other sound collage–oriented artists.

Pierre Joris is a poet, translator, essayist, and anthologist who has published over forty books, most recently *Canto Diurno #4: The Tang Extending from the Blade* (2010), *Justifying the Margins: Essays 1990–2006* and *Aljibar I & II*. Other recent publications include *Meditations on the Stations of Mansour Al-Hallaj 1–21* & *Paul Celan: Selections*, as well as *Lightduress* by Paul Celan, which received the 2005 PEN Poetry Translation Award. With Jerome Rothenberg he edited the award-winning anthologies *Poems for the Millennium (volumes I & II)*. He teaches at the University of Albany, SUNY.

Douglas Kahn is research professor at the National Institute for Experimental Arts at University of New South Wales in Sydney. He is the author of *Noise, Water, Meat: A History of Sound in the Arts* (1999) and *Earth Sound Earth Signal* (forthcoming), and editor, with Larry Austin, of *Source: Music of the Avantgarde* (2011) and, with Hannah Higgins, of *Mainframe Experimentalism: Early Computing and the Foundations of the Digital Arts* (2011).

Rudolf Kuenzli is a professor of comparative literature and English at the University of Iowa. He is also the director of the International Dada Archive at the University of Iowa. His previous publications include *Dada Artifacts* (1978), and contributions to *Artforum, Muttersprache,* and *Diacrtitics.* He has also edited with Stephen Foster *Dada Spectrum: The Dialectics of Revolt* (1979), *New York Dada* (1986), with Francis Naumann *Marcel Duchamp: Artist of the Century* (1988), *André Breton Today* (1989), *Surrealism and Women* (1991), and *Dada and Surrealist Film* (1996). Phaidon published his volume on Dada in 2006.

Rob Latham is an associate professor of English at the University of California, Riverside. A coeditor of the journal *Science Fiction Studies* since 1997, he is the author of *Consuming Youth: Vampires, Cyborgs, and the Culture of Consumption* (2002). He is currently working on a book on New Wave science fiction of the 1960s and 1970s.

Jonathan Lethem is the author of eight novels, the most recent of which is *Chronic City,* as well as two collections of short fiction and one of essays. His writing has been published in over thirty languages.

Carrie McLaren founded *Stay Free!* in 1993. A longtime blogger, she speaks regularly on the topic of advertising and media. She is coeditor of *Ad Nauseam: A Survivor's Guide to American Consumer Culture* (2009).

Kembrew McLeod is an associate professor of communication studies at the University of Iowa and an independent documentary filmmaker. His books and films focus on both popular music and the cultural impact of intellectual property law. His *Freedom of Expression®: Resistance and Repression in the Age of Intellectual Property* received the American Library Association's Oboler book award for "best scholarship in the area of intellectual freedom" in 2006. He coauthored with Northwestern law professor Peter DiCola the book *Creative License: The Law and Culture of Digital Sampling,* published by Duke University Press (2011). Most recently, he co-produced the documentary *Copyright Criminals,* which premiered at the Toronto International Film Festival and aired on PBS's Emmy Award–winning documentary series *Independent Lens.* McLeod's music and cultural criticism have appeared in *Rolling Stone, New York Times, Washington Post, Los Angeles Times, Wilson Quarterly, Village Voice, Mojo, Spin,* and the *New Rolling Stone Album Guide.*

Negativland have been creating records, fine art, video, books, radio and live performances using appropriated sound, image, and text since 1980. Mixing original materials and music with things taken from corporately owned mass

culture, the group rearranges these bits and pieces to make them say and suggest things that they never intended to. In doing this kind of cultural opposition and culture jamming (a term coined by the group in 1984), Negativland have been sued twice for copyright infringement.

Davis Schneiderman is a multimedia artist and the author or editor of eight books, including the recent novels *Drain* (2010) and *Blank: a novel* (2011) and the co-edited collections *Retaking the Universe: Williams S. Burroughs in the Age of Globalization* and *The Exquisite Corpse: Chance and Collaboration in Surrealism's Parlor Game*. He is the chair of the English Department at Lake Forest College, and also the director of Lake Forest College Press/&NOW Books. He edits *The &NOW AWARDS: The Best Innovative Writing*.

David Tetzlaff is an independent media artist and critic. He was formerly an associate professor of Film at Connecticut College.

Siva Vaidhyanathan is a cultural historian and media scholar and is currently associate professor of Media Studies and Law at the University of Virginia. From 1999 through the summer of 2007, he worked in the Department of Culture and Communication at New York University. Vaidhyanathan is a frequent contributor on media and cultural issues in various periodicals including the *Chronicle of Higher Education*, *New York Times Magazine*, *Nation*, and *Salon.com*. Vaidhyanathan is a fellow of the New York Institute for the Humanities and the Institute for the Future of the Book. He is currently finishing his book, *The Googlization of Everything*.

Gábor Vályi is a scholar of cultural sociology and a DJ. He teaches courses on the cultural history of recorded music, subcultural economies, and the consumption of popular culture at the Budapest University of Technology and Economics. He is writing his dissertation in sociology on the practices of identity and belonging in the "crate digging" scene—a translocal hip hop related record collecting collectivity—at Goldsmiths College (University of London).

Eva Hemmungs Wirtén is a professor and the director of graduate studies in Library and Information Science in the Department of Archival Science, Library and Information Science, Museology, and an associate professor in Comparative Literature at Uppsala University, Sweden. She is the author of *No Trespassing: Authorship, Intellectual Property Rights, and the Boundaries of Globalization* (2004) and *Terms of Use: Negotiating the Jungle of the Intellectual Commons* (2008).

Italicized page numbers indicate illustrations.

American New Wave science fiction (SF), 281. *See also* New Wave science fiction (SF)

analog media, 43, 82, 83. *See also* audiotapes

angel metaphor, 268–71

Antin, David, 190

Anton, Robert, 166–67

appropriation art, 294–95, 297; graffiti writing as, 29, 31, 33; literary collage and, 291–93, 298–300; lyrics and, 11–12, 299; music appropriation and, 20–22, 226; originality and, 291, 299. *See also* collage; indigenous/folk music appropriation; indigenous/folk music appropriation in classical music

The Arcades Project (Benjamin), 10, 52, 54, 55, 268, 270–71

art as business, 127–28

artistic movements, 1. *See also specific movements*

Art Strike (1990–1993), 59–60

ASCAP, 306, 313

audiotapes: CIA's psychological warfare and, 106–7; collage history and, 1, 6–7, 79, 82, 121; cut-ups and, 103–7; musique concrète technique, 6–7; originality and, 78; remix and, 6–7; repeated replacement of fragments of speech on, 101–3; tape effects and, 78, 79. See also *Sad News*

audiovisual collages, 121

Aunt Jemima stereotyped image, 208–9, 211, 217n11

authors/owners: ambiguity in collage and, 89–91, 93n5; collective ownership by indigenous groups, 222–23, 228–29, 246; copyright law and, 136–39; Dunn on, 77; hip-hop sampling and, 89–91; indigenous/folk

music appropriations and, 226–31; intellectual property law and, 147, 226, 231, 243–44, 248–49; KLF and, 170–71; literary collage and, 145–47, 151n18; mashups and, 135–38, 146–47; originality and, 136–38, 254, 257; public domain and, 219; recorded music and, 219; romanticism of, 170; Vaidhyanathan on, 44–45; violence and, 228

avant-garde: collage and, 1; infinite element understanding among, 35; literature and, 296; New Wave science fiction and, 278, 280–81, 283–84; sample clearance fees and, 158–59; tropicalia artists and, 249; video installations and, 274. *See also specific artists*

Baartman, Saartjie, 210, 217n10

Badiou, Alain, 25, 35

Ballard, J. G.: literary styles and, 279–80, 282–83; on originality, 285; psychological explorations and, 278–81, 284; on Surrealism, 281, 284, 288; technocracy critiques and, 279–83; text cut-ups and, 281–82; visual techniques and, 279, 281–82. *See also* New Wave science fiction (SF)

Barbie, 15–17. *See also* Mattel

bargaining power, 45–46, 48–49

Bartók, Béla, 20–21, 219–25, 230–32, 235n1, 235n2, 236n4

BBC Radio News, 94–95, 100, 103–5, 176–77

Beatles, 19, 79, 132–34, 140, 148n3, 163–65, 169

Beck, 19, 160–62

Bendix, Crosley, 8, 169

Benjamin, Walter: ambiguity of culture

and, 85; angel metaphor in literary collage and, 268–71; *The Arcades Project*, 10, 52, 54, 55, 268, 270–71; copyright law and, 10, 11; literary collage and, 9, 52–54, 84, 135; on photographic apparatus metaphor, 303–4; on politics and collage, 8–9, 22, 276, 283

Bernstein, Charles, 185, 191

billboard alterations, 7–8, 178–84, *179–84*

biopharmaceuticals, 139, 228–29

blacks. *See* African Americans

blaxploitation, 202, 204, 213

bloopers, 100–101

blues, 45–46, 244, 291, 294, 301, 310

Böll, Heinrich, 101–3

Bollier, David, 14–15

Bomb Squad, 153, 157. *See also* Public Enemy

Bowie, David, 274–75

Braque, Georges, 201, 205

Brazilian cultural diversity, 21, 246–50

break-in, and "Sad, very sad" news reports, 97–101

Brecht, Bertolt, 276–77

Breton, André, 303

British Copyright Act, 137

British New Wave science fiction (SF). *See* New Wave science fiction (SF); *specific periodicals and writers*

Brown, Julie, 235n2

Brown, Michael F., 228–29, 233

Buchanan, Bill, 98, 119, 132

Buck-Morss, Susan, 85

Burroughs, William S.: audiotape cut-ups and, 103–4, 106; authors/owners and, 145–47, 151n18; collaboration and, 140–47, 150n12, 151nn13–16; image of collage as metaphor and, 267; New Wave science fiction text cut-ups and, 278, 281–83; plagiarism and, 140, 150n11, 300; on power of collage, 273; reproduction and, 139–46; on technology techniques, 27; text cut-up method and, 27, 134, 139–47, 149n6, 150nn11–12, 272–73, 300; *The Third Mind*, 134, 140–47, 150n11, 151n13, 272–73; tongue-slipping and, 104–5

Burton, Brian (Danger Mouse), 133, 135–37, 140, 147, 149n5, 150n7

Cage, John, 35, 79, 191

Campbell v. Acuff-Rose Music, Inc., 124

Canto Diurno (Joris), 192–93

Carnell, John, 279–80

cartoons, 302

Cauty, Jimmy, 18–19, 164–65, 167–68, 170, 172–73. *See also* KLF

celebrity stars, 213–14

censorship/free speech, 16, 18, 42–43, 123, 126, 128–29, 139

cento (patchwork poem), 9, 135–36, 149n4

Central Intelligence Agency (CIA), 106–7

Chander, Anupam, 259

Christian culture, 29–31, 35

Chuck D, 89, 153, 155–57, 249. *See also* Public Enemy

CIA (Central Intelligence Agency), 106–7

classical music. *See* indigenous/folk music appropriation in classical music

classical music compositional practices, 118. *See also* indigenous/folk music appropriation in classical music

class, 21, 199, 201–2, 204–5, 207–8, 210–11, 216

of persecution by artists and, 232;
romanticism of copyright and,
21–22, 50; Sony Bono Copyright
Terms Extension Act, 136; Statute
of Anne, 136, 261; theft and, 307;
unrecorded music and, 232. *See also*
intellectual property law

Copyright Violation Squad (CVS), 60

corporate control of media culture:
African Americans and, 244; copy-
right law and, 13–15, 47–48, 292;
creativity and, 243, 255–56; fair
use and, 15–16; hip-hop sampling
and, 13–14, 117, 120–21, 129, 155;
Illuminati and, 167; intellectual
property law and, 12, 14; language/
corporate-speak and, 17–18; liter-
ary collage and, 316; sample clear-
ance fees and, 225

Corso, Gregory, 142, 151n14

Cox, Renee, 210

Creative Commons, 137–38, 247

creativity: collage-as-metaphor in lit-
erary collage and, 264, 272, 275n1;
corporate control of media cul-
ture and, 243, 255–56; in critique of
copyright law, 262; cultural access
gaps and, 244–45; cultural diversity
and, 240–42, 247–50; Disney and,
255–57; freedom of expression and,
239–41, 246–47; gender and, 257;
gift economy and nonmarketplace
values of, 237–38, 244–47, 311–13,
316–17; globalization and, 238–45;
intellectual property law and, 243–
44, 254–56, 262; literary collage
and, 302, 311–13, 316; marketplace
value and, 238–40, 242–44; pub-
lic domain and, 238; social change
and, 237–38; UNESCO report and,
239; violence and, 248, 315

Cubism, 201, 205

cultural diversity, 224, 236n4

cultural sampling. *See* Ofili, Chris

culture: ambiguity in collage and,
84–86, 93n2; Christian, 29–31, 35;
cultural access gaps and creativity,
244–45; cultural diversity and
creativity, 240–42, 247–50; free,
24–25, 291; hip-hop sampling and,
84; signs of, 304–5

culture jamming, 13, 16–20, 17, 169

cut-ups: audiotape, 103–4, 106; liter-
ary collage text, 27, 134, 140–47,
150n12, 151nn15–18, 272–73; New
Wave SF text, 278, 281–83

CVS (Copyright Violation Squad), 60

Dadaism, 2–3, 58, 92, 140, 150n10, 201,
271–72. *See also specific artists*

Dalí, Salvador, 279, 281–82, 284, 288

Danger Mouse (a.k.a. Brian Burton),
133, 135–37, 140, 147, 149n5, 150n7

Debord, Guy, 3, 165

Deconstructing Beck, 19, 160, 162

Deleuze, Gilles, 87, 93n1, 187, 188, 190–
91, 193–94

DeLillo, Don, 272–73

De Man, Paul, 87

Derrida, Jacques, 11, 89, 186–87

détournement technique, 3, 58, 118–19

diasporic African culture, 205–11

Dick, Philip K., 30–31, 33

digital mana, 32–35, 37n5

digital media, 42, 82–83. *See also* re-
corded music

Digital Millennium Copyright Act
(DMCA), 17–18, 136

Discordianism, 167–69

Disney, 14, 76, 136, 255–57, 307, 310, 316

disruption of seeing/seeing, 200–201,
203, 207–8, 216

Dixon, Willie, 45–46, 310

DJ Spooky (Paul Miller), 37, 149n6

DMCA (Digital Millennium Copyright Act), 17–18, 136

Dr. Dre, 156

"Doctorin' the Tardis" (KLF), 170–71

documentary films, 50, 247

Donne, John, 298–99

Double Captain Shit . . . (Ofili), 212–14

Doupland, Douglas, 269–70

Downhill Battle, 133, 134, 147

Drummond, Bill: on "All You Need is Love," 168–69; on authors/owners, 170–71; on billboard alterations, 169; flaming out by, 173–74; hiphop sampling and, 18–19, 164–65; 175–77; "illegal art" and, 19, 165; *The Manual* (KLF), 171–72; No Music Day event and, 176–77; on organization/disorganization, 166; on recorded music industry, 175, 177

Duchamp, Marcel, 26, 33, 136, 140, 265

Dutch Association for Popular Culture (VVVC; Vereeniging voor Volks Cultur), 108–9

Dylan, Bob, 20, 244, 291, 299, 311

Ebsen, Buddy, 114–15

Electronic Frontier Foundation, 134, 258

electronic media, 1–3, 27, 60–61, 80–81, 95, 116n1. *See also* audiotapes

elephant dung incorporation in art, 203–5, 207, 212, 217n3

Eliot, T. S., 1, 296, 302–3

Ernst, Max, 201, 281, 284

Escher, M. C., 279, 283–84

ethnomusicology (folk melodies collection practices), 221–24, 226–27, 230, 235n2

fables and fairy tales, 255–56

fair use: copyright law coexistence with, 160–63; corporate control of media culture and, 15–16; DMCA and, 17; hip-hop sampling and, 122, 124, 126–30; reuse and, 126–27; Vaidhyanathan on, 41, 46–47

Falconer, Delia, 9, 135

fans, production/consumption by, 134–35, 149n5, 156–57, 162, 168

Fear of a Black Planet (Public Enemy), 154–55, 168

Federman, Raymond, 276–77

Feld, Steven, 226–28, 234, 240

female sexuality critique, 207–11

file sharing, 25, 32, 92. *See also* Napster

films: blaxploitation, 202, 204, 213; collage in, 50; collage-as-metaphor in, 273–75; copyright law and, 47; documentary, 50, 247; movie dialogue, copyright law, trademarked products and, 12; public domain and, 304

Finch, Christopher, 284–85

fine arts, 118–19

Fisher, Allen, 194–98

Fitch, Janet, 264–69

Florida, Richard, 241

"The Flying Saucer" (Buchanan and Goodman), 98–99, 132, 148n1

fold concept, 144, 190–91

folk traditions: collage and, 200–201; ethnomusicology and, 221–24, 226–27, 230, 235n2; industrial folk cultures and, 25–27, 34–36, 36n2; visual techniques and, 204–5, 214–15, 218n15

Forsythe, Tom, 15–16, 146

free culture, 24–25, 291

free and freedom, 254, 258–60, 262

freedom of expression, 18, 22, 42, 228–29, 239–41, 246–47, 251n7

free speech/censorship, 16, 18, 42–43, 123, 126, 128–29, 139

Gates, Henry Louis, Jr., 28, 47

gender: copyright law and, 22, 257, 262; creativity and, 257; female sexuality critique and, 207–11; originality and, 22, 258; photography and, 201–2, 204–5, 207–8; visual techniques and, 21, 199, 202, 204, 210–11, 216

gift economy/nonmarketplace values of creativity, 237–38, 244–47, 311–13, 316–17

Gil, Gilberto, 21, 246–50

Gillis, Gregg (a.k.a. Girl Talk), 160–63

Ginzburg, Carlo, 207–8

Girl Talk (Gregg Gillis), 160–63

Giuliani, Rudy, 207, 217n7

Glass, Philip, 158–59

globalization: copyright law and, 138–39, 150n9; creativity and, 238–40, 241–45; intellectual property law and, 139, 150n9, 243, 246; music appropriation and, 20–22, 226. See also indigenous/folk music appropriation

Goodman, Dickie, 98–99, 119, 132

graffiti, 29, 31, 33

Grand Upright v. Warner Bros., 90

grassroots level, and collage, 125, 128

Gray Album (Danger Mouse), 133–37, 139, 146–47, 148n3, 149nn4–5

Greetham, David, 137

Grey Tuesday protest, 133, 134, 147

Guattari, Félix, 188, 190, 193–94

Guthrie, Woody, 3–5, 311

Gysin, Brion: authors/owners and, 145–47, 151n18; collaboration and, 140–47, 150n12, 151nn13–14; infinite element in art and, 26–27, 35; text cut-ups and, 27, 134, 140–47, 150n12, 151nn15–18, 272–73; *The Third Mind*, 134, 140–47, 150n11, 151n13, 272–73

hackers, 22, 26, 34, 36, 166–67, 257–58

Hall, Vera, 227, 234

Harris, Lyle Ashton, 210

Harris, Michael, 208–9, 211

Harris, Oliver, 143, 151n12

Heartfield, John, 2–3, 108, 110

Heck, John, 77–78, 80, 81, 82, 83

Hegel, Georg Wilhelm Friedrich, 34–35, 86

hegemony, 21–22, 252–53, 260–62

Heidegger, Martin, 93n1, 303

Hickey, Dave, 87, 93n2

hip-hop sampling: about, 1, 153, 175–76; African Americans and, 1, 202, 207, 210–11; ambiguity and, 84, 89–93; analog media and, 82; art as business and, 127–28; authors/owners and, 89–91; censorship and, 123, 126, 128–29; coexistence of fair use and copyright law approach and, 129–30; collaborations and, 165, 168; collage and, 13, 118–21, 128–29, 131; context and, 77–78; copyright law and, 121–23, 129–30, 154, 222, 244, 293; corporate control of media culture and, 13–14, 117, 120–21, 129, 155; culture and, 84; culture jamming and, 13, 169; Dadaism and, 92; détournement technique and, 118; digital media and, 82–83; DMCA and, 17–18; fair use and, 122, 124,

collective authors/owners, 222–23, 228–29, 246; biopharmaceuticals in, 139, 228–29; Brazilian, 21, 249; freedom of expression and, 228–29, 246–47, 251n7; inequities and, 215, 227–28, 248–50; intellectual property law and, 228–29; marketplace values and, 239–40; public domain and, 248

industrial folk cultures, 25–27, 34–36, 36n2

infinite element in art: avant-garde and, 35; Christian culture and, 29–31, 35; collage and, 31–32; digital mana and, 32–35, 37n5; file sharing and, 32; graffiti writing as appropriation of, 29, 31, 33; hip-hop sampling and, 28–30, 33–34, 36, 37n4; industrial culture and, 29–30; industrial folk cultures' understanding of, 25, 27, 34–36; Jamaican DJing records and, 27–28, 301; magical practices and, 27, 32–34; as mathematical concept, 28–29, 34, 37n6; naming power and, 34; science fiction writings and, 30–31

intellectual property law, 162, 252; authors/owners and, 226, 231; communication acts and, 2, 228–29; corporate control of media culture and, 12, 14; creativity and, 243–44, 254–56, 262; fables/fairy tales and, 255–56; free/dom in critique of, 259–60; freedom of expression and, 18, 22; gender and, 22, 257, 262; globalization and, 139, 150n9, 243, 246; hegemony and, 252–53, 262; indigenous cultures and, 139, 228–29; intellectual property terminology, 39–40; literary collage and, 20, 141; national/international borders and, 262–63; privatization of intellectual property and, 130; public domain and, 262–63; racism's impact on, 248–49. *See also* copyright law; intellectual property rights

intellectual property owners, 12, 14, 17, 18, 244. *See also* intellectual property law; intellectual property rights

intellectual property rights, 22, 39–40, 133, 229, 252–53, 257, 260, 262. *See also* intellectual property law; intellectual property owners

International Workers of the World (Wobblies; IWW), 4–5

Internet: computer hackers and, 22, 26, 34, 36, 166–67, 257–58; fans remixing hip-hop on, 156–57; file sharing and, 25, 32, 92; Napster and, 25, 32, 38–39, 92, 175; public domain and, 130–31; shrinkwrap/clickwrap contracts online and, 41; Web sites and, 17–18, 121, 292

intertexualities, 186–87

interventionist collage, 19–20

IP system. *See* intellectual property law

It Takes a Nation of Millions to Hold Us Back (Public Enemy), 152–55

Ivens, Joris, 108–9

Ivey, Bill, 244–45

IWW (International Workers of the World; Wobblies), 4–5

Jamaican DJing records, 27–28, 301

Jameson, Fredric, 239, 274

JAMS, 19, 164, 166, 169

Jay-Z, 132–34, 137, 140, 147

jazz, 103, 195, 208, 224–25, 244, 301

Jefferson, Thomas, 38, 306–7, 312

journalism, 50, 297

Justified Ancients of Mu Mu (pseud.), 19, 164, 166–68. *See also* KLF

juxtapositions, 189–91

Kahn, Douglas, 6–7, 94–116

Katz, Joel, 8, *181, 182*

K Foundation, 173–74. *See also* KLF

Klee, Paul, 268–69

Klein, Naomi, 7–8

KLF: "All You Need is Love," 168–69; authors/owners and, 170–71; Beatles, hip-hop sampling, and, 19; billboard alterations and, 169; Cauty and, 18–19, 164–65, 167–68, 170, 172–73; collaborations and, 165, 168; conceptual high jinks and, 168; culture jamming and, 169; "Doctorin' the Tardis," 170–71; flaming out and, 172–74; hip-hop sampling and, 18–19, 164–65, 175–77; "Houston Joins the JAMS," 165; "illegal art" and, 19, 164–65; *The Illuminatus! Trilogy* (Shea and Wilson) and, 166–67; Justified Ancients of Mu Mu (pseud.), 19, 164, 166–68; K Foundation, 172–73; *The Manual*, 171–72; No Music Day event and, 176–77; organization/disorganization and, 166; production/consumption by fans and, 168; pseudonyms of, 19, 164; recorded music industry and, 175, 177; The Timelords (pseud.), 19, 164, 170, 172; Turner Prize spoof, 173–74. *See also* Drummond, Bill

Kodály, Zoltán, 20–21, 219–25, 230–32, 235n1, 235n2, 236n4

Kosh, Kenneth, 151n12, 311

Kruger, Barbara, 3, 13, 59

Kuo Ying-Nin and Hsin-Chu, 227

Lander, Dan, 95–97

Lessig, Lawrence, 16, 24, 253, 257, 292–93

literary collage, 185–86, 275n2, 290–91; African Americans and, 21, 199; ambiguity of culture and, 85; angel metaphor in, 268–71; appropriation art and, 20, 291–93, 293–97, 298–300; appropriation of lyrics and, 11–12, 299; audiotape cut-ups and, 103–4, 106; authors/owners and, 145–47, 151n18; collaborations and, 140–47, 142, 150n12, 151nn13–16, 295; collage-as-metaphor, 264–65, 268–73, 275n1; collage in cultural production, 301–2; copyright law and, 9–12, 11–12, 291–93, 295, 306–7, 316; corporate control of media culture and, 316; creativity and, 302, 311–13, 316; Dadaism and, 140, 150n10; experimental, 51–57; free culture manifesto and, 24, 291; hip-hop sampling and, 20, 294; "illegal art" and, 292–93; intellectual property law and, 141; intertexualities and, 186–87; key to sources and, 317–25; mashups and, 20, 293–94; monopoly on use under copyright law and, 307–8, 315; New Wave science fiction text cut-ups and, 278, 281–83; nomadic poetry and, 188–90; nonmarket-place values of creativity/gift economy and, 246, 311–13, 316; open source music culture and, 301; photography as metaphor and, 303–4; Picasso and, 185–90; plagia-

rism and, 20, 140, 150n11, 296–97, 300; politics and, 8–9, 22, 276, 283; power of collage and, 273; preservation/recirculation of literature and, 303; public domain and, 304, 313–16; reproduction and, 139–46; second use/use and, 308–10; signifiers and, 186–87; signs of culture and, 304–5; source hypocrisy and, 310–11; text cut-up method and, 27, 134, 139–47, 149n6, 150nn11–12, 272–73, 300; timelessness in literature and, 304–5; tongue-slipping and, 104–5; undiscovered public knowledge and, 314–15. *See also specific writers and writings*
literature: appropriation in, 20, 293, 295–96, 298–300; avant-garde and, 296; monopoly on use under copyright law and, 315; originality and, 296–97; preservation/recirculation of, 303; timelessness and, 304
Litman, Jessica, 253
Lomax, Alan, 227, 234, 301
Luckhurst, Roger, 282–83

magical practices, 27, 32–34
magnetic tape technologies. *See* audiotapes
The Manual (KLF), 171–72
"Marines" (billboard alterations), *184*
marketplace values of creativity, 242–43. *See also* nonmarketplace values of creativity/gift economy
Marks, Toby (Banco de Gaia), 228
mashups, 92, 117–18, 148n1; aesthetic pastiche and, 134–35, 149n4; authors/owners and, 135–38, 146–47; as collaborative art, 137–38; copyright law and, 133–35, 148n2; hip-hop sampling and, 132–34, 148n3;

"illegal art" and, 134, 148n3; intellectual property rights and, 133; literary collage and, 20, 293–94; production/consumption by fans and, 134–35, 149n5
Mattel, 12, 15–17, 146, 148
Mauss, Marcel, 32–33
McCaffery, Steve, 190
McLaughlin, Pad, 8, *181*
McLuhan, Marshall, 54, 264, 278, 285
mediascapes, 273–75
Mehrjui, Dariush, 315
Mickey Mouse, 14, 76, 136, 255, 307, 316
Miller, Paul (a.k.a. DJ Spooky), 37, 149n6
minstrel character, 208, 213–14
Mr. Len, 158–59
Moby, 227
Moholy-Nagy, László, 7, 78
Monroe, Marilyn, 214, 218n14
Monty Python, 43–44, 255
Moorcock, Michael, 280–81, 283–84
moral acceptability, of indigenous/folk music appropriation, 220–21, 223, 233–34, 235n2
"MORALE is Lowest" (billboard alterations), *180*
moral rights, 43, 45, 48–49
Motion Picture Association of America (MPAA), 307–8
MTV, 48–49, 149n6, 243
Muddyman, 234
Mukurtu Wumpurrarni-kari Archive, 247, 251n7
music appropriation, 20–22, 226. *See also* indigenous/folk music appropriation; indigenous/folk music appropriation in classical music
music lyrics, 299
musique concrète technique, 6–7

208–10; sexuality and, 21, 199, 202, 210–11, 216; spirituality and materiality links and, 211–12; stereotyped exaggerations and, 204, 207–9, 217nn8–9; virgin–whore dichotomy and, 201, 211–12

Olson, Charles, 194

Only Skin Deep (exhibit), 201–2

open source music culture, 301

Oppenheim, Dennis, 14, 310

originality: appropriation art and, 291, 299; audiotape effects and, 78; authors/owners and, 136–38, 254, 257; gender and, 22, 258; intellectual property owners and, 244; KLF and, 170; literature and, 296, 297; New Wave science fiction and, 285; nonmarketplace values of creativity/gift economy and, 317; plagiarism and, 54, 150n11, 316–17; production/consumption by fans in mashups and, 134–35, 149n5; recycling by artists and, 88; undiscovered public knowledge and, 314–15

Oswald, John, 1, 132, 148n1, 165

Paik, Nam June, 274

Paolozzi, Eduardo, 279, 283–85

patchwork poem (cento), 9, 135–36, 149n4

pay to play, 124–25

peer-to-peer systems, 39

Percy, Walker, 305

Perloff, Marjorie, 185–86

Peterson, Nicholas, 202, 207, 215

photocopying, 7, 58–61, 62–75, 78

photography: class issues and, 201–2, 204–5, 207–8; electronic gates for digital formats and, 42–43; as metaphor, 303–4; photo collages, 200; photographic apparatus metaphor, 303–4; public domain and, 304; race, gender, class, sexuality, and nationalism issues, 201–2, 204–5, 207–8

photomontages, 2–3, 85, 108, 275, 279, 284–85, 289

PhotoStatic Magazine, 7, 57–61, 62–75

Picasso, Pablo, 141, 185–90, 201, 205, 217n6, 310

Piché, Tomas, Jr., 200

Pinney, Christopher, 202, 206

placement/replacement, 87, 101–3. *See also* collage

plagiarism, 150n11, 166; cartoons and, 302; copyright law and, 140, 150n11; imperial, 310; Lethem on, 20, 296–97; originality and, 54, 150n11, 316–17; paradoxes of, 296–97; sampling as creative, 19; student, 52, 54–55, 297

Plagiarism®, 54, 79–83

Platt, Charles, 284, 285

poetry collage: cento and, 9, 135–36, 149n4; interweaving in, 192–93; Joris on, 185; juxtapositions and, 189–91; long-term projects in, 192–98; multiplex of events in, 195–98; process-showing and, 194–95; rhizome model and, 190, 193–94; seams/seems and, 190–91

political economy of black space, 206–7, 215–16

politics: ambiguity in collage and, 84, 91–93; collage and, 8–9, 22–23, 276, 283; cultural production of media fiction and, 106–7; hip-hop sampling and, 22–23, 84, 91–93; literary collage and, 8–9, 22, 276, 283; New Wave science fiction's sociopolitical repercussions and, 276–77

symbols, 47–48, 50; on intellectual property terminology, 39–40; on international scope of copyright law, 254; on market incentive, 44–45; on merchandising and licensing rights, 40; on moral rights for artists, 43, 45, 48–49; on peer-to-peer systems, 39; on privatization and private control, 42

VEC project, 95, 97

Veloso, Caetano, 21, 249

The Velveteen Rabbit (Williams), 309

Venn diagram, 88, 93n3

Venus Hottentot (Harris and Cox), 210

verbal collage. *See* literary collage

Vereeniging voor Volks Cultur (Dutch Association for Popular Culture), 108–9

video art, 274, 293

Vinge, Vernor, 34

violence: authors/owners and, 228; collage and, 89, 93; creativity and, 248, 315; cultural diversity solutions to, 248; indigenous group authors/owners and, 228; mediascapes and, 274; New Wave science fiction and, 282, 289; of ownership in hip-hop sampling, 91; race conflation with, 212, 214; "Sad, very sad" news reports and, 99, 110–11; sex conflation with, 212, 214; solutions for, 248; stereotyped images of blacks and, 206

virgin–whore dichotomy, 201, 211–12

visual techniques: collage and, 185, 189, 275n2; complex meanings and, 21, 199, 202, 204, 210–11, 216; New

Wave science fiction and, 278–85, *286, 287,* 288; photocopying and, 81–82

Von Lewinski, Silke, 260

Von Lichberg, Heinz, 298

VVVC. *See* Vereeniging voor Volks Cultur

Warhol, Andy, 14, 26, 119, 136, 212–14, 310

"War Machines" (billboard alterations), *180*

Warumungu people, 247, 251n7

Waters, Muddy, 301

Whiteread, Rachel, 173–74

whore–virgin dichotomy, 201, 211–12

Williams, Margery, 309

women, 199–201, 207–12. *See also* gender; sexuality

"Wordsworthian formula," 137–38

World Intellectual Property Organization, 260

World Trade Organization (WTO), 242, 252, 260

writing practices, 9, 29–31, 33, 140, 150n10. *See also specific writing practices*

Wynette, Tammy, 165

xerox art, 58–59, 60–61, 62–75

Xerox Corporation, 7

YAWN (zine), 59–60

Yes Men, 16–17

zines, 57–61, 62–75. *See also specific zines*

Kembrew McLeod is an associate professor of communication studies at the University of Iowa and an independent documentary filmmaker.

Rudolf Kuenzli is professor of comparative literature and English at the University of Iowa and director of the International Dada Archive.

Library of Congress Cataloging-in-Publication Data
Cutting across media : appropriation art, interventionist collage, and copyright law / Kembrew McLeod and Rudolf Kuenzli, eds.
p. cm.
Includes bibliographical references and index.
ISBN 978-0-8223-4811-5 (cloth : alk. paper) —
ISBN 978-0-8223-4822-1 (pbk. : alk. paper)
1. Copyright—Art. 2. Collage—Social aspects.
3. Intellectual property. I. McLeod, Kembrew, 1970–
II. Kuenzli, Rudolf E.
KF3050.C888 2011
346.04′82—dc22 2010049739